CW01370223

TRAMS

Books by the same author

TRAMCAR TREASURY
TRANSPORT TREASURES OF TRAFFORD PARK
ON THE TRAMS
HERITAGE TRAMS

Previous Page: Tramlink in the park. A fine view of a Croydon tram gliding past the daffodils in Lloyd Park in March 2004.
Photo: John Bradshaw

TRAMS
AN ILLUSTRATED ANTHOLOGY

Dennis Gill

Robert Hale • London

© Dennis Gill 2011
First published in Great Britain 2011

ISBN 978-0-7090-9089-2

Robert Hale Limited
Clerkenwell House
Clerkenwell Green
London EC1R 0HT

www.halebooks.com

The right of Dennis Gill to be identified as
author of this work has been asserted by him
in accordance with the Copyright, Designs and
Patents Act 1988

A catalogue record for this book is available from the British Library

2 4 6 8 10 9 7 5 3 1

Design by Eurodesign
Printed in Singapore

Contents

Foreword .. 9
Acknowledgements .. 11

Stories .. 13

Why I'm Sorry for my Grandson 13
Castles of Crystal 14
Exciting Excursion 17
Sea Wall ... 19
Fortified by a Special Brew 20
Beauty Sleep Ruined 23
Adventurous Journeys 25
Air on a G-Tram .. 34
Train's Tram ... 35
Traumatic Tales .. 39
Arduous Work for a Boy of Thirteen 41
Tit-Bits Financed Matlock's Cable Trams 43
It Hurt Like Blazes 46
Steam Tram Capers .. 47
Could Never Forgive Churchill 53
Evil-Looking Concoction Saved the Day 54
Galleon or Sick Elephant? 55
Subway Memories .. 60
Pet Put Passengers to Flight 63
'Tram' Goes Back a Long Way 64
Stopped Forever by an Earthquake 68
Trams in Miniature 68
Through God's Good Country to Loch Lomond 71
Tramological Topics 72
Jobs for the Boys .. 73

First Day at Work	79
Try the Horse Tram, Look You	80
Memories of the Famous	82
Horses were Artful and Comical	89
Bang, Crash, Smash!	90
Symphony of Tramcar Themes	92
Auxiliary Conductor	95
Armistice Eve Exploit	97
By Tram to Amusement Parks, Tea Gardens and Beauty Spots	98
Ran a Pasty Special and Ore Trains	106
Passengers Escaped Massacre	108
Last Tram Run in London	110
Tramophilia	112
Riding the Buffers	113
Lost his Teeth among the Coppers	116
My Forty-Five-Mile Trip in Oldest Tram	118
Trams in Literature	119
A Vanished Tram Comes Back to Life	123
Trackwork was his Passion	126
Another World	128
Caught up in Conflict	130
Famous Cartoonist's Confession	132
All Dressed Up	133
Heritage Tramways	137
Record-Carrying Tramcars	139
Finding her Sealegs	140
Assassination at the No. 14 Tram Stop	141
Out of Control	143
Stripped by Exuberant Well-Wishers	146
According to Jekyll and Hyde	149
Glittering Spectacle	154
Crisis on the Top Deck	159
Good-Humoured Belfast Banter	160
Wonderful Asset in Fog	162
Bombed off the Face of the Earth	163
Bedtime Story	169
Lorry Driver Averted Tragedy	170
Snowploughs Kept Tracks Open	171
Most Damnable Outrage	176
Veritable Chariots of Fire	178
Fired on by Snipers	179
Golfing Fun on the Mitcham Run	180
The Heroism of Thomas Chadwick	184

Trams for the Twenty-First Century . 189
Volunteer Driver . 192
Toastracks – A British Phenomenon . 195
Record-Setting Driver . 197
Beware! Cattle and Sheep on the Tracks . 200
We Collect Trams . 203
Some Fell by the Wayside . 207
Toppled by a Gale . 211
Historic Film Discovery a Boon for Tram Lovers . 212
Much to Be Said for Tramcars . 215
Comic Postcards . 216
Thrown in at the Deep End on the Blue Road . 218
Gone, But Not Forgotten! . 219
What a Lovely Way to Go . 227
Would you Believe it . 230
The Track Record . 237

Poems . 243

Ballad of the Met . 243
Hey Ding-a-Ding! . 244
How they Take the Cars at Blackfriars Bridge and other Places 245
Thou Shalt Not . 245
Ode to the Tramcar . 246
Morning Tram . 246
Managers in Verse and Song . 247
Predestinate Grooves . 248
Memories . 248
The Pirate Tram . 250
The Tram . 251
What a Blessing! . 251
To the Memory of the Midnight Tram . 251
The Broomstick Train . 252
T is for Tramway . 252

Songs . 253

Riding on Top of the Car . 253
The Tramcar Song . 254
The Tram . 254
The (Burnley) Tram . 255
On a Good Old Trolley Ride . 256

Foreword

This book is a compilation of writings from many sources about tramcars and the untold joy they brought to the people who rode on them. They are about the men and women who worked on them – the conditions they had to endure, their experiences, their foibles, their faults and their dress. They are about the fun children had riding on them and the many tricks they got up to; about the enthusiasts who love trams and the efforts they have made to save, preserve and restore them; and about the passengers – their behaviour and their memories. They are also about the adventurous journeys that could be undertaken by tram; about the mishaps and misfortunes they suffered in times of war, conflict and bad weather. In fact, this book is about all aspects of trams seen through many eyes – those of famous people, the not-so-famous, passengers, enthusiasts and, of course, tramway workers, including managers, drivers and conductors.

I was urged to compile this collection by Geoffrey Claydon, President of the Light Rail Transit Association, many moons ago. Both he and I realised that there were lots of good stories, some buried in magazines and books, that had been written about trams, but which hadn't been given full exposure in tramway circles or indeed the wider world. Conversely, there were stories that had been written in tramway circles and specialist books that were suitable for a more general readership. So I set about collecting them, spending many hours browsing through books in local libraries, and this work is the result of my endeavours.

Sadly, for a number of reasons, it doesn't contain all the stories I came across and which I would have liked to have included. To make up the shortfall I have written several pieces myself, most containing extracts from various sources.

The stories are in an order designed to continually entertain and keep the reader's interest, rather than in some regimented order. For I would like this book to be one the reader can dip into and enjoy, in the same way I regularly dip into Arnold Bennett's *Matador of the Five Towns*. The first story, 'Why I'm Sorry for my Grandson', written in 1966 by James Rothwell, sets the scene nicely, for it puts in a nutshell what is so fascinating about a tram. But there is no need any more to feel sorry for our grandsons – or our granddaughters – for there are more places today than there were in 1966 where they can discover that the tram is very much alive and kicking. As they will also learn if they browse through this book.

The author conducting by invitation for one day on the Great Orme cable tramway at Llandudno during a special weekend celebrating the line's ninetieth anniversary in 1992.

Acknowledgements

Gathering material for this book has been a long job, covering a period of years in fact, and I am very grateful to all those who have assisted me in one way or another. In particular, I would like to express my gratitude to all those contributors who have allowed me to reproduce extracts from their works or use their photographs. Without their permission, which has been generously given, this book could not have gone ahead. They are acknowledged in the introductions to each chapter or within the text and captions.

My special thanks go to Geoffrey Claydon, President of the Light Rail Transit Association. It was Geoffrey who spurred me on to undertake this work, and his advice and enthusiasm has been invaluable. He also provided me with material and many leads. I owe him a great deal.

Secondly, I cannot praise highly enough Malcolm Fraser of Durham City who has spent many hours patiently and skilfully colouring a good proportion of the older views reproduced in these pages. Nothing has been too much trouble for him and he has been very helpful in providing editorial material and photographs from his own collection.

Thirdly, I owe a big debt of gratitude to my wife Betty and our family, Karen and her husband Roger, Alison and her husband Kenneth, Philip and Joanne and her partner Robert, for their unstinting and understanding support and help. Without their care and patience, especially during the time I was recovering from major emergency surgery, *Trams* might never have been compiled. I would particularly like to thank Betty for her help with proof reading; Alison and Joanne for helping with e-mails, internet searches and the printing of photographs; and my son-in-law Roger for scanning and copying photographs onto disk. Above all, though, I have to thank my grandchildren, Lydia and Joe, for considerably brightening the lulls in my writing and dragging me away from my computer more times than I can remember. But for their interventions I might well have suffered eyestrain and writer's cramp (or should that be computer cramp?).

Fourthly, it would be remiss of me if I did not express my wholehearted appreciation to John Hale of Robert Hale Ltd for agreeing to publish this work in these difficult times. His perception, enthusiasm and motivation have been very encouraging.

Others I would like to single out for their special help include: David Holt of Stretford, who also assisted with the scanning of photographs onto disk; Richard Wiseman of North Yorkshire, for checking through my facts in the chapter entitled *The Track Record* and for his help with photographs; Robert Mara of Prague, for checking through my article on the assassination of Heydrich; and Peter Gemeinhardt of Offenbach, for his help with copy and photographs.

Some of the authors and photographers whose contributions are included in this book, alas, are no longer with us. In these cases permission to reproduce them has been granted by the following and I extend my thanks to all of them: Raie Appleby, widow of John Appleby; Terry Barham, son of Fisher Barham; Norma Davey, widow of Michael Davey; Jean Haywood, widow of Ted Haywood; Stephen Hyde, son of Geoffrey Hyde; Joan Pearson, widow of Mark Pearson and daughter of Elaine Loader; Betty and Ray Petty, cousins of Stanley Webb; and Ian Yearsley, executor for John H. Price.

My thanks also to the many individuals from far and wide who have helped with supplying information or material, or who have been particularly helpful with photographs. They include Roger Benton, George Blake, Howard Broadbent, Alan Brotchie, Dave Brown of Alcoa, Richard Buckley, Jill Byrne, Geoffrey Claydon, Ian Coonie, Terry Cooper, Bernard Donald, Allanagh Doogan of Radio Telefis

Éireann, John Downer, Clifton Flewitt, Paul Fox, Malcolm Fraser, Eve Freund, David Frodsham, Ted Gray, Chris Gent of the Tramway Museum Society, Richard Hargreaves, Stanley Heaton, Geoffrey Heywood, Norman Johnston, Arthur Kirby, James Kilroy, Stanley King, Brian Longworth, Falk Lösch of Dresdner Verkehrsbetriebe, Hugh MacAuley, Sarah MacLeod of The Arkwright Society, Jacques Peeters of BTTB, Michael Russell, Derek Shepherd, Graham Sidwell, David Smith, Jim Soper, Gloria Townsend-Parker, Tony Wilson of Travel Lens Photographic, Ian Yearsley and Tony Young.

I must also give due credit to all those people who have answered all my enquiries and helped me find appropriate material and locate copyright holders. First and foremost among these have been the staff employed by Stockport Direct and Stockport Libraries, especially the assistants in the Central Library commercial section and the very charming and helpful ladies at the Cheadle branch, who have dealt very patiently and capably with all my book searches and loan enquiries. The library staff at Birmingham, Croydon, Falmouth, Little Sutton, Southampton, Waterford and West Dumbartonshire have also been most helpful, as have the Matlock Civic Society, the Mitcham and Sale golf clubs, the D.H. Lawrence and Arnold Bennett societies and various newspapers such as the *Gloucestershire Echo*, the *Falmouth Packet*, the *Irish Times*, the *Munster Express* and the *Cork Examiner*. My thanks to all of them.

Finally I feel I should mention that I have made every effort to credit material correctly. Where none is given in cases where material is still in copyright it is because I have been unable to trace the copyright owner, and for any omission that may cause offence I offer my sincere apology. I must also apologise to anyone who may have assisted me in the collection of material or facts and whose name I have inadvertently overlooked.

A tramway network in action. Trams of three operators – Sheffield Corporation, Rotherham Corporation and the Mexborough and Swinton Tramways Company – are lined up in this view taken in College Square, Rotherham. The front two cars, from Sheffield and Rotherham, are working on the joint Sheffield–Rotherham service; the two open-toppers behind belong to Rotherham and Mexborough.

Stories

Why I'm Sorry for my Grandson
By James Rothwell

James Rothwell remembers the trams he loved in this article, which was published in the *Liverpool Echo* in June 1966. He explains why he is sorry his grandson will never be able to enjoy the thrill of a tram ride through Liverpool's streets. (Reproduced with permission from the *Liverpool Daily Post* and *Liverpool Echo*.)

I'm sorry for my grandson. True, he has the clinic and inoculations and fine clothes. His father drives him where he wants to go. He has a baby bouncer and a teddy bear as big as himself. Before he is ten he will probably fly to another country. He will find school exciting and toll-free. Life for my grandson will be fun, but I'm sorry for him all the same. He will never ride on my tram.

My tram was all iron, wood and blue sparks. It came clanking down the hill from the park. The driver wrestled with the shiny brass handle with

Given half a chance, these grandsons climbing aboard this Salford tram will soon be having loads of fun – and getting up to 101 tricks while the conductor is not looking.

These days, grandsons – and granddaughters too – can experience what it was like to ride on a tram at the various heritage tramways scattered around Britain, like the one on Birkenhead's waterfront or at Beamish in County Durham, where these youngsters are enjoying a tram ride at the popular 'living' open-air museum.

A memorable outing for some thirty grandsons on an American-built eight-wheel open-topper running on the Isle of Thanet tramway between Margate and Ramsgate in Kent.

one hand and waved to me with the other as he stopped for my mother and me. On cold winter days we would sit on the long wooden slatted seats that ran the length of the trams so that people could face each other.

Under the seats were great bags of sand. When the ice tore at my face and the rails shone diamond hard, the driver stamped on the iron pedal and down went the sand to give the wheels 'grip', as he explained to me.

Such a marvellous man was the driver. He wore an overcoat weighing more than I do – or so he told me – and huge gloves. If I was lucky I could watch him through the red glass of his door, as he pulled on the power handle to make us charge faster and faster through the streets. Sometimes, a foolish horse or human got in the way, and then the driver swung the power handle backwards. All the standing passengers fell in the laps of those on the slatted seats and baskets rolled and everybody laughed, except the driver who shouted and shook his fist at whoever had dared to impede him.

On the long climb back up the hill, he left the tram to drive its own slow way to the park. From an enamel jug he poured tea into the lid and drank great gulps, making sucking and lip-smacking noises. This proved his supreme importance, for, although my mother took me to task for these noises, she uttered not a word to him. He ate enormous bacon sandwiches with his tea and the crumbs clung to his moustache like snowflakes on a winter apple tree.

But summer days were the best. We walked up the hill to the park terminus. The tram fussed up from town and the conductor took his bamboo pole from the lamp standard and ran round the tram with the trolley. We climbed to the open top deck, where the seats had clever wooden flaps that could be turned over after a shower. The tram raced down the hill with the trolley whistling and flashing and the wind pulled my ears. As we approached the town there was a railway bridge where the trolley was pressed flat, as a train rumbled and grumbled overhead, and tennis ball drops of water fell on my nose.

I'm sorry for my grandson. When he is alone in his heated bedroom, what will allay his fears? The clouds raced across the moon when I was small, frightening me so that I stuck my head under the blankets. Then I heard my tram taking the bend at the bottom of the street. The iron wheels screeched on the shiny rails, calling to me, 'Don't be afraid'.

There was my tram, my driver, full of bacon sandwiches and tea, and the conductor, ready to turn round with his bamboo pole. I laughed at the clouds and the moon, for my tram was near, full of laughing people. There aren't any trolleys on a motor car and there's no sand under the seat. I'm sorry for my grandson.

Castles of Crystal

By Gilbert Thomas

Tramcars received more literary bouquets in their time than any other form of transport, according to Gilbert Thomas, the author and poet, who remembers the changeover from horse to electric in the Midland town where he lived at the beginning

of the twentieth century. (From *Times May Change* by Gilbert Thomas, © 1946 Epworth Press. Used by permission of Methodist Publishing House.)

'Castles of Crystal, Castles of Wood'. So Miss Sitwell calls the tramcars that are rapidly disappearing from the streets of many of our cities. It is strange, as the *Observer* remarked some time ago, that while the tram has been 'the Ishmael of our streets', it has received more literary bouquets than other forms of transport which have perhaps inspired warmer general enthusiasm. G.K. Chesterton, we were reminded, declared that the top of a deserted tramcar was the best place on earth for conversation: 'to talk on the top of a hill is superb, but to talk on top of a flying hill is a fairy tale'. Mr Wells has described tramcars at night as 'ships of light in full sail', while Arnold Bennett said:

> They are enormous and beautiful; they are admirably designed, and they function perfectly; they are picturesque, inexplicable and uncanny…. There never was anything like them before, and only when something different and better supersedes them will their extraordinary gliding picturesqueness be appreciated.

Miss Maude Royden and Miss Rose Fyleman are among oddly varied witnesses to the nocturnal 'beauty' of the 'imperial cars that slide in glittering strings', and the *Observer* writer might have added some lines from Mr Alfred Noyes, who has always had an eye for the romance of Babylons, old and new:

Oh, what does it mean, all the pageant and the pity,
The waste and the wonder and the shame?
I am riding tow'rds the sunset thro' the vision of a city
Which we cloak with the stupor of a name!

I am riding thro' ten thousand tragedies and terrors,
Ten million heavens that save and hells that damn;
And the light'ning draws my car along tow'rds the
 golden evening star,
And they call it only 'Riding on a tram',

The tramcar has had, so to speak, a dual personality. A Cinderella by day, it has after dusk become a Fairy Queen. The younger generation, who take brilliantly illuminated streets and floodlighting for granted, can hardly imagine the impression made upon us who saw the miracle of the first electric trams by night. Nor was that so very long ago! It was less than forty years since the spectacle was to be seen of the pioneer LCC electric cars in Finsbury Pavement having to crawl – the very picture of outraged dignity – between the remaining horse-drawn trams with which they had for some months to share the same track as far as Old Street. Forty years! Yet time enough for an invention to startle us by its novelty; to take its place in the seemingly eternal order of things; and then to become a mere 'survival'!

I was in my early 'teens when the tramway service in the Midland city where I then lived was electrified. We were a little in advance of London, which lagged in this matter oddly behind the times. I was, of course, thrilled to see the roads dug up and double lines of shining new metals replacing the single track, with occasional loops, that had served the horse-cars. Even

Arnold Bennett described electric trams as having 'an extraordinary gliding picturesqueness', which is captured here in this tranquil scene of a Colchester car heading to Lexden on a stretch of single track. The scene, painted by the artist Malcolm Root of Halstead, Essex, is much today as it was when the trams were running. Car No. 10, incidentally, was supplied to the corporation at a cost of £575. Compare this with the cost of a supertram today, which is in the region of two million pounds.

A Scott Series tinted postcard view depicting the changeover from horse to electric tramways at Chesterfield in 1906, a scene typical of that recalled by Gilbert Thomas, author and poet. Both cars are outside the new electric tram depot in Chatsworth Road.

more exciting was it to watch the overhead wires being fitted to the standards; most thrilling of all when everything was ready at last and the Mayor, in full regalia, drove the first electric tram along the main thoroughfare. Nor shall I ever forget my earliest ride to school to the accompaniment of hissing wires. Strange how soon one grew accustomed to that sound, until one ceased to hear it consciously at all! But for a time it made one feel that one was indeed gliding along the road under faery impetus.

Nevertheless, even as a boy, I realised that the change to electric traction was not all gain; and it is the yellow-and-white horse-trams of my childhood that I remember most affectionately. There was a homeliness, an intimacy, about them that has increasingly gone out of life with its growing mechanisation. True, I was especially favoured. The tram terminus on our route was just at the end of our road. There the horses were detached and reversed; there each car remained for some minutes before returning. I got to know the drivers and conductors as individual characters; and 'characters', in the Dickensian sense, many of them were! The horses, too, were my friends. I knew their names and their every idiosyncracy. Once an hour a bus left the tram terminus for an outlying village. The fresh horses from the depot in town worked a tram to this point and were then harnessed to the bus, whose tired steeds were transferred to the returning tram. It was an additional joy to see this process carried out, and occasionally, under a specially friendly driver, to lend a helping hand.

Some of the horse-car drivers, with their homespun suits and bowler hats, became smart liveried 'motormen' of the new trams. For a few years, though our route now extended beyond our own road, I remained on saluting terms with my old cronies, who always had an eye for their former patrons as they whirled past them. Then I grew up and went out into the world. Many of the old drivers probably died or took less strenuous jobs; and in any case, with the ever-growing volume of traffic, impersonality on the road became the rule. Yet whenever I return to my childhood's city, as I did the other day, it is not my old school companions or the

Time seems to be standing still in this rural scene at the Dogsthorpe tram terminus at Peterborough. G.K. Chesterton would have loved it, for he thought the top of a deserted tramcar was the best place on earth for conversation. Empty tramcars, alas, don't pay dividends, and at Peterborough, they paid nothing at all for twelve consecutive years.

officially acknowledged friends of our old family circle that I miss most sadly. I find myself gazing at every passing tramcar, hoping, while knowing it vain, to see a once familiar figure on the motorman's platform. The trams themselves linger on; but their reprieve will now, I imagine, be short.

Well, one must not be sentimental. I should not wish to ride on horse-cars today; and even the 'Castles of Crystal' may rightly disappear at the bidding of necessity. Change we must have. Yet the truest progress of all will come when we find a way of combining the new efficiency with the old human touch.

Exciting Excursion

By James Kirkup

James Kirkup, the novelist, poet and travel writer, is a prolific author, producing a book almost every year since 1950. In 1957 he produced the first volume of his autobiography, *The Only Child* **(published by Collins), which, as the title suggests, is about his childhood. This extract describes the thrill of a ride he took on the tramcars that ran in his home town of South Shields, on the mouth of the River Tyne. The standard-gauge trams, ranging from ancient to modern, served South Shields until 1946. They ran from the Pier Head on one side of the town to Tyne Dock on the other and to various suburbs in between, including Laygate, Chichester and Westoe. It was the tram rides to Westoe to visit his grandmother that Mr Kirkup remembers with great affection.**

Sometimes, at weekends, and particularly on Sunday mornings, my father would take me to see my other grandmother, his mother, and his sister, my Aunt Anna. They lived in a biggish house at Westoe, a rather better-class part of the town, and in order to get there we would board a tram in Mile End Road or Ocean Road and go rattling and shaking up the incline of Fowler Street into the more gradual slope of Westoe Road.

The iron tram wheels would be grinding in the tracks, the wooden safety-guards at front and back occasionally clattering on the cobbles as the tram dipped and rolled. There always seemed to be a great number of stops. The cracked bell was always ringing, but sometimes there would be no one waiting at a 'request' stop, and we would go surging and swaying on, getting up a fine turn of speed, with the ornamental panels of blue and yellow and ruby glass shivering and chattering and the mufflered driver clanking and cranking away in front, his mittened hands on the antiquated controls, his foot pounding the warning bell that was let into the floorboards.

The seats were of hard, ribbed wood or varnished planks with backs that could be swung backwards or forwards according to the direction in which the tram was travelling. Overhead, the trolley would be singing on the electric wire, emitting startlingly vivid blue flashes when its little wheel ran over the joins in the cable. I was fascinated as well as alarmed by these

James Kirkup will never forget the fun of riding along in summer sunshine on the packed top deck of a roofless South Shields tram, like this one, photographed on Stanhope Road by West Park not long after it appeared in service in 1905 with fashionable new curtains in the saloon windows and with a smartly dressed crew.

sudden flashes, and often asked for an explanation. 'It's the muck', is the only answer I can remember my father giving.

We would always ride upstairs, and it was like being on the back of a bird, especially if you sat right up in front, over the driver's head. The trams had open-air platforms upstairs at front and back, and in fine weather the Corporation even brought out vehicles that had no roof at all over the upper part. I shall never forget the fun of riding along in summer sunshine on the packed top deck of a roofless tram, rocking away along Ocean Road, the sea in the distance and the deep blue sky and the humming, lifting and dipping wires sparkling overhead.

But I seem to recall best a journey we made by tram one winter night. We were going to visit my Granny at Westoe, and I was very excited, because an evening excursion was something quite unheard of for me. It had been raining; the gas lamps lit the gleaming pavements and cobbles with a double radiance. The shaking tram wires were sending down showers of white raindrops. Everything in the tram seemed fresh and glittering. The breezy windows sparkled with long zig-zags of rain and the passing street lamps gorgeously flared through the panels of blue and yellow and ruby glass. Outside, it was cold and windy, and we could feel the gale buffeting against the side of the tram, making it sway and lurch more than usual, and throwing the passengers against one another. There were bursts of laughter and snatches of song, and the fresh, clean, cold sea-wind was blowing right through the upper deck. Above, a high half-moon seemed to be skidding along on its back through piles of black, white-lined rags. It was a wild night, with a sense of magic in the offing. The people in the tram did not seem like ordinary mortals; a kind of exhilarating gaiety had seized them, and it seemed to lighten their bodies and illuminate their faces. At times I was sure we were really flying.

We were sitting, my father and mother and I, in the coveted seat right at the front of the tram, over the driver's head. I was kneeling on the hard, ribbed seat that so satisfyingly corrugated my knees, enjoying the brilliance, the movement, the gaiety, and the glorious feeling of *being up late*. We began to grind up the bank, with a sickening, groaning noise that seemed to drag at my bowels, and slowly we rose, past the tree-set hospital, to the Fountain Inn at the top of the hill. This hill is actually a very gentle slope, but to a five-year-old it seemed like a mountain, and the old tram's laboured efforts to get to the top made it appear even steeper than it really was. When we reached the top, the tram had to turn to the right, and this was always a hair-raising manoeuvre, for I was sure, every time we turned that corner, that the tram was leaving the rails.

What a grinding and griping and jerking there was! I could hardly bear to look at the glimmering rails in front, and yet I had to look, in fascinated horror, as the front of the tram seemed to swing right off the track, as if it would never return; but then, slowly, it would nose its way round into the centre of the track

Countless children, like James Kirkup, gained immense pleasure from riding on open-top cars which took them to parks or the country, especially these poor children on an excursion in Ipswich, run for them by the Royal Ancient Order of Buffaloes.

again, and I would heave a deep sigh of gratitude for the thrilling moment.

But it was time to get up and make our way down the twisting, slippery metal stairs, clinging to the brass hand-rail that heaved and shook. Ours was the next stop, at 'The Fountain' – a dismal grey granite horse-trough, which in those days was the terminus. We clambered down, and waited to watch the conductor run round the tram, a hastily lit fag in his mouth, pulling the chinking trolley in a wide arc behind him, and setting it, with many a crackling flash, on the hissing wire, while the driver drank hot tea from a blue enamel can brought steaming hot from home by his wife.

Sea Wall
By L.A.G. Strong

L.A.G. Strong (1898–1958), poet, novelist and broadcaster, was born in Plymouth of Irish parents, and spent many holidays in Ireland as a child. He recalls how a journey by trailer tram to Sandycove in Dublin nearly ended in disaster for one little boy in *An Irish Childhood*, **edited by A. Norman Jeffares and Anthony Kamm and published by William Collins in 1987. (Courtesy HarperCollins Publishers Ltd, © A. Norman Jeffares and Anthony Kamm, 1987.)**

The tram was one of the big new ones, with a covered top. They climbed up, and took seats near the front. Nicky preferred the other kind, because he could watch the trailer skimming along on the wire overhead, and hear its song; but the back door of the tram was open, and he soon realised that he could hear the trailer, even if he couldn't see it.

The top of the tram was crowded. Big men smoking pipes sat around; he could not see properly in front of him. Soon they started, the tram nosing its way suspiciously along in all the traffic, crawling up past the Bank, past Trinity, along the Green, and then, with a sound of pleasure, beginning to go faster along the clearer roads towards Merrion Square. The narrow sides of the streets fell away, the tall gloomy houses were succeeded by smaller, kindlier houses; they were in suburban roads, gentler, friendlier roads, with trees, and already, though they were headed away from the sunset, the skies were lighter, the air came fresher, and the song of the trailer grew to the steady rising and falling buzz that Nicky loved so well. Wider and wider the roads became, lighter the skies, and faster the tram sped homeward. The big men sitting around them had to raise their voices to be heard. Nicky looked at them, watching the play of their faces, as they uttered words he could not hear, watching them puff at their great pipes, or knock them out against the leg of the seat; bewildered by the bawling of their voices.

Then the houses fell right away, and they were out on the open road by Merrion, rushing along by the wide stretch of the sands and the bay. Evening was coming on; the arm of Howth lay far-flung and dim; the sands stretched away, limitless, glimmering; one could not discern where they met the sea. On them here and there, far out, stooped the tiny black figures of the cockle gatherers. The tram stopped for a moment, and a new noise roused Nicky. He looked and saw, quite close to the road, the railway, with a train rushing along towards them, its engine

L.A.G. Strong recalls riding on trams like these during his childhood days in Dublin.

straddling widely, the clank of its mechanism echoing off the low brown wall between it and the sands. Then the tram started off again, drowning the train's sound, till he could hear only a soft woolly puffing as it rushed past. The wall looked extraordinarily clear and close, because there was nothing definite beyond it, only the soft shimmer of the sands. A couple of boys were walking along the top of it, balancing, their arms outstretched delicately against the frail evening air.

The tram gathered speed, and the song of the trailer rose in ecstasy. Nick's head began to nod. He was sleepy. The song of the trailer rose and fell, rose and fell; the skies kept opening and shutting, with a roaring of alternate light and darkness: and every now and then something bumped him into a fresh awareness of his surroundings.

It was darker. They had passed Booterstown; they were among trees. The voices of two men talking came to him with a sudden unnatural loudness.

'Yes,' said one. 'I hope to go and see him to-morra. But sure, to-morra where might I be? I might be in Rathdrum, the same as I was tellin' ye. I might be in Dublin. I might be in Foxrock, or in Malahide—'

'Or in God's pocket,' put in the second voice.

There was a silence, in which the first speaker, a big, red-faced man, stared at his companion.

'Faith,' he said at last. 'Ye must be a very religious man.'

'Oh,' said the other, well content with the impression he had produced, 'I wouldn't tell ye that for certain, now.'

Then Nicky, after one blink at the main street of Blackrock, fell asleep in good earnest, and knew no more till his mother was shaking him and telling him they were just coming to Sandycove station.

'We're getting down a stop sooner,' she explained 'because Daddy wants to get some tobacco.'

It was cold out of the tram. A wind was blowing. Nick's legs were stiff. He walked along reluctantly, holding fast to his mother's hand. Their father strode on ahead to the tobacco shop, Jack trotting beside him. Nicky blinked, and tagged along, enduring, till they should reach home.

Their father had not come out of the shop by the time they reached it, so they stood, looking in at the window. George, who after his own manner had been walking by himself just behind them, on the edge of the pavement, was for the moment forgotten. A breeze stirred along the street, raising a newspaper, which careered grotesquely along till it hit a wall. Laura snuggled her chin down into her collar, and shivered.

The door swung open, and Nick's father stood beside them.

'You needn't have waited,' he said, half apologetically. 'I'm sorry to have— Merciful God! Look at that child!'

He pointed. Laura stood frozen with horror. A tram was rushing down the short hill, full speed round the curve. Almost in the path of it, close beside the lines, stood George. They saw him look coolly at it, stretch out his hand, as if calculating his distance, then shift his feet a little nearer. Suddenly the street was full of shouting. White faced, the tram driver shoved on his brakes. With a hideous grind that sharpened to a shriek of anguished metal, the tram slid to a halt, sparks flying viciously from beneath its wheels. Recovering himself with an oath, Nick's father ran forward: but other hands were there before him, and George was dragged off to the pavement and to safety.

He stared at them all with a calm and dreamy amazement.

'But it's quite all right,' he kept repeating. 'I only wanted to touch it as it went past.'

Fortified by a Special Brew
By Mark Pearson

Drivers and conductors on the early trams had to be a hardy breed, and prepared to work long hours. Mark Pearson describes what they had to endure, and touches on some interesting aspects of the changeover from horse to electric in his book *Leicester's Trams in Retrospect* (published by the Tramway Museum Society in 1970).

People who now think in terms of a thirty-five-hour week as being a reasonable allocation of their time to work, will no doubt shudder when they realise that in the 1870s the tramway staff put in a full seven-day week of 105 hours, taking their meals while standing at the terminus or while on the trot. A driver received twenty-five shillings a week, a conductor twelve shillings and sixpence, and a trace horse lad four shillings and sixpence. Drivers were paid a bonus of one pound if they had gone six months without having a horse down.

One can well imagine what was entailed in being exposed to all weathers for such long hours. It seems the men thought nothing of it, counting themselves fortunate to be in such good steady work.

A friend, whose father, James Hudson, worked on both the horse trams and the early electric cars, tells me that although he lived to be seventy-five, he had

pneumonia three times. During the winter he went to work fortified by a brew concocted from Spanish onions and demerara sugar which had to be left to mingle overnight. He also chewed plug tobacco or hard liquorice to keep his face and jaws from being petrified in cold weather. Another favourite fortifier was a fig soaked in rum. The brass control handles were very cold and it was not possible to gain an adequate grip if gloves or mittens were worn. When he returned from a spell of duty, his hands were often blue and greatly swollen with huge cracks and chilblains into which his good wife rubbed mutton fat....

Horses cost from £35 to £45 each. They were purchased when about five years of age and worked until twelve (if they survived that long!). It called for no little skill on the part of the driver to get the best out of his charges without cruelty. In the hands of thoughtless drivers, there is no doubt that the unfortunate animals suffered a great deal. The following examples taken from the horse registers make this only too clear:

> Absolutely useless ... Past our work ... Dropt dead ... Died – broken back ... Died – ruptured liver ... Went mad on Aylestone section ... Broke both front legs ... Destroyed ... Foot coming off – sold for eleven shillings ...

When the new tracks were laid for the electric trams,[1] horse trams appeared in many places where they had never before been encountered, though only until the electric cars were actually put into service.... The upheaval was inevitably drastic, whole streets being closed to traffic for weeks on end. Temporary track was employed to maintain services, and horse buses were used to ferry passengers past the longer stretches of excavation.

Mr A. Mark Hefford, for many years tramway engineer, relates how one Tom North, a butcher by trade, whose shop was at the corner of Wand Street, was prosecuted for driving his cart along the temporary track which had been laid on the pavement in Belgrave Gate. He must have had a good defence, for he got away with it....

The mammoth task of putting down the special trackwork at the Clock Tower, generally accepted as being the most complex in Britain, and which weighed well over a hundred tons, was completed in just ten days....

There cannot be many people who rendered forty-eight years' service to the Tramway Department, as was the case with Mark Hefford. While still an office boy he was invited, along with his father, to take part in the very first full course trial of the electric services about a month before the system opened.[2] Along with about forty other officials and guests ... he boarded an immaculate new tram just before midnight. One

Generally accepted as being the most complex in Britain, this special trackwork was laid at Leicester's Clock Tower in only ten days in 1903. Made by Hadfields of Sheffield it weighed more than a hundred tons.

can well imagine his awe and excitement as the car left the depot and ran smoothly along the new tracks to the Clock Tower and on to Stoneygate. Mr Hefford also had the distinction of being one of the favoured few to ride on the very last ceremonial car when the system closed in 1949....

There were a number of folk who had misgivings about the advent of the electric cars, and wrote to the press to express them. A Miss Achison told how she had heard from her sister in Leeds to the effect that the trams there, rumbling through the points and crossings near her residence, caused a dreadful noise, travelled at an outrageous speed and caused ornaments to fall from the mantelpiece!...

In December 1923, Leicester's first completely enclosed car made its impact on the scene. When No. 86 came in for overhaul and top covering, it was rebuilt to an entirely new design. The stairs were altered to enable passengers to gain either saloon without barging into each other, which invariably occurred on the rest of the cars because the bottom of the staircase was right against the entrance to the lower saloon....

I often heard the conductor shout, 'Hurry along, please! Any more for Noah's Ark!' when the car was loading at the Clock Tower. Presumably No. 86 earned this nickname because of its ability to admit the 'animals' two at a time!...

Adequate warnings were posted on each car of the dangers of boarding or leaving it while in motion. Despite this, on average over 500 people were injured annually by engaging in this foolhardy process....

Behaviour of the travelling public was pretty good in 1928 when compared with present-day standards. In that year there were only five convictions for breaches of the bye-laws. There were two for obstructing the car; one for refusal to pay a fare; one for assault on a conductor; and one for using obscene language. ...

The staff often referred to the open-toppers as 'breadbaskets'. There were only eleven of these left in 1925–7, and they only appeared on fine summer days or as football specials, rush-hour extras and the like. There was something very fascinating about riding outside on an open-topper. Perhaps it was that one obtained a completely unobstructed view of the world below. Or maybe it was that one could watch the passage of the trolley wheel along the wire and listen to the musical variations as each span-wire insulator was passed over. My fondness for these cars was not shared by my father however. 'Wretched things!' he would say. 'They were all like that to start with. Not much fun having to scrape six inches of snow off the seat before you could sit on it, I can tell you!' My dear mama had an extraordinary notion that the open-toppers were only for workmen in dirty clothes, and despite repeated assurances that her idea was erroneous, she flatly refused to board one, preferring to let one pass and wait for a more civilised covered-topper to come along.

[1] In 1903.
[2] Leicester's tramway system was officially opened on 18 May 1904.

Nearly fifty years after the laying of the special trackwork at the Clock Tower, Leicester's last tram passes the town's famous landmark on its farewell journey on 9 November 1949. In forty-five years the city's cars clocked up 171,802,000 miles and carried 2,068,450,000 passengers.

Beauty Sleep Ruined

By Arnold Bennett

Among the collection of twenty-two stories written by Arnold Bennett in *Matador of the Five Towns* (first published in 1912) is one about a dentist, newly arrived in the Five Towns from St Albans, 'Three Episodes in the Life of Mr Cowlishaw, Dentist'. In the first episode, reproduced here, Mr Cowlishaw is far from enamoured with the Five Towns' trams.

Mr Cowlishaw – aged twenty-four, a fair-haired bachelor with a weak moustache – had bought the practice of the retired Mr Rapper, a dentist of the very old school. He was not a native of the Five Towns. He came from St Albans, and had done the deal through an advertisement in the *Dentists' Guardian*, a weekly journal full of exciting interest to dentists. Save such knowledge as he had gained during two preliminary visits to the centre of the world's earthenware manufacture, he knew nothing of the Five Towns; practically, he had everything to learn. And one may say that the Five Towns is not a subject that can be 'got up' in a day.

His place of business – or whatever high-class dentists choose to call it – in Crown Square was quite ready for him when he arrived on the Friday night: specimen 'uppers' and 'lowers' and odd teeth shining in their glass case, the new black-and-gold door-plate on the door, and the electric filing apparatus which he had purchased, in the operating room. Nothing lacked there. But his private lodgings were not ready; at least, they were not what he, with his finicking Albanian notions, called ready, and, after a brief altercation with his landlady, he went off with a bag to spend the night at the Turk's Head Hotel. The Turk's Head is the best hotel in Hanbridge, not excepting the new Hotel Metropole (Limited, and German-Swiss waiters). The proof of its excellence is that the proprietor, Mr Simeon Clowes, was then the Mayor of Hanbridge, and Mrs Clowes one of the acknowledged leaders of Hanbridge society.

Mr Cowlishaw went to bed. He was a good sleeper; at least, he was what is deemed a good sleeper in St Albans. He retired at about eleven o'clock, and requested one of the barmaids to instruct the boots to arouse him at 7 a.m. She faithfully promised to do so.

He had not been in bed five minutes before he heard and felt an earthquake. This earthquake seemed to have been born towards the north-east, in the direction of Crown Square, and the shocks seemed to pass southwards in the direction of Knype. The bed shook; the basin and ewer rattled together like imperfect false teeth in the mouth of an arrant coward; the walls of the hotel shook. Then silence! No cries of alarm, no cries for help, no lamentations of ruin! Doubtless, though earthquakes are rare in England, the whole town had been overthrown and engulfed, and only Mr Cowlishaw's bed left standing. Conquering his terror, Mr Cowlishaw put his head under the clothes and waited.

He had not been in bed ten minutes before he heard and felt another earthquake. This earthquake seemed to have been born towards the north-east, in the direction of Crown Square, and to be travelling southwards; and Mr Cowlishaw noticed that it was accompanied by a strange sound of heavy bumping.

Look at the medieval charm in this view of the Potteries and you would hardly imagine that the tram moving sedately on its tracks would be capable of creating noise of earthshaking propensity. But a succession of cars operated by the Five Towns Electric Traction Company managed to keep Mr Cowlishaw, dentist, from his slumbers, especially one car which had 'flats' on its tyres.

He sprang courageously out of bed and rushed to the window. And it so happened that he caught the earthquake in the very act of flight. It was one of the new cars of the Five Towns Electric Traction Company, Limited, guaranteed to carry fifty-two passengers. The bumping was due to the fact that the driver, by a too violent application of the brake, had changed the form of two of its wheels from circular to oval. Such accidents do happen, even to the newest cars, and the inhabitants of the Five Towns laugh when they hear a bumpy car as they laugh at *Charley's Aunt*. The car shot past, flashing sparks from its overhead wire and flaming red and green lights of warning, and vanished down the main thoroughfare. And gradually the ewer and basin ceased their colloquy. The night being the 29 December, and exceedingly cold, Mr Cowlishaw went back to bed.

'Well,' he muttered, 'this is a bit thick, this is!' (They use such language in cathedral towns.) 'However, let's hope it's the last.'

It was not the last. Exactly, it was the last but twenty-three. Regularly at intervals of five minutes the Five Towns Electric Traction Company, Limited, sent one of their dreadful engines down the street, apparently with the object of disintegrating all the real property in the neighbourhood into its original bricks. At the seventeenth time Mr Cowlishaw trembled to hear a renewal of the bump-bump-bump. It was the oval-wheeled car, which had been to Longshaw and back. He recognized it as an old friend. He wondered whether he must expect it to pass a third time. However, it did not pass a third time. After several clocks in and out of the hotel had more or less agreed on the fact that it was one o'clock, there was a surcease of earthquakes. Mr Cowlishaw dared not hope that earthquakes were over. He waited in strained attention during quite half an hour, expectant of the next earthquake. But it did not come. Earthquakes were, indeed, done with till the morrow.

It was about two o'clock when his nerves were sufficiently tranquillized to enable him to envisage the possibility of going to sleep. And he was just slipping, gliding, floating off when he was brought back to realities by a terrific explosion of laughter at the head of the stairs outside his bedroom door. The building rang like the inside of a piano when you strike a wire directly. The explosion was followed by low rumblings of laughter and then by a series of jolly, hearty 'Good-nights'. He recognized the voices as being those of a group of commercial travellers and two actors (of the Hanbridge Theatre Royal's specially selected London Pantomime Company), who had been pointed out to him with awe and joy by the aforesaid barmaid. They were telling each other stories in the private bar, and apparently they had been telling each other stories ever since. And the truth is that the atmosphere of the Turk's Head, where commercial travellers and actors forgather every night except perhaps Sundays, contains more good stories to the cubic inch than any other resort in the county of Staffordshire. A few seconds after the explosion there was a dropping fusillade – the commercial travellers and the actors shutting their doors. And about five minutes later there was another and more complicated dropping fusillade – the commercial travellers and actors opening their doors, depositing their boots (two to each soul), and shutting their doors.

Then silence.

And then out of the silence the terrified Mr Cowlishaw heard arising and arising a vast and fearful breathing, as of some immense prehistoric monster in pain. At first he thought he was asleep and dreaming. But he was not. This gigantic sighing continued regularly, and Mr Cowlishaw had never heard anything like it before. It banished sleep.

After about two hours of its awful uncanniness, Mr Cowlishaw caught the sound of creeping footsteps in the corridor and fumbling noises. He got up again. He was determined, though he should have to interrogate burglars and assassins, to discover the meaning of that horrible sighing. He courageously pulled his door open, and saw an aproned man with a candle marking boots with chalk, and putting them into a box.

'I say!' said Mr Cowlishaw.

'Beg yer pardon, sir,' the man whispered. 'I'm getting forward with my work so I can go to th' futbaw match this afternoon. I hope I didn't wake ye, sir.'

'Look here!' said Mr Cowlishaw. 'What's that appalling noise that's going on all the time?'

'Noise, sir?' whispered the man astonished.

'Yes,' Mr Cowlishaw insisted. 'Like something breathing. Can't you hear it?'

The man cocked his ears attentively. The noise veritably boomed in Mr Cowlishaw's ears.

'Oh! *That!*' said the man at length. 'That's th' blast furnaces at Cauldon Bar Ironworks. Never heard that afore, sir? Why, it's like that every night. Now you mention it, I *do* hear it! It's a good couple o' miles off, though, that is!'

Mr Cowlishaw closed his door.

At five o'clock, when he had nearly, but not quite, forgotten the sighing, his lifelong friend, the oval-wheeled electric car, bumped and quaked through the street, and the ewer and basin chattered together busily, and the seismic phenomena definitely

recommenced. The night was still black, but the industrial day had dawned in the Five Towns. Long series of carts without springs began to jolt past under the window of Mr Cowlishaw, and then there was a regular multitudinous clacking of clogs and boots on the pavement. A little later the air was rent by first one steam-whistle, and then another, and then another, in divers tones announcing that it was six o'clock, or five minutes past, or half-past, or anything. The periodicity of earthquakes had by this time quickened to five minutes, as at midnight. A motor-car emerged under the archway of the hotel, and remained stationary outside with its engine racing. And amid the earthquake, the motor-car, the carts, the clogs and boots, and the steam muezzins calling the faithful to work, Mr Cowlishaw could still distinguish the tireless, monstrous sighing of the Cauldon Bar blast furnaces. And, finally, he heard another sound. It came from the room next to his, and when he heard it, exhausted though he was, exasperated though he was, he burst into laughter, so comically did it strike him.

It was an alarm-clock going off in the next room.

And further, when he arrived downstairs, the barmaid, sweet, conscientious little thing, came up to him and said, 'I'm so sorry, sir. I quite forgot to tell the boots to call you!'

Adventurous Journeys

By Dennis Gill, with extracts by
D.H. Lawrence, *Frank and Teretta Mitchell*
and Michael Russell

Long adventurous journeys by tramcar could be made in the years when the tram reigned supreme on the roads. It was possible to travel forty or more miles by tram in parts of Britain, and in a spirit of adventure some intrepid travellers set off from their home town to see how far they could journey on the metals.

When I was a young lad, I was fortunate in having a father who owned a Riley Nine motorcar. We had it for many years, and it served us well during the years we lived at Southend-on-Sea and Waddesdon, the Buckinghamshire village to which we were evacuated in the Second World War. In those days motorcars were made to last, and I remember going on holiday in it to all sorts of places, even during the war – to places like Weston-Super-Mare and Cornwall. I remember, too, the journeys we made to the north of England to visit relatives in Cheshire, Lancashire and Yorkshire. On these occasions we would often pass through towns where there were gleaming tram lines in the roads and wires strung overhead. Whenever I saw them I was intrigued, even more so when we were stuck behind a tramcar, or passed one going the other way. What extraordinarily fascinating vehicles they were, I thought. And where did the tram lines lead to?

My curiosity was first aroused at Southend-on-Sea, where I was born, and also at Stockport, where my grandparents lived. Before the war both these towns still had trams, green and cream eight-wheelers in Southend, and red and cream four-wheelers in Stockport. By the time I was fourteen I had grown quite attached to the dinky little Stockport cars, with their longitudinal seats downstairs and open balconies upstairs. Intriguingly, I had also noticed that the lines they ran on stretched tantalisingly beyond the town's boundaries. Then one day I spotted a green and cream tramcar in the town centre. One of my eleven aunts called it a 'Green Linnet' and told me it came from a neighbouring town called Hyde. This strengthened my resolve to go tramway exploring at the first opportunity. There were obviously many tramways about which I knew nothing at all.

Alas, by the time I was old enough to travel on my own, some of the tramways had disappeared. But Birmingham, I discovered, still had trams, and when I was sixteen years old there came the day when my parents dropped me off on the outskirts of the city so that I could explore its tramlines from end to end. My joy was unbounded when I boarded a tall blue and cream narrow-gauge Birmingham car and climbed the staircase to the upper deck to begin my first big adventure on my own in a strange city.

Like J.B. Priestley, in his book *English Journey*, I had no idea where the tram was going. The place names in Birmingham meant nothing to me. But I took a seat at the front of the car and, with one eye on the tracks, and the other on the changing scene, followed the tram's stately swaying progress. But unlike the tram which Priestley boarded a year or so before I was born, mine did not take me past mile after mile of 'mean dinginess'. Nor did my tram 'lumber and groan and grind along like a sick elephant'. In fact, my tram took me with a melodic swishing and droning sound, mixed with a few ringing and whining crescendos, for mile after mile down a pleasant tree-lined main road, past colleges, presentable houses, giant car plants and attractive suburbs to the foot of the scenic and invigorating Lickey Hills – where Midlanders flocked in their thousands by tram for an enjoyable day out. You could hardly imagine

Cover of the leaflet tracing the route taken by the Ripley Rattlers. The leaflet, which was issued by Nottinghamshire County Council in 1986, contains a brief history of the line, past and present photographs taken along the route, a map and a number of colourful sketches.

that Priestley and I were riding on the same trams in the same city.

What particularly amazed me was the way my tram kept leaving the streets and shooting onto private tracks laid between trees down the middle of dual carriageways. Clearly, a town was not worth its salt if it did not have segregated tramways like these. Here were vital throbbing arteries along which thousands of townsfolk were being carried swiftly and safely to factories, offices, shops, schools and university, and places of entertainment and recreation. I thought it was wonderful, and a fine example of town planning. There was nothing dreary about the journey at all and the tram rolled along its ballasted and grassed tracks without having its progress slowed by motorcars, lorries and buses. I discovered there were many more miles of these private tram tracks on the median strips of dual carriageways. What a giant folly it was for Birmingham to dig them up. How ideal they would have been for today's supercharged supertrams, like those now running between Birmingham's Snow Hill and Wolverhampton.

I suspect, from reading their works, that quite a few great literary writers must have loved riding on the old trams as much as I did. One gets the impression, for example, that Arnold Bennett (1867–1931) must have found them quite fascinating. His novels and short stories are sprinkled liberally with references to horse, steam and electric trams, some quite lengthy, but capturing the sensations, sights and sounds one experiences when riding on a tram. In one story he calls the electric trams 'eager and impetuous velocities', while in his *Clayhanger* trilogy he describes how a steam tram set off with a 'deafening clatter of loose glass-panes and throbbing of its filthy floor'. Another great writer of the twentieth century who excelled at writing wonderful descriptions of trams was D.H. Lawrence (1885–1930), who was born in Eastwood, a small township in the East Midlands, which was served by the Nottinghamshire and Derbyshire Tramway. Lawrence must have ridden on this tramway regularly and you get the impression from him that to travel on these tramcars was always an adventure.

They were known locally as the Ripley Rattlers, although Lawrence never mentions this. Painted in a light-green and cream livery, they started operating in 1913, and lasted until 1932, when they were replaced by buses. They ran a distance of fifteen miles from Nottingham through Kimberley, Eastwood, Heanor and Codnor to Ripley, mostly on single tracks, which had an amazing total of 316 passing loops. These passing loops, on average every eighty yards, were on the left-hand side of the standard-gauge track, so if you were travelling from Nottingham to Ripley you were swung this way and that as the car negotiated each loop in turn.

The tramway connected a string of hamlets, villages and townships of various sizes, opening up opportunities, creating greater intercourse, and enabling workers to get more easily to the collieries, ironworks, brickworks, hosiery and knitwear factories, and so on, dotted along the line. The cars soared up and down hills and dales, starting 100 ft above sea level at Nottingham and gradually rising to 490 ft at Ripley. They ran over and under bridges, round tight bends, past lines of tall trees that were once part of Sherwood Forest, through glorious countryside one minute and depressing surroundings the next. They rattled past cottages and black terraced houses, pubs and churches, schools, shops, market places and cinemas. And they started their journey outside the Co-op in Nottingham and finished it outside the Co-op in Ripley. By all accounts, the

Ripley Rattlers must have offered one of the most thrilling, intoxicating and awe-inspiring tram rides of their day. Much of this Lawrence conveys so admirably in the following extract from his short story *Tickets, Please* (first published in 1922),[1] which is reproduced by permission of the Estate of Frieda Lawrence Ravagli and Pollinger Limited.

> There is in the Midlands a single-line tramway system which boldly leaves the county town and plunges off into the black, industrial countryside, up hill and down dale, through the long ugly villages of workmen's houses, over canals and railways, past churches perched high and nobly over the smoke and shadows, through stark, grimy cold little market-places, tilting away in a rush past cinemas and shops down to the hollow where the collieries are, then up again, past a little rural church, under the ash trees, on in a rush to the terminus, the last little ugly place of industry, the cold little town that shivers on the edge of the wild, gloomy country beyond. There the green and creamy coloured tram-car seems to pause and purr with curious satisfaction. But in a few minutes – the clock on the turret of the Co-operative Wholesale Society's shops gives the time – away it starts once more on the adventure. Again there are the reckless swoops downhill, bouncing the loops: again the chilly wait in the hill-top market-place: again the breathless slithering round the precipitous drop under the church: again the patient halts at the loops, waiting for the outcoming car: so on and on, for two long hours, till at last the city looms beyond the fat gas-works, the narrow factories draw near, we are in the sordid streets of the great town, once more we sidle to a standstill at our terminus, abashed by the great crimson and cream coloured city cars, but still perky, jaunty, somewhat dare-devil, green as a jaunty sprig of parsley out of a black colliery garden.
>
> To ride on these cars is always an adventure. Since we are in war-time, the drivers are men unfit for active service: cripples and hunchbacks. So they have the spirit of the devil in them. The ride becomes a steeple-chase. Hurray! I have leapt in a clear jump over the canal bridges – now for the four-lane corner. With a shriek and a trail of sparks we are clear again. To be sure, a tram often leaps the rails – but what matter! It sits in a ditch till other trams come to haul it out. It is quite common for a car, packed with one solid mass of living people, to come to a dead halt in the midst of unbroken blackness, the heart of nowhere on a dark night, and for the driver and the girl conductor to call, 'All get off – car's on fire!' Instead, however, of rushing out in a panic, the passengers stolidly reply: 'Get on – get on! We're not coming out. We're stopping where we are. Push on, George.' So till flames actually appear.
>
> The reason for this reluctance to dismount is that the nights are howlingly cold, black and windswept, and a car is a haven of refuge. From village to village the miners travel, for a change of cinema, of girl, of pub. The trams are desperately packed. Who is going to risk himself in the black gulf outside, to wait perhaps an hour for another tram, then to see the forlorn notice 'Depot Only', because there is something wrong! Or to greet a unit of three bright cars all so tight with people that they sail past with a howl of derision. Trams that pass in the night.

A Notts and Derby tramcar on a trial run in 1913. This is one of the tramcars that D.H. Lawrence found it an adventure to ride on.

Unfortunately I was unable to ride on the Ripley Rattlers; they were scrapped shortly after I was born. But from my subsequent travels to other cities which still had trams I was able, to some extent, to experience similar adventurous rides, and some, in fact, that were quite different. For instance, in Leeds there were modern bogie tramcars that ran off the roads altogether and swung onto private tracks laid through a wood and a park. In London I found they had trams that ran through a tunnel and long bogie double-deckers that reminded me of submarines running on a tram-only reservation along the Thames Embankment. While in Glasgow they had modern double-deckers, which some said were the finest in the world, running at faster speeds for longer distances (over twenty miles) including long sections across fields, down country roads and on roadside reservations. In Sunderland I discovered, to my great amazement, that they had a great array of second-hand cars from places which had dispensed with trams, like Accrington, Bury, Huddersfield, Ilford, Manchester, Mansfield, and South Shields. In a short space of time I explored all the tramway systems left in mainland Britain. There was hardly a stretch of track that I had not ridden on.

This desire to explore further afield by tramcar soon had me taking advantage, on 26 July 1952, of one of the first cross-channel day-trips in order to tour a hundred miles or so of tramway along the Belgian coast. In one day eleven of us travelled by tram from Ostend to Le Zoute and Bruges, near the Dutch border, and from there to La Panne and Furnes (Veurne), close to the French border, and finally back to Ostend to catch the ferry back home. We were riding aboard cream single-deck cars all day and I must admit that somewhere along the line, as we sped beside the sea, I was lulled into a deep sleep to make up for that which I had lost on the cross-channel ferry.

These lines on the Belgian coast were once part of an extensive network of tracks that stretched all over the country, enabling you to travel from one town to another by either electric, steam or diesel tram. They were operated by the Société Nationale des Chemins de Fer Vicinaux (SNCV) and at their peak in 1940 the track totalled more than 3,000 miles, while the fleet consisted of some 3,000 cars.[2] The tracks radiated in all directions from the capital, Brussels, and other major towns like Liège, Antwerp and Charleroi. A few years later I rode on some of these lines, including one which took you from the centre of Brussels to the famous battlefield at Waterloo, where Wellington defeated Napoleon. Some of the SNCV tracks seemed to stretch into eternity, often running alongside long, straight roads with little change of scenery; you had to be a hardened lover of trams to set off on lengthy explorations of the system, especially on those lines which plunged through mile after mile of beet fields or clattered past giant slag heaps in the mining areas around Charleroi.

Another large network in Europe was to be found in the Ruhr, and on 9 August 1958 I made a seventy-seven-mile circular tour of the connecting lines on a special car hired by German tram fans. We started in Essen and our route took us through Steele, Gelsenkirchen, Bochum, Herne, Recklinghausen, Hüls, Polsum, Gladbeck, Bottrop, Osterfeld, Oberhausen, and Mülheim, before returning to Essen

Bradfordians in their best weekend clothes flock to Forster Square for joyous tram rides out to the countryside.

some eleven hours later. There were several other English fans on the tour, some of whom were known to me.

These days it is not unusual for people to board a plane and fly to Dublin, Paris, Tallinn or Amsterdam for a day out. In the early years of tramways it was the practice for young and old alike to board trams at weekends for a ride out into the country. It was a very popular, welcome and eagerly awaited outing. In 1914, when Bradford opened its seven-mile route to Bingley and Crossflatts, there were long queues on Sundays and bank holidays for the trams, many passengers making the journey to Bingley and back purely for the pleasure of taking a breezy ride on an open-top tram. This description of a trip on one of the inward-bound cars between Bingley and Saltaire appeared in *Gossip*, the magazine of the Bradford Tramways Department.

> Ting, ting, ting. Full up! With a gentle jerk the car starts off down the hill. We've been lucky, for the next waiting car has a covered top. Round the bend with increasing speed, the stiff breeze blows in our faces. Out of Bingley town we glide, along the straight narrow road beneath overhanging trees; the metallic echo of the tramcar's gears sounding strangely in this erstwhile quiet place. Out into the open country, winding downhill towards Cottingley Bridge, the magnificent panorama of the Aire spreading away towards Shipley, with Milner Field and Hope Hill on the skyline. …
>
> The widening of Cottingley Bridge is hardly completed, and as an inspector with a flag signals our car slowly over the temporary single line, we have ample time to catch a glimpse of the river, over the smooth clean Yorkshire stone parapet on the new side of the bridge. …
>
> Our car climbs the hill towards Cottingley Bar; and as we wait on the loop halfway up for a Bingley-bound car to pass, we gaze down the steep slope to where the river flows through the fresh green pasture with its grazing cattle; stretching down the valley until it is lost in the thickly wooded grounds of Bankfield.
>
> On the bank to the right, as we approach Cottingley Bar, some of the cottage doors are open and there are faces at the windows. Never before have the cottagers seen crowded tramcars passing their doors at Easter. Another car has come up behind us; it has just been equipped with the new high-powered motors which seem to annihilate distance. But it has a covered top; many of its top deck passengers are cooped up inside, in a reek of tobacco smoke.
>
> At Cottingley Bar a section of new-looking wall marks the place where the Toll Bar house was demolished not so very long ago, to widen the road; and as we go once again over the points into single line we enter into an avenue of stately trees, bordering the grounds of Cottingley Manor. They have grown so tall that their branches almost form a vaulted roof overhead. …
>
> As we cross over the Shipley boundary at Nab Wood the car begins to bounce like a rocking horse, and as it sways and jolts over the points again and again we are so intent on holding on that we hardly observe that we are passing along a most unusual stretch of tramway route, which winds like a snake

Tourists enjoying the thrill of a ride on an open-top tramcar at the National Tramway Museum. The Museum's tramway runs for part of its length up the side of a hill, giving breathtaking views equal to those obtained by adventurous tramway travellers in the early years of the twentieth century.

through the heart of a thick wood. But it's all been very enjoyable, and there is time to get our breath again at Saltaire as we draw up behind a line of cars which are loading up with Shipley Glenites. Looking round at the rosy wind-blown faces of our fellow passengers we feel that the ride has done us all good.

People queued in most big towns for trams that would take them for long rides out into the country. In the West Midlands, as well as waiting in their thousands for the Lickey Hill trams, they formed long queues in Birmingham and Dudley for excursion trams to Kinver, the 'Switzerland of the Midlands'; this gave an adventurous ride across meadows, along a canal and past the famous caves at Kinver Edge. One could go on and on listing lines like these: the scenic seaside tramway between Llandudno and Colwyn Bay in Wales; the spectacular, precipitous cliff-hanging line between Douglas Head and Port Soderick on the Isle of Man; and the stunning Giant's Causeway line in Northern Ireland with its majestic panoramic views of the Atlantic coastline and occasional glimpses of basking sharks, seals and porpoises, not to mention waves breaking over rocks many feet below. They all had their devotees and it was a pity many of them had to go so soon, especially those that disappeared before the Second World War.

Tram rides out into the country did not necessarily have to be long. Short rides into the country sufficed in some towns as long as they brought the rider plenty of fresh air in place of the polluted air he had to breathe in for the rest of the week. In some places you could even hire tramcars to take parties into the country or places of amusement (in Ashton-under-Lyne, for example, tramcars were hired at two shillings a mile to take children to the zoo at Belle Vue). In Stockport in 1904, the newly opened tram service to Gatley, then more rural than it is today, attracted hordes of fresh-air seekers. In their book *Gatley* (published by the Vicar and Churchwardens of St James' Parish Church in 1980), Frank and Teretta Mitchell wrote about the huge influx of day-trippers at weekends.

> The people of the then tiny village of Gatley viewed the coming of the electric trams with pleasurable anticipation tinged with some apprehension. The doomsayers, of whom Gatley has never been short, predicted that the trams would bring in hordes of rowdies from surrounding industrial towns. Nothing of the kind happened. Hundreds of trippers did come, and were charmed by Gatley's rural beauty. They bought pots of tea at the farms and cottages, and returned home peacefully. The Rev. John Bruster, Vicar of St James, no doubt heaved a sigh of relief as he wrote in the Parish Journal for April 1904, Eastertide: 'We had a large influx of visitors brought by the trams throughout the day (Good Friday) and so far as my own observations went there was nothing to complain of in the conduct of the trippers, nor have I heard any complaint, except for one against some people who passed through Gatley village late at night. Of course, it was a very new experience for most of us to see so many people about, and to some extent that in itself was disturbing. If, however, we are not incommoded in the future more than we have been hitherto, it will be a great relief to anxiety, and a testimony to the well-behavedness of the British Fresh-Air Seekers.'

In the early years of the last century, fresh-air seekers in Stockport travelled in their hundreds by tram to savour 'the rural charms' of Gatley. No. 25 tram is stood outside the Horse and Farrier public house, still in business today. Note the car's decency panel is green – waiting, no doubt, for an advertisement to be painted on it.

For people packed into terraced houses in the grimy and very industrialised heart of Stockport at the beginning of the twentieth century, these excursions by tram into the countryside were clearly something to be welcomed and treasured, as the following paragraph from the Mitchells' book illustrates.

> Advertisements for the tram service to Cheadle and Gatley were circulated in Stockport and district, and glowing descriptions were made of the journey. One person wrote: 'A spin through Brinksway, and the car emerges into a new spick and span villadom. A whiff of fragrant hay greets the passenger as he whizzes along the road. Through the pretty village of Cheadle the passenger can see a vast difference from Brinksway – creepers clinging to the sides of dwellings in lovely luxuriance. Farther afield, one may see a dwelling here and there, which is a picture to bring light to the eye and gladness to the heart. And in the surrounding gardens all is summer loveliness – a thing of beauty and a joy for ever in its season....'

As tramways stretched their tentacles and linked up with surrounding towns, some excursionists were not satisfied with rides out into the local countryside. Keen to widen their horizons, they set out, instead, on long journeys by tram from one metropolis to another or from one county to another, and even across the Pennines. And it was made easier in the heyday of the tram when the linking up of tracks created long continuous lines of tramway, as were to be found in most of the giant conurbations.

In 1917, for example, a man travelled all the way from Wigan to Wharfedale, mostly by tramcar – a distance of some eighty miles. He made the trip, which took twelve hours, to save money and because he thought it would be an interesting experience, 'something to talk about in the smoke room'. His journey took him through Hindley, Atherton, Bolton, Bury, Heywood, Rochdale, Halifax, Bradford and Leeds, and involved his changing cars fourteen times. He was quite fascinated to discover how much the trams he rode on differed from each other, and how scenic some of the lines were, especially those in Halifax, which went way out into the countryside. He said:

> The Halifax cars are built on a narrow gauge. And if you are riding, as I did, on top, you get a periodical shaking up. But they take you through a lovely country. In the trams you appear to be riding over and above the hills, and when the car is on its best behaviour, you fancy yourself sailing through space.

The Halifax system was the hilliest in Britain, with steep gradients on every line and two routes climbing more than a thousand feet above sea level. He observed that in Yorkshire 'trams seem to be run for the convenience of the people, and not so much for the fat aldermen, who like to tell the ratepayers on budget day how much they have "earned" on the trams'.

There were only two sections of his journey that were not made by tram. One was the seven-mile gap between Rochdale's Summit terminus and Halifax's Hebden Bridge, which he covered by bus and foot, and the other between Guiseley and Wharfedale, which he covered by trolleybus, one of the first to operate in Britain. In all he travelled on nine tramway systems and fifteen different trams, his total fare coming to three shillings and seven pence. 'Looking back on it, I honestly felt I had never enjoyed a day so much in my life,' he said.

His ten-mile tram ride from Leeds to Guiseley was quite scenic, passing Kirkstall Abbey and climbing into Airedale through Horsforth, Rawdon and Yeadon. In fact, at that time Guiseley was a popular destination with the Leeds fresh-air seekers, and at the end of the day the queues for the trams back to Leeds were over a mile long and not cleared until the early hours of the morning.

Another intrepid adventurer at the beginning of the twentieth century, who travelled fifty miles by tram between Manchester and Leeds, liked the new Rochdale electric tram which took him from Sudden into the centre of Rochdale, but wasn't at all impressed with the steam tram which took him from Rochdale to Littleborough. He wrote, in a local paper:

> Rochdale's new cars, which commenced running on the Sudden section a week or two ago, are worthy of an enterprising corporation. No death-dealing microbes lurk in cushion seats, for there are no cushions. In one corner, however, hangs a pretty little clock, a very useful innovation, and on the glass panel of the sliding door figures the Rochdale coat of arms and motto – 'Crede signo' which, rendered literally, is supposed to mean 'Believe the sign'. The transformation from this smart car to the antiquated steam tram, with a snorting, smelling engine, which leaves Rochdale for Littleborough, was not to my liking, but I had to grin and bear it. The cumbersome machine jostled along on the narrow gauge, almost throwing us from our seats, and the effluvia from the iron horse reminded one of a sniff from the engine-room of a Douglas boat. To add to my discomfort a fellow-passenger did his best to set my teeth by munching grapes and strewing the floor with skins.

Altogether I was glad when that half-hour's ride was over.

It was possible to make long journeys by tramcar in London. Apart from a small gap between Swanscombe and Horns Cross, you could venture about forty miles on the tramways that stretched from Gravesend across London to Uxbridge. Circular holiday trips were arranged for one shilling from London through Kingston to Hampton Court and back by Hampton, Twickenham and Kew – twenty-four miles altogether. You could also travel nearly forty miles by tram in the Glasgow conurbation – from Wishaw through Motherwell, Hamilton, Glasgow, Clydebank and Dumbarton to Loch Lomond. Glasgow had the longest tram route in Britain – from Renfrew Ferry in the west via Barrhead to Milngavie in the north, a distance of almost twenty-three miles. It was introduced in 1934, and there was a period when you could ride the whole distance for two and a half pence. For the same fare you could ride from Ferguslie Mills at Elderslie through Paisley and Baillieston to Airdrie, a distance of more than twenty miles. Strikers marching from Greenock to Edinburgh took advantage of the bargain fare to save their legs by riding the full length of the line.

In May 1938, some fifty tram enthusiasts travelled sixty miles on London's newest tram, Bluebird (No. 1) from Waltham Cross in Hertfordshire via the Kingsway tunnel to Purley in Surrey and back. For their five-shilling ticket, probably then the dearest tram ticket ever issued, they passed through fourteen boroughs and had tea en route. Six months later, enthusiasts rode on Birmingham's most modern tramcar, No. 843, a luxury lightweight vehicle, from the centre of Birmingham out to Dudley, all the way across the city to Rednal, and then back to the centre – a total distance of nearly forty miles.

These journeys, though, paled into insignificance when compared with the epic journeys that could be made in America in the heyday of the interurban tram.

The longest trip, changing cars, was between Elkhart Lake, Wisconsin, and Oneonta, New York, a distance of 1,087 miles.

In 1904, a man travelled 500 miles by trolley car on his honeymoon. He took his bride from Wilmington, Delaware, to York Beach, Maine. What she thought of it all isn't recorded.

In 1912, American operators demonstrated how far a tramcar could be driven over different tracks. They drove one 260 miles from Boston to New York, as the following report from the *Tramway and Railway World* for 1 June 1912 shows:

The record long-distance journey by electric tramcar has been completed by the arrival in New York of the first experimental car from Boston, a distance of nearly 260 miles by road. The experiment was made by the principals of the Boston, New Jersey and Connecticut Tramway Companies. The car, which was thirty-three hours on the road, stopped at New Haven, Connecticut, for the night, and the actual running time was only eighteen hours. For purposes of quick travelling a service between New York and Boston would not be particularly valuable, for the journey can be made by railway in between five and a half and six hours. The experiment, however, is interesting as showing what can be done with the electric car. The car was fitted with a buffet, at which meals were taken en

It was once possible to journey more than twenty miles across Glasgow by tram. One of the city's luxurious Cunarder cars rolls down a rural section of track between Darnley and Spiersbridge, to the south of Paisley, in 1955.

route. Two motormen and two conductors made up the official staff. The route was via Worcester, Springfield, Hartford, New Haven, Bridgeport, Norwalk, Stamford, Port Chester and Mount Vernon, and the car ran on existing tram lines, except when crossing the Darien River, where a special track had to be laid.

The two most adventurous journeys I would have fancied undertaking, and regret never having done so, both reached sierras – one in Spain and the other in California. The one in Spain was the Granada Tramway, which ran from Granada into the Sierra Nevada, Spain's famous mountain range, and friends say it was the most beautiful tramway in the world. The tramway crossed twenty-one bridges and ran through fourteen tunnels, clinging to mountain ledges and meandering along a river and through a high gorge before reaching the terminus at a spectacular waterfall. It vanished before I was aware of how marvellous it was.

The other tramway system I clearly would have enjoyed was in Southern California, stretching northwards from Los Angeles to Mount Lowe and southwards to the North Pacific Ocean. This network belonged to the Pacific Electric Railway, which boasted it was the biggest system in the world, with more than a thousand miles of standard interurban electric trolleycar lines radiating from Los Angeles to exotic-sounding places such as Hollywood, Beverly Hills, Pasadena, San Fernando, San Pedro, Long Beach, Santa Ana, and (far to the east) San Bernardino and Redlands. In all it linked some 130 cities, towns and communities and covered a coastline of some sixty-five miles. It carried 100 million passengers a year and employed some 70,000 people. The giant interurban trolleycars running on its reserved track lines were nicknamed the 'Big Red Cars'. They travelled at high speed, and, as they were not obliged to stop for road traffic and crossings, covered the sixty miles from Los Angeles to San Bernardino, for instance, in 105 minutes. This did, however, include time for stopping at halts to set down and pick up passengers. They negotiated rugged canyons en route to mountain resorts, plunged through the orange groves of the great San Gabriel valley as well as sugar beet and celery fields, and skirted the foothills of the great Sierra Madre mountains, making the whole vast area around Los Angeles readily accessible to many people. Some 2,700 interurban trams were scheduled to run each weekday over the network and many whole-day sight-seeing trolley trips were organised for tourists on board luxuriously upholstered parlour cars.

The big red cars were not to be confused with the smaller streetcars which worked the local lines in the different towns, like those in Hollywood, for instance, which were featured in the Harold Lloyd early silent films. These included *Girl Shy*, in which Harold was portrayed dangling from the trolley pole of a streetcar speeding at full power driverless through the streets.

It is still possible to find tramways which offer adventurous tram rides today, but you have to look far afield. Michael Russell, probably one of the country's most intrepid tramway explorers, has visited most of the world's exotic tramways, and all but one of those in Russia. In 2004 he journeyed to the Urals to ride on one of the most rural tramways in the world at Volchansk, which he described as a 'ghost town' tramway – but a classic in every respect. Describing his visit in the September 2004 issue of *Tramways and Urban Transit*, Michael wrote:

Idyllic scene on a Russian tramway that transports the adventurous tramway traveller back in time. This Volchansk tram (No. 8) is passing a derelict farm on its 6 km journey through picturesque undeveloped countryside.

Volchansk is almost at the northern limit of the north Urals industrial belt. Its wealth was based on open-cast coal-mining, but the great majority of the mines were closed as a result of 'perestroika'. The settlement has no passenger railway service and is something of a 'ghost town', with high levels of male unemployment. The surviving tram route, 8.8 km long, links Volchanka, the southern village where the depot is situated, with the northern village (Lesnaya Volchanka), en route traversing about 6 km of undeveloped country, passing derelict farm buildings, paralleling sparsely trafficked roads and criss-crossing a network of railway lines bearing witness to the area's former industrial importance. The line is entirely single-track and mostly on reservation or private right-of-way, with one intermediate passing loop, but within the southern village the single track is laid in the middle of the street in a manner reminiscent of the Belgian vicinal tramways. Stops are infrequent, but those in the rural section are all named and provided with passenger shelters. By all logic, it should have ceased operation when the local mine closed in 1995, and the fact that it has kept going is remarkable.... For the adventurous tramway student a visit presents a logistical challenge, but the achievement is not unrewarding.

[1] A TV play of *Tickets, Please* was screened on television in September and October 1965. Part of the action was filmed at the National Tramway Museum the previous March aboard a Notts and Derby tramcar, which was actually a Johannesburg tramcar made to look like Notts and Derby tram No. 14. The tramcar carried Ripley on its destination screen and an advertisement for the *Nottingham Post* emblazoned round the balcony. It looked quite authentic, so few Granada Television viewers would have realised it was not the genuine article.

[2] The SNCV electric lines totalled 1,479 km, and the non-electric (steam and diesel) 3,333 km according to W.J.K. Davies in his book *100 Years of the Belgian Vicinal.*

Air on a G-Tram

By Peter Collier

In thick fog, two Bolton trams bumped into each other on a stretch of single track on the 'G' route[1] to Walkden. Neither driver was prepared to give way. Peter Collier of Little Sutton, on the Wirral, writing in the *Bolton Evening News* for 18 February 1997, reveals how the confrontation was eventually settled by a small boy on a bicycle.

The five-mile single track between Bolton and Walkden was punctuated at regular intervals by loop lines that served also as tram stops close enough for each to be seen from the next one to it.

Bolton Tramways Department regulations were quite clear: if two trams were stopped facing each other on adjacent loops, the first one to begin to move away from the stop had right of way over the other one. Applied sensibly and courteously it worked well. Even in fog, coded signals were exchanged using foot-operated clangers, giving plenty of warning and avoiding mishaps. But any system is only as good as those who use it, so when poor visibility combined with even poorer relations between belligerent drivers, resulting in complete absence of any sort of communication between them, the outcome was inescapable.

It just happened to occur in thick fog between Hill Top and Topping's Bridge. Neither driver could see the other, so each clanged a warning before moving onto the single track: contact was aural for several seconds through the murk before it became visual.

Standing astride his bicycle, George was suddenly excited by the sound and sight of two twelve-ton monsters approaching each other at suicidal speeds in front of his house. Being only eight, however, he didn't quite appreciate the significance fully enough to shout to his mum in the kitchen. She in turn was quite familiar with the noise of 'the rattlers' every ten minutes or so at this time of day, so, as she said later, she wasn't alarmed by what she thought was only one tram in the smog.

The impact, however, left neither of them in any doubt: she didn't even stop to pick up the knife she had dropped on the kitchen floor, but ran to join George outside. The vehicles must have braked hard, because the only damage to either was to their front lamps. The drivers were still standing upright at their controls, white knuckles on the handles, staring at each other, rigid and motionless, their noses almost a foot apart.

Not so, however, the passengers. They were busy picking themselves up from the slatted floor, having slid ever so gracefully onto it from the polished bamboo seats. They were quite used to doing this, albeit more usually sideways into the centre aisle, whenever the tram hit bits of track its bogeys couldn't cope with. But this was different: the most unlikely couples had been thrown together in scenes bearing uncanny resemblances to bitterns wooing.

As soon as it was realised what had happened, the silence was broken by violent verbal reactions. Passengers, drivers and conductors began shouting obscenities at each other. The air between them was so

The air was saturated with expletives and sparks flew when a Bolton tram met one coming the other way on single track on the Walkden route. But there was no chance of this preserved Bolton tram meeting another tram head-on while taking part in Fleetwood's Tram Sunday, for on this street it is running on double-track. The tram, No. 66, shown here with local dignitaries on the front platform, was restored by enthusiasts in Bolton and is now preserved at Blackpool. It is the sole survivor of Bolton's fleet of 165 cars.

saturated with expletives that George's mother pushed him indoors, but he immediately ran out again the back way. Nothing as exciting as this had ever happened outside his house, and he wasn't going to miss a second of it.

Drivers, conductors and passengers paired off as sparring partners, each blaming the other for the melee: each telling the other how it should be resolved; each telling the other where to go. Within minutes they were joined by an inspector from the next tram waiting at Hill Top, but this did nothing to ease matters, because he was immediately regarded by everybody as being on the side from whence he had appeared. Nevertheless, he appealed to each driver in turn, but neither would budge, verbally or physically. Each claimed the other had been abusing the rule for years, and said he would stay where he was for as long as it took.

The temperature suddenly rose even higher when one of the conductors pulled the other's trolley wheel off the wire, and started to run with it in an attempt to face it the opposite way. The other one followed suit, and sparks flew as both trolley bars and conductors collided. As the minutes passed, the older passengers began to return to their seats, out of the cold: some started to turn on their own drivers, and one or two of them even managed to raise a wry smile at their predicament. Then an inspector appeared from the opposite direction, whereupon the colourful descriptions and recriminations and suggestions and accusations and unauthorised signally began all over again. But neither driver was going to back off: complete stalemate had been reached: minds had closed: permanent deadlock reigned paramount.

Then something happened. Out of the fog came a little boy. On his bicycle. George tugged at the sleeve of one of the inspectors, who at first ignored him. Again he tugged: he'd had enough of this game. It had been exciting at first, but this impasse was boring now.

'What is it, son?' the inspector snapped. He, too, wished it was all over. It was home-time rush-hour, and all his trams were in the wrong place.

As George whispered, the inspector leaned to listen. Gradually his mouth dropped open and his whole face lit up. He ran to the other inspector, repeated what George had said, and together they shouted for the drivers and conductors. Then they all swapped trams, swung round the trolleys, and parted, showing only two smashed tail lights as evidence of the incident.

'George: Come back inside this minute!'

His parents never did understand the reason for his demure, self-assured smile as he sat down with them for his tea that day.

[1] The Walkden route, originally lettered 'F', became 'G' in the Second World War.

Train's Tram

From The Daily Telegraph

The press were full of praise for the American entrepreneur George Francis Train[1] when he opened Britain's first street tramway at Birkenhead on Thursday, 30 August 1860, after having been turned

away by Liverpool and other major cities. Train printed all their praises in his commemorative book *First Street Railway Banquet in the Old World*, published after the opening and reprinted by Adam Gordon in 2004. **This fascinating editorial from The *Daily Telegraph*, reproduced in the book, saw the tramcar as a means of bringing discipline to the traffic chaos that existed even then by providing a faster and smoother form of transport for the benefit of many. It gives an insight into transport problems at that time and the distinct feeling that congestion in big city centres was no easier then than it is today. You also get the impression that they were digging up the roads in Queen Victoria's day as frequently as they are now. The *Daily Telegraph*, like its contemporaries, was not quite sure what to call Train's vehicle, describing it as a 'street railway'. They used the word 'tram' to mean a sunken beam or rail made of stone or wood.**

We have to ask those of our readers who have attained mature age to take their thoughts back about thirty years, and to indulge in a retrospect of a wonderful 'steam carriage' – patented, we believe, by a person named Hancock – which was wont to ply between Finsbury and Paddington. This vehicle was a species of amalgamation of a stage-coach with a kitchen range. The funnel, if we remember aright, rose above the 'boot'; there was a helmsman in front; and the tires of the wheels were of immense breadth. Somehow, the 'steam carriage' did not come to anything. We believe that Mr Hancock threw the surplus of his energies into India-rubber, and with more success. Another ingenious gentleman, named Perkins, likewise devised a street locomotive; but that, too, ended as it began – in smoke. It must be remembered that these abortive attempts at the perambulation of the public thoroughfares by mechanical power were concurrent with the introduction of omnibuses into this country. Mr Hancock was the contemporary of Mr Shillibeer.

Curiously, during the thirty years that have elapsed since those hearses for the living were transplanted from Paris to our soil, we have scarcely endeavoured to improve the system of locomotion in our streets. Our four-wheelers and Hansoms may be a trifle more rapid in their progress than the old hackney coaches and high-wheeled cabs with the driver in a perch by the side; we have a General Omnibus Company; and the Winding-up Act knows something about that unhappy 'Saloon' speculation which was to regenerate everybody and which satisfied nobody; but it is not less a fact that we have remained for a quarter of a century almost stationary in the economy of our street traffic. We have the same vulgar drivers – the same insolent and extortionate conductors. There is no system to check the number of passengers who travel. The offer of liberal premiums has been unsuccessful in producing such a thing as a handsome or commodious omnibus; nor does the wholesale purchase of omnibus 'times' by a joint-stock association appear to have brought about a millennium. However, it is not on omnibus reform that we wish at present specially to dwell. Our business is more with the roads on which omnibuses run. We want to know how long this gigantic 'block up' and this frightful 'dead lock' in the London streets are to continue. We want to know whether any means can be found for relieving the over-burdened traffic in our thoroughfares, and for enabling our citizens to travel with comfort and celerity from one end of the metropolis to the other.

The present position of affairs in our streets is clearly intolerable. Granting, even, that the sewers, the paviours, the gas companies, and the electric telegraph people refrain from grubbing up the roadway, making Piccadilly a series of precipices, and opening pitfalls in the Strand, the main avenues of London are at all times of the day most inconveniently and dangerously thronged. We have a 'rule of the road', but, equally as a rule, it is disregarded; and the history of a day in a London street is but a chronicle of collisions, locked wheels, broken axles, starred panels, dead horses, smashed children, and blasphemous language. It is perfectly scandalous that in this enormous and wealthy city we cannot drive from Regent-street to St Paul's, in a

With arm outstretched, George Francis Train stands on the top deck of his Birkenhead tramcar on 30 August 1860 – the day his tramway became the first to open in Britain. The 5 ft 2 in gauge line ran from Woodside Ferry to Birkenhead Park, and cost about £2,000 a mile to construct. Train invited many distinguished guests to the opening, including crowned heads of Europe, the Pope, and famous authors and poets, but none accepted.

Hansom cab, without being blocked up by hearses, drays, luggage vans, and dustmen's carts; that delicate ladies in their broughams should be exposed to the ruffianly and ribald slang of costermongers who are trying to pass them; that there should be brawls and conflicts with the police at the corner of every street; that the lives of foot passengers should be imperilled by the frantic feats of reckless drivers; and that, to complete the saturnalia of confusion, hordes of over-driven cattle should be thrusting their horns among the horses.

We have truly need of a Society for the Prevention of Cruelty to Animals, for the amount of pain and suffering inflicted on dumb brutes through the overcrowding of our thoroughfares is both lamentable and disgusting. As the slave stood behind the Roman conqueror in his car of triumph to remind him that he was mortal, so does the knacker's cart follow in the wake of the nobleman's carriage, with its satin-skinned steeds. A jolt and a crash in New-street, Covent-garden, or on Holborn-hill, may in a few moments convert three hundred pounds worth of horseflesh into very little better than carrion, available only to the industrials of Cow-cross, as materials for mortar and for glue.

How is this state of things to be remedied? That it *must* be remedied, and that speedily, is apparent to the meanest comprehension. After much vigorous struggling in the formation of a company, we are to have, it seems, under-ground railways, which we only hope will turn out more profitably than that costly toy, the Thames Tunnel. But this subterraneous system of thoroughfares is even now only at its preliminaries; and, when the underground railways are completed, a majority of the public may entertain objections to travelling in a labyrinth of dry sewers. There has been recently a talk of parochial subways; and there are always some enthusiastic idealists whose aim is 'Excelsior', who look towards the sky, who perpetuate the dreams of Montgolfier and Philahe le Rosier, and who will never be satisfied till an aerial machine starts every morning from Camberwell, and a 'stand' of balloons, with Aquarius from the Zodiac as 'waterman', hovers at the end of Regent-street. Meanwhile we may say, using the converse of Galileo's proposition, '*Eppur si muove*'. While we are waiting for our up-above or underground communications, the dismal procession of jammed-up vehicles continues on the earth itself. At this fortuitous nick of time railways, or rather tramways, in the streets themselves have been suggested.

An energetic representative of American 'Spread-eagleism', Mr George Francis Train, has started a Street Railway at Birkenhead, in Cheshire, over against Liverpool. The three-horse omnibuses which rattle through the streets of the giant city of the Mersey were already, to some men's minds, huge enough; but Mr Train has piled Pelion upon Ossa, and his colossal omnibuses gliding along the trams between Woodside Ferry and Birkenhead Park present a curious spectacle of stupendous weight

Manchester was one of the towns that turned George Francis Train away in 1860 and it was seventeen years before the city allowed horse trams to venture onto its streets. But soon there were more than 500 trams in service like the one shown here on the service from High Street to Harpurhey in the north of the city. The car is at the terminus, outside the Farmyard Hotel at Barnes Green, just short of Boggart Hole Clough, a popular public park.

combined with easy rapidity. The experiment at Liverpool, based upon the data of the New York Street Railways, has been certainly successful. We believe that Mr Train intends, if he can obtain the municipal approbation, to extend his railway omnibus system to the main streets of Liverpool, and a powerful organization is in progress to establish this mode of communication in London itself. We have already a sunken tram on Westminster Bridge; but the ambitious purpose of the men of business, who look upon Street Railways as a lucrative investment, is, we believe, to lay down rails in all the principal thoroughfares in the metropolis, and to eliminate from the present maze of entangled vehicles a perfectly safe and easy process of continuous locomotion.

It is not to be denied that very serious difficulties stand in the way of the accomplishment of this object. A vigorous controversy has arisen respecting the practicability or non-practicability of Street Railways in London. We have given insertion to a host of letters on the subject, replete with arguments *pro* and *contra*, and have hitherto been contented with affording full scope for the ventilation of an important topic. But it strikes us that the time has now arrived when it behoves us, as journalists in whom the public repose some confidence, to offer an authoritative opinion on Street Railways. The many thousands who read our daily issue know that the governing doctrine of The *Daily Telegraph* is to use its power for the welfare of the community at large; that we are indifferent to class interests and to party prejudices; and that with might and main we have supported and will support, that which is good and true, whether it proceed from a Whig, a Tory, or a Radical source.

While the theme of Street Railways was yet susceptible of discussion, we forbore to deliver a verdict on one side or the other; but we have let our correspondents have their say. The case has been fully put and answered, and the arguments for and against clearly summed up. Our verdict is to this effect: – Give Street Railways a trial. We have money enough to spare for an experiment. If they fail, we can afford to pay the bill, and try to do something better. As we have hinted, we do not shut our eyes to the difficulties that lie in the path. They are as numerous as they are grave. Our shrewd and sensible correspondent, the 'New Yorker', has pointed out some of these difficulties; but it appears to us that the arguments in his last letter rather tell against his own proposition. Moreover, the experiences of Broadway and the Bowery are scarcely applicable to London. The metropolis is unique, unapproachable, and *sui generis*; and even Mr Train may find that the objects he could carry out with success in Dale-street, Liverpool, would be defeated in Oxford-street, London.

The 'New Yorker' asserts that where Street Railways have been formed in America the value of house property has depreciated. This reminds us of the shopkeepers of the Rue St Honore, who, during the Reign of Terror, petitioned Robespierre that the tumbrels might pass another way, as the customers who bought jewellery and millinery didn't like to see the people who were going to be guillotined; but, so far as London is concerned, we do not believe that any alteration in the traffic would create the slightest difference in the value of house property. In New York the commercial and the fashionable element are intimately intermingled. Wall-street and Fifth Avenue shake hands, and the dry goods and the trotting wagon move side by side. But in London, commerce and fashion have each its own district. Belgravia is, morally, a thousand miles distant from Bethnal-green, and such thoroughfares as the Strand, Oxford-street, Cheapside and Piccadilly are less streets than highways between the many distinct cities which in the vast amalgam make up London.

Again the 'New Yorker' propounds a doctrine very distasteful to English ears, when he states that by the introduction of Street Railways the poorer classes will profit, to the detriment of the wealthy. In England we don't wish the rich to suffer, but we *do* wish the poor to be benefited. *Rem quocunque modo, rem*; and, if suffering is inevitable, the few must suffer for the benefit of the many.

If the practicability of Street Railways be established; if the bugbears of steep gradients at Holborn and Ludgate-hill can be got over; if safe and commodious crossings can be made, it is the people who will reap the largest benefit from increased facilities for locomotion. Why should the middle classes exclusively enjoy the healthy suburbs of London? Why should not the industrious mechanic, the petty shopkeeper, the bricklayer's labourer, live at Kennington, or Fulham, or Dalston, and be smoothly and rapidly propelled every morning by a Street Railway to his daily toil? Why should Demat be kept eternally pent up in noisome courts and allies, when for the expenditure of a few pence a week he might possess the comfort and convenience which even the poor Frenchman is blessed with when he is driven along a Street Railway from Versailles or St Cloud to the Quai de Billy? It is, we think, in the highest degree injudicious to deprecate Street Railways without giving them a fair trial. Let us battle with Holborn and Ludgate Hills even as we have battled with Chat Moss and the Box Tunnel. A temporary failure may be the precursor of a permanent success. At all events

George Francis Train's short-lived tramway line on the Bayswater Road in London. Opened and closed in 1861, it ran from Porchester Terrace to Edgware Road – a distance of almost a mile – and never actually reached Marble Arch, seen behind the tram. The illustration is taken from a painting reproduced on one of Train's pamphlets.

the trial can do us no harm.

We do not look at this Street Railway question as one of pounds, shillings and pence. It may pay or it may not pay. We regard it in its grander and more humanising light, as an element of civilisation. Philosophers of the school of Volney are fond of asserting that civilisation is eternally repeating itself; that nations increase, and become luxurious and polished, and almost perfect, and then fall into decadence, till nothing but a sand-heap is left of Carthage, and a jagged rock of Tyre the magnificent. A better faith should teach us that the civilisation we enjoy will *not* decay; that there is as much difference between the perfection of Pompeii and the splendour of London as between the lowest type of man and the most educated monkey – a vast and impassable gulf. Were we Pagans we might prognosticate a deluge. As beings living under a purer dispensation, we look forward to the fulfilment of a promise. The meanest and commonest adjuncts of our work-a-day life – railways, omnibuses, steamers, postage-stamps, sewing machines, telegraph-wires, are all types of progress – of a progress that is tending towards an end.

That end will be when mankind is truly regenerate, when we have progressed beyond profligacy, and war, and drunkenness, and fraud, and all wicked things, when we have so civilised ourselves – whether it be in five hundred or five thousand years – when the moment shall come for Omnipotent Forbearance to say, 'It is time' – and when the evil and the just, the Gentile and the Jew, shall all hold up their hands at the Great Assize, and be judged according to their works, and receive their symbol.

[1] George Francis Train (1829–1904) went on to open other tramway lines in London, the Potteries, Darlington and on the Continent. In 1862 he returned to America to build the Union Pacific Railroad and in 1870 travelled round the world in eighty days, inspiring Jules Verne to create his famous story about Phileas Fogg. He then went round the world twice more, taking less time on both occasions. He also stood unsuccessfully as Republican candidate for the American presidency in 1872, and lived his last days, reduced in circumstances, in a New York hotel. After his death in 1904 his brain was weighed and found to be the twenty-seventh known heaviest in the world. A plaque commemorating Train's venture was unveiled at 23 Lord Street, Liverpool, by Loyd Grossman on 16 January 2004. Train's uncle had a shipping agency at this address, and it is where Train first worked when he came to England.

Traumatic Tales

By James Kilroy

The Hill of Howth, which sits on a peninsular just outside Dublin, was served by two tramways – one running from Dublin to the fishing harbour at Howth, and the other running from Howth Station up one side of the hill and down the other to Sutton Station, giving spectacular views over Dublin Bay and the Irish Sea. James Kilroy has written two books about Howth and its former trams, from which the following stories, describing three traumatic incidents, are taken. The first is from *Trams to the Hill of Howth*, a loving tribute and colourful portrait published by Colourpoint Books in 1998.

Concerning the Howth to Dublin tram I would like to tell a short story, to the best of my knowledge previously untold. It was related to me by the late John Byrne, who lived in Cheancor Road at the time.

When he was a lad, some time during the First World War, he was on his way to school by tram and boarded the city bound car at Sutton Cross, having travelled downhill from Cheancor Road by one of the 'Hill cars'. After a while he heard a strange wailing on the open upper deck like no sound he had ever heard before. It was high pitched, hollow and eerie. He could hold his curiosity no longer and ran upstairs to see what was causing these strange sounds.

He found a small child, about four or five years old, with his anxious parents trying to console him. When John moved closer to learn the cause of the problem, he discovered that the child had been playing *soldiers* with a ceramic chamber pot on his head. This had slipped down over his skull and could not be retrieved. The poor lad was frantic in his darkened trap and could not be pacified, and was on his way to the Mater Hospital to have it *surgically* removed.

The conductor, who had been collecting fares in the saloon, now mounted the stairs and quickly retreated, returning with a large brass switch key. He studied the 'po' for some moments and then applied a quick tap of the key and the 'po' came away in two clean halves. He announced that the very same thing had happened to his own son some weeks previously and he had seen the method of release.

It is difficult to imagine what would have happened had the 'po' fractured into many sharp pieces, injuring the child. The company would have been liable and the conductor could have lost his job. He took a chance and fortunately it paid off. The much relieved family continued their journey to the city and decided to visit the zoo to help the youngster to forget his trauma.

The second story, also from *Trams to the Hill of Howth*, took place on a hill car running from Sutton to Howth and involved motorman Billy McNally's conductor, whom James Kilroy declined to name on account of the embarrassing nature of the incident. Apparently it was customary for tram crews to stop off at Gaffney's Summit Inn for a pint to relieve the dreary winter run. Following one of these stops, they were approaching The Enterprise shop at the terminus in Howth station, when the conductor whispered to Billy Mac to 'drive the tram further down the track into the shadows' as he needed to take a leak:

There were no passengers and the station yard was soulless, so Billy responded to his buddy's request. What he was not to know was that the little used section of track beyond 'The Enterprise' had become overgrown and clogged with mud and the tram was marginally raised above the tracks losing contact with the rails.

A knowledge of electricity would help the understanding of this incident, and it is important to realise that electricity must run in an unbroken circuit. The overhead cable provides the outward current, which descends the trolley pole to power the motors and then travels through the trucks and wheels to make contact with the rails. The rails are bonded with copper strips and they provide the return route for the current going back to the power house. Losing contact with the rails, the tram body was *live* and the poor conductor was unaware of this. Now, we all learnt at school that water is an excellent conductor, and when contact was made with the wheels the home bound current took a short cut … to the unfortunate conductor! Billy Mac heard his friend's groans of pain and found him curled up, rolling in agony beside the tram. It is said that the poor man did not walk straight again for many days. No doubt the fellow never forgot his unexpected lesson in basic electricity. It took a following tram to haul Billy Mac's tram back on track.

In his first book *Howth and her Trams* (published by Fingal Book Publishers in 1986) Jim Kilroy records for posterity many of the anecdotes told to him by the tramwaymen of Howth. They are illustrated by cartoons, and one story, entitled 'An Act of God', describes what happened when a severe storm struck the hill trams in 1949.

In the summer of 1949 the Peninsular of Howth was struck by one of the most severe thunderstorms ever recorded. The day started as a beautiful sunny Sunday. Crowds of Dubliners had flocked to Howth to walk her majestic paths, scale her noble hills, swim

A tram on the scenic Hill of Howth tramway. There were few visitors who were not enchanted by the magic and splendour of the line, with its magnificent views of the Irish Sea and distant Lambay in the setting sun.

in her seas or simply laze about. Nelly Redmond recalls the day well: indeed she told me she could never forget it as long as she lives. The Shamrock Tea Rooms at Howth Summit was packed with holiday crowds, and each tramcar from Howth and Sutton[1] brought more and more people. It was intensely hot and throngs of people lay sprawled about the hill and the Summit tram was doing great business. Nelly was a waitress at the Shamrock Tea Rooms and the green sward about the Shamrock was coloured with people.

Tom Redmond[2] was setting off from Sutton when it happened. Amid the mirth and happy talk, no one had noticed the black cloud creeping over the hills like the flagships of war. The skies donned a cloak of steel grey and the gulls above shone luminous and eerie as they wheeled about. Suddenly a peal of thunder broke the silence and a loathsome rumbling swept the hills. The skies opened and rain drops as big as pearls danced heavily on the ground. It was as if someone had turned out the lights and the seas had swept over the land, as crowds of holidaymakers dashed for the shelter of the tram to make a quick descent to safer ground.

Tom had just pulled in at the Baily loop and could hear the scurrying of feet as the upper deck was abandoned to the pelting raindrops. As he reached out to throw the control into first notch, he felt a shock tremble through his arm which glued him to the controls for a few seconds before flinging him backwards across the platform. He can recall the numbness down his left side as he continued his journey to the Summit, shaking like an aspen leaf. The lightning was relentless. The tracks shone like silver threads ahead and the drenched sleepers sparkled as flash upon flash sizzled across the navy sky. The Hill of Howth groaned like a sinking ship.

When Tom reached the Summit he saw Billy McNally and his conductor in car No. 5 waiting for him to clear the section. Suddenly a belt of lightning sent fingers of icy light reaching out to the trolley standard which stood deserted on the upper deck of No. 5. Tom saw a glow run down the trolley rope and split the front of No. 5 in two like a cracked egg, as the crowds fled the electric tramcar in panic. Tom could see Billy shaking as they both ran for cover. Picking up courage, Tom and Billy eventually continued on their way. The trams were the only moving things that crossed the frightened hill as the storm raged incessantly until late that evening. Even when Billy talks about it now he feels his flesh begin to creep as he recalls the sky lit up as if on fire.

[1] The two termini.
[2] The motorman.

Arduous Work for a Boy of Thirteen

By George Grundy

George Grundy served fifty-two years in the transport industry, ultimately retiring as general manager of the Stalybridge, Hyde, Mossley and Dukinfield undertaking in 1944. He started working at the very young age of nine, but it wasn't until he was thirteen that he entered the transport industry, becoming a night-shift engine cleaner on the steam tramways in the Potteries. He recalls some of the cruel tricks played on him by other boys and describes a couple of his experiences as a steam tram driver. This account comes from his autobiography, *My Fifty Years in Transport* **(published by Transport World in 1944 and reprinted by Adam Gordon in 1998).**

The work was very arduous for a boy of thirteen. I was not strong enough to lift half-hundred weight bags of coke from a footplate into the bunker, but as time passed I gained the knack of handling these coke bags.

I was now quite happy at my work, but had only been employed on the tramways for three months when I ran into trouble in a way which taught me a lesson. One night an engine driver left his engine over a pit where the fire boxes were emptied, and after a workmate and I had taken the fire from underneath the boiler and emptied the ash pan, we decided to drive the engine into the shed. We opened the steam regulator and away we went. Unfortunately, we could not stop soon enough, with the result that we ran into another engine, doing considerable damage.

The next morning we had to appear before the engineer and manager, Mr Whytehead. He was a very kind gentleman, and I shall never forget the lecture and advice we received at that interview. At the conclusion, he told us both to have patience and we should be engine drivers some day, and his words certainly came true.

Part of our work was to carry shovels full of red-hot coke from the furnace to the engines in the shop, to get up steam in readiness for the driver's arrival. It was also part of the engine cleaners' duty to go out at 3.30 a.m. to knock-up the drivers for early duties, which commenced at 4.40 a.m.

All the boys were initiated on the first night, after supper. The older boys would make a square with the mess-room seats, and then stand on the forms, with

the newcomer standing on the floor in the centre without any chance of escape. Each of the older boys would then pull the new boy's hair until he whistled a tune.

Many new boys returned to the sheds after knocking-up duty, terrified and breathless with running, saying they had seen a ghost. This was just another trick played by the older boys, who covered their heads with white bags, making two holes for the eyes. I know the trick nearly startled me to death.

Another practical joke was to find a new boy having a nap after supper, and to run the nozzle of a hosepipe up the leg of his trousers. One boy was left to turn on the water at the valve, and the terrible screams that followed would be received with laughter from the boys in hiding. Yet another trick was to tie the legs of a boy's trousers with string, and then pour hot sand down the top until his trousers bulged; in this case force was used. These tricks were cruel, but their redeeming feature was that they made boys very hard, and enabled them to take punishment with courage.

On attaining the age of fifteen I was transferred to the ticket and traffic office. This change gave me an opportunity to study and improve my education and become conversant with the ticket system. About this time, the bell ticket punch was introduced, and it was very interesting to watch the method of checking and counting the small round snippings, which were placed on a piece of plate glass marked with small squares, all in numerical order. The various coloured ticket snippings were sorted out and placed in the squares by means of a stocking needle, and the total numbers would then be compared with the various denominations of tickets sold, as shown on the conductors' summaries.

After a few months I was instructed to learn tram conducting on a route of about one and a half miles, from the Copeland Arms Hotel, Stoke, to the west end of the city. This route was operated by a single-deck three-compartment tram drawn by a steam engine. The men operating the service were relieved for meals, and I was called upon to relieve the conductor.

Twelve months later, being still fired with ambition for the engineering side of the job, I was transferred to the engine running shed to carry out mechanical repairs. After gaining quite a lot of engineering knowledge, and passing out as a fully qualified mechanic at the age of nineteen, I then returned to the traffic side as an engine driver, and was very elated at the prospect of being put in charge of an engine on the road. In those days, the number of hours per working week was sixty, for which the wage was thirty shillings, plus overtime. This was recognised as a highly paid job.

I retain a vivid memory of my first accident. As I was driving my engine past Stoke Town Hall at approximately ten miles per hour, a fishmonger driving a pony and flat-bottomed cart loaded with two barrels of herrings came round a corner too quickly. As soon as he saw my engine he tried to pull up, with the result that the pony slipped and fell on the tram track, which was always very slippery at this point in damp weather owing to the roadway being paved with wooden blocks to minimise the noise of the street traffic for the occupants of the Town Hall.

In the midst of giving an Aberdare tramcar a coat of paint, a boy pauses in his labours to pose for the photographer.

The consequences of this accident were very amusing. The herrings slithered all over the roadway, and a number of dogs soon got busy and had a good meal. I am pleased to record that I was exonerated from blame.

The next accident of note was when a child ran across the roadway in front of my tram. I made a good emergency stop by reversing the engine and opening the steam regulator and sanding device. By this action the child was missed by inches. In the circumstances I did not report this occurrence, but two days later the manager informed me that the parents of the child had been to see him, and desired him to congratulate me on making such a marvellous stop and thereby avoiding a fatal accident. At that time the company gave rewards for life-saving, but I was told that owing to my failure to report the incident a reward would not be allowed. Needless to say, this taught me a lesson, and I never again failed to report an accident, irrespective of whether there was injury or damage.

Tit-Bits Financed Matlock's Cable Trams

From The Matlock Steep Gradient Tramway

When Tony Bennett sang about little cable cars that climbed halfway to the stars, he was referring, as everybody knows, to the cable cars in San Francisco, which were hauled up and down the city's steep streets by a single cable running in a slit in the ground. To Rudyard Kipling they were nothing short of a miracle, and when cable cars started running up Bank Road, Matlock's heartbreak hill, in 1883, they must have appeared an even greater miracle to the local townsfolk, especially as they had been talked about for years before. In truth, the miracle was wrought by the publisher, George Newnes, a local boy made good. For it was he who provided the finance for the project from the wealth he had acquired through publishing *Tit-Bits* and the *Strand Magazine*, then two of the best publications in Britain. Mr Newnes, however, was a successful business man and saw that there was a big demand for the tramway to transport visitors to the many hydros which had sprung up at the top of Matlock Bank. The cars ran for almost thirty-five years – from 28 March 1893 until 30 September 1927 – longer than any other cable cars in Britain except those still operating up the Great Orme in North Wales. The full story of the Matlock cable cars is told in the booklet *The Matlock Steep Gradient Tramway* which was first published in 1893 and reprinted in 1972 by the Arkwright Society.

There is a fascination, almost a romance, about the story of the Matlock cable tramway which is quite compelling. It belonged to the now-distant era when the hydros were booming on Matlock Bank, when Matlock advertised itself, nationally and internationally, as the 'Metropolis of Hydropathy'....

Many of the passengers carried by the cable trams were visitors bound for the hydros. At peak times,

Britain's only remaining cable car line is on the Great Orme at Llandudno in North Wales. The line is in two halves, and passengers have to change cars halfway up the track. In this view the cable car is descending the lower incline.

A Matlock cable car loads up with passengers before climbing the 1-in-5½ gradient up Matlock Bank. Built with finance provided by Sir George Newnes, famous publisher of the magazine *Tit-Bits*, it was the steepest cable tramway in the world on a public road, but closed on 30 September 1927. It was the last cable tramway to operate in England. The tramway shelter (left), with its ornate clock tower, announces that cars run every ten minutes.

luggage often was piled onto the boarding platforms to the extent that the driver was left with little more than a 'peephole'! A trip up the Bank from the loop-line lower terminus in Crown Square, where the traffic island now stands, cost twopence. It was cheaper coming down – one penny....

Mr Ainsley Hallam, of Lynholmes Rise, Matlock, whose father, the late George W. Hallam, was a tram driver for twenty-one years, recalls that new uniforms were provided for drivers and conductors each Good Friday. And it was not just a case of better the day, better the deed.... Easter marked the start of the holiday season, and smartly turned-out tram crews enhanced the resort's image. ...

Construction of the tramway was, in itself, a remarkable engineering feat. Matlock was rightly proud (and should still be proud) of the fact that its cable tramway line from Crown Square up Bank Road to the top of Rutland Street was the steepest in the world on a public road, with a gradient of 1-in-5½.

The original paragraphs from the 1893 edition of the booklet are particularly interesting for they include a description of how the gripper mechanism on the cable cars worked.

The gradients are exceptionally severe.... The distance from Crown Square where the line starts to the depot at the terminus is only half a mile, but the rise in that short distance is over 300 ft. In other words, every

Two of Matlock's cable trams stand outside the depot at Wellington Street at the top of the incline. The depot boasted a large waiting room with a ladies' cloakroom and other conveniences.

time that a pedestrian walks up from Crown Square to the tram depot at Wellington Street he performs a feat almost equal to that of ascending St Paul's Cathedral from the base to the cross. The same feat stated in another way implies that the amount of energy expended in this walk by a man of average weight is equivalent to over 50,000 ft-lbs units – sufficient to raise a weight of one ton to the height of 22.5 ft. Indeed, when we say that it takes three horses to draw a load of 16 cwt up this road people will appreciate the amount of energy saved by the use of the tramcars….

The gripper for connecting the car to the cable is both at the front and rear ends of the car, but only one gripper is used at a time. This gripper consists of two steel jaws between which the cable passes. When desiring to start the car the driver simply tightens the jaws onto each other and thus onto the cable by means of a screw operated by a handwheel, and the car moves along with the cable and at the same speed as the cable….

In a steep gradient everything depends upon the efficiency of the brakes on the cars, and it is pleasing to be assured that the brake system adopted on this line is peculiarly suitable and thoroughly reliable. While the car is firmly clipped to the cable by means of an ingeniously devised gripper it cannot travel faster than the cable itself; but when passengers want to be set down and taken up the driver releases the gripper from the cable and brings the car to a standstill by means of a powerful brake. Each car is provided with two brakes; one is the ordinary or working brake, and the other is an emergency brake. Both brakes can be worked from either the front or rear end of the cars. To give an idea of its application we have only to mention that when a car is going at full speed it can be pulled up dead in a distance less than its own length.

The depot for the cars was at the upper end of the line to safeguard against flooding. To begin with, there were three cars, two working at a time, the third being kept for emergencies. Painted blue and white, they had garden seats inside and out, and carried thirty-one passengers, thirteen inside and eighteen on the upper deck. They were later joined for a few years, until its withdrawal in 1914, by a cable car purchased second-hand from the Birmingham cable system.

In the introduction to the 1972 edition of the book, S.V. Fay commented on the demise of the tramway in 1927:

Now, forty-five years after the last tram rattled into the depot, it is easy to reflect that the tramway could still be performing a useful public transport function, and to suggest that it would be a powerful magnet for the tourists is merely stating the obvious. With all the benefits of hindsight, it is equally easy to accuse the Matlock Urban District Council of 1927 of lack of foresight and imagination in deciding to scrap the trams. It was no snap decision.… The cable tramway had never been a financial success but, up to 1913,

The clock tower from the old Matlock cable tramway waiting room is now preserved in Hall Leys Park in the centre of Matlock. It is little more than a stone's throw from Crown Square, where it once stood. (Shown on opposite page.)

losses had been modest – a total of about £800 in twenty years. But then the position worsened, and from 1917 onwards the Council were facing deficits of up to £1,000 a year. One of the factors appears to have been high maintenance costs....

Even the late Mr Lubin G. Wildgoose, the man who fought for it to the end, did not consider it a thing of beauty or joy. Basically, it was a strictly functional passenger transport undertaking which financially foundered because it was not paying its way....

Councillor Wildgoose did introduce one note of sentiment – he maintained that the Council had no right to dispose of an undertaking which was a gift to the town of Sir George Newnes. At the start, the service had been operated by the Matlock Cable Tramway Co. Ltd, but in 1898 Sir George bought out his fellow shareholders at a cost of £20,000, and presented the tramway to the Council as representatives of the people of Matlock....

So ended the story of the cable tramway which had been launched with such jubilation and junketing thirty-four years earlier. If Councillor Wildgoose had won the day, the trams might still have been making history as they plied up and down the 1-in-5½ gradient of Bank Road. They would have been a valuable link between Crown Square and the County Council Offices, the College of Education – successors to the hydros – and the new housing estates that have opened up on Matlock Bank. Undoubtedly, tourist cameras would have clicked incessantly in the summer months.

Travelling up Bank Road today it is difficult to imagine that it once carried a cable tramway. One relic, however, that still survives is the ornate Clock Tower tramway shelter that stood at the lower terminus of the line in Crown Square. It can be seen today standing in the town's Hall Leys Park. Built in 1899, it was donated to the town by Robert Wildgoose, but was not much used by waiting passengers. For a while it became a betting shop, but then it was boarded- and locked-up, and ultimately moved into the park not long after the line's closure.

It Hurt Like Blazes

By John McGuigan

The first electric tramway in the United Kingdom was opened in September 1883 between Portrush and Bushmills in Northern Ireland and extended two years later to serve the Giant's Causeway, today a World Heritage site and the foremost tourist attraction of Northern Ireland. It first employed the third rail method of current collection and the power came from a hydro-electric station at Walkmills. In his book *The Giant's Causeway Tramway* (published by Oakwood Press in 1964) John McGuigan describes the amusing comments made about the third rail by one of the promoters of the line, Mr William Traill, and a leading shareholder, Sir William Thompson, when they came under cross examination at the inquiry into the Parliamentary Bill.

Sir William Thompson, during examination by the committee, agreed that he had been engaged in electrical science for many years, and had been consulted at all stages of the electrical experiments on the tramway. He was closely questioned on the effect which an electric current at 250 volts would have on human beings and animals. He stated that at that pressure, 'the maximum current which would pass through a human being would be about one tenth of an amp or one five-hundredth of a strong working current'.

This quickly brought the question, 'If 500 people all touched the conductor rail simultaneously would the tram be stopped?' Sir William refused to be drawn further than to admit that such a contingency 'would seriously impair the insulation of the line, and diminish the power of the tram'.

Mr W.A. Traill was also examined. Having stated that there was little danger to persons from the live rail, especially as clothing was a fairly good insulator, he was asked would it not be dangerous if a beggar with torn trousers – or a Highlandman – sat on it. Mr Traill replied that this very same question had been posed during the Board of Trade inspection of the

The popular and world-famous cable cars in San Francisco are a national monument. This car is climbing the Powell and Market line with a view of Alcatraz in the distance. (PETER GEMEINHARDT)

Victorian ladies enjoying the view of Dunluce Castle from the Giant's Causeway tramway in Northern Ireland in the days when it was operated on third rail.

line, prior to its opening, by the inspecting officers, Major-General Hutchinson and Major Armstrong. At that time he himself had removed his trousers from the appropriate portion of his anatomy and sat on the live rail, as had Dr Hopkinson, without any dire result.

Mr Traill stated, furthermore, that far from being dangerous, the shocks received from the live rail were beneficial for rheumatism, and not only himself but other people also, purposely took shocks from the rail with beneficial results. A Portrush doctor sent his patients out to take shocks from the rail and one man who was unable to open his hand at the beginning of the treatment was able to do so after a three-week course.

Years later, when relating the live-rail-sitting incident to his daughter, the latter asked, 'And did it really not hurt?' Mr Traill's reply was, 'It hurt like blazes, but we weren't going to let the inspectors know that.'[1]

[1] Eventually, warning notices appeared alongside the tramway which said: 'Do not touch the naked conductor running alongside the track'. As can be imagined, ribald comments were made about that!

Steam Tram Capers

By Dennis Gill, with extracts by Dr Michael Harrison, Geoffrey Hyde, Stanley Webb, Keith Stretch, C. Gilbert and Ronald Harmer

Steam trams ran in this country for only a short period of time – from the mid 1870s to the early 1900s. They ran mainly in the major conurbations, but there were a few rural lines which survived a little longer, the last of these, from Wolverton to Stony Stratford, being brought to an untimely end by the General Strike of 1926. They did not run without incident, as the following stories make abundantly clear.

Altogether more than 500 steam trams were in operation in some fifty towns in the United Kingdom. Of these almost half were in the north of England, one of the biggest concerns being the Manchester, Bury, Rochdale and Oldham Steam Tramways Company, which ran a network of interurban lines (some thirty-three miles long and on two different track gauges) connecting a belt of towns immediately to the north of Manchester.

The first steam tram to run in England was in the form of a combined steam engine and carriage, which

An early tinted commercial postcard view of one of Rossendale's steam tramcars and its crew posing with an inspector for the cameraman.

made several trial trips in London in 1873, but it was not a great success. More popular was the standard steam tram, which consisted of a separate tram engine (known as a 'dummy') hauling a carriage, usually a double-deck eight-wheel bogie car seating sixty and normally fully enclosed. They towered over most other vehicles and were not always popular with the travelling public, for they were grimy, sooty, evil-smelling, noisy, and very ungainly, despite attempts to give the engines an acceptable appearance. Arnold Bennett, who travelled on the steam trams of the North Staffordshire Tramways Company, gives us a vivid impression of their unpleasantness in his novel *Clayhanger* when he mentions 'the odour of warm grease that trailed from the engine', and the 'throbbing of its filthy floor'.

Another source of complaint was the sparks and cinders that flew out of the chimneys of the steam engines, as highlighted in a letter to the *Yorkshire Post* in 1883:

> Last evening I rode to Headingley on the top of the tramcar drawn by the engine, and whatever our authorities are doing to allow such a nuisance as this diabolical machine to travel another time up that road I do not know. Up Cookridge Street and Woodhouse Lane the engine did not send an odd spark or two out of the chimney, but one continuous stream of sparks 10 ft or 12 ft high, and covering passengers on the top with pieces of cinder insomuch that some put up their umbrellas to protect themselves. How horses will be got to face such an infernal machine goodness only knows.

To cut down the volume of appalling black smoke they gave out, steam trams were run on coke, but even then, in the Potteries, one councillor suggested that they would be rid of the smoke nuisance if the trams were run on Durham smokeless coke instead of coke from the Etruria gas works. And this was long before the introduction of smokeless zones – way back in the 1880s, in fact.

Running steam trams, though, was a tough assignment. Severe restrictions were imposed on them by the Board of Trade, making their life, on the whole, a misery! They were governed to travel no faster than eight miles an hour, they were not to emit visible smoke or steam, they were not to operate with blast or exhaust noises, and their working parts, for the most part, had to be concealed from view. In Burnley, over a period of 111 days during the winter of 1881–2, the steam tramway operator was prosecuted thirty-nine times, mainly for emitting steam. The local press said the prosecutions amounted to persecution of an undertaking which offered great convenience to the general public. At a public meeting a councillor caused much laughter when he said the police were looking for as much smoke from funnels as an ordinary smoker could blow off! (This clearly indicated how very finicky the police were being in bringing the charges. After all, these were steam trams!) In their first 152 days, the steam trams carried more than 245,000 passengers, which showed that the public perceived the trams in a very different light to the police.

The persecution of the company was fully chronicled by Dr Michael Harrison in his article 'The Tram Restored at Burnley' which appeared in the winter 1996 issue of the magazine *Tramway Review*.

> On 7 February[1] six more charges were heard at the County court, one for permitting a noise from the blast or fan of one of the engines and the other for what was now described as the 'old offence of emitting steam'. On 23 January, No. 1 engine was ascending the (1-in-18.7) gradient from Whitegate to Cheapside but when it got near the crown of the brow it came to a standstill. The driver backed for seventy yards and then made a successful second attempt. During the delay a large quantity of steam was emitted from the funnel and a great noise was made from the blast. Three days later the same engine was witnessed emitting steam in Burnley Road, Padiham. The solicitor stated that the tramway company were seeking tenders to work the trams without steam. The blast pipe of No. 1 engine had been modified … the engine was now going as well as they could make it. At this the police superintendent asked if the company was aware that there was an information against this engine for the last Saturday night in the borough (this would have been 4 February); how therefore was the engine perfect? 'Is it that you cannot improve the engines at all and that whatever you do they will emit steam?'
>
> Francis Wilson, engineer to the company, replied: 'We have the engines from Messrs Kitson and we cannot alter them.'
>
> Superintendent: 'Don't you know that these engines are in the habit of emitting steam regularly?'
>
> Witness: 'That is the construction of them and we cannot remedy them.'
>
> Solicitor: 'We are trying our best to conform to the law.'
>
> Superintendent: 'But you don't conform. I am sick and tired of prosecuting these cases.'
>
> Solicitor: 'No doubt you are.'
>
> Two further cases were then proved.…
>
> The fines imposed on the tramway company

varied from £10 (the maximum penalty) to five shillings; for about twenty-five cases the penalty averaged about thirty shillings and sixpence. The forty-one known cases to mid-March probably totalled about £38 in fines plus court costs of perhaps £29. The average fare income was about £131 per week, so the whole sorry business had taken half one week's income. This was equivalent to a tax of 1.6 per cent of the passenger income, excluding the fees of the barrister and two solicitors; a penalty which could be increased as magistrates thought fit.

Dr Harrison commented that the prosecutions had developed an air of Gilbertian farce, the 1875 *Trial by Jury* coming to mind.

There was some retribution for the company when the superintendent of the police, who had appeared at so many of the prosecutions, was thrown from his horse when it slipped on one of the tram rails and fell. As a result of all the prosecutions, the company was forced in the end to replace the steam trams by horse trams. Dr Harrison wrote:

> The abolition of the steam trams was debated again in the Burnley Town Council meeting on 3 May. The trams had carried 358,363 passengers in 226 days, or 1,585 per day. One councillor said he lived alongside the tramway but he had never seen a nuisance any respectable person need complain of. A certain section of the bench had been allowed to have too much of their own way. The things the tramway company had been guilty of were a mere bagatelle and nothing more.

Geoffrey Hyde commented on the victimisation of steam trams in his book *The Steam Tram Era,* published by the Manchester Transport Historical Collection.

It is of interest to note that out of the forty-eight pioneer steam tramways in our towns, only two were built and operated by the local authority, the rest suffered municipal 'take-over' after twenty years of successful operation. Little wonder that the companies were loath to use their profits to finance long-term development and improvements. Not only were they tied in this manner, the operators were continually harassed in a manner in some cases that could be justly termed victimisation.

They were continually subjected to litigation for emitting steam from their engines – yet the steam lorries and traction engines of the day, which had none of the efficient smoke and steam control devices of the tram engines, rarely attracted the attention of the local police.

A steam tram if parked for more than five minutes at a terminus was considered to be a nuisance and an obstruction, but strangely this did not apply to the municipally owned electric car which replaced it.

By statute the tram engine was forbidden to emit any noise or clatter of machinery, and woe betide the depot manager if it did do – but no complaints were made against the noise and clatter of the horse-drawn buses and lorries of the day.

The tramway companies were accused of turning the streets into a quagmire at the termini where the engines took on fresh water, but always the mud was to be found on that part of the road which was the responsibility of the local authority – the tramway companies were compelled to maintain their part of the highway in good order.

Even before they started to operate, the promoters were penalised by clauses in their agreements ('protective clauses' as they were called) which subjected them to the expense in some places of paving the whole width of the streets through which

Engines and cars of the Accrington steam tramway being broken up in July 1907.

they ran with expensive granite setts; of laying even more expensive wood block paving in front of the places of worship, and for fifty yards on either side; and in one town the operators had to light the streets through which the tracks ran.

The steam trams of the South Staffordshire Tramways Company appear to have been victimised nearly as much as those in Burnley, and according to Stanley Webb in Volume One of *Black Country Tramways*, which he published himself in 1974, there were many complaints about water on roads at stopping places, smoke, steam, noise, not keeping to proper half-hourly intervals, furious and reckless driving, overloading of cars, drivers refusing to give way on single sections, and so on, although the press were full of praise for the great convenience provided by the trams. Mr Webb mentioned some complaints of a different nature.

> Shopkeepers in Bridge Street (Walsall) said that the wooden pavement had not worn well and the tramways had driven other vehicles to the very edge of the footpaths. Owing to the dirty state of the streets, whenever there was a heavy shower of rain the shop windows were splashed with mud half-way up. The shopkeepers, having suffered so much by the invasion of the trams, expect that the street shall be kept as free from mud as possible.
>
> In the Walsall Town Council meeting, the Streets Committee complained that the Tramway Company could not be permitted to put salt on the rails, because it caused sore legs to horses, was dangerous to human beings and damaged the roads. The Company asked to be able to use salt at points only, which was agreed to. Complaints about the emission of steam and smoke came from all parts of the system, although Handsworth seems to have been particularly strong about this. The Council had had a letter on this subject from the Anti-Steam Tram Nuisance Association.

While the steam trams in the Black Country and Burnley were notching up complaints and prosecutions at every twist and turn, those in other towns were not exactly having fun either. Rochdale's steam trams, when climbing Drake Street, were facing an energy problem. The locomotives simply were not powerful enough to do the work demanded of them, as Geoffrey Hyde points out in his history *The Manchester, Bury, Rochdale and Oldham Steam Tramway* (published by The Transport Publishing Company in 1979).

> In Rochdale, passengers preferred to walk up Drake Street than trust themselves to the trams on this hill. Almost daily engines had to run backwards down the hill because they had insufficient power to climb the gradient and derailments were a frequent occurrence as a result. The *Rochdale Observer* commented that 'it would not be a remote possibility if one day an engine, car, and passengers were not deposited in the River Roche unless more care was taken at this point'. A crisis was reached in June 1884 when two women jumped screaming from the top of a car, which, according to eye-witnesses, was running backwards down Drake Street out of control. As it happened their panic was unwarranted because the driver was reversing in order to take another run at the hill, and the tram stayed on the rails, but one of the women died as a result of the injuries which she sustained. The tramway company tried to allay the public fears by promising larger and more powerful engines in the immediate future, but these in fact did not arrive for many months.

Wigan's steam trams were faced with an even more curious problem, which resulted in a case of assault. It is mentioned in Keith Stretch's book *The Tramways of Wigan* (published by the Manchester Transport Museum Society in 1978). The victim of the assault was a steam tram driver, who was attacked by one of the participants in a religious walk.

> A strange incident occurred on Sunday, 1 July 1894, which led to the appearance in court of one Stephen Green, summoned by John Halton, tram driver, for assault. From the evidence given in court it seems that at about 3 p.m. on that Sunday, Halton was driving his tram up Wallgate when he encountered a religious procession (one of the 'walks' still common in Lancashire towns at this time of year). He stopped for about five minutes, but then became worried about the level of water in the boiler, and feared that if he did not soon reach the Market Place, where he could take water, he would have to drop the fire. He asked a policeman if he could proceed but was advised to wait another couple of minutes, after which the policeman waved him on. He moved forward slowly, but when he drew near the procession, it spread all over the road, and there was a lot of booing and shouting. He continued to move ahead, but Green came up and threatened him, refusing to listen to his explanation that he was low on water. He took up a hammer to defend himself, but Green grabbed him and pulled him off the engine, 'tearing his trousers from top to bottom', and a fight began, which was eventually stopped by a policeman.
>
> In court, a lot of irrelevant evidence was produced,

one side alleging that the tram was an obstruction on the highway and the driver had no right to move ahead into the procession 'in a manner calculated to cause injury or loss of life', and that the Wigan Tramways Order provided that 'nothing in this Order shall interfere with the public right of use of the highway'; while the other side alleged that it was the procession which had wilfully spread out over the whole roadway when there was plenty of room for the participants to walk clear of the tram track. Green's solicitors even argued that Halton had deliberately set out to disrupt the Church of England procession because he was a Roman Catholic. The magistrates rightly ignored all this verbiage, which had little to do with the actual assault, and Green was found guilty and fined ten shillings.

Not many people alive today remember the steam trams, and those that do have only vague impressions. In 1965 the magazine *Modern Tramway*, in its April and May editions, published the memories of a man who vividly remembered the Birmingham steam trams, the most successful in Britain, almost sixty years after they ceased running. He was C. Gilbert, who, shortly before his death in March 1964, wrote down his recollections of the steam trams operated by the City of Birmingham Tramways Company, including the following paragraphs about two light-hearted incidents he witnessed at the start of his career.

> I was apprenticed in 1900, and lived with my boss until my people returned to King's Heath six months later. From then onwards I travelled on the steam trams an average of 2,500 miles each year until 31 December 1906, when they stopped running. One morning, going down Mary Street on the 6.30 a.m. from King's Heath, the car had just passed Hallam Street and day had not broken. The conductor put his head inside the car, with a grin on his face from ear to ear, and said: 'Have any of you blokes put a roll of sheet iron on the front platform? If you have it has just fallen off!'
>
> When the car stopped at Edward Road the driver got off and walked round to say something to the conductor. After we started off again, the conductor said it was all right, it was the chimney which had fallen off the engine. The top portion of the Kitson chimney was of the stovepipe type. There was a joint level with the condenser, held together by four bolts in two angle iron rings. These had rusted away and the jerk when going through Hallam Street loop had caused it to topple off.
>
> The next item was rather exciting and alarming at the time, but happily there were no bad results. This again occurred on the 6.30 a.m. from King's Heath, via Balsall Heath, on which I was travelling as usual. We left Alcester Road and started off down Park Hill quite normally, but had not gone far when our speed began to increase greatly. When we reached the loop half-way down, by Augusta Road, we just 'slammed' through it. At the bottom of Park Hill there was another passing loop, with half-a-dozen people waiting to get on. We did not stop and they did not get on! The track at the entrance to the loop swung to the left, and at the further end, swung to the right, the gradient here being 1-in-18. Then we went through Hallam Street loop at the fastest rate I have ever travelled on a steam tram. The gradient flattened out beyond here and the driver managed to pull up at Edward Road. There was some excitement, but no one seemed to know what had happened; there was certainly no automatic speed control in operation.

Horses were frightened of the first steam trams to venture onto the roads. When they caught sight of them for the first time, they would often rear up on their hind legs, this in turn causing consternation and alarm among humans in the vicinity. When the Brighton District Tramway Company opened its steam tramway between Hove and Shoreham in July 1884, William Wilkinson, who supplied the first two engines, told the directors at the opening luncheon that 'horses shied a bit at the engines at present, but they would get "educated up" to them very quickly'. Ronald Harmer, in the summer 1965 issue of *Tramway Review*, described the advice Mr Wilkinson offered to horse owners and what happened when four horses came face to face with a steam tram the following month.

Mr Wilkinson offered some gratuitous advice to horse

Steam trams operated by the City of Birmingham Tramways in service on the New Street Station to Sparkbrook route. Those running to King's Heath were not without incident, as C. Gilbert recalls.

owners and to those in charge of horses, saying that if their horses became frightened by the engines, they 'should not be flogged or they would then become quite out of control'. He went on to say that he had placed very careful men on the engines and that if the horses were very restive they would stop the engine. Mr Wilkinson then advised that 'the drivers of horses would find it a good plan to take the animals up and let them smell the engines, after which they would no longer be frightened'.

On Monday, 4 August 1884, there was, however, quite a serious accident from that very cause, the horses attached to a drag [*coach or open carriage*] on its way to Brighton being frightened by seeing the steam tram engine coming towards them. All four became unmanageable and, slewing to the side of the road, ran the wheels up the embankment and overturned the drag into the road, spilling its occupants in all directions. Of three ladies and two gentlemen riding on top two of each sex were thrown into the roadway without serious hurt, but the other lady fell between the coach and the tram and became trapped there for some time. She was found to be 'much hurt' when eventually extricated.

Taking note of public feeling following the accident, the Company introduced horse cars when it expanded its service the following year. The steam trams continued to operate until 1888 in conjunction with the horse cars, which then ran on their own until 1913.

One or two incidents involving steam trams did have a humorous side, and there was an amusing incident at the official inspection of the Lockwood to Huddersfied line, but the Mayor of Huddersfield was not impressed, as this report in the *Huddersfield Chronicle* in November 1882 shows.

The first journey was made down Chapel Hill to Lockwood and in going down the hill the Inspector (*Major-General C.S. Hutchinson of the Board of Trade*) had the engine stopped several times in order to test the power of the brakes with which he seemed quite pleased. The journey to the terminus at Dungeon Wood was completed without a hitch as also was the return journey to Lockwood, then the engine was taken to the terminus at Salford and back to Chapel Hill.... Upon reaching Chapel Hill (*1-in-11½ gradient*)... the car was loaded with passengers to test the power of the engine, a severe test indeed when it is considered that it was a foggy day and the rails were in consequence very slippery. It ascended the hill at a good pace, but when opposite Buxton Road Chapel, the Inspector ordered the engine to be stopped so that he might test its capacity to re-start from that point with a load. Several unsatisfactory attempts were made, and finding that the engine could not be got to move, the car was relieved of twenty-five of its passengers and then it was able to get up the gradient. The Mayor of Huddersfield explained that the corporation would prohibit the stoppage of the engine to take up or set down passengers on such a gradient as Chapel Hill. When Buxton Road was reached it was discovered that the brake had been on the car ever since it left the Lockwood terminus, thus it was thought that had the brake been taken off, the engine and car would have climbed the hill satisfactorily.... The Inspector stated that he was highly satisfied with the permanent way and gave formal permission for public use. At 5 p.m. the car and engine were tried again on Chapel Hill with a load of forty-four passengers and the engine stopped and re-started without any difficulty.

[1] 1882.

A Wantage steam tram hauling three passenger cars approaches Grove Bridge. The tramway, which ran from Wantage to the Great Western Railway station at Wantage Road, operated from 1876 until 1925. It was one of the longest-surviving steam tramways in Britain.

Could Never Forgive Churchill

By Stanley Guildford Collins

Stanley Collins, the son of a cable car driver, was a London tramwayman from 1913 until 1951, and drove Streatham's last tram through the gates of a scrapyard. His memories of his days on the trams are published in The Wheels Used to Talk to Us, **edited by Terry Cooper and published by Sheaf Publishing of Sheffield in 1977. In the following extract he recalls the days of the General Strike, and explains why he could never forgive Winston Churchill.**

Neill Lomax, impersonating Churchill, stands beside a London tramcar, at a 1940s weekend at the National Tramway Museum. Churchill was a national hero during the war, but the stance he took during the General Strike of 1926 did not endear him to London tram driver Stanley Guildford Collins. Neill, a volunteer at the museum for more than thirty years, regularly impersonates Churchill at various events.

In May 1926 there was the General Strike. We came out in support of the miners and there was hardly any transport in London at the time. The busmen were out and the railways had stopped as well. We all got the sack. A note came through the door saying, 'You are instructed to return your uniform to the depot where you were employed,' so we all went down to Clapham. I don't mind telling you, I had butterflies in my stomach. I was not long married with a baby to support, and there I was with the sack. The union secretary, I believe it was George Schofield, said there was nothing to worry about and he collected all the notices up, tied them up with a blue ribbon and put a nice bow on it, then someone jumped on a bike and went up to 23 Belvedere Road and pushed them through the letter-box.

We wouldn't let any trams run, although some volunteers and officials did try to take them out. One came out at Clapham but it didn't get far, and I heard of another that ran out at New Cross. You only had to go half a mile up the road, find a big bolt and jam it in the slot-rail.[1] That would stop them. It would either break the plough or bring the carrier down. That was what happened along the Old Kent Road, so we were told. At Clapham all the police were on horses, and a lot of the men jumped on the tram as it came out of the depot and started smashing windows.

We had to run up a little court with the baby in the pram because the police went mad. They were coming right up on the pavement with their horses, they had long sticks and were just lashing out at anyone, women and all were getting hit; they couldn't care less. One of the coppers was on a big grey horse, and I heard later that he was 'done' up at the Elephant and dropped down the toilet in the middle of St George's Road.

Churchill appeared on the scene, and in one of his speeches he said, 'If they won't go back to work, get the guards out and shoot them back.' I could never forgive Churchill for that. They say Churchill in the last war was a marvellous leader. Perhaps he was, because he had the voice, and when he was broadcasting to the Nation about 'We'll stew them in their own gravy', he was five and six hundred feet underground[2] saying that.

We were only fighting for our rights. We'd come back from the war to unemployment and unhappiness.

[1] London's trams picked up their current from a slot between the rails, using a plough.
[2] In his bunker.

Evil-Looking Concoction Saved the Day

By Norman Johnston

Fintona, a small town deep in the heart of County Tyrone, Northern Ireland, was well served for three-quarters of a century (1883–1957) by a solitary one-horse double-deck tram that connected it with Fintona Junction on the Londonderry and Enniskillen railway almost a mile away. The tramcar, because of its unique character, became quite famous. Numerous poems and songs were written about it, and it was featured in many newspapers and magazines. This amusing story about an incident involving Dick, the tram horse, and Willie McClean, who drove the tram from 1922 until the line's closure in 1957, appears in Norman Johnston's book, *The Fintona Horse Tram*, which was published by the West Tyrone Historical Society in 1992.

A book on the Fintona horse tram can hardly avoid a special section on Willie McClean. I have never heard a bad word about him, as he was universally liked and respected. Tom Bradley, stationmaster for the last seven years, described him as 'one of nature's gentlemen'. He was utterly reliable and responsible and could handle Dick in a way no one else could. When Willie was around, Dick knew who was in charge. When Willie wasn't there, Dick would often play up. Passengers found Willie courteous and helpful, and he enjoyed a chat as he drove the tram. He was the one man that visiting English railway enthusiasts all knew by name....

Jack Griffin, who worked as a boy porter at Fintona around 1947, used to travel up from his home in Dromore each morning on the 7.15 a.m. from Enniskillen. He usually took the tram from the Junction down to the goods store. One morning he arrived to find there was no tram and no Willie McClean. Rather puzzled he set off down the line on foot. As he neared Fintona he could see the tram at the station, but no sign of Dick or Willie. When he got there he discovered Willie in a small shed and Dick lying in the corner. The horse was sick, and Willie had cancelled all trams for the day.

'Would you give me a hand to get him up?' said Willie.

They did that, and, rather unsteadily, Dick was walked down to his stable where he promptly lay down again. This was a bad sign. A horse has to be bad before it lies down. Willie noticed that Dick kept looking over his shoulder down his side. 'I think he's in pain. He might have indigestion,' he said. Willie mixed about a pound of salts and Jack helped him administer the dose. It did no good, so they sent for the vet, Ernie Johnston.

Ernie produced a very evil-looking concoction from his bag and mixed it in a basin. It was black and looked like tar. It took the three of them to get it down Dick's throat. When he had finished Ernie got up and said, 'That'll fix him.'

'Aye,' said Willie. 'That, along with what I gave him.'

'What!' said the vet. 'What did you give him?'

When Willie told him the vet looked grim. 'Shut

Dick the horse pulls the Fintona horse tram along the unique branch line in County Tyrone. Dick was popular with visitors from all over the British Isles and when he retired was found a comfortable, much-deserved home on a nearby farm.

the door on him,' he said, 'he'll never get over that.'

When he'd gone, Willie thought for a moment, and then he said to Jack, 'I'll shut no door on him. Help me get him up.'

So they got poor Dick up and out into the yard. Willie then carried out the process called 'ringing the horse'. This meant that Willie held a long rope and walked the horse round in a circle. Dick didn't like it one bit, and it took Jack behind him cracking the whip to keep him going. Suddenly Dick's sides started to heave and there was a loud rumble from his gut.

'Look out, Jack,' warned Willie. When Dick let fly a moment later, he produced enough to fill a wheelbarrow. You could have smelled the stench in Dromore. But the trouble was over, and Dick started eating at once. He was back at work the next morning. Willie blamed it all on grass seed hay.

Galleon or Sick Elephant?

By Dennis Gill, with extracts by 'A Driver' and Michael Corcoran

Trams have been described in many ways – romantically as 'high-built glittering galleons', less picturesquely as 'sick elephants', and very unkindly as 'lurching, swaying, points-jumping trolley tossers'. But it is the comparison with galleons that has captured the imagination more than any other.

Many times the double-deck tramcar has been compared with a galleon – especially in literary works of some merit. While I am able to understand these flights of fancy and appreciate that undoubtedly there are some similarities, not once, while riding on tramcars, have I ever felt I was sailing on a galleon. This is hardly surprising, for I have never had the opportunity of sailing on a galleon (who today has?). What's more, I always thought galleons carried treasure, but not one piece of silver have I ever found on a tram. I have, however, sailed on the tall ship *Winston Churchill*, and it was one of the most thrilling and exhilarating experiences of my life. I even climbed to the crow's nest, and a hair-raising adventure that was. But at no time while I was on board the tall ship, was I put in mind of a tramcar. You would have to be quite a romantic to believe that a tramcar even remotely resembled a galleon in full sail – or the *QE2* in all her majesty. Yet time and time again, since tramcars first appeared in our towns and cities, they have been compared with ocean-going craft.

Famous poets and writers, more than anybody, have made the comparison. The poet George Russell called them 'the high-built glittering galleons of the streets that float through twilight rivers from galaxies of light'; while L.A.G. Strong likened a Howth tram to a 'galleon in ramshackle, dotty splendour', and the columnist Stanley Baron said, 'there was a majestic sway about this vehicle that recalled the Spanish Main'. H.G. Wells, that famous science fiction writer and fairly accurate prognosticator, called the tramcars running down darkened streets 'ships of light in full sail'; and Sir Alan Herbert, in his poem about London's last tram, compared it to a 'battleship of glass'. The novelist Howard Spring portrayed trams as 'slave galleys bringing the slaves to and from their chains'; another novelist, Frank Swinnerton, described them as 'ships that pass very slowly at night', and the *Chiswick Times* said that the woodwork of the tram's roof and sides 'reminds one of the fittings in the saloon of a handsome yacht'. One could go on and on, quoting other writers in similar vein, but I will mention only one other – the author (using the pseudonym 'A Driver') of the delightfully written essay *Goodbye Trams and Eniorerpeeze?*, which has been in my cuttings file for more than fifty years. The cutting bears no clue as to where it first appeared, or even when (although I suspect it was sometime in 1950), but I must say 'A Driver' draws a fascinating comparison with ships.

> There is something thrilling and romantic about a tram; especially at night, when you can hear it coming and humming over the rails a mile away.
>
> Presently it swings into view, all lit up like a showboat, with friendly little lights winking and blinking while it batters and clatters over the points, until it draws up with a roar and the driver gives a careless flick to one of the big brass handles, which flies round with a lovely clickity noise – like the turnstile at the zoo.
>
> There is an air of mystery and magic to a tram. People always talk about boarding it. You get on a bus, but you board a tram.
>
> Boarding a tram is not quite the high adventure one might imagine. There are no tarred sailor-men in pigtails armed with cutlasses standing by to repel boarders. But well there might be; because what is prosaically referred to as 'upstairs' on a bus is called the 'upper deck' on a tram. And instead of pressing a hooter the driver bangs a bell, like the one they beat at sea to mark the middle watch.
>
> On the upper deck you will find at each end of the tram (or should we say for'ard and astern?), instead of ordinary seats for two, a small glass-enclosed cabin

The ship's bell – sorry, tram bell – on this Southend-on-Sea tramcar is clearly visible just above the tram driver's left shoulder. It was used to warn other traffic and pedestrians on the road of the tram's approach. Unlike Southend-on-Sea, most tramways used gongs.

with a semi-circular wooden bench at one end. Workmen sit there and smoke dark shag in clay pipes; and the whole atmosphere is like the foc'sle of a ship where sailors make and mend, and carve small square-rigged craft to put in glass bottles. And a tram creaks and groans and sways like a Spanish galleon in the wind.

Consider, too, the mystery of steering a tram! Bus driving, of course, is a skilled job, but at least you know how it is done. Every small boy knows about gears and double-declutching: and those who go in for train spotting would think nothing of having a go at driving the Royal Scot.

But I defy any boy to steer a tram! The dark secret of tram driving has never been revealed. It is only whispered by old tram drivers on their death beds and passed down from father to son. A tram driver is always a jolly, stoutish looking man with whiskers who might easily be one of the pirates of Penzance or a coachman out of one of Dickens' books. He stands proudly on the outer deck, like some captain on the bridge; but what he does with those two mysterious handles to make the tram go or stop is beyond all human understanding. After a life-long study we still remain baffled.

On reflection though, I must admit that tramcars in some towns have put me in mind of ships bucketing and swaying in a storm. And I cannot deny that the old trams had masts, bulkheads, saloons, decks, scuppers and tumblehomes, or that they were made of good solid timber which creaked and groaned like

A tramcar that actually sails. *Sulyda*, a two-berth yacht constructed with timber from scrapped Blackpool tramcars, is pictured near Hightown on the Mersey estuary, more than forty years ago, with its owner, Gordon Brown, then a member of the Blundellsands Sailing Club.

Brighton's sea-going tram running through the waves on rails laid on the sea-bed. Named the *Pioneer*, but known to most people as *Daddy Longlegs*, it ran from 1896 until 1901 between the Banjo Groyne and Rottingdean – a distance of nearly three miles. The illustration is taken from a 1958 advertisement for James Booth & Co. Ltd of Birmingham (now part of Alcoa), which appeared on the front page of the magazine *Light Metals*.

the timbers of a ship. Nor must I forget that trams had 'pigtails', too, even if these pigtails were a curly device stuck on the ends of trams for securing the trolley cord at roof level. And I cannot escape from the fact that some of the early trams, like those at Southend-on-Sea, for instance, carried a ship's bell above the driver's head which was used to warn other traffic of the car's approach. Yet I wonder how many people really imagined they were setting out on an ocean-going cruise or sailing with Captain Cook when they boarded a tram. And I can't help wondering, looking at it from a different perspective, how many seafarers actually compared their ships with a tramcar. The only quote I have come across (which was quite derogatory, in fact) was one made by an experienced mariner, who said, according to a Swansea newspaper, that he would 'rather take a sea voyage in a gale from Jersey to Plymouth – when he has known the ship 'rock' so much that all the plates have been broken – than journey from Pandy to Porth in a tramcar!'

With all these similarities to sea-going craft, it cannot have been too much of a surprise when in 1896 a tram actually put to sea at Brighton and ploughed majestically towards Rottingdean through 16 ft-high waves for a fare of only sixpence each way. Nothing seems to have been beyond the power of those Victorians. But while it was definitely sea-going, this tram (if one could call it that) was nicknamed Daddy Longlegs, for to enable it to go through the water the body of the tram was built on stilts. The Prince of Wales loved it and rode on it (or should I say sailed on it) several times, and many people in Brighton regarded it as the eighth wonder of the world. Russian engineers even came over to inspect it, and the Americans thought it beat anything 'yet done by us inventive Yankees'.

In fact, this eighth wonder was very much like a section of pier, but with legs on wheels running on tracks laid on the sands and with a trolley pole on top enabling it to pick up current from overhead wires. There was a sumptuous saloon on the lower deck, similar to what you might find on any self-respecting yacht, and an open upper deck, both decks being fitted with knifeboard seating and railings. The track for the wheels was set in concrete blocks, and the four-wheel trucks at the end of each braced leg were encased in steel plates, somewhat resembling, says Alan Jackson in the magazine *Modern Tramway*, a 'midget submarine'. Daddy Longlegs carried lifebelts, a lifeboat, a flag and a ship's bell.

Daddy Longlegs at low tide. Notice the trucks at the end of each braced leg.

Sadly it ran for only a few days before it was wrecked in a severe storm. But it was rebuilt and ran until 1901, when operations were ended not by further gales, but by a notice being served on the company by the corporation. Apparently the corporation wanted the company to move its lines further out to sea as they wished to lengthen certain groynes on the foreshore. The company couldn't afford the expense, so ceased operations.

Daddy Longlegs ceased long before I was born – even some years before my mother was born – so it was never remotely on the cards that I would get to sail on it. But I have photographed its present-day equivalent, running through the waves on huge rubber tyres between Bigbury-on-Sea and Burgh Island on the south coast of Devon. And I have been on a tram in which I could have sailed all the way from Liverpool to Brighton had I been so inclined. Not that you could instantly recognise this seaworthy tram, for it looked more like a sailing boat. But, if you took away its mast, sails and marine ply, you would have been left with – shiver my timbers – mahogany frames that once rocked and lurched down the tram tracks on Blackpool's promenade. This two-berth boat, named *Sulyda*, was built by a Cleveleys master joiner using wood from scrapped tramcars, withdrawn from service after the closure of the Marton route in Blackpool.

I have often contemplated what started the comparison between tramcars and ships. Did it originate from works of literature or did it stem from the practice of decking out trams as lifeboats, cabin cruisers, yachts, gondolas, warships, liners, Viking ships and so on to mark special occasions, such as carnivals, victory celebrations and royal visits? No town, of course, disguised its trams as sea-going vessels more than Blackpool, where most day-trippers or holidaymakers will have seen the *Lifeboat* and the *Gondola*, not to mention the *Blackpool Belle* paddle steamer, the *Hovertram*, *HMS Blackpool* (rebuilt in 2004 as *Frigate 736)* and the *Cevic Trawler*, cruising up and down the promenade during the Illuminations.

Adding fuel to the fire is the fact that tramcars in South Shields bore names of ships built on Tyneside, like *Nelson*, *Mauretania*,[1] *Monarch of Bermuda* and *Protector,* while one was named *Collingwood* after Lord Nelson's second in command, whose monument overlooks the Tyne at Tynemouth. And even more pointed is the fact that various classes of tramcar were given seafaring names such as *Cunarder* in Glasgow, *Dreadnought* and *Boats* in Blackpool, *Showboat* in Leeds, *Liner, Oceanic* and *Cabin Car* in Liverpool, *Submarines* in Newcastle and Dublin, and *Windjammers* in Dublin. Interestingly, the reason the term *Windjammers* was given to certain Dublin tramcars running to Dalkey is explored by Michael Corcoran in his book *Through Streets Broad and Narrow* (Midland Publishing, 2000).

To Dublin tramwaymen, the Dalkey balcony cars quickly became known, for several reasons, as 'Windjammers'. A feature of these trams was a canvas sheet on each platform which could be unrolled and fastened to close off the stairwell, thus protecting the motorman from the elements. The similarity to a flapping sail probably inspired the nickname, the nautical likeness being further emphasised by the

Today's rubber-tyred non-electric equivalent of Daddy Longlegs is to be seen at Bigbury-on-Sea, on the south Devon coast. It runs through the waves at high tide across a causeway to Burgh Island, where this photograph was taken.

Not exactly a galleon, but certainly maritime in appearance, this Burnley tram disguised as a steam yacht sets off from the depot on a fund-raising exercise for the local hospital.

trolley rope, sometimes called the rigging, plus the ship-like swaying of a Dalkey eight-wheeler at speed. A slight creaking from the tram's timber joints contributed yet another element to the sensation of being on board a ship.

There was also the opening mechanism for the upper deck windows, all four of which on each side were wound up or down simultaneously by a wheel on the balcony bulkhead, somewhat like a ship's wheel. The sight of a tramcar ablaze with light swinging through the dimly lit streets of the period would have been likened to that of luxury liners that so caught the public imagination around that time.

Surprisingly, steam trams, which by no stretch of the imagination are anything like sea-going vessels, were nicknamed the *Baltic Fleet* in Accrington. The reason for this was simply that their funnels resembled the smoke stacks of the Russian war ships that attacked our fishing fleets in the North Sea at the time of the Russo-Japanese War. On the other hand, not far away, the steam trams in neighbouring Rossendale were known as *Armoured Trains*, which was a more plausible nickname, especially as all working parts were concealed from view, as are all the parts of an armoured vehicle. (See illustration on page 47.)

The press saw trams in a less romantic light than the great writers of literature, calling them 'dinosaurs', 'bull elephants', 'rattletraps', 'anachronisms', 'gigantic nuisances', 'misshapen monsters of the track' and even, with some feeling, 'lurching, swaying, points-jumping trolley tossers' to mention but a few of their not-so-very-kind brickbats. This, I should hasten to add, was in the latter days of the trams, when they were creaking with age and falling apart at the seams and when *The Times* saw fit to call them monstrous, adding 'Their wheels, chained to rails, forever sobbed, wailed, moaned as if in torment; their bodies heaved and swayed, pitched and tossed in restless agitation....'

Yet only half a century before, when trams were being launched on the streets, immaculate and shining like a new pin, writers were reaching for their thesauruses to find suitable words of praise, as they are today when faced with the sleek, smooth, quiet and comfortable tramcars that are being re-introduced to streets all over the world.

To the writer Ford Maddox Ford the new electric trams appeared 'romantic and a little wonderful'. Other writers called them 'marvels of the age', 'mechanical successes lit with a dazzling brilliance', 'castles of crystal', 'graceful pretty vehicles', and 'imperial cars that slide in glittering strings'. A reporter in Bradford likened them to 'a magic fairy barge'. Some stretched their imaginations even further, calling them 'travelling houses on fire', 'vast sarcophagi', and 'greenhouses'. Few passengers in those days saw them as dinosaurs or called them 'trolley tossers'.

So what were the old tramcars of yesterday? Were they galleons or jangling juggernauts; sailing ships or, as J.B. Priestley described them, 'sick elephants'? I don't think the tram was any of those things. Nor were they, as one London columnist put it many

moons ago, 'swaggering roistering Bacchanalian old rascals' or, going to another extreme, 'affectionate old aunts'. To my mind the trams of yesteryear were unique. They had a distinctive character of their own and there was nothing to compare with them. They were vehicles of absolute magical splendour engendering communal spirit, civic pride and a sense of adventure. But more than that, they offered pleasant and enjoyable rides – the best, in my view, and certainly not, as somebody once unkindly put it, 'the best you could purchase outside a fairground'.

In complete contrast, today's trams are very smart and very fast avant-garde vehicles, with streamlined designs, computerised controls, quiet-as-a-whisper running and floating-on-air riding qualities. There are no other vehicles on the road to touch them and they are definitely a cut above their predecessors. In fact, they are incomparable and most decidedly bear no resemblance whatsoever, thank goodness, to any craft sailing on the high seas or any unhealthy pachyderm lumbering through the jungle.

[1] The 'Mauretania' tramcar was fitted with a siren warning device, in place of the standard bell. It scared the living daylights out of South Shields pedestrians whenever it was sounded, causing old ladies to scream and youngsters to scamper away in alarm, and prompting one newspaper correspondent to suggest that the tramcar should be renamed 'Frankenstein' or 'Dracula'.

Subway Memories

By John H. Price

John H. Price, former editor of Cook's Continental Timetable, was a proficient, knowledgeable and revered tramway enthusiast. He was a leading authority on trams and it would probably be true to say he knew more about the subject than anybody else. He held high office in tramway preservation circles and as well as being an author was a regular contributor to periodicals. The library at the National Tramway Museum is named after him, in memory of his achievements. No anthology on trams would be complete if it did not contain at least one example of his work, and these extracts from an article he wrote about London's Kingsway Tramway Subway, referred to by tram drivers and conductors as 'the chute' or 'drainpipe', are an excellent testimonial. The article appeared in the December 1963 issue of the magazine *Modern Tramway* (published jointly by the LRTA and Ian Allan Ltd).

Once in a while, one finds a subject that lends itself to a treatment other than the normal, one on which it is worth the trouble of looking back and finding out what people thought, or said, or wrote about it at the time, and how they remember it. The Kingsway Tramway Subway in London is a case in point, and in this second article we propose to gather together some of these threads and see what results....

The subway's greatest admirers were the children, who never tired of the strange sensation of riding on a tram through the echoing blackness, with dimly perceived walls looming up inches from the window, giving a sense of speed never experienced in the open air. The most thrilling experience was the southbound glide down from Bloomsbury, like a liner going down the slips or (as the *Railway Gazette* once put it) 'a performing elephant taking to the ring on roller-skates'. The embankment-bound trams would wait at the island, poised for departure, and would then sweep round the curve and dive down the slope, to

A No. 31 car at the High Holborn station running in the only tramway subway in Britain – the Kingsway tunnel in London. The picture was commissioned by John Price, the author of this article and a leading tramway preservationist, and painted by Ashley Best.

vanish in a rattling darkness....

Today, eleven years after the trams ceased to run, the northern ramp of the subway is still there,[1] disused and derelict, to rekindle these memories and cause a new generation of children to wonder what it was all about, as their parents try to explain the tracks and describe the vehicles that once ran there.

But to the former tramwayman that 1-in-10 gradient with the position-light signal holds different memories, the way you could hold a car on the slope by using the first notch of power and no brake, the time when the handbrake wouldn't hold and you slid back, the time when the breaker blew on the slope and the car rolled all the way back to Holborn; you realise now why they had signals to prevent more than one tram being in the section at a time. On 9 April 1948 this actually happened three times in succession to an E/3 car on service 33, probably because the breaker was set to trip at the wrong value, and only after three attempts and three backward runs did the car manage to surmount the slope and continue its journey. It is surprising that the LCC never seem to have considered fitting some of the Subway cars with air-wheel or air-track brakes.

Subway drivers were a special race, senior men picked for the job, and a reader who knows some of them has told us how they were chosen. To drive on the subway routes a driver had to have at least two years' experience on street routes, but when staff shortage became acute because of the war this was reduced to six months. The southern depots (Wandsworth, Norwood and Camberwell) had plenty of routes on which they could train, but Holloway had no non-subway tram routes after 1939, and as subway drivers left they had to ask trolleybus drivers with tram experience to volunteer to go back on trams....

One thing that sticks in the crews' memories is an accident, yet the Kingsway Subway had such an excellent safety record that there is scarcely anything to record. No passenger or intending passenger was ever killed (a tram's lifeguard was even more effective than a tube-station suicide pit), and the only fatality known was the sad case early one morning when the first car through, running early, overtook and killed an unauthorised person who was pushing a barrow through one of the single-track sections. The only other occurrence was at the end of 1951, when car 1992 ran into the rear of car 182 at Aldwych station, causing injuries to several passengers; this was apparently due to a brake failure coupled with the fact that the magnetic track brake would not react to the manganese steel used for points and crossings....

The subway usually enjoyed the full-time attention of three inspectors, one each at Holborn and Aldwych stations, and one at the Embankment end, who worked a switch for the special traffic-light phase and prevented pedestrians from trying to cross the tracks when a tram was about to enter or leave. Before the lights were installed, a flagman was on duty here to hold up traffic on the Embankment as the cars crossed. As London Transport property, the subway was in the realm of London Transport (later BTC) Police, and if anything happened the inspector would do his utmost to despatch the offender on a tram to the upper regions, where the crew could call the Metropolitan Police instead: a reader has described how he saw this done with a passenger who refused to pay his fare.

The subway was lit at 110 volts a.c., and on the

London tramcars enter and leave the Thames Embankment entrance to the Kingsway tunnel, under the dark span of Waterloo Bridge. The tunnel was originally built for single-deck cars and enlarged to take double-deckers in 1931.

(very rare) occasions when the traction supply failed, the inspectors could shepherd the passengers out along the tunnel into the street. The subway was closed off at night by lattice gates, and could not be used as a refuge by down-and-outs or drunks; there were not even any rats, only a very occasional dead pigeon.

So far as the ordinary passenger was concerned, subway memories will probably centre on the speed and convenience (Westminster–Bloomsbury in seven minutes) and on the reasonable fares, especially the wide range of transfers; each fare card for the three subway services contained about 300 transfer possibilities....

The passenger could tell a subway car from the rest by a special indicator above the destination blind ('Via Kingsway Subway').... In the subway, he could tell which station he was at by the blue bull's-eye nameboards on the walls, some at lower-deck and some at upper-deck level, and he had to remember to get off by the front platform and the front stairs (as instructed by a small red notice on the door-glass), using the stairhead door which the driver was supposed to open and close but sometimes forgot.

Although there was no all-night service through the Subway, the day service continued until midnight, and a particularly celebrated car was the 11.55 p.m. from Westminster to Highgate, popularly known as 'The MPs' Tram'. This was the last north-bound car of the day, and on nights when the House of Commons was sitting late you could invariably see a few Members scurrying to catch it and travel to their North London homes or Bloomsbury hotels. The 11.55 for years had a regular driver, Thomas Walter Manley, who came to know all the Members and once had no fewer than sixteen of them on his car, in the days of wartime petrol rationing.

The London motorist would have little to recall of the Subway, apart from a vague irritation at special traffic-light phases solely for trams, but if he was a visitor there was the danger that (as happened to one reader's uncle) he might spot a gap in the traffic at Southampton Row and accelerate through it, only to find himself dropping rapidly towards a small black hole with a tram shooting past him inches away on the other track. In most cases he would be able to back out in time, but we believe that at least one motorist was hounded all the way through to the Embankment by an angry tram in hot pursuit. This is quite apart from the various occasions when motorists have driven through for a wager; the first one we can find was in 1927,[2] and one or two more cases occurred in the closing months, quite apart from the tests carried out by the Ministry....

When the last night arrived, two special trams were run to mark the occasion. The last regular service car through the subway was the 11.55pm from Westminster to Highgate, car 185 on route 35, with Driver Alfred Keir and Conductor John Howes. No. 185 with some 100 passengers aboard was seen off by a kilted piper and despatched from Holborn by 'Paddy' Walker, a retired inspector who had known the Subway from the inside for twenty-four years. The last southbound 33 was tailed from Addington Street by No. 197, hired and decorated by Lambeth Borough Council, and at Aldwych Station No. 185 passed No. 173, a special car hired by Holborn Borough Council for a trip from Theobalds Road to Westminster and back. There was also a sizeable squad of police, but the only unexpected occurrence was the passage (southbound) of a 1904 Oldsmobile car piloted by a gentleman with a military moustache, after which the Mayor of Holborn's tram was something of an anti-climax. Later that night, the thirteen remaining trams of Holloway Depot were driven through the subway to New Cross, minus route boards and indicators, the last of all being car 184 driven by union-representative Driver Tom Fitzpatrick.

After the closure, the disused subway soon attracted the attention of writers and cartoonists. On 9 July 1952, Lee[3] of the London *Evening News* created a ghost tram emerging from the subway at Bloomsbury and scaring a policeman. On 23 November 1954, Peter Sellers, Harry Secombe and Spike Milligan devoted one of the Goon Show programmes on the BBC to *The Last Tram*, a car whose driver and conductress (Henry Crun and Minnie Bannister) were so determined to be London's last tram that they hid in the subway for two and a half years and had a secret entrance below a block of flats. Flook[4] of the *Daily Mail* cartoon-strip, once stole a London tram and found a secret spur leading from the Subway on to the Central Line, along which he drove the tram to Mile End with a Tube train close behind, and cartoonist Giles in his days with *Reynolds News* once created the reverse situation, with a Tube train straying into the subway and meeting a tram.

The ghostly atmosphere was real enough, and could be felt very strongly on the occasional organised visits.

John Price went on to list the subsequent visits to the subway after its closure, including one by the Tramway Museum Society on 10 April 1958, to mark the fiftieth anniversary of the opening:

We found to our surprise that the London Transport

telephones in the inspectors' room just north of Holborn station were still connected up, and we were sorely tempted to use them and start a ghost story among the switchboard girls. One of the party celebrated the occasion by riding through the subway on his scooter, but perhaps he can be forgiven, for it was he who saved tram No. 1858....[5]

Although the underpass[6] has changed most of the Subway almost out of recognition, the location of the road entrance and exit are such that the former extremities of the Subway will still remain as they were, derelict but intact, one beneath Waterloo Bridge, the other at Southampton Row. Dismissing prosaic explanations of traffic engineering, we prefer to think that this is London County Council's way of paying tribute to the tram, and that their actions were guided by Paul Jennings of the *Observer*, who pleaded in 1952 that the subway should not be sealed off but just left disused, so as to perpetuate the legend of a Ghost Tram. 'Let us have no statues of great tram designers for memorial', he wrote; 'Let us have this lonely quiet in the heart of London, to be passed like a haunted churchyard, with fitting trepidation....'

[1] And still was today in 2010.
[2] According to Alan Jackson, writing in *Tramway Review*, the motorist was drunk, and when he reached Southampton Row found he couldn't get out because the gate there had been locked. Mr Jackson said: 'The LCC nightwatchman described how he was "thunderstruck" at seeing the car and had to step into a recess to save himself.' The motorist was fined £1 12s at Bow Street.
[3] A cartoonist.
[4] An animal caricature.
[5] Now preserved at the East Anglia Transport Museum in Lowestoft.
[6] Then under construction.

They were problem children ... but we had a great affection for them. They came swaying, lurching and grinding along at about 10 mph. The Addiscombe trams ran from the Whitgift Hospital via George Street and Cherry Orchard Road, until abruptly terminated by the bridge at Bingham Halt, where the ceremony of reversing took place....

As children we found these ponderous vehicles a continual source of interest and excitement. When possible we always travelled on the roofless upper deck, which had twin slatted seats each side of a centrally-sited metal post supporting the pole which ended in a pulley wheel that swished endearingly along the overhead electric wire. Narrow twisting stairs at each end enabled penniless small boys of nearly fifty years ago to make a quick exit. In inclement weather the upper deck travellers sat under umbrellas and pulled a canvas covering over their knees. How thrilling when the pick-up arm suddenly shot skywards and after bouncing around finally came to rest looking like a rocket stick pointing irresponsibly towards heaven. The pulley was finally coaxed on to the wire again by a patient conductor manipulating a long hooked bamboo pole or tattered piece of rope.

Actual derailment caused the biggest thrill. We sometimes placed ourselves in a strategic position at the Cherry Orchard Road corner, which could always be relied upon to produce the best derailments, and special jacks were kept permanently outside the Leslie Arms for getting them back on the rails.... Re-railment depended for its thrills upon how far the tram had run from the rails. Sometimes we blissfully watched a perspiring conductor and driver trying to complete the electrical circuit by using a long iron crowbar attached to the front of the tram which, owing to the one big lamp amidships, made me think of the face of Cyclops.

Pet Put Passengers to Flight
By R.S. Hunt

As a child, R.S. Hunt had a great affection for the open-top tramcars operated by the South Metropolitan Electric Tramways between Croydon and Addiscombe. Some of his childhood recollections of them appeared in the *Croydon Advertiser* for 23 August 1968 under the heading 'How the white rat helped to raise cash for Selsdon's bird sanctuary after frightening a fat lady and derailing a tram....' This slightly shortened version of his article is reproduced by courtesy of the editor.

One of the South Metropolitan trams so much loved by R.S. Hunt pauses for the photographer in Stafford Road on its way to Sutton. The full name of the company – the South Metropolitan Electric Tramways and Lighting Company Ltd – is given on the side of the tram.

Far removed in appearance from the first-generation trams, this sleek articulated low-floor car, designed to carry more than 200 passengers, is one of twenty-four new trams now serving the Croydon area. Built by Bombardier in Vienna, they can travel at 50 mph and run from the centre of Croydon to Wimbledon, New Addington and Elmers End.

If successful the tram moved backwards amid showers of sparks, making two neat grooves in the wooden road blocks. Sometimes another tram was used as a tow....

Two particular drivers were our heroes. There was the large rotund jolly one whose motto was 'slow but sure' and who navigated his tram without mishap from one end of the line to the other.... The other, our favourite, was tall and thin and of a reckless disposition.... He could be relied upon to derail his tram at least twice on the journey and, if our luck was in, the overhead arm would come off too! He always made us feel we had full value for our pennyworth....

Our greatest achievement occurred one day in high summer. My brother and I had been inveigled into organising an exhibition of pets at school in order to help raise money for the purchase of the bird sanctuary at Selsdon. We sallied forth with Chippy the white rat, so named because he had been donated to us by a leave-taking ship's carpenter whose girlfriend objected strongly to his presence.

Chippy, whose character left much to be desired, had an endearing habit of leaving the warm space under my blazer, climbing out, walking up my lapel, round my collar and descending on the other side into the warmth and safety whence he came. It happened that the thin driver's tram was crowded with bargain-hunting female shoppers who did their best to avoid overflowing into the central aisle. We, as usual, were in front confidently hoping that at least the tram's arm would come off the wire, when suddenly Chippy decided upon a circular tour.

A fat lady, hugging an enormous shopping basket, spotted him and, letting forth a shriek like a steam siren, precipitated herself towards the rear door followed by an undignified surge of terrified shoppers. The tram came to an abrupt halt as Chippy returned to his haven of warmth....

'Yer can't bring rats on 'ere,' bawled the conductor as he advanced upon us and unceremoniously deposited us in gaping bewilderment upon the pavement, while the trembling passengers climbed aboard again.

Smarting under this injustice we started to walk when 'Oh justice!' there was the tram well and truly derailed at Hall's corner; our thin driver had not let us down.

Triumphantly we held Chippy aloft as we walked past the row of frustrated, angry faces. We dare not stop to watch the re-railing operations as the lean driver appeared to bear us some animosity and we suspected that his long thin legs were capable of a hidden turn of speed.

The exhibition was also a great success. We raised several pounds ... and Selsdon duly got its bird sanctuary.

'Tram' Goes Back a Long Way

By Dennis Gill, with extracts by Peter Jacques and David Holt, and brief letters by Alec G. Jenson, J. Herbert Roberts, Michael Weaver and Ian M. Coonie

The word 'tram' goes back a very long way, in fact as far back as the days before Christ. In recent years modernists have felt the need to dispense with the word and replace it with a more futuristic one to

give the new streamlined avant-garde trams a sleek new image. But the word 'tram' is not easily buried and I suspect it will be around for many centuries to come.

Some people have found it very confusing that it was a man called Train who brought the tram to England (at Birkenhead in 1860), and, quite understandably, ask if it was a man called Tram who gave us the first railway. In fact it is not by any means a flippant question, as the following extracts from early editions of the magazine *Tramway Review* reveal. These extracts also raise another interesting confusion by pointing out that the vehicle that runs on a tramway is called a tram, whereas the vehicle that runs on a railway is not called a rail. And they also show that the word 'tram' goes back further in history than hitherto imagined. The discussion was started by Peter Jacques in his short article, entitled 'Tramway Etymology', which appeared in issues 22 and 23 (combined) of the magazine in 1957.

> There is a popular misconception that the word 'tram' is derived from the surname of an early pioneer, Ultram. In point of fact it was to be found in Frisian and Middle Low German about six hundred years ago in the form of 'trâm' or 'trame', meaning a wooden beam or shaft. It eventually passed into English and was definitely used in 1516 to mean the wooden frame of a truck used in mining.
>
> Towards the end of the eighteenth century, the practice of running mining trucks on wooden rails commenced, and it appears that from the first, the name 'tram' was given to each section of wooden rail. By 1800, the term 'tram-road' was in use, to refer to the road of trams (wooden rails) laid in parallel lines for the transportation of minerals in trucks.
>
> The term 'tramway' did not appear until 1825 and it was not until 1860 that it was accepted to mean a tram-road with rails laid flush with the street surface for the operation of passenger cars.
>
> In the United States, the term 'street railway' was preferred, and in 1872 'tramway' took on the special meaning there of a cable railway with cars suspended from an overhead line.
>
> The construction of the first passenger tramway in the world is credited to a Frenchman, Loubat, in New York in 1842, and subsequently his tramway in Paris was called the *'Chemin de fer Américain'*. The French soon took the English word into their language, and in 1878, the Academy officially recognised the term 'tramway', meaning a street railway for the conveyance of passengers.
>
> The Italians took the English term, with slight modification, to give 'tranvia' and the Russian language also contains the word 'tram'. The Germans, on the other hand, followed the American lead and coined the word 'Strassenbahn', meaning literally, 'street railway'.
>
> The word 'tramcar' was first used in 1873. It is interesting to note the appearance of the term 'rail coach' in recent years, to refer to the latest single-deck tramcars for Blackpool. As tramways are gradually developed into 'rapid transit' installations, it is very possible that the new term will pass into common usage, at the expense of the word 'tramcar' which, in England at any rate, has rather conventional associations.[1]

Peter Jacques' article brought some interesting comments from readers in subsequent issues. From Alec G. Jenson, London, issue 24:

> I was interested in Mr Jacques' note on the derivation of the word 'tram'. Surely the gentleman to whom he refers was Benjamin Outram (father of Sir James Outram, one of the Indian Mutiny heroes) who, in 1774, manufactured at Butterley (*in the East Midlands*) some cast iron plates to the design of Mr John Curr, agent to the Duke of Norfolk, which were laid in Sheffield. According to the late Mr Fred Bland of Edgar Allen and Co. Ltd, they were 6 ft x 3 in x ½ in with a lug at each end for bolting to the sleepers. These plates were, however, unsatisfactory and it was Outram's partner, William Jessop, who invented a more satisfactory rail known as the edge rail.
>
> Regarding the origin of the word 'tram', the Encyclopaedia Britannica states that the word originated in Scandinavia, where the word 'tråm' or 'trum' also had the meaning of a beam of wood as in the Frisian or Middle Low German referred to by Mr Jacques. It may be that both forms originated from the same root as the Latin 'trabs', that is to say, from the common Aryan language of the Stone Age.
>
> Bland also refers to the use of the word 'tram' in England in a will dated 1555 in which a sum of money was left for the repair of a 'highway or *tram*'.
>
> It is interesting to tramway enthusiasts that 'trams' (wagons) were run on 'tramways' whereas no one ever referred to a 'rail' running on a railway! It is also a pleasant thought that tram-ways or tram-roads existed and were referred to as such over 200 years before railways were born.
>
> The French originally termed horse tramways *'voies ferrées à traction de chevaux'* (horse railways) or, as Mr Jacques records, *'chemins de fer Américains'*.

From J. Herbert Roberts, Rhyl, issue 24:

Under 'Tramway Etymology' your contributor, Mr Jacques, refers to the word 'tram' and its derivation in English and other languages. In these islands, the Welsh language is an original British language and the words 'Tramwy', 'Tramwyo', mean to traverse, cross or journey, and I possess Welsh dictionaries of 1815 in which the word appears.

Incidentally, in the Welsh edition of 'Pilgrim's Progress', by John Bunyan, the English form commences, 'As I journied through the wilderness of this world …'. The Welsh edition commences '*A mi a tramwyo trwy anialwch y byd hwn*', so that the word 'tramwy' meant a description of movement or motion, and as Welsh descends from Ancient British, then one may surmise that before 55 BC the word was in use in these islands.

From Michael Weaver, the Bowes Museum, issue 105:

With reference to 'Tramway Etymology' … the earliest known use of the word 'tram' in connection with roads is to be found in the will of Ambrose Middleton in 1555. This was published in Volume 112 of the Surtees Society (Wills and Inventories Volume Three). The original will is lodged in the Department of Palaeography, University of Durham.

The sentence in question runs as follows: 'Also I geve and bequithe to the amending of (the) higheway or tram frome the west end of Bridgegait in Barnard-castle (afore) said … brydge-ende there 20s.'

Bridgegate in Barnard Castle is the main road below the ruins of the castle leading to the only road bridge across the river Tees. The road on the other side of the river, apparently at one time, was known as the Tramwalls and as a consequence it has been suggested there might have been a primitive tramway to slate quarries at Brignall about three miles away, although I am very doubtful of this suggestion. My own view is that possibly the road surface of Bridgegate was improved by laying wooden beams in it.

From Ian M. Coonie, Paisley, issue 108

Regarding correspondence on the early use of the word 'tram', I would draw attention to the poem by James I of Scotland in the fourteenth century, 'Christ's Kirk oan the Grene', where the line occurs: 'Bet on Wath Barrow Trams'. No doubt this refers to the shafts of such a two-wheeled vehicle as stated in the etymology.

So the word 'tram' has a long history, going back, perhaps, before 55 BC according to Mr Roberts. And it would appear that the word is here to stay and may last in our language for another 2,000 years. Yet, surprisingly, a few years ago there were some who felt that a more fanciful alternative was needed for the word. This was at the time when the tramway revival began in the 1980s. Some authorities and some enthusiasts were reluctant to use the word 'tram'. They feared it might not create the right impression among people who knew nothing about the revolutionary new vehicles about to be launched on our streets, especially as sections of the press were illustrating stories of the revival with pictures of 1901 trams. They feared that some people, in all ignorance, might imagine that the old open-top trams of 1901 were about to be foisted upon them. To allay these fears a new image was needed, so fanciful names were coined in the same way as High Speed Gas was coined to give gas a new image in the 1960s. For trams, new nomenclature, such as 'light rapid transit' (LRT), 'light rail vehicles' (LRVs), and even 'duorail' was conceived. It was no surprise, therefore, that when new trams were eventually introduced into Manchester in 1992 they were called 'The Metrolink'. Officialdom never referred to them as trams. The public, though, quickly embraced the

Every inch of the way a tram, but operating as 'The Metro', this car is on the service which opened between Birmingham and Wolverhampton in 1999.

new highly sophisticated vehicles and had no hesitation in calling them 'trams'. After all, why not call a spade a spade.

Birmingham also adopted the word 'Metro' for the new trams running on the line between the city and Wolverhampton, calling it the Midland Metro. Metro actually comes from the Greek word 'meter' for mother and 'polio' for city resulting in the word metropolis, meaning 'mother city'. When the first underground railways in the world were constructed in London in the 1860s, they were designated the Metropolitan Railway and the Metropolitan District Railway, which Paris then adopted for their underground – *Métropolitain*, soon abbreviated to Metro. Hence the current use of the word.

David Holt, who was at one time the Light Rail Transit Association's development officer, wrote a fascinating account of the novel step taken by Greater Manchester Metro Limited to conjure up a new snappy name that would be on everybody's lips when talking about Metrolink. It appeared in his book *Manchester Metrolink* (published by Platform Five in 1992).

> To coincide with the arrival of Metrolink's first tram in late August 1991, Greater Manchester Metro Limited (GMML) and BBC Manchester jointly ran a 'Nickname Metrolink' competition on the *North West Tonight* television programme. The idea was to find a snappy short name which people would use for the system; Chicago's elevated railways are affectionately called 'The El' and London's underground is commonly referred to as 'The Tube'. What was wanted was a similar pet name for Metrolink.
>
> Over 1000 entries were received from viewers. Many of them suggested names connected with Manchester's past association with the cotton industry, such as 'The Thread', 'The Shuttle' and 'The Cotton Reel'. One particularly imaginative viewer suggested 'ABBA' for 'Altrincham to Bury and Back Again'. Even more appropriate was 'TRAM' for 'Travel Right Across Manchester'; but the genius who invented this brilliant acronym thought the name far too obvious to submit, otherwise it would surely have left all the other entries standing.
>
> The winner was a lady who chose 'The Met' (shouldn't it have been 'The Med' in view of the trams' Italian origins?). This is being adopted by GMML with the intention of encouraging the public to refer to travelling by 'The Met' rather than by tram. Before the war, London's Metropolitan Electric Tramways were affectionately known as the MET by tramway enthusiasts and employees, but the public stuck to 'tram' unless they had to make a distinction between those belonging to the MET and those belonging to other operators. The same name and the same home truths apply in Melbourne today.
>
> Any doubt about what the public will call the vehicles [*in Manchester*] was dispelled by a conversation overheard at Victoria as the first one was taken into the streets for clearance tests. 'Here comes the LRV,' said a punctilious dad to his small son, who couldn't have been more than four years old. The little lad set his father on the right track towards a more homely appellation: 'Why do you call it an LRV dad? It's a tram!'

Strangely enough, I have never heard anybody in Manchester call the Metrolink 'The Met'. Most people I have come across, even the BBC in their traffic reports, call them 'trams'. The winner of the competition, if nobody else, must be terribly disappointed.

Fear of the old-fashioned images of trams, thankfully, has dissipated to such an extent that, in a 180-degree turn, buses such as those at York have been designed to look like trams, lending an air of modernity and sophistication.

It is also interesting to note that when Geoffrey Claydon, the country's foremost expert in tramway law, devised the Transport and Works Act in 1992, he decided to get rid of all the fancy names, including that of light railway, and opt for just two: 'railways' and 'tramways', thus ensuring the continued use of the terms 'tramway', 'tramcar' and 'tram'.

[1] The Tramways Act of 1870 refers to the vehicles as 'carriages'. In later legislation they became 'tram carriages' and finally 'tramcars'. This last term is used in the current Road Traffic Acts and in model clauses prescribed under the Transport and

A Manchester Metrolink car on the service to Altrincham heads out of St Peter's Square in September 1992. A competition to find a catchy name for the Metrolink produced 'The Met', which has never caught the public's imagination.

Works Act 1992 and currently in draft regulations on disability discrimination. So where 'tram' is the popular term, 'tramcar' is the legal term (likewise with 'trolleybus' and 'trolley vehicle'). In fact, the word 'tram' has not gone out of fashion. It is likely to be with us for a very long time.

Stopped Forever by an Earthquake

By Graham Stewart

A number of tramway systems have been brought to a sudden end in a variety of ways, but few as frighteningly as the one in Napier, a town on the east coast of New Zealand's North Island, which was devastated by an earthquake. The fateful day is recalled by Graham Stewart in his absorbing and lavishly illustrated book *The End of the Penny Section* **(published by Grantham House, New Zealand, in 1993).**

The day was typical of Hawke's Bay in the summer – warm, with a clear sky and hardly a breath of wind to stir the dust. As three sailors from the visiting British naval sloop *Veronica* climbed on board a Napier tram standing at the Port Ahuriri terminus, motorman Jim Minto checked his fob watch.

The 10.48 a.m. car from the port in the summer of 1931 was usually well patronised by women who went into town to view the bargains before luncheon at a tearoom. Motorman Minto gave a nod to his conductor, Frank Fulford, to indicate that it was time to be on their way. With the motorman's foot-gong clanging, the quaint little four-wheeler started the return trip along Bridge Street. As the tram trundled across the road bridge by the Iron Pot, waterfront workers were busy loading produce into small coastal ships and schooners berthed in the basin. In the port township, several women boarded the car, choosing, as usual, to sit in the central enclosed saloon. In Waghorne Street, Minto shut off power to reduce speed before entering the loop by Stafford Street and the car glided around the corner.

Then it struck.... The earthquake seemed to come in huge waves under the tram, lifting it, then shaking it violently. At first Jim Minto thought his tram had parted company with the rails. As he said later, 'The tram was shaken like a fox terrier playing a rat.' Although shocked, passengers remained on their seats. When the second wave of earth tremors came, with the crash of falling chimneys and the agonising groan of homes fighting against the convulsions of the land, passengers and crew hurriedly left the tram. Fire broke out in a warehouse opposite, threatening to engulf the tram, now stranded without power. Minto and Fulford enlisted the help of a local motor-carrier who, with his Dennis hard-tyred lorry, managed to push the tram to safety along Waghorne Street to the Presbyterian Church. Motorman and conductor made hard the brakes and decided to walk into town.

In Shakespeare Road they met the crew of an outward-bound car standing helpless by their vehicle. The sight that greeted the four tramwaymen is now history. A city in ruins, with the tramway overhead draped at crazy angles across wrecked motor cars and roadways. On the Napier South line in Hastings Street a single tram stood like an orphan, robbed of its life blood, having just left the terminus where the main south railway crosses Hastings Street when the quake unleashed its force on Napier.

Back at the depot in Thackeray Street, three trams had toppled into the maintenance pits. The conductor of another tram waiting to go into service in the depot yard had taken cover under one of the seats, and would not budge. A fortnight later Jim Minto returned to his deserted tram in Waghorne Street to find his lunchbag untouched. Three weeks were to pass before tractors towed the three stranded tramcars back home to the depot. The earthquake of 3 February 1931 cost 256 people their lives and silenced the Napier Corporation Tramways for all time.

Trams in Miniature

Tramway modelling has been growing steadily since the war under the auspices of the Tramway and Light Railway Society, which caters for modellers' needs. Members spend many painstaking hours recreating the world of the tram in miniature form to a wide range of scales. A few even build models to a scale that is big enough to carry children, and in one or two cases adults.

They not only build their own trams from scratch, replicating trams that ran in service, but recreate the street scenes. Some of their layouts are true to life, and one member in Blackburn not only faithfully recreates all aspects of street life, but domestic life and working life as well, showing for instance bill posters and road repairers at work, women hanging up washing in their gardens, families eating meals and going to bed, and so on. The pictures on these pages show some of the modellers' achievements.

Trams in Miniature | 69

A model tram with a long history. Built by Claude Lane at his home in Barnet in 1949, this 15 in-scale model of one of the streamlined trams that ran in Darwen, Lancashire, gave rides to children on transportable track at garden fetes and other events in the London area during its first year. Subsequently, it operated on stretches of permanent track laid in St Leonards, Hastings (1951) and Rhyl (1952–7) and then came successively under the ownership of Ian Cormack in Glasgow (1958–78) and the Merseyside Tramway Preservation Society in Liverpool (1978–94) before being purchased in 1994 by Denis Butler of Cheshire, pictured with the tram in his garden.

Charles Forster with one of the ceramic models of trams he made in the workshop at his home in Holbrook, Derbyshire. A lifelong tram enthusiast, Charles was inspired in his modelling by Emett. 'It's the character of the tram I'm after – their ornateness and individuality – rather than the nuts and bolts,' he said. Examples of his work can be seen at the Museum of Harlow in Essex.

Engineer Bob Hill, on 13 August 1989, with some of the model trams he runs on his garden tramway at his home in Cheshire. Bob also runs full-scale trams at the Heaton Park Tramway in Manchester.

Trams No. 9 and 17 at the Colyton terminus of the Seaton narrow-gauge tramway in Devon. The three-mile line is laid on the track bed of the former Seaton Junction to Seaton branch line railway, and passes through the breathtaking scenery of the Axe Valley, giving excellent views of the estuary's bird life.

Model trams made out of Meccano on display at the Cheadle and Marple Sixth Form College, Stockport, in 1989. Admiring the models is tramway enthusiast Geoffrey Lomas of Maidstone.

A 7 mm scale realistic model tramway layout at the 2008 Festival of Model Tramways held at the Manchester Museum of Transport. The layout is of the Sunderland Sealane tram terminus at Seaburn, and the models are of an ex-Huddersfield car (left) and an ex-MET car. Notice the tram shelter, the real version of which is preserved at the North of England Open Air Museum at Beamish.

Modeller John W. Price driving a battery-powered 7¼ in-gauge model tramcar on the garden tramway at his home in Lancashire. The car was originally built by John in 1972 and rebuilt by him in 1981. The track is 144 ft long, with sidings.

Through God's Good Country to Loch Lomond – and Pickpockets

By Alan Brotchie and Robert Grieves

One of the longest interurban tramways in the British Isles was the eleven-mile line that ran from Dalmuir West on the outskirts of Glasgow to Balloch on the shore of Loch Lomond. Operated by the Dumbarton Burgh and County Tramways Company, it went through 'God's good country', as the *Glasgow Citizen* put it, serving Old Kilpatrick, Dumbarton, Renton and Alexandria on the way. In its early days it was extremely popular and well patronised. Thousands of Glaswegians used the service, taking the corporation cars to Dalmuir and changing there onto the Dumbarton Company's green and cream four-wheel open-toppers. In their book *Dumbarton's Trams and Buses* (published by N.B. Traction in 1985), Alan Brotchie and Robert Grieves describe the scene during the first weeks of operation.

The weather was perfect and the prospect of a day at Loch Lomond for one shilling and twopence (sevenpence each way) brought thousands of Glaswegians to Dalmuir.... A ten-minute service,[1] using seventeen cars, was run.... On that first Sunday no less than 30,000 passengers were carried. Every corner of every car was occupied, every standing space taken, people even sitting on the backs of the upstairs seats. One child was caught round the neck by the trolley rope of a passing car and thrown to the street, fortunately without serious result. One overladen car, having difficulty in starting, afforded a barefoot urchin observing the event the opportunity to shout to the sweating driver, 'Awa' an' gie the cuddy a drink!' It was after midnight on both Saturday and Sunday before the last car ran. The management reported nobody left behind. Balloch had never seen a day like it, with all facilities doing roaring business. The potential for the bona-fide traveller was immediately exploited, and at Balloch others beside the cuddy got a drink. (To obtain alcoholic refreshment on a Sunday then, one had to be a bona-fide traveller.) The tramways, like the Clyde steamers, were made for the benefit of such trade. The Balloch Hotel charged sixpence (!) for bottled beer, much to the disgust of the tippler. This was hard to forgive, especially when the drouthy found it a costly business, one remarking, 'Drinking in the beauty of the scene did not seem to make them one bit less thirsty.'

The Glasgow papers all printed special articles on the opening of the line, the *Citizen* waxing eloquent:

> When Tobias Smollett – to whom a striking monument stands by the roadside in the 'Rantin' (Renton) – wrote his lines to Leven's 'limpid waters' the invasion of the sacred spot by the electric tramcar had not entered his philosophy.... And the scenes for which the cars are responsible are not without character of their own, in which the true poet could find a fitting theme for his lay. This was evident in a striking fashion in the gloaming, when the cars hummed their way down long, leafy avenues away up among the massed shadows of tall trees lining the roadway and the little spark given off by the trolley-wheel danced about like the flitting of a firefly. The very idea of transferring the crowds of city-dwellers from the baked pavements to the cool greenery of the country – maintaining all the time the close personal touch with the various points in the itinerary that the railway cannot give – is the realisation of a theory which only a few years ago would have been regarded as a mere poetic fancy.... For those who want a day of delight through God's good country, the car ride to Loch Lomond will afford endless pleasure. That was the unanimous verdict among those who took part in Sunday's procession from Brigton to Balloch by tramcar.

Two weeks later, with the popularity of the trams continuing each weekend, at the start of the annual Glasgow Fair Holidays, the manager put on a seven-and-a-half-minute service, with every available car out on the streets and every available employee driving. They were needed, and police were called in to marshal the crowds of intending passengers....

The crush brought with it an unfortunate side effect – pickpockets. In August three pickpockets were sentenced to three months with hard labour for working their trade upon the unsuspecting crowds on the trams. They aroused suspicion by joining in the crowds trying to get on a car but seldom boarding; getting off at Alexandria and getting on the next car following; going up the stairs and blocking the passage so that in the crush the accomplice could *work* the melee. A Glasgow traveller lost ten pounds from his hip pocket, a wine merchant twelve pounds in gold and a number of fourpenny pieces, another man sixteen shillings and a woman four shillings. (The larger amounts may well have been holiday savings – in those days thirty shillings a week was a good wage, tram drivers earning fivepence an hour.)

[1] To Balloch.

Tramological Topics

By John McShane

John McShane recalls many aspects of Glasgow trams that fascinated him as a boy. These memories are taken from 'The Last Tram', which appeared in the magazine *Scottish Field* in 1962.

It is surprising the types who indulge in the secret practice of tramolatry. I have a friend who is mature, responsible, hard-headed, a considerate husband, a kind father. I was rummaging in one of his cupboards to see if he had as many of my books as I had of his, when I came across a car-stop sign. He was hoarding it against the day when he would own a house which would have a garden where he could erect a pole on which he could fix the sign. Once unmasked, he almost cried as he recalled missing a spiral staircase, and how frustrated he felt without a judy-door from one of the trams he courted on. I am not sure whether a 'judy' was one of the sliding doors upstairs we used to jam against personable females by pressing a foot on the adjoining panel, or the downstairs door with a porthole.

He never got round to telling me, rattling off instead on tramological topics like the distinction between a sign saying 'all cars would stop' and one saying 'cars would stop if required', or the ineffable noise made on cobbles by a safety guard, or the thrill of grabbing twigs at the Thorn from the top of a Kilbarchan tram. He is a blood brother of the man said to have been seen in the Nullarbor Plain with a destination roll on the roof of his car proclaiming to all whom it might concern beneath the Southern Cross that he was making for Bishopriggs via Monkland Street.[1]

The tram trip I remember best – always excepting the toast-rack trail to Ettrick Bay (next stop, Tirnanog) with chocolate eggs from a henny-penny-in-the-slot and a lonely sea at journey's end – was the run to Rouken Glen. There was no boating pond in the park then, but one stop beyond was a tea garden with a wonderful lighthouse in a wonderful lake. It was really an overgrown puddle, I suppose, but framed in the arches of the years it makes a picture of ecstatic bliss.

On one occasion delight was piled on delight when I was allowed to stand under the stairs and look over the side as we rocked down from Eastwood Toll past the trees to Rouken Glen, because my father, who seemed to know people everywhere we went, was a friend of the conductor....

These coronation cars are at the Glenfield terminus of route No. 28 from Renfrew Ferry, and are standing at a spot where young boys could gather tar from bubbles among the cobbles on hot days.

I remember when all the trams turned green and were numbered – as the Jeremiahs said, with their days. In time, however, routes went deep. I could boast that the number of our close was 678, and the way to us was by trams 6, 7, and 8. The 7 and 8 went to Hogganfield Loch, past the previous terminus at Riddrie with convicts clearly discernible in the purlieus of Barlinnie....

On hot days we gathered tar from bubbles among the cobbles, savouring the taste of fear between the rails. Or we hung around stops, begging tickets from disobedient passengers who had failed to deposit them in the boxes provided. The motive for collecting tickets was a persistent but unconfirmed rumour that if we amassed enough (the exact number was never specified) with a 7 anywhere in the serial number, a vague ex-serviceman, somewhere, somehow, got a nebulous artificial limb. In those days tickets were tickets, long and strong, and full of reading matter in the form of fare-stages. A schoolmate of mine acquired considerable panache from having his address among them; he used to save tickets for visiting cards. Tickets served as nail-files, toothpicks, whistles, hatband decorations, dolls or crackers for fractious children, window wipers and darts....

In wind or rain it was advisable to take the seat opposite the stairs where you had fair shelter and a view of comings and goings. The price you paid was the risk of a finger in the eye or a snap brim in the teeth when the car lurched. Very rarely did a glamorous piece, by whom it would have been a pleasure to be buffeted, prove to be other than well-balanced and agile....

I remember how reliable trams were. Money chests, heaved aboard at suburban offices, were invariably put off intact at Bath Street.[2] So rarely did a tram take the wrong turning that the immediate

reaction was panic. This was quickly followed by exasperation when it turned out that the tram behind was merely being allowed to become the tram ahead.

[1] There was a Liverpool enthusiast who had a miniature indicator blind on his car dashboard and as he drove round the city the blind would show the appropriate destination – another blood brother, perhaps, of the man on the Nullabor Plain. There was also a Liverpool enthusiast who drove to work every day playing a tape of tram noises on his car stereo so that he could pretend that he was driving a tramcar.
[2] Glasgow Tramways' head office.

Jobs for the Boys

By Dennis Gill, with extracts by Barry Edwards, Arthur Kirby, Edward Gray, Albert Tull, Charles Rycroft, Steve Palmer and John Appleby

Before 1902 you could leave school at the age of ten, and it was fairly common to find boys working on the trams in one capacity or another. Even from 1902, the year the leaving age was raised to fourteen, boys were still obtaining work on the trams, right through to the 1930s and, in a few isolated cases, the 1950s.

Jobs for boys on the trams, whatever the year, were not easy to come by. There was plenty of competition, and the first labour exchange did not open until 1912 (in Plymouth). One of the most sought-after posts in horse tram days was that of trace boy (or tracer), which entailed looking after the additional horse that was hitched to trams to assist them up hills that were too steep for one or two horses alone. The trace boy had to hitch the horse to the tram while it was still moving, and then ride on it to the top of the hill and back down again, ready to assist the next tram. The famous novelist Arnold Bennett described the trace boy, perched on the back of the third horse, as a 'tiny, whip-cracking boy' and added that he 'lived like a shuttle and even in wet weather was the envy of all other boys'. The extra horses were known as trace, cock, link, tip, chain or pull-up horses, and most knew what was required of them without much goading. Hitching the horse to the tram as it was moving, however, was no mean task for a young lad, as can be gleaned from Barry Edwards' well-illustrated and well-researched book *The Story Of Transport In Derby* (published by the Breedon Books Publishing Company of Derby in 1993).

A trace boy urges his steed forward while assisting a Nottingham horse tram up the steep incline on Derby Road toward Canning Circus.

As we approach the end of Cornmarket ... we notice another horse approaching the car, called variously a 'cock' or 'trace' horse. These trace horses were in the care of a 'link' boy and were on hand at the bottom of a steep or steady hill like St Peter's Street to help the single horse pull its load. We have a vivid description of how this worked, from an eyewitness account of a former Mayor of Derby, W.H. Salisbury,[1] who started his working life as a 'link boy'.

'I had to wait at the bottom of St Peter's Street for a horse tram. I had my horse and a line with a hook at the end. As the tram approached I had to attach the hook to the tram, jump on the horse and ride it up St Peter's Street. At the top near The Spot, I had to unhook. You had to be smart on this job, because the drivers didn't stop. The horse would turn and go back to the Cornmarket without any direction from me. On one occasion the road was greasy and I slipped on the turn. Away went the horse and I was left on the ground.'

Sometimes a cheeky link boy would fix the hook and then swing on to the front platform and ride up St Peter's Street alongside the driver, handling the reins from the platform.

I have an unidentifiable magazine cutting recalling a similar method of working for the horse trams which were running until 1907 on Pentonville Road, between King's Cross and Islington in London. Here, the trace horses had long chains attached to their collars with hooks on the end, which the trace boys had to drop into an eye or hook on the nearside undercarriage of the horse tram as it was gathering speed to climb the incline. It required considerable skill on the boy's part to do this with one hand while with his other he spurred the trace horse to keep alongside the tram. To warn the trace boy of their approach, as they climbed up the hill from King's

Cross to Islington, the horse tram drivers blew whistles, which also served as a warning to other traffic to clear the tracks. On hearing the whistle the trace boy would have his horse trotting at the ready beside the track, in the same way that a relay runner trots alongside the race track ready to receive the baton in an athletics stadium. Once the hooking had been successfully completed the trace boy would jump onto the front platform and ride beside the driver up the hill.

The author of the article recalls that having discovered that trace boys were paid fourteen shillings a week he decided it was the job for him. He went to the tram stable, behind the Angel at Islington, and eventually persuaded the horse keeper there to give him a job. On his first day he had the help of another boy, who demonstrated the procedure, but on the second morning he was on his own.

> It was hopeless – I just could not time properly the hooking of my horse to the oncoming tram, and the result was absolute chaos; the tram stopped, my horse went galloping off with me holding the chain and running after it, tram and van drivers swearing, and one of them hit me with his whip. What a day! Talk about a traffic hold up.
>
> When I took my horse back to the stables that evening another boy, a bit older than myself, was just going on late turn and he said to me, 'Never mind Cock, come and have a go with me. There ain't much traffic about this time of day and I'll show you.' Well, of course, I did and that kind boy showed me the tricks of the trade and I made a go of it. I got very conceited and showed off quite a bit: the horse trotting smartly, hook slipped in neatly, jump on to the platform, chat to the driver on the way up, and ride the horse side-saddle back down the hill ready to repeat the performance. But I went too far and cheeked the horse-keeper, and that was the end of my fourteen shillings a week.

The process of hitching horses to a moving tram was a source of great delight and amusement to mischievous young boys idling their time away in some towns, and they were known to upset the trace boys by giving the signal to pull before the horse was connected, causing it to charge to the top of the incline on its own, leaving the tram marooned and the trace boy furious. The Sheffield Tramways Company employed four trace boys, but only one of them full-time. He was paid twelve shillings for a seven-day week. The trace boys in Sheffield were known as 'tip lads', but being a tip lad in Sheffield was no piece of cake, for the tramway company employed a number of horses that had formerly seen service in the Army. Unfortunately the tramway to Hillsborough passed the Hillsborough Barracks and when two tip horses waiting to be harnessed heard the bugle being played one day they responded magnificently to the call and dashed smartly to the barracks. They were found later by their tip boy standing in line on the parade ground.

Boys also worked on the horse trams as stable boys and depot hands, but the most prized duty was that of conductor. Chester was one town that employed boy conductors, and they were required to be pretty agile on their feet, for not only did they have to collect fares and generally look after passengers, they also had to deliver parcels to houses along the route. As

A boy conductor working on the Saltney to General Station horse tram service at Chester. As well as collecting fares he had to deliver parcels en route – all for a shilling a day. The photograph was given to me by the driver's widow, Mrs Eagleton, a shopkeeper at Hoole.

the tram wouldn't wait while they delivered the parcels, they had to run fast to catch up with it. They worked for eight hours every day and were paid a shilling a day for their trouble. At Christmas time, passengers were reminded to reward the boy conductors for their hard labours by the following words which appeared in the cars:

In this glad season of joy
Please remember the driver and boy.

Some passengers didn't take too kindly to the employment of boys as conductors, complaining that they were not always dutiful. But boys being boys, it would have been quite surprising if one or two were not mischievous or cheeky. The most mischievous were known, at times, to leave intending passengers standing by the side of the road. In Glasgow some of the boys would waste time by amusing themselves on the back platform and allow their buddies to ride free, as many as eight being counted clinging to the back of a car on one occasion.

Boys of fourteen to seventeen who were employed as conductors on Bristol trams before the First World War were replaced by young ladies aged eighteen to twenty-five during the war. When the war was over the Bristol Tramways were in no hurry to replace the girls with men, and this incensed the ex-servicemen so much they attacked the trams, bringing them to a halt and smashing the windows, using destination boards and sand boxes from the trams as implements of destruction. Some thirty trams had to be withdrawn from service and, after receiving a deputation from thirteen discharged soldiers, watched by an angry crowd of 2,000, the tramways company eventually agreed to replace the girls with men.

In the early years of electric trams, boys were also employed as trolley boys, point boys and parcel boys, with girls also being taken on as trolley girls in Manchester and Salford in the First World War.

Trolley boys were taken on to assist the conductor (or guard, as he was called in Manchester) so that the conductor could give his whole-hearted attention to his main duty of collecting fares. For instance, trolley boys had to help passengers climb aboard and alight, and make sure nobody was left behind at stops. Before ringing the starting bell they had to ensure that alighting passengers were safely off the platform and that no intending passengers were clinging to the boarding handrail. They were expected to use the bell at all times, and not stamp their feet or jump on the warning gong. They were also required to stand with their hands on the trolley rope while cars were going round sharp curves or going over crossings, ready to put the trolley back on should it come off the wires. In addition they were called upon to assist with the setting of destination indicators, turning the trolley pole, changing points, and so on. They were expected to turn up for their duties looking smart and cheerful, with clean collars, shiny buttons and polished shoes. They also had to be well mannered and well behaved.

Nowhere were trolley boys and girls more numerous than in Manchester and Salford. By 1930, there were more than a thousand trolley boys working on Manchester's large double-deck bogie trams, but four years later they had all gone. The attitude of the trolley boys came in for some unkind criticism. The *Manchester Guardian* described the trolley boy as the 'lord of the platform and the bell', and said that he commanded passengers 'with the full enjoyment of one taking part in a fight instead of helping to conduct a public service'. But the boys had their advocates as well as their detractors, as Arthur Kirby explained in his book *Dan Boyle's Railway*, published by the Manchester Transport Museum Society in 1974.

Trolley boys in Salford had to be smart in appearance and well disciplined, like this 16-year-old, and occasionally had to go on parade for a military-style inspection.

Manchester was the biggest employer of trolley-boys; apart from the function indicated by their title they were expected to assist the guard generally in handling passengers and collecting fares. They were by no means universally approved of; in February 1906 a passenger wrote to the *Manchester Evening News*: 'Sir, I should like to ask, cannot something be done to improve the manners of these boys? If it is part of their duty to marshal passengers, should they not receive instructions how it could be done less offensively, both for their own sakes and that of consideration for the feelings of passengers. It is a very pathetic sight to see a poor little frost-bitten trolley-boy ordering a whole car full of people about, "Now then, there, move up there; how many more times do you want telling?" That is exactly how I heard it on Saturday last, just for all the world as if it were a batch of prisoners en route for Siberia. I suppose these boys are the future conductors, and if they are about to grow up without any check, car travelling will soon be unbearable.'

'Trolley-boy' said in reply, 'I should think some of the passengers who travel by these cars would do well to improve their own manners before they talk about others. Some of the passengers treat us more like dogs than boys, all because we are employees of the corporation.' In defence of the trolley-boys a passenger said that telling passengers to move up was well merited in nine cases out of ten because the passengers were so selfish.

In Salford, where in the region of a hundred trolley boys were still being employed in the early 1930s (despite attempts to make them redundant in the early 1920s), an association of former trolley boys was formed, and it was still going strong for many years after the Second World War. Edward Gray writes about the Salford trolley boys in his history *Salford's Tramways* (published in two parts by Foxline Publishing in 1997–9), and the following extract (from part one) describes how the boys were encouraged to be smart and courteous.

It was a common belief among travelling Salfordians that only the cheekiest and most impudent youths were ever offered this sort of employment. The management took a different view, and instructed the boys to be 'civil and obliging' at all times on pain of instant dismissal. To ensure that the trolley-boys earned a reputation for 'smartness in conduct and appearance', attendance at drill and physical exercise sessions in the depot yard was compulsory. On these occasions, the boys would be paraded and inspected military-style, and at one time the youth judged to be the smartest and cleanest in appearance was rewarded with the easiest turn of duty.

The required attendance of the trolley-boys at the drill and physical training sessions led to a complaint from the motormen and conductors, who protested that the boys should not be withdrawn from the cars at busy periods. The criticism met with no sympathy from the general manager, who responded that the staff of most other tramway undertakings had to manage without any assistance whatsoever.

Following union pressure, and also in an attempt to prevent fare evasion, Liverpool took on thirty trolley boys in 1920, but they were not as popular as in Manchester and Salford, and five years later no more were employed.

A number of towns employed boys to change points by hand. This was a very important job and boys had to be on their toes to perform the task and especially to be careful not to send a tram down the wrong tracks. In towns where hand-operated points were in use at important junctions, the task of switching the points was given to older, more responsible men. Portsmouth employed point boys until 1924, when the points were switched automatically by the tram driver's controls. The boys were paid twenty-five shillings a week, with no holidays apart from Christmas Day. They were issued with a uniform but, because of an initial error, this did not include trousers – only tunic, overcoat, cap and mackintosh. To change the points the boys had to brave other traffic, unlike London, where the points were changed from the pavement using a large hand-pulled lever. Albert Tull, a former Portsmouth point boy, writing in the summer and autumn 1984 editions of *Tramway Review*, described the equipment they used.

Two boys at work on the Great North Road in Newcastle. The one on the left is a point boy, who is setting the points at Jesmond Road to allow the horse tram to continue straight ahead to Gosforth. The other, a trace boy, is leading his horse as it assists the tram up the slope.

The point-boy's tool was a long round iron bar forged with a chisel end for insertion into the rails at the point, the other end being formed into a ring for hand gripping. After shutdown, the point bars were commonly left behind the nearest telephone kiosk until next morning. The two rails at the point were linked by a screwed rod under an inspection plate, and it was essential to check periodically that both points moved equally in case of play developing on the rod. In dry weather the points were kept watered for freedom of operation. The number of points operated per boy varied from one to four.

Three sections of single track were under the control of the point boys, and the boys used hand signals during the day and hurricane lamps after dark to prevent trams colliding. Albert also applied for and obtained two flags, one red, the other white, to reinforce his daylight hand signals. He recalls what happened one night when his hurricane lamp failed.

The hurricane lamp functioned from its inception until 1922 approximately, but it failed one night when a somewhat inebriated member of the staff ordered me to light the lamp. I protested that it was not yet dark. 'Boy Scouts' motto "Be prepared!"' he replied sternly. 'Give me the lamp!' With some trepidation I obeyed. 'Watch!' he commanded. He held the lamp high and then let it go. It fell to the ground in a shower of glass. 'Pick it up!' he snapped. Again I obeyed. He then unscrewed the wick and poured the paraffin all over the pavement. 'I'm off to the pier, boy, to see the show!' Slapping my back he departed, leaving me disconsolate with the wreckage.

This I sent back to the depot stating there had been an accident. Back came the reply: 'If you are so careless you can't be relied upon to take care of property entrusted to you, you deserve to go without a lamp, and go without a lamp you will!'

That night, smarting under the undeserved rebuke, I wrote a note to the superintendent requesting an electric signal without stressing the unfortunate incident. This was sent off next day. It was written on a gilt-edged correspondence card (twenty-five for sixpence at Woolworth's). The lavish opulence of the gilt edging was, however, sadly marred by a large oily thumbprint – the result of handling the wrecked lamp. Nevertheless, there resulted an impressive electric signal operated from the 550 volt overhead wires, and this functioned until the demise of the trams....

The trams served as transport for the *Evening News*, the driver's platform being loaded with batches of the latest edition. On arrival at North End and other selling points, the point-boy's job was to board the tram and convey these parcels to the shops, and even to assist in selling them by the roadside.

Another task for the point-boy at Fratton Bridge was to deal with the horse-drawn coal carts passing over the bridge. He had to lock the nearside rear wheel by a chain, thus braking the vehicle as it descended the bridge, and then run down and uncouple the chain at the bottom to save the driver dismounting. This service was given freely, but some of the drivers would offer a penny or tuppence for this service.

Albert Tull was not alone in having a prank played on him while serving as a point boy. According to Stephen Lockwood in his book *Trams Across the Wear*, a point boy at the gas office corner in Sunderland was kidnapped by Sunderland Technical College students as a rag week stunt in 1951. Unfortunately this prank caused a major delay on the tramway as the points were left unattended. The rag committee was obliged to send a letter of apology to the transport department explaining that the prank was 'unofficial' and apologising for the rumpus it had caused.

Liverpool employed point boys at some seventy junctions in the city centre until the early 1920s, by which time most of the points at junctions were electrically operated. They were not provided with shelter and were forced to carry out their duties whatever the weather, earning themselves a great deal of sympathy from the public, but none from the management, although by 1900 they were provided with caps and capes and from 1904 free passes on the trams. For a period, Liverpool also employed boys to flag cars through some tricky sections of single-track working.

In contrast, Birkenhead Corporation employed only three point boys, mainly to switch the points at the Woodside Ferry terminal, where there was a six-track layout, often referred to by tramway staff as the 'Grid'. Charles Rycroft recalled his days as a point boy in the summer 1986 edition of *Birkenhead Tram Matters*.

Although twenty-two trams could be housed on the six tracks, the variance in running schedules meant that the point-boy was obliged to use his initiative to ensure that certain services had preferential treatment and got the 'right of way' when leaving the grid. We were expected to memorise the departure times of each route, Monday to Friday, as well as Saturday's busy timetables. Few of the points ever gave us trouble as they were serviced regularly by a mechanic. The only point that went out of tune on odd occasions

was the automatic one, the first to be encountered by tramcars reaching the Grid.

On Saturdays, one of the point boys was sent to switch the points in Borough Road, which was used by cars taking football supporters to the home games of Tranmere Rovers at Prenton Park. Mr Rycroft explains that:

> There was a perk attached to this duty. The last of the football specials to the ground carried two non-paying passengers, namely the inspector and the point-boy concerned. On arrival all crews (including the inspector and the point-boy) retired gracefully into the ground with a free ticket. Happy days!

After the Second World War point men or point boys were still being used in a number of towns, including Blackpool. In 1959, Steve Palmer, then a seventeen-year-old student, applied for a job as a point boy, and describes how he fared in the hardback edition of his book *Blackpool and Fleetwood by Tram* (published by Platform Five in 1998.)

> I was seventeen when I first joined the Transport Department – too young to be a guard – and so I became a point-boy. When school was finished for the summer, I reported to the traffic superintendent, who sent me across to the tailor's shop to get my uniform. In those days the tailor issued uniforms from a crowded upstairs room, reached by walking through the old Blundell Street depot.... The tailor had not got much time for students, and gave them cast-off garments which more-or-less fitted. Because I was working outdoors, I was issued with tunic and trousers, a mackintosh and a peaked hat. The uniform colour was navy blue, piped with green, and the silver buttons bore the corporation crest and the legend 'Blackpool Corporation Tramways'. Proudly clutching my bundle, I made my way to the tram stop at Manchester Square, and got a free ride home; I was now one of the staff!
>
> At that time there were eight point-boys; two regulars who manned the Royal Oak points in Lytham Road, and the rest of us, students, who were sent to the points at Central Station (Tower), Pleasure Beach, Talbot Square or Bispham. Our job was to ensure the smooth flow of cars by switching the points and pulling the overhead frogs for cars reversing there.[2] During the season, the points were fixed for the loop-lines used by the through-cars, while we switched the points for short-workings. There was a certain art in swinging the points to make sure that the blades went right over, and at that time the lever was inserted in a slot at the side of the track. This was moved to in-between the rails after an occasion when somebody pulled the points back when a car was half across, with disastrous results! In 1959, the number of cars in service was such that there was a car every few minutes along the Central Promenade....
>
> As a point-boy, it was important to strike up a good friendship with your inspector, who would often send you on messages to the depot, or into town to get his dinner. On one such occasion, when coming back from the depot canteen with a full brew-can, I ran for a railcoach at Manchester Square, slipped off the step and was showered with hot tea as I hit the Promenade. Sympathetic holidaymakers picked me up, but my inspector was not pleased when I returned to Pleasure Beach with cuts and bruises, but without the brew. I quite liked working at Pleasure Beach loop, where you could pull the points and then ride round the circle and chat to the crew. At lunch-time rows of cars in all shapes and sizes would stack on the loop, while the crews had the half-hour break in an eight-hour shift. One day I was sent down to Royal Oak to relieve the regular point-boy, while he went to the training school for guards. He showed me the times of the Marton cars scratched conveniently on the pole, and warned me to pull the frog hard to avoid dewirement as cars turned into Waterloo Road....

Parcel boys were employed on many of the tramway systems operating parcel collection and delivery services. The parcels were carried on the tramcar driving platforms, but as the services developed they were carried on special parcel trams (as in Manchester) or on small baggage cars towed behind (as on the Black Country tramways). As well as parcels, trams in some towns carried other goods on the driving platforms. Bradford, for instance (where an extensive parcel service was operated from 1905 until 1949), also accepted prams, pushchairs, bicycles, rolls of linoleum and newspapers. The parcel boys in Perth also delivered the council minutes to the fire station, power station and abattoir. Cheltenham started an express parcel service on its tramway in 1911, and took on two or three parcel boys to introduce the service. John Appleby, in his book *Cheltenham's Trams and Buses Remembered* (which he published himself in 1964) describes how the parcel boys delivered the parcels with the additional help of bicycles and push-trucks.

> On the Cleeve Hill route a boy would catch the first morning tram up to the Rising Sun Hotel with his truck on the motorman's platform and stayed there meeting each car. Newspapers were also delivered

into the district in this way, and the boy remained at Cleeve Hill until recalled by the office. The boy's duties were from 8 a.m. to 8 p.m., with one hour for dinner and twenty minutes for tea; wages were five shillings a week.

Ex-parcel boy Fred (Nobby) Ballinger recalls putting 5 cwt of coal on his hand truck on the front of a Cleeve Hill car. Alighting at the Rising Sun with his extraordinary load, he pushed it to the home of Colonel Hatch at Nutters Wood and was rewarded with a twopenny tip and an apple. Another ex-parcel boy, Bill Tombs, with two other lads had to deliver three sizeable trunks to Colonel Hatch one evening. They had to be collected from Lansdown Station, put on the tram and then pushed, on the largest truck they had, to Nutters Wood. By the time they left his house it was getting dark. As they were pushing the empty truck through the fields towards Southam they saw the lights of the last car coming down the hill. Intent upon catching it, they left the truck and ran for all they were worth, just in time to leap on board before it swung southwards towards Cheltenham. Colonel Hatch paid a special rate and even the boys were generously rewarded with a ten-shilling note between them.

In Huddersfield, from as early as 1892, boys were employed as bell boys, or 'ringers', to assist conductors on Saturday evenings. They were paid one shilling for an evening's work. In 1915, this amount was increased, and the reasons for this were reported in the *Tramway and Railway World*.

The Council has adopted a recommendation that bellboys on the cars be paid one shilling and sixpence for five hours' work. Alderman Aston, chairman of the Tramways Committee, stated that the boys, who were employed on Saturday evenings, formerly received one shilling. The results were not very satisfactory, and the ringers were dispensed with. On the representations of the men, owing to the crowded state of the cars, and the reduced lighting increasing their work, the Committee decided to again engage ringers, but with the object of obtaining a better class of boy the pay has been increased to one shilling and sixpence. Each boy would be provided with a cap, to which a number would be attached. The boys would be attached to particular cars, and be under the control of the conductors, instead of being allowed to jump on and off cars at will.

In the 1930s the rate of pay for the bell boys had become two shillings and sixpence. By then, the boys worked mainly on the longer routes, such as the No. 3 from Outlane to Waterloo, the No. 4 from Marsden to Bradley, and the No. 10 from Sheepridge to Honley.

Boy scouts assisted conductresses on the Birmingham trams during the First World War. They boarded full trams at the Edmund Street terminus and rang the bell and shouted out the names of stops until the conductress had collected all the fares. Then they jumped off the tram and returned to Edmund Street to board another full car.

[1] William Blakemore, former general manager of Salford City Transport, started his career at the age of ten as a Salford Tramways parcel boy. Another manager who started his career in tramways as a boy was George Grundy, former manager of the Stalybridge, Hyde, Mossley and Dukinfield transport undertaking. His account of his early days on the trams appears elsewhere in this book (see 'Arduous Work for a Boy of Thirteen' page 41). The most famous manager to start his tramway career as a boy was Sir James Clifton Robinson, who achieved fame as the managing director and engineer of the London United Tramways. Born in 1848 at Birkenhead, he became an office boy at the age of twelve to George Francis Train, the American who in 1860 constructed Britain's first street tramway at Birkenhead.

[2] A frog is a fitting in the overhead wiring which switches the tram's trolley pole onto the correct wire at junctions.

First Day at Work

By D.H. Lawrence

The Rainbow **is one of D.H. Lawrence's most famous and best-loved novels. Published by Methuen in 1915, it is about the Brangwens who live in the Erewash valley on the Derbyshire and Nottinghamshire border. Their home is at Cossethay (a corruption of Cotmanhay) on the edges of Ilkeston, from where Ursula Brangwen sets off one Monday morning in September to start her career as a school teacher in Ilkeston. She travels on a crimson and cream open-top car of the Ilkeston Corporation Tramways, which started conveying passengers between Cotmanhay, Hallam Fields and Ilkeston Junction Station in 1903. This extract is reproduced with the permission of the estate of Frieda Lawrence Ravagli and Pollinger Limited.**

She heard the tramcar grinding round a bend, rumbling dully, she saw it draw into sight, and hum nearer. It sidled round the loop at the terminus, and came to a standstill, looming above her. Some shadowy grey people stepped from the far end; the

conductor was walking in the puddles, swinging round the pole.

She mounted into the wet, comfortless tram, whose floor was dark with wet, whose windows were all steamed, and she sat in suspense. It had begun; her new existence.

One other passenger mounted – a sort of charwoman with a drab, wet coat. Ursula could not bear the waiting of the tram. The bell clanged, there was a lurch forward. The car moved cautiously down the wet street. She was being carried forward, into her new existence. Her heart burned with pain and suspense, as if something were cutting her living tissue.

Often, oh often the tram seemed to stop and wet cloaked people mounted and sat mute and grey in stiff rows opposite her, their umbrellas between their knees. The windows of the tram grew more steamy, opaque. She was shut in with these unliving, spectral people. Even yet it did not occur to her that she was one of them. The conductor came down issuing tickets. Each little ring of his clipper sent a pang of dread through her. But her ticket surely was different from the rest.

They were all going to work; she also was going to work. Her ticket was the same. She sat trying to fit in with them. But fear was at her bowels, she felt an unknown, terrible grip upon her.

At Bath Street she must dismount and change trams. She looked uphill. It seemed to lead to freedom. She remembered the many Saturday afternoons she had walked up to the shops. How free and careless she had been!

Ah, her tram was sliding gingerly downhill. She dreaded every yard of her conveyance. The car halted, she mounted hastily.

She kept turning her head as the car ran on, because she was uncertain of the street. At last, her heart a flame of suspense, trembling, she rose. The conductor rang the bell brusquely.

She was walking down a small, mean, wet street, empty of people. The school squatted low within its railed, asphalt yard that shone black with rain. The building was grimy, and horrible, dry plants were shadowily looking through the windows.

She entered the arched doorway of the porch. The whole place seemed to have a threatening expression, imitating the church's architecture, for the purpose of domineering, like a gesture of vulgar authority. She saw one pair of feet had paddled across the flagstone floor of the porch. The place was silent, deserted, like an empty prison waiting the return of tramping feet.

Ursula went forward to the teachers' room that burrowed in a gloomy hole. She knocked timidly.

'Come in!' called a surprised man's voice …

Try the Horse Tram, Look You

By Mark Pearson

Writing in the October 1993 issue of *The Journal* (the magazine of the Tramway Museum Society), Mark Pearson, tramway cartoonist and author of *Hold Tight, Please* and *Leicester's Trams in Retrospect*, recalls his first trip on the Pwllheli and Llanbedrog horse tramway, a delightful little North Wales line which withstood the march of progress in the twentieth century until 1926.

Passengers who have just alighted from the Pwllheli and Llanbedrog horse tram head off in the direction of the Art Gallery at Llanbedrog.

A tramcar experience which I count as the most remarkable during my lifetime occurred in 1922 when I was but seven years old. My father owned a large Siddeley-Deasy car (predecessor to the Armstrong-Siddeley) in which the family were heading for Abersoch, a village on the tip of the Lleyn peninsular in North Wales, where we were to spend a fortnight's holiday.

On entering Pwllheli, the clutch failed and we had to leave the car at a garage near the railway station, with the help of the AA. Enquiries by my father as to hiring a car or taxi to get us to Abersoch proved fruitless. The three taxis were all busy with a wedding.

'Get you on the tram to Llanbedrog,' suggested a local bobby. 'Dai Roberts lives by the terminus there and he will take you on to Abersoch in his motor if he is free. Or you could try Evans the coal. He has a pony trap.'

Now a thriving resort, Abersoch was then a collection of fishermen's cottages, a few bungalows and a pub called the Vaynol where we were to spend our holiday. Beyond Llanbedrog the road was narrow with a suggestion of grass in the middle. There was no bus service.

The AA man and a lad from the garage helped us carry our bags to the tram terminus, father obtained tickets for us all from a building which served as a waiting room and ticket office, and we all climbed aboard an open, single-deck, one-horse tramcar which was taking on passengers. The car was about 16 ft long with steps at all four corners and had seats, I think, for about twenty passengers. When everyone was settled, the driver gave a cluck-clucking noise and we were off. The track was pretty grotty and the tram pitched and rolled like a rowing boat in a choppy sea. To my parents, the whole thing was a bit of a nuisance and a bore. To me, the experience was one of sheer delight!

The tram rocked and rumbled its way towards the coast where the route ran behind sand dunes for several miles with the motor road just the other side of the hedge. Eventually we turned sharply to the right and finished up at the terminus where there was a shop, tea-room and a sort of library-cum-picture gallery.

While the rest of us had tea and muffins, father went in search of Dai Roberts and was lucky to find him sawing logs behind the shop. He was a hefty chap with a flat cap on his head and a cigarette butt behind his ear – an amiable man with a broad grin who, on learning of our predicament, broke into a raucous guffaw. Tea finished, we all piled into his Clino and he took us the three miles to the Vaynol.

On the way, I spotted an old Avro biplane in a field where some worthy ex-RAF type was taking folk on aerial trips at five shillings a time, and on arrival at the hotel I was amazed to find that they had a pet ostrich in the garden which I later discovered had an insatiable appetite for pebbles!

After about a week, the garage phoned to say the car was ready and the hotel manager kindly took us to Llanbedrog terminus in his Humber. This time we got on a remarkable little saloon tram which was only big enough for twelve passengers. On this occasion we didn't go straight back to the town terminus but went along the promenade. We got out at the far end and spent an hour on the sands. Lined up, along the roadside and round the entrance to the depot, was the most amazing collection of trams imaginable. Some were open, some toastracks and several types of small enclosed saloons, no two

This horse tramway, like the one at Pwllheli, ran by the sea between Sandgate and Hythe on the south coast and lasted nearly as long, closing five years earlier in 1921.

exactly alike. I often wonder who built them. They were all one-offs.

Time was not very important in those days. On one occasion we stopped at a passing loop to let another car go by. The other car stopped and for about five minutes a jolly chat, all in Welsh of course, took place between the two drivers while one of them treated his horse to a carrot. We had no idea what they were going on about until a passenger behind us, who was bilingual, shouted, 'They'll beat Criccieth too, I shouldn't wonder!'

Many years later we all went back to Abersoch and Pwllheli but alas the little horse trams were no more. I found faint traces of where the track had been on the promenade and decided that the gauge had been 3 ft 6 in.

Memories of the Famous – In Brief

By Dennis Gill, with extracts by Joan Moules, Dame Thora Hird, Geoff Mellor, Jean Alexander, George Melly, Russell Harty and Harold Macmillan

From being nearly squashed to death by trams to having fun running beside them. From scooping up horse tram manure to gathering tram patter for stage acts. These are some of the wide-ranging memories of trams recalled by personalities in various walks of life, including stars of stage and screen.

Many autobiographies of famous people contain fond memories of tramcars. Some personalities, for instance, remember riding regularly on tramcars in their childhood and the pranks they played when the conductor wasn't looking: putting halfpennies on the tram tracks so that they would be flattened by a passing tram and turned into make-believe pennies or collecting tickets and folding them this way and that and then connecting them together to make concertinas – a skill George Melly, the Liverpool-born jazz musician, appears to have perfected.

One of the favourite games of another famous Lancashire entertainer, Dame Gracie Fields, was to grab hold of the back of a tram in Rochdale, where she was born, and run with it as fast as her legs would carry her until the gathering momentum of the tram forced her to let go. It was a game that lots of children played, some going further and jumping on the rear fender to grab themselves free rides. However, this sometimes tragically resulted in them falling under the wheels of a tram and either losing a limb or, worse, their life. We have to be thankful that no harm came to Gracie as she raced after the Rochdale trams. Apparently, her love of trams never left her, for one of her pleasures was to go tram riding between shows. She recalls this in *Our Gracie* by Joan Moules (published by Robert Hale Ltd in 1983).

'They were wonderful days,' said Gracie. 'We would rehearse in the mornings, then back to the digs for lunch, which we had already bought and taken into the landlady to cook. Then the afternoon was free. Most of the girls went to the pictures, but I nearly always used to go on the tram as far as it would take

Barnsley tram No. 1 packed with cheering children follows in the wake of General Booth, the founder of the Salvation Army (seated at the back of the motorcar, left) on his visit to Barnsley on 1 August 1905.

me. Usually the trams ran into the country and I loved it. I'd breathe in all the lovely fresh air, then back on the tram and get ready for the show in the evening.'

Dame Thora Hird, one of Britain's best-loved actresses, and like Gracie a Lancastrian, had memories of the horse trams in Morecambe, where she was born in 1911. In her autobiography *Scene and Hird* (published by W.H. Allen in 1976) she recalls that the Morecambe horse trams, which ran until 1926, left a useful by-product. (This extract reproduced by kind permission of her daughter, Jannette Scott.)

> We had tram lines in Cheapside, not those for electric trams but for horse trams. They started from the front of the Royalty Theatre in Market Street and trundled down Cheapside on the first part of their journey–to Lancaster, four miles away.
>
> The two horses were changed at the Tram Stables – always an exciting incident in the journey – and changed again at Cross Hill on the return trip. I loved the trams and can remember how sorry I was when progress demanded they must finish.
>
> I was sorry about something else, too. Now we had an orange box full of soil in our back yard and faithfully every year a green plant bloomed in profusion. The something else I was sorry about was that not only had the trams and horses gone, but so had most of the horse manure. Year by year, our plant had been fed on as much horse manure as would cover a two-acre field, but it never did as well after the trams finished.

Another entertainer who had attachments to Morecambe was Albert Modley, the comedian. He set up home in the seaside resort, and was renowned for using trams in his stage act. Geoff Mellor in his book *They Made Us Laugh* (published by George Kelsall of Littleborough) writes:

> Francis Laidler, the great Yorkshire impresario, heard of Albert Modley and his talent, and found a part for him in his 1930 pantomime production of *Babes in the Wood* at the old Prince's Theatre in Bradford. Our Albert got nine pounds a week for his efforts and thought this riches indeed.
>
> In this pantomime the famous 'tram act' was born, and forty years later it was still getting laughs. The very sight of Our Albert on stage with his drums was enough to raise the shout: 'Give us your tram act!'
>
> For this, the little comedian let down a front cloth to the drums, painted like a tram front, complete with light and number. The cymbals and other impedimenta constituted the controllers and brake, and with many a crash, thump and ting-a-ling the 'tram' was soon well away.
>
> Albert interpolated the proceedings with pungent patter, such as: 'Where are we going? Where the lines go, of course! And just to be sure we get there, we're following a bus marked Duplicate!'
>
> This grand little comedian wrote all his own material, and seldom used a script, for, as he explained: 'He was never sure what he would say next!'

It was on the top deck of a tram that one of Albert Modley's contemporaries, Billy Russell, the stand-up comic, got an idea for a new act. He was riding on a Birmingham tram to the Aston Hippodrome in 1919 when he looked down and saw a gang of navvies re-laying a stretch of track. One of them looked up at the tram and wiped his brow, reminding Billy of 'Old Bill in Civvies'. So at the first opportunity Billy made himself look forty years older with the help of make-up, a bulbous nose, a walrus moustache and a clay pipe. Describing himself as 'On behalf of the Working Classes', he tried the act out on a tour of Lancashire Halls, and was an immediate success.

Actress Jean Alexander, famous for her roles as Hilda Ogden in *Coronation Street* and Auntie Wainwright in *Last of the Summer Wine*, remembers trams on the other side of Morecambe Bay in her autobiography *The Other Side of the Street* (published by Lennard Publishing of Harpenden in 1989).

> That summer in Barrow was a golden time. I remember the sun, the lazy days on the beach with bucket and spade, ice-cream cornets, and chips smothered in salt and drenched in vinegar that we ate out of a newspaper. Walney Island was just across the water from Barrow, reached by a causeway with a toll bridge at the Barrow end, and it cost a penny to go over to the island by tram. To us children it was like venturing into the unknown Congo. Although we used the tram nearly every day at home in Liverpool this one over the toll bridge had a mysterious quality about it that thrilled us every time we clambered aboard.

Frank Whittle, the inventor of the aircraft jet engine, was unlikely to forget one encounter he had with trams. According to *Kontakt*, the magazine of the Scottish International Tramway Association, Whittle was speeding through Leicester on a powerful motorbike when he caught up with one of the city's tramcars. The magazine added:

> Whittle decided to overtake the tramcar on its off-

side, but as he did that he realised to his horror that he was now meeting a tram coming the other way head on. So he swerved round the tram on its nearside only to find that a bus was running alongside the tram. Frank Whittle ended up clinging to the radiator of the bus and with a severely damaged bike. If the position of the trams had been slightly different then Britain might have missed out on the lead in jet engine development it once enjoyed.

George Melly, the famous jazz musician and singer, wrote at length about his Liverpool childhood in his autobiography, including the following extract about trams, in which he reveals that it was from trams that another entertainer, Arthur Askey, obtained his famous catchphrase. (This extract taken from *Scouse Mouse* by George Melly (Copyright © George Melly), reprinted by permission of A.M. Heath and Co. Ltd.)

> Liverpool people never called a tram a tram. It was either a tram-car or, more commonly, the car. 'I went into town like on the car.' The tram conductors had a certain bravura. They seemed to enjoy pulling on the leather strap, strung down the centre of the lower deck, which went 'ting-ting' in the driver's cabin. They cracked their ticket punches with enthusiasm, and shouted 'I theng yow!' when offered the fare (or 'fur' as most of their customers pronounced it). The late Arthur Askey adopted that 'I theng yow' as his slogan, but few outside Liverpool knew where it came from.

The television personality Russell Harty wrote a weekly column in *The Sunday Times*, and in the issue for 31 May 1987, he explained how a bomb that fell on Blackburn in the Second World War caused acute distress to his family:

> This concerns Hitler's obsessive desire to wipe out my Auntie Alice. She is not a woman to be trifled with. She got on to a tramcar in Penny Street, sat on the long bench near the door, arranged her shopping and paid the conductor one single fare to Brownhill. Just before the tram clanked away, the bomb fell in the next street and blew her out of the door and into a ruffled and undignified heap in front of the Cinema Royal.
>
> When she had recovered her hat, her shopping and her composure, she got back onto the tram and resumed her position, grim-lipped. Her outrage was, apparently, terrible to behold, but was as nothing compared with the look she gave the conductor when he asked her to produce her ticket, or else pay again.

The famous poet Sir John Betjeman loved trams as much as he loved old churches, railway architecture, golf and Cornwall. He mentions trams in quite a few of his poems, one worthy of note being 'Parliament Hill Fields'. So when he was once asked by the BBC to take part in a television programme satirising the disappearance of trams from Birmingham's streets, he declined in no uncertain terms, pointing out that he liked trams and regarded their disappearance from our streets as a disaster.

Dennis Wheatley, the writer of crime fiction, travelled regularly on the London trams that ran from Brixton Hill to Victoria. He preferred to travel upstairs because nobody was allowed to stand on the top deck, so he did not have to endure strap-hangers leaning over him. But he was not enamoured with the fug caused by tobacco smoke, or the smell of cheap tobacco and rain-soaked clothes.

When the film actor Robert Shaw was a child he played in the lower deck of a redundant tram at his parents' Bolton home, while the singer Elton John some years ago bought a retired Melbourne tramcar for his garden. It was pictured, bearing the name 'The Australian', in a tabloid newspaper.

Jack Warner, famous for his TV role as Dixon of Dock Green, recalled riding his bicycle to school one day and skidding on tramlines in the path of a horse-drawn hay cart. Fortunately, a policeman who witnessed his fall dashed to his rescue and scooped him up in time.

Beniamino Gigli, the great Italian tenor, had by the age of twenty-eight won widespread acclaim, but had never appeared at La Scala. Every time he walked across the Piazza della Scala he would look at the opera house, which he called an 'impregnable fortress', and imagine his voice soaring above the orchestra. But as he did so, he had to shut his ears to the sound of Milan's trams which 'clanged and screeched' in front of the great building. His opportunity to sing at La Scala soon came, however, when he was invited by Toscanini to sing in a performance of *Mefistofele*. One can be certain that his rendition would have been so powerful it would have shut out even the loudest clank of the trams outside.

Before trams vanished off the streets of London in 1952, many Members of Parliament could be seen travelling on them to and from Westminster. The Members found the trams, which passed close to the Houses of Parliament, quite handy. The tram ride former Prime Minister Harold Macmillan probably remembered more than any other, however, was not at Westminster but in Middlesborough, when he was first elected as Member of Parliament for Stockton. After the declaration of the poll he walked out of the

Borough Hall into Stockton High Street, which was filled with people as far as the eye could see. He described the scene in the first volume of his autobiography *Winds of Change* (published by Macmillan and Co. in 1966).

> It seemed as if the whole population was out that night. I well remember the mass of upturned faces. For the first time in my life I heard the roar from thousands of throats, acclaiming victory.... It was impossible for us to get away through the surging crowd. The police wanted us to leave by the back of the hall through a street that ran parallel with the High Street. This I refused to do. Finally, as a compromise, I agreed to walk out of the front of the hall, where a gangway was kept by the police, and mounted with my wife to the top of a tram which had somehow been halted not far away. On this, after considerable delay, we rode triumphantly away.

Herbert Morrison, the famous Labour Minister of Transport and Peter Mandelson's grandfather, was educated in south London and in his childhood travelled on the LCC trams. I remember reading that once a week his mother gave him a penny for his tram fare to the nearest public baths, but he never took the tram. He walked to the baths and back instead, and spent his penny on a comic. It was not, perhaps, a good example for him to have set, for in later life he became Minister of Transport, and was responsible for merging all the tramways in London (along with buses and underground railways) into the London Passenger Transport Board.

One of Herbert Morrison's colleagues while in government was the great trade unionist, Ernest Bevin, who reached the high office of Foreign Secretary – a far cry from the days, early in his career, spent as a tram conductor on the Bristol tramways, earning twelve shillings a week.

Some famous people, while not working on trams themselves, had relatives who had done so, for example: the comedian Tommy Trinder, whose father was a London tram driver; the writer, scientist and former Minister, C.P. Snow, whose grandfather, W.H. Snow, was a foreman engineer on Lincoln's tramways and the first man to drive an electric tram in the city; George Robey, the 'Prime Minister of Mirth', whose father (a civil engineer) was connected with the laying of London's suburban horse tramways; and President Nixon, whose father was a trolleycar motorman on the Whittier line of the Pacific Electric network in California. In fact, in his speech resigning the Presidency, Nixon said, 'My old man was a motorman.'

Few notables, if any, turned out for the tramway opening ceremonies that took place in the early years of the twentieth century, apart from the openings of the London United and the London County Council tramway.

Lord Rothschild opened the London United Tramways on 10 July 1901, and among the distinguished guests was Arthur Balfour, Unionist Leader in the House of Commons (1895–1911) and Prime Minister (1902–5), who had the pleasure of riding on one of the inaugural cars from Shepherd's Bush to Southall and back to Chiswick, where a sumptuous lunch was laid on at the tram depot. The luncheon was enlivened by music, including Berger's *Electric March*, played by the Red Hungarian Band. Toasting the success of the London United, Balfour said that he looked to the tramways 'not merely to diminish the evils of metropolitan congestion but greatly to add to the highest pleasures of life of the metropolitan inhabitants'. He added that nothing Parliament could do could match the benefits to the public of such enterprises as the London United in improving the lot of people in crowded areas by providing cheap and speedy transport to the outskirts of London.

Members of the Royal family were out in force two years later when the Prince of Wales, later to become King George V, opened the LCC tramways on 15 May 1903. He was accompanied by the Princess of Wales and his sons Prince Edward and Prince Albert, who succeeded him on the throne in 1936. The Prince of Wales, after starting the car, joined his sons at the front of the open top deck, and they then all produced halfpennies to pay for their fares as they had no wish to begin by defrauding the council. They were issued with special tickets printed in blue and gold on white, and rode from Westminster Bridge to Tooting, where they inspected council houses on the Totterdown Fields Estate. The Chairman of the LCC Highways Committee, Mr J.W. Benn (grandfather of the famous Labour politician Tony Benn), told the royal party that the LCC hoped in the course of a few years to bless London with a system of electric traction which would command the admiration of the world, solve the great housing problem, and confer other benefits upon the people. As events subsequently proved, London fell far short of commanding admiration, London Transport consigning the LCC's tramway network to oblivion, and today the capital has little in the way of tramways (apart from Croydon Tramlink and the Docklands Light Railway) to match developments in other parts of the world.

As with the opening ceremonies, there were few notables at tramway closing ceremonies, apart from

Filmstar Jayne Mansfield waves from the Blackpool Belle illuminated tram in 1959 after having switched on the resort's illuminations.

the Labour politician Bessie Braddock, who attended the last rites at Liverpool in 1957, and the singer and actor Maurice Chevalier, who was at the closure of the Versailles tramway earlier in the same year.

One ceremony, however, that has always attracted famous people by the score is the switching-on of the lights in Blackpool. The long list of those who have performed the honours in past years includes George Formby, Dame Gracie Fields, Dame Shirley Bassey, Sir Stanley Matthews, Jayne Mansfield, David Tomlinson, Ken Dodd, Sir Matt Busby, Les Dawson, Michael Ball, Ronan Keating and Westlife. Some of these personalities would no doubt have ridden on one of the illuminated trams afterwards. George Formby, for example, rode on the gondola illuminated car and delighted the crowds by singing 'Twenty-one Today' and 'She's a Lassy from Lancashire'. Stars such as Joanna Lumley and Derek Batey were also in

Television star Joanna Lumley gives a friendly wave to onlookers as she takes a trip on preserved Hill of Howth tram No. 10 at Blackpool in 1985 during the town's centenary celebrations.

Pete Waterman, the record producer and railway entrepreneur, at the controls of Southampton open-topper No. 45 after opening the new visitor admission area at the National Tramway Museum in 1994. The tram was the first to be preserved by enthusiasts in 1949, when they purchased it for £10.

Memories of the Famous – In Brief | 87

Prince Charles and Princess Diana accompanied by Malcolm Rifkind, the then Scottish Secretary, take a ride on the balcony of preserved Glasgow tramcar No. 22 – one of the attractions (on loan from the National Tramway Museum) at the Glasgow Garden Festival in 1988.

attendance at the events held to celebrate the centenary of Blackpool's trams. Both rode on the trams and Derek Batey judged a tug-of-war between tram drivers and tram enthusiasts.

VIPs have been putting in appearances regularly at the National Tramway Museum at Crich in Derbyshire. As well as the museum's successive royal patrons, Prince William and Prince Richard of Gloucester, visitors have included George Brown, Gwyneth Dunwoody, Edwina Currie, Glenda Jackson, Oliver Reed, Sir Jimmy Savile, Matthew Parris, Anneka Rice, Cliff Michelmore, Johnny Ball, Pete Waterman and the Sugar Puff Monster.

Sir Jimmy Savile also hit the headlines in the Isle of Man in the days when he was presenting *Top of the Pops* by pulling a full horse tram along Douglas promenade. A casino boss had bet Sir Jimmy £50 that he couldn't do it. Sir Jimmy put on a horse collar and with the Mayor holding the reins, won the bet in fine style in front of a crowd of 20,000 who had turned out to witness the feat. The money he won was presented to charity. (See also 'Volunteer Driver' page 192.)

Prince Charles, Princess Diana, Margaret Thatcher and her husband Dennis were some of the distinguished persons who rode on the National Tramway Museum cars which ran at the Glasgow Garden Festival in 1988. These rides were publicised in the newspapers, especially in Scotland, but one that received scant coverage was the visit of Princess Anne to the Summerlee Museum of Scottish Industrial Life at Coatbridge, where she drove a restored Lanarkshire tram. The visit took place on 11 September 2001, a day when unforeseen cataclysmic events in America dominated the news. Princess Anne also visited the Gateshead Garden Festival in 1990 and travelled on Metropolitan Electric Tramways car No. 331, which was on loan from the National Tramway Museum.

Queen Elizabeth the Queen Mother rode on a Douglas horse tram in July 1963 from Summer Hill to the Villa Marina. Her ride on the horse tram was described by the press as one of the highlights of her

The Duke of Gloucester, patron of the Tramway Museum Society, drives the newly restored Cardiff water car at the fiftieth anniversary celebrations of the National Tramway Museum on 20 May 2009.

88 | Trams: An Illustrated Anthology

While he was Prime Minister, Tony Blair opened the Metrolink extension to Salford Quays on 6 December 1999. He is shown here on board tram No. 2006, at the start of its journey from Piccadilly Station to Salford Quays.

The Queen enjoying a ride on Manchester's new Metrolink tramway system on 17 July 1992 after opening it.

visit to the island. The car, decorated with flowers, was pulled by the tramway's senior horse, Winston. The Manx Electric Railway over the years has carried a number of Royals: King Edward VII and Queen Alexandra, who rode in car No. 59, the directors' saloon, from Douglas to Ramsey in 1902; Princess Margaret and Lord Snowdon, who made an evening trip up Snaefell from the Bungalow; Princess Alice, who rode aboard car No. 59 from Laxey to Ramsey in 1975; and her son Prince Richard, Duke of Gloucester, who drove one of the cars for a short distance in 1979.

In recent times, royalty and eminent personages have also been enjoying trips on the new generation of tramcars. Passengers on the new Metrolink trams in Manchester, for example, have included the Queen (who officially opened the network on 17 July 1992); former Prime Minister Tony Blair and his deputy, John Prescot; former Tory leader William Hague; and Kent Nagano, then principal conductor of the Hallé orchestra. The former transport minister, Barbara Castle, also drove a borrowed Docklands tram on Metrolink demonstration track at Debdale.

After opening the Metrolink system, the Queen rode on car No. 1010 all the way to Bury, which allowed her to experience for herself the fast, comfortable journey Mancunians are now able to enjoy every day, and to see at first hand the contribution the trams are making to the economic and social life of the area.

The Queen also opened the Newcastle Metro on 6 November 1981 and the Docklands Light Railway on 30 July 1987, while Princess Anne opened the

The Queen arrives in Bury by tram after having opened Manchester's new Metrolink tramway system on 17 July 1992.

Naming of trams is a current trend on the new generation of tramcars in Britain. Midland Metro car No. 7 is named after Billy Wright, legendary football captain of England and Wolverhampton Wanderers and husband of Joy Beverley of the famous Beverley sisters. Their daughter, Vicky, and granddaughter, Kelly, pose for a photographer at the naming ceremony, which was held at the Wednesbury depot on 13 May 2008.

Sheffield Supertram on 23 May 1994 and the Midland Metro tramway (running between Birmingham and Wolverhampton) on 14 September 1999. Neither of the new tramway systems at Croydon and Nottingham have seen Royal personages, but Nottingham's system was opened on 8 March 2004 by Alistair Darling, who was then the Secretary of State for Transport.

Some celebrities have had tramcars named after them. The only modern open-top tram in Blackpool is named after Princess Alice, the former Duchess of Gloucester; she unveiled the plaque bearing her name on 6 June 1985, during the centenary celebrations of the resort's trams. No other member of the royal family appears to have had this honour, although some South Shields tramcars were named after Roman Emperors. And a Midland Metro tramcar is named after Billy Wright (the famous England football international and former captain of Wolverhampton Wanderers), while Dame Gracie Fields, Sir Matt Busby, Sir John Barbirolli and Sylvia Pankhurst are among those who have Metrolink cars named after them.

Horses Were Artful and Comical

By A.E. Hill

A Northampton man, A.E. Hill, wrote a letter to his local newspaper about his days on the horse trams, which ran in the town from 1881 until 1904. He paints a very good picture of working conditions in those days and describes how some of the tram horses behaved. His letter appeared in the *Northampton Independent* on 29 September 1950, and is reproduced by kind permission of Northamptonshire Newspapers Ltd.

Sir, In your issue of 1 September you gave a picture of an old Northampton horse tram of the 90s in East Park Parade. I looked carefully at the picture and recognised myself at the back as the conductor. The driver is Mr Harry Facer, and the two horses are 'Sweep' and 'Smut'. Both were good horses for pulling, but 'Sweep', on the off, was very artful. If you carried the whip in your hand he would pull; if you laid it down he would relax and let the other pull.

Now as regards the horses looking thin, they were well-fed but just imagine the pull from Franklin's Gardens to the 'White Elephant' at Kingsley, all on the collar, and running, not walking, during a very hot day in summer. I have seen the sweat drip off the horses like rain, leaving large pools on such days. Grooms would meet them outside the stables in Abington Street with buckets of oatmeal and also water.

Each pair of horses had to do four hours at a stretch. The Company used to buy the horses from Wales and also from the Army. Each horse used to have its name on its stall; there were nearly a hundred in all. Some of them were very comical. We used to have one called 'Bones', an ex-Army horse. If you went into his stall, he would soon kick you out, but give him a lump of sugar and he would be like a kitten!

I used to have a bit of fun with him when I had a fresh driver on, especially if we had to stop at the top of Black Lion Hill.

I would ring the bell to stop, then I would tap at the window for the 'right away' and the driver would release the brakes, but would 'Bones' move? He would not budge and the driver would get into such a sweat. Then I would ring the bell twice and off would go 'Bones', but not until he heard the bell the *second* time. One night along East Park Parade someone had spilt some flour or salt right across the track and the horses stopped dead. We just could not get them to cross it, so I had to go and borrow a brush from one of the houses and sweep it up before they would move.

In winter in slippery weather we often had both horses fall. Then the tram would strike them and I have seen raw pieces of flesh, just above the tail, as large as your hand. Thank God for the mechanical transport that exists today!

No. 4 was my regular tram. The regular trams used to come out at 8 a.m. and what they called the special cars came out at 11 a.m. Those on special trams used to get there at 8 a.m. and used to clean the trams out or go up into the loft and help cut chaff and crush beans. Then they would go to the saddle room to have a wash and brush up ready to come out, for it was a very dusty job. It used to be 11 p.m. before I was done at night and sometimes it was nearly midnight. Then I had to walk to Hardingstone in all weathers, snow or rain, and it used to be one o'clock before I got to bed only to be up again just after 6 a.m. to get to the depot before 8 a.m. Sometimes it rained all the way and often I was pretty wet when I got there and carried on in the rain all day. Perhaps, if there came a deep snow we had to go snow ploughing and salting.

We used to get two holidays a year – Good Friday and Christmas Day. If you wanted a night off from 6 p.m. you had to get someone to relieve you and pay him one shilling. Conductors on regular trams got fourteen shillings a week and drivers twenty-one shillings. We used to have rough times with some passengers, especially on race days when we used to run from Castle Station to the Racecourse at a fare of threepence.

Yours truly, A.E. Hill, Northampton.

Bang, Crash, Smash!
By Arthur Kirby

While Manchester's famous No. 53 circular tram (known affectionately as the 'little tram') was appreciated by the vast majority of Mancunians, there was a small minority, mainly in the Moss Side area, who seized upon every opportunity to castigate it. Their vociferous complaints were directed at the American-style single-deckers, known as 'California' cars, which operated the service. They had become unbearably noisy as the standard of track maintenance declined, especially around the time of the First World War. Arthur Kirby highlights some of the more hard-hitting complaints in his book *Manchester's Little Tram*, published by the Manchester Transport Museum Society in 1990.

Having fun on the horse tramway at the Bradford Industrial Museum are Ben the Shire horse (apparently camera shy), Katy Baker, and, on the platform of the tram, Leanne Almond and Ken Bellwood.

The main objects of complaint were the 'clanging' points of the passing loops.... From 5.30 a.m. to close on midnight it was 'bang, crash, smash'; Sunday had become, particularly in summer, 'a perfect pandemonium'. The number of empty houses along the route was cited as evidence that the trams had made life along it 'well-nigh intolerable'. In comparison, the 'ordinary' tram was said to be 'peaceful and a thing of joy'.... Other grumbles concerned unnecessary clanging of the gongs through the custom of saluting each other when passing....

A local doctor wrote: 'The noise and vibration caused by these cars has reached a pitch almost beyond the possibility of endurance. The clanging of the points and the bumping over the crossings is simply fiendish. At my own corner the vibration caused by the cars has been such as to cause every picture on the house walls to be thrown down.

Incandescent mantles are scattered to bits in a few days. Bottles are jerked off the shelves. The whole house trembles as if in the throes of an earthquake, and the idea of a moment's rest during the day and half the night is absurd. From 5.30 a.m. until midnight quiet is unknown and sleep impossible. The bumping over the Princess Road crossing is simply too dreadful for words. Unfortunate people living along the route of these cars suffer unutterable tortures should they happen to be the subjects of nerves or not in the best of health. I have seen several driven almost to the verge of insanity by the noise and vibration. In one particular case the disturbance drove a man to commit suicide. There is no exaggeration in any of these statements, as residents along the line will testify....'

Another passenger referred to broken-winded cars on the circular route: 'At every revolution of the wheel they give a gasp which becomes very monotonous – not to say painful – to the sympathetic ear. In some cases, instead of a gasp, there is a metallic crash, as though at every turn the wheels went through points. To round Belle Vue Gardens, where the cars go for a mile or so at top speed, on the outside seat of one of these crashing cars is a dreadful experience for a sensitive person. Whether the car wheels want tightening, or whether they want oil, I don't know, but it is very clear that they want treatment of some sort.'...

The track also came in for criticism. One passenger who used the Upper Chorlton Road line wondered whether the specification for the concrete foundations for the rails required them to be laid level or 'as the waves of the ocean'. If the latter was the case, he could understand the reference to rolling stock....

Complaints about the noise of the cars persisted throughout the operation of the route. In July 1926 the cars were alleged to cause a continual nuisance for nineteen and a half hours out of twenty-four. It was presumably noisier in foggy weather on the loop sections of the route because the cars signalled their presence by persistent sounding of the gong.

But the 'little tram' did not receive just brickbats. It was accorded a few bouquets as well, like this pleasing tribute which appeared in the *Manchester Guardian* on 1 April 1918.

The little tram that travels from Brooks's Bar to Cheetham Hill cultivates exclusively a circle of its own which is quite domestic. Other cars enter

This restored 'little tram', which languished for some sixty years on the moors near Huddersfield after it was withdrawn from service, now operates in the attractive setting of Manchester's Heaton Park. There is not much chance of it causing pictures to be flung off walls today, for there's not a house in sight in this view.

momentously into the life of the city, but the little tram doesn't go to town at all. You cannot think of the little tram as suddenly going off at a tangent from the shops in Wilmslow Road and joining the processional roll of the Palatine Road cars, with an appointment at the top of Portland Street and afterwards lunch in St Anne's Square. Nor can the little tram be imagined away in Blackfriars Street amongst those definitely industrial cars which, as they pass out into the gloom of railway arches during late afternoons, seem to commune with themselves about an eight-hour day and the Whitley Report. The little tram, in fact, lives on the doorstep, so to speak, does the shopping and gets the dinner ready. It may be observed any morning coming along Raby Street with margarine on its mind, and (through carrying so many old ladies in its time) looking very like an old lady itself – in a red shawl.

The No. 53 tram route was the first to be abandoned in Manchester, the service being taken over by motorbuses on 6 April 1930.

Symphony of Tramcar Themes

By Dennis Gill, with extracts by Peter Harvey, D.W.K. Jones, John Gahan, John V. Horn, Ian Yearsley and James Kilroy

During the years they ran on our streets, tramcars created so many marvellous sounds (some even being compared to dinosaur cries) it is a pity they were never arranged into a symphony.

A wide range of sounds was emitted by the old trams: crescendos from the motors, humming from the air reservoirs, squeals from wheel flanges going round sharp curves, sizzles and swishes from trolley wheels on overhead wires, clangs from driver's gong, tintinnabulations from conductors communicating with their drivers and punching tickets, drum beats from wheels passing over joints; the list was endless. Not surprisingly, some of these sounds caught the imagination of writers, as the following extracts reveal.

Peter Harvey, writing in the *The Star*, Sheffield, not too long after the city's new breed of supertrams started running, likened the sound made by the old trams to that made by dinosaurs.

Before Sheffield's last lot of trams went off the road in 1960, a well-known national record company issued an extended play record of the sounds they made. It was never going to top any charts, but as audible nostalgia it worked quite well.

While I was standing in High Street for a while the other day it struck me that recording engineers would have some difficulty making a record of the sounds of Supertram. There aren't that many. Even the clang they make before setting off is not as strident as the old tram bell used to be, the one the driver stamped on with his foot. (The one we all stamped on with our feet given half a chance.)

They don't clank, rattle or bump over joints in the rails (partly because there aren't as many joints in the rails as there used to be).

But the sound that is really missing, compared with pre-1960, is the sound that trams used to make when they went round corners. On gentle curves, it was a kind of short, subdued squeal, rather like the sound one imagines a small dinosaur would have

Flange squeals were one of the most distinctive sounds made by tramcars as they swung round curves. In Sheffield they were something like the squeal of a dinosaur, according to Peter Harvey, writing in the *Star*, the city's newspaper. The squeals made by these cars as they negotiated the curves in Fitzalan Square must have reached quite a crescendo.

Recording engineers would have difficulty recording the sounds of Sheffield's supertrams, like the one pictured here, as they don't make many, as Peter Harvey realised when he was standing in the city's High Street one day.

made if another small dinosaur had trodden on its toe. Or the sound a medium-sized lady dinosaur might have made if a medium-sized male dinosaur had pinched her bottom.

On anything tighter than a gentle curve – on a really sharp bend – especially if the bend also included negotiating a set of points, the old trams emitted a prolonged and very loud bout of squealing, rather like the sound one imagines a very large dinosaur might have made if it was seriously wounded. Or the sound bull elephants made when they were threatened by the baddies in Tarzan films.

Some of the old trams sounded as if they were going through seven different kinds of agony when they went round sharp corners. One of the best places to study this noise was at the bottom of Staniforth Road where the bend was virtually a right angle. Every tram that went round that corner had a good squeal.

I haven't heard a single squeal from Supertram yet; the occasional little mumble, but no squeals. They're remarkably well behaved.

Mention tramcar flange squeals to Ray Coxon, a West Midlands tram enthusiast, and he would immediately recall the time he was listening to an organ recital that was being broadcast from Birmingham Town Hall. In a lull between two pieces he distinctly heard some of the flange squeals made by a tram negotiating a track curve in the region of the Town Hall. It was suggested to him that it might not have been a tram he heard, but merely the organist having a bit of fun by emulating the curve squeal of a tram on the organ. We will never know, although Ray, of course, was most insistent that the squeal came from a tram and not the organ.

One person to whom tram sounds were sheer magic was D.W.K. Jones. He explained why in his foreword to Volume One of Cyril Smeeton's book *The Metropolitan Electric Tramways* (published by the LRTA and TLRS in 1984).

> Enough has been said to explain the hold the MET had on a young enthusiast such as myself, who daily used the cars and loved every inch of track, every swirl of finely shaded gilded numbering, lettering and lining which adorned the trams, and perhaps above all the sights and sounds of action – the tremendous deep hum of a heavily laden car getting under way, the note gradually rising to a near-scream as the statutory limits of speed were exceeded (they usually were), and then the sudden sharp descending note as the brakes clamped to the rails and another shattering stop ensued. Ten passengers, five seconds, two bells and away. Not a moment lost!

John Gahan, a Merseyside author and tramway enthusiast, wrote about the sounds of the gong and the trolley wheel in his article entitled 'Tramway Entertainments', which appeared in the Merseyside Tramway Preservation Society Newsletter in November 1982.

> The warning gong was a musical accompaniment to the tramcar's progress through busy streets, though latterly the Liverpool gongs sounded like a kick on a

tin can. Some drivers used the gong sparingly, while others played merry tunes on them. Even though a gong sounded archaic in the latter days, it was a distinctive tramcar sound that was a pleasant change from the incessant hooting of motor vehicles.... In the days of the 'Bellamy' trams with open top-deck verandahs, one could sit outside at the back and watch the trolley wheel as it hissed along the wires, sometimes exactly above, sometimes veering to either side, while on passing under railway bridges it went far to the side and came low down. The trolley wheel gave a little 'clunk' as it passed each insulator, accompanied by a blue flash, and we used to play a game of counting every flash between the Pier Head and our home stop.

More recollections of the musical sounds emitted by trams appear in John V. Horn's book *Dover Corporation Tramways* (published by the Light Railway Transport League in 1955).

Pleasant sounds were the rising whine of tramcar motors up the incline from Beaconsfield Road; the powerful hum, broken by the fourfold rhythm of the staggered joints, of a car ascending Crabble Hill; and best of all, on a still summer evening, was the quiet yet lively tok-tok ... tok-tok ... tok-tok ... of a car on the sleeper track at River; if one listened carefully, there was a delightful little piece of syncopation in the rhythm as the car ran over a special short length of rail that had been inserted at the northern end of the Coleman's crossing curve; thus: tok ... tok-tok ... tok. And there was a growing murmur, like that of a giant tuning-fork, in the overhead poles as the car came nearer. Now there is only the unmusical roar and poisonous smell of diesel exhausts.

The various sounds made by Manchester trams were particularly delightful to the young ear of Ian Yearsley. One can almost detect the different timbres when reading his prose in *The Manchester Tram* (published by the Advertiser Press in 1962).

On straight track a tram would roll quite smoothly, but where the lines went round a sharp curve, the car would meet more resistance and would often make a grinding and scraping noise.... Some curves, such as the one in Coupland Street behind the Dental Hospital, were of just the right radius to produce a loud ringing note, which on a quiet day could be heard anything up to a mile away. This 'curve squeal' was the most distinctive of all the orchestra of tram-noises, and I do hope someone managed to preserve it on a tape-recording, for it has vanished entirely now. Sometimes I half-hear it in the squeal of a shunted railway brake-van on a sharp curve, but it is not the same, for a four-wheel vehicle gives a short, single note and the Manchester tram's curve-sound was a chord, one note from the big wheel combining with another from the small one. Sometimes it continued for three or four seconds, all the way round the corner....

When he was driving a tram in service the driver would wait for the starting bell, glance in his mirror to make sure that no one was still getting on, then turn the controller clockwise to the first notch and release the handbrake. This gave quite a smooth start, and once the car was under way and the brakes fully released, he would turn the controller to the second notch, then the third, then the fourth. This was the 'top series' position, and by this time the car's gear-noise would have ascended through half an octave and the car would be running at about twelve miles an hour. To go above this speed involved the parallel notches, a slight jerk from No. 4 to No. 5, and the rest of the octave until the car would be chunnering at nearly 25 mph on top notch and humming loudly as it went. After a bit of this, the driver would shut off the power and let the car coast (a Manchester tram would coast for more than 400 yards from a 25 mph start, if you let it) and you would get a different set of noises; on the older cars the gears would start 'ringing', on the newer ones the gears would chunner quietly, leaving the sound of the wheels as the dominant noise until the car approached the next stop. Then the driver would give two and a half turns on his handbrake, the brake-shoes would bite the wheels, juddering as the car slowed, and finally you would stop, with the car rocking gently on its springs with the movement of the passengers.

James Kilroy, writing in the spring 2003 issue of *Tramway Review*, recalls the various distinctive sounds made by Dublin's trams as they trundled through the city's streets.

I am fortunate enough to remember the Dublin City trams.... Just a lad of six years at the time, I was greatly impressed by these massive trundling fortresses.... I could feel them tremble through the cobblestones as they approached, vibrating through my very being, and anchoring themselves deeply into my heart and memory. I was intrigued by the low growling moan of their motors, which soared to a high pitch on acceleration, their earthy rumblings, the clinking of steel against steel, and the screeching shrieks as they rounded corners. I was a little apprehensive about the shower of sparks which

occasionally spat from the trolley-pole as it glided along the overhead cable, crackling and swishing on its way. I remember thinking at the time that it sounded like the sizzling of sausages in the pan. One would hear the 'sizzling' of the overhead cables long before the tram arrived. The trams were a vibrant part of the street, and seemed to have a birthright to be there. They were mobile pieces of architecture as they floated effortlessly by, and I was in awe of them.

Sadly no composer has ever attempted to write a symphony of tramcar sounds, although one or two scores have been produced about railway locomotives, the most popular, perhaps, being *Coronation Scot*, composed by Vivian Ellis, who once described himself as a 'musical train spotter'. The popularity of the piece was considerably enhanced when it went on to become the theme tune for the BBC's long-running radio series *Paul Temple*. As it is, tramway enthusiasts have to content themselves with the few tramway songs that have been composed down the years. And the most famous of these, which touches on tram sounds more than any other, is *The Trolley Song*, first sung by Judy Garland in the film *Meet Me In St Louis*.

For those who like to recall the full-blooded sounds made by the tram, a number of long-playing records were produced in the 1970s, including one by the BBC from their sound archives. Entitled *Trams*, it included the historic broadcast of the last Stalybridge, Hyde, Mossley and Dukinfield tramcar to run in Hyde, featuring the distinctive whine from the car's motors. It also included sounds of trams in Belfast, Birmingham, Blackpool, Cardiff, Douglas, Eastbourne, Edinburgh, Glasgow, Llandudno and London. Decca, under the Argo label, produced a long playing record entitled *Sounds of Bygone Transport*, which contains five sequences of London trams, including one capturing the sound of a car travelling through the Kingsway Tram Subway.

Auxiliary Conductor
By John D.A. Floyd

During the Second World War, auxiliary conductors were allowed to serve on trams and buses in many towns, mainly in the morning and evening rush

The front of the record sleeve for the BBC long-playing mono record *Trams*, issued in 1971, which contains recordings from the BBC Archives of horse, steam, cable, electric and diesel trams at work on standard and narrow-gauge lines in Britain. The tram on the front of the sleeve, designed by Andrew Prewett and incorporating a lithograph by Prescott-Pickup, is London United tramcar No. 148. On the reverse are illustrations of Glasgow, Birmingham and Eastbourne trams.

hours, and large numbers of them were appointed. Leeds, for instance, took on more than a thousand. The auxiliaries performed their duties whenever they travelled on the trams, and in return were allowed to travel free. Their duties consisted of assisting the regular conductors – seeing passengers safely on and off the platforms, giving bell signals to the driver to stop and start, and calling out the name of each stop, particularly during the black-out hours, when it was impossible for passengers to see whether or not they had reached their destination. This article by John Floyd, who believes he was the first airman to serve as a tramcar auxiliary in Britain, appeared in the magazine *Modern Tramway* (published jointly by the LRTA and Ian Allan Ltd) in January 1967.

In the spring of 1943 I was posted as a trainee wireless mechanic to the RAF Radio School in Bolton. The Radio School occupied more or less the whole of the then recently completed Bolton Technical College. There was no 'camp'; everybody on the strength – instructors, administrators and trainees – was billeted out on private householders round the district. I was allocated a comfortable billet with a kindly widow at Tonge Moor, and as we all went home to lunch this involved travelling down to Bolton and back twice daily on the cars of route 'T', our fares being reimbursed by the RAF. Having noticed some civilian auxiliary conductors at work on other routes, I applied to Bolton Corporation to be enrolled as such, but was told I needed permission from the RAF. I applied for an interview with the station commander who, when he had got over the shock of my request, pronounced himself not empowered to grant it, but he did agree to forward my request to the Air Ministry. In less than a month permission was received and I returned in triumph to the transport office to be enrolled (I believe) as Britain's first serving Royal Air Force auxiliary conductor. I was issued with a dark blue armband embroidered in yellow, a permit, and a leaflet of instructions giving among other things, a list of the bell signals.

And so, four times a day for the next four months until I was posted to my first squadron, I took up my position on the rear platform of the 'T' car and, resplendent in AC2's uniform and official armband, rang the bells to and from the town. Most of the time it all went very smoothly. I do, however, recall a couple of incidents when things suddenly stopped running smoothly, and here they are.

Incident number one concerned an elderly driver who had a habit of taking a somewhat longer rest at the Tonge Moor terminus than the timetable officially allowed for. Then on the way back to Bolton, if intending passengers did not hop on quick enough to suit him he would engage first notch and away. Next day he did this just as a rather fat lady was starting to heave herself on. She staggered, fell backwards and remained sitting in the roadway while I furiously rang a succession of three bells for 'Emergency Stop'. About twenty yards further on the car stopped and I ran angrily down the road to the front of the car to give the driver a piece of my mind for starting before I had given him the signal. I was certain he could hear me, as 'T' cars had no windscreens, but he just stood there, with red face and brown leather apron, staring straight ahead. I returned to the rear platform by which time the fat lady had got herself up off the road, had caught the car up again, and was belaying the regular conductor with streams of invective beside which my comments to the driver had been the embodiment of mildness itself.

That evening after classes I wrote to the transport manager and reported the driver. The next evening I arrived home at my billet to find an inspector awaiting me in the front parlour. He was very sympathetic and asked me to go through the whole incident again. Then he told me that the platform crews had made it a stipulation, before they would allow auxiliary conductors to be recruited, that the latter would not be allowed to report them for misconduct. His advice to me, therefore, was that if I were to see this particular driver at the controller again, I should let him go by and wait for the next car!

Incident number two occurred one Saturday evening on the last outward car. It was nearly full when it left Bolton Station. After the first stop it was really bulging with at least twenty standing passengers inside and more on the rear platform. With strict instructions to me not to let any more on, the regular conductor went on top to collect the fares. At the corner of Deansgate was a junction where routes 'H' to Halliwell and 'N' to Horwich turned left while 'T' cars went straight ahead and, after crossing Churchgate, went down a steep dip. At the top of this dip was the next tram stop. At this junction the trolley very often came off, and so it was usual for the conductor or his auxiliary to hold the lower end of the rope so as to yank it down should there be a dewirement. Bolton was, of course, blacked out, but as we started going across the junction I looked along the outside of the car and I could just make out, in the moonlight, a great crowd of prospective passengers surging out into the road to meet the car. Quickly I rang 'four bells' and as the car started to accelerate I remembered the trolley rope and held tight. Unfortunately I held *too* tight, and as we went into the

dip, the height of the wire above the car increased, but the trolley was unable to rise to keep with it, and contact was lost.

Completely blacked out ourselves now, we shot past the crowd and went sailing down the dip. Then the driver, noticing that his power had gone, realised that the trolley must have come off and slammed on the emergency brake. I was still hanging on to the trolley rope and this kept me more or less upright. Most of the other standees, however, were not holding on to anything in particular, and they were all precipitated to the front of the car – a mass of shouting and swearing humanity piled several deep on top of each other. As the car slid to a standstill I saw the crowd at the tram stop start running down the road in pursuit. I knew I could not prevent them from boarding by words or force; I just had, at all costs, to get the car away again before they could reach it!

I leaned backwards over the rear controller and looked upwards. There was the trolley wire, a clear, thin black line against the moonlit sky. I held my breath and slowly let the rope slide through my grasp. Would I be lucky? Yes, at my first attempt the little wheel went right onto the wire and our lights came on again, then four bells on the strap and to my relief, we rumbled off again, just as the leaders of the would-be 'boarding party' were within a yard of the car. Phew!

Armistice Eve Exploit

By John Appleby

How a young airman came to drive a tram on Armistice Eve in 1918 is told by John Appleby in this extract from his book *Bristol's Trams Remembered*, which he published himself in 1969.

Few members of the public can lay claim to suddenly having to take control of a crowded tramcar. But this happened to a young airman when the driver could not be found and was apparently lost in the cheering crowds which swelled across Bristol Centre on Armistice Night 1918. The conscript airman was Frank Dix.[1] All his life he had wanted to drive a tramcar. He lived in London, and when war came he volunteered his services for the newly-formed Air Arm and later received a posting to Filton, Bristol. Here he was lucky in having relatives at nearby Westbury-on-Trym, and on his various off-duty visits to them on the trams which crossed the Downs, he befriended several of the regular drivers.

It wasn't long before one of his new-found friends let him 'have a go', and his pet ambition was quickly realised on the Westbury Road metals. So elated was he with his experience, albeit a short one, that he was soon telling his pals at camp of how he drove a tram to Westbury and back – a tale they found hard to swallow; little did he realise the embarrassment his imparted secret would cause him a few weeks later.

Came 10 November and with news of the impending Armistice, young Frank and his fellow airmen rode into town to celebrate victory. Only too soon it was 10.30 p.m. and time to catch the last car back to Filton. The Tramway Centre was crowded with cheering revellers and the Filton car was full but showed no sign of moving, as the driver had not arrived. For some time they waited in vain and tempers were becoming frayed when one of the airmen remembered that Dix had boasted he could drive a tram.

Without any more ado he was propelled onto the front platform and told, in no uncertain way, to get 'cracking'. In vain he protested that driving an empty tram in broad daylight was a different proposition to taking one overloaded through narrow streets under black-out conditions; his appeal to reason merely encouraged the others to goad him on. The black-out was still absolutely complete and to him, in the circumstances, quite terrifying. There were no street lights, the shops were closed and in darkness and, to quote the conductress, the night was as black as 'the inside of a dirty sock'.

Filled with fear and trepidation, the unaccustomed driver, still in HM uniform, moved the car slowly round the curve into Colston Avenue, six airmen friends sitting up the front staircase and another deputed to the other end to see that no one 'fell off the back', as people were said to be hanging on by their teeth.

Advice from types on the staircase was, of course, unceasing, but all went reasonably well until Zetland Road Junction, where he badly misjudged the distance and notched up before the trolley wheel had passed the overhead contact. There was an ominous 'clunk' out front and the next moment the tram struck the points at a good 12 mph and swung violently left into Zetland Road instead of right into Gloucester Road. How they did not leave the rails is not known and it can only be concluded that the car was so overloaded that it hadn't enough 'lift' to leave the grooves. After a round of applause from the passengers and admonitions from the conductress, who had to get off and turn the trolley, he managed to

With no sign of a driver appearing (he was in fact 'legless'), airman Frank Dix was pushed into driving a packed Bristol tram on the eve of the Armistice in 1918. He drove it to Filton, where he was eventually met by an irate inspector. The car he drove would have been not unlike those shown on this collectors' postcard, drawn by well-known transport artist Eric Bottomley of Ledbury.

reverse the tram back to the main line without further mishap.

From then on, with double track along Gloucester Road, all went well until the belated tram and its inexperienced driver reached Horfield Depot, where two unexpected denouements awaited their arrival. There was a furious inspector who wanted to know where the **** they had been to. Advice from the staircase ceased abruptly and Dix was just wondering how on earth he was going to deal with this fresh situation when he was suddenly enveloped in an aura of beer, two arms came over his shoulder and a hoarse voice said, 'Couldn't help it, mate. Yer can't move down at Centre fer crowds – lucky to be 'ere at all reely.' With that Dix was pushed back and his place taken by a uniformed figure who turned out to be the driver who had been 'sleeping it off under the stairs'.

However, the inspector obviously decided that the driver was in no fit state to continue and proceeded to drive the car to the terminus himself. Starting off with the obvious intention of making up some of the lost time, he got away smartly and was just putting the control handle into parallel[2] when the luck ran out, for the horse-drawn milk float he hit was carrying no lights whatsoever. During the ensuing moments the situation on the front platform became both crowded and confused. The three blokes on the staircase were instantly precipitated down the steps onto the inspector and driver, where they were at once joined by the indignant, frightened and somewhat weighty horse from the milk float.

It was at this point in the proceedings that young Dix decided to make himself scarce by running back to his hut on the aerodrome as quickly as his legs would carry him. Once in the safety of his own bunk he was able to consider his unfortunate tram driving episode. Little did he realise that he would again drive a crowded tramcar, albeit under different circumstances and nearly half a century later, this time at the Tramway Museum, Crich, under the expert instruction of Merlyn Bacon, the Museum's own chief driving instructor. And on this special occasion, just as the memory of his Bristol experience was being rekindled, power failed and the tram had to be towed back into the depot.

[1] Who ultimately became editor of the magazine *Tramway Review*.
[2] Top speed.

By Tram to Amusement Parks, Tea Gardens and Beauty Spots

By Dennis Gill, with extracts by Brian Turner and Steve Palmer, M. Evans and Stanley Webb

While tramway amusement parks flourished in America, they enjoyed little success in Britain, although some operators accrued extra revenue – if only for a few years – by opening tea gardens at the end of a line, while one or two operators, such as Blackpool and Manchester, benefited from the opening of privately owned amusement parks.

To boost the numbers of passengers riding on their cars, American trolleycar operators built pleasure

grounds or amusement parks (which they called luna or electric parks) at the end of their lines. These parks flourished all over America, one of the most famous being Coney Island at Cincinnati, and thousands of people rode to them by trolleycar to enjoy spins and thrills on roller coasters and water chutes, giant wheels and carousels. The only way to gain admission to some of the parks was by trolleycar, which in consequence would often be packed to the seams. Some of the parks also opened zoological gardens, put on entertainments in large pavilions and halls and held firework displays. The operators vied with each other to put on the best attractions, like 'Bump the Bumps', which was a big hit at one park. So successful were some of these ventures that some companies employed staff specially to dream up bigger and brasher attractions to push up their ridership and ticket sales. Tickets sold on some cars also gave passengers admission to the parks.

In Britain tramway amusement parks never became the rage that they were in America. In fact, the only amusement park of any size built by a tramway operator in Britain was the one opened in 1908 at Lofthouse Park by the Wakefield and District Tramways. It had elephant rides, bioscope shows, firework displays and other attractions, but no big fairground rides and so never enjoyed the success of the trolley parks in America. Tea rooms or tea gardens were also provided by the tramway operators in Rothesay, Paisley, Plymouth, Belfast, the Isle of Man, and the Hill of Howth, while in a number of towns, notably Blackpool and Manchester, the tramways accrued considerable revenues by taking passengers in their thousands to large amusement parks, which did have big fairground rides, built, not by them, but by private businesses.

Lofthouse Park was constructed on the tramway line connecting Wakefield with Leeds via Rothwell. It was operated by the Lofthouse Park Company, a subsidiary of the Wakefield and District Tramways, and when it opened, great things were predicted for it. The *Tramway and Railway World* on 2 July 1908 said the new enterprise was being watched with much interest by those concerned in tramway management and went on to describe what had been achieved in the year since the land was purchased.

> The visitor may proceed by tramcar either from the centre of Leeds or Wakefield – for mutual running powers were some time ago arranged between the Leeds and Wakefield tramways – and besides the usual cost of a return ticket by tramway, no further charge is now made for admission to the park. A double siding has been constructed at the park gates to provide for the convenient handling of the traffic. On entering the gates a view is at once obtained of a large portion of the park. In the centre of the scene is a fine pavilion containing a large concert hall, grill room, cloak rooms, and so on. The hall is large enough to seat 1,000 people, and is fitted with a stage and the necessary equipment of a theatre. To the left of the stage is an alcove for the orchestra, which is between the pavilion and an outside platform which can be used for dancing. An excellent floor has been provided for dancing in the hall itself.
>
> In front of the building an attractive bandstand has been constructed, and behind it is an interesting rock garden with plants of various kinds. At night both the pavilion and bandstand are brilliantly illuminated by a great number of coloured lamps. A bowling green, puzzle garden, and numerous side shows are provided for the entertainment of those who frequent the park, while a native village, peopled with inhabitants of the Philippines, is at present a staple attraction. An excellent beginning has been made with flower beds, which add much to the pleasant appearance of the forecourt. Daily concerts and firework displays on stated evenings are a part of the regular programme of the park, and the company is preparing numerous other amusements which will eventually make it possible for their patrons to indulge in any favourite sport. An athletic ground will be laid out and there will be ample space for cricket, football, and so on. Later a lake will be made so that boating and skating will be possible in season.
>
> A novel feature is the construction in the park of a sub-station with a glass front so that visitors may see the motor generators at work....[1]
>
> On the occasion of the visit of Yorkshire tramway managers, a luncheon was served in the pavilion, and afterwards there was a brief toast list. Mr G.E. Leon, Chairman of the Lofthouse Park Company, presided ... and gave a brief account of the enterprise ... he said they had begun in a modest way, but they were ambitious that the scheme should grow. He believed it would prove both a good business enterprise and a great boon to the neighbourhood.

As events showed, the project proved to be nothing of the kind. For a year or two it was moderately successful and in 1910 was leased to a local group of businessmen, who found the running of it hard going. The massive crowds it was hoped would arrive, week after week, month after month, never materialised, and the park had more or less fizzled out by the Second World War, when it became, of all things, a prisoner-of-war camp. The park's failure may have been due to the fact that it didn't have any giant

funfair rides, such as the flying machine, giant helter skelter, switchback, steam-powered roundabout and scenic railway with which the Blackpool Pleasure Beach was wooing Fylde coast holidaymakers at that time. And which it is still doing most successfully today, although with more modern breathtaking rides reflective of the age.

In fact, the Blackpool Pleasure Beach is Europe's biggest amusement park, attracting about six million visitors a year. It was opened on the sand dunes at South Shore in 1896 by Willaim George Bean and John Outhwaite, and from the beginning offered amusement rides, many of which were subsequently obtained from America. They chose the South Shore sands for their site because the opening of Blackpool's tramway system in 1885 had made that area of the resort increasingly popular with visitors. Brian Turner and Steve Palmer wrote about the origins of the Pleasure Beach in their book *The Blackpool Story* (commissioned by the Corporation of Blackpool to celebrate the centenary of the borough and published by the authors, 1976).

Tramcars have been carrying holidaymakers to and from Blackpool's famous amusement park at Pleasure Beach ever since the first fairground ride was erected in 1904. Waiting for a load of passengers outside the present-day complex is preserved Sheffield tramcar No. 513, one of a number of historic tramcars on loan to Blackpool Tramways.

The South Shore fairground was a ramshackle, disreputable place, highly unpopular with the local residents, but Bean and Outhwaite saw the immense possibilities of the site, if it could only be rid of its roughest elements. They took the plunge and bought 40 acres of the sands nearest the beach, between the tram terminus and the Star Inn. Their aim was to develop the fairground on the lines of the permanent open-air pleasure ground at Earls Court, which in turn was inspired by the great amusement parks of America where the public's appetite for novelty was sated by a succession of ingenious mechanical devices operated by independent promoters.

The first such attraction at South Shore, opened in 1904, was the Sir Hiram Maxim Flying Machine, one of four such rides designed by the famous inventor – the others being at Earls Court, Crystal Palace and Southport….

For the 1906 season, Bean and Outhwaite officially christened the fairground the 'Pleasure Beach', and made further progress in establishing the site as a permanent attraction, notably by laying on a supply of electricity from the tramway system. This was a shrewd move for in addition to making the Pleasure Beach attractive to night-time visitors, it established Bean and Outhwaite as important consumers of municipal electricity. Equally important was the effect that the Pleasure Beach had on the tramway system, for the tramways manager, Charles Furness, eventually had to lay special tracks to cater for the Pleasure Beach traffic. W.G. Bean dryly commented: 'I often say to Charles Furness that we endeavour to entertain people within our walls so thoroughly that they stay until they have not even a tram fare left. That rather worries Mr Furness.'

Mr Furness need not have worried, for every mealtime thousands of visitors poured out of the Pleasure Beach onto the waiting trams….

The Pleasure Beach enjoyed the great advantage of being at the extreme end of the promenade and the tram-track, making it a natural destination for visitors, but in 1912 the corporation announced plans to extend the promenade to Squires Gate where it would join the coast road to St Anne's. The new promenade had to cross the company's land, and the Pleasure Beach in return stipulated that no form of entertainment should be allowed on the stretch of land south of their site. The corporation also agreed not to run trams beyond the Pleasure Beach for a period of fifteen years from 1913. As it happened the war intervened and work was not started until 1921….

The southward extension of the promenade was opened in October 1926. The total cost was £32,000 for

the roadway, tram track, sunken gardens and a paddling pool at Harrowside. The company had agreed to trams running on the new promenade, but insisted that southbound trams should stop at the Pleasure Beach and that all trams turning round there should show 'Pleasure Beach' as the destination instead of the old 'South Shore'. The Pleasure Beach and the South Pier were the only entertainment companies to be advertised free of charge on the indicators of the corporation trams, a distinction not enjoyed by the Tower until 1965.

The trams turned at the Pleasure Beach on a large two-track turning circle constructed opposite the main entrance, with a parking track for trams waiting for the departing crowds. At the height of each summer season the corporation has sometimes had to press all its serviceable tramcars into service to carry all the holidaymakers looking for a variety of spins and thrills at the Pleasure Beach, which has kept pace with changing tastes over the years. Today it has some spectacular crowd-pulling attractions, such as the Avalanche, the Monster, Big Max, Valhalla and the Infusion. The Blackpool Tramway has also undergone considerable change over the years, and is now looking forward to the introduction of new trams so that it can continue to take holidaymakers to the Pleasure Beach. The corporation, although having no financial stakes in the amusement park, has drawn considerable revenue over the years from the traffic it generated. In fact, one could probably say that, but for the Pleasure Beach and the enormous success it has enjoyed all these years, there would be no Blackpool Tramway today.

In the days of the tram the only other amusement park that could rival Pleasure Beach was Belle Vue in Manchester. This, too, provided valuable revenue for the Manchester Corporation trams. It was opened by John Jennison between Hyde Road and Kirkmanshulme Lane in 1836, a long time before the Pleasure Beach and well before the first tram ran in Britain. At first it was little more than a collection of birds and animals, but by the time the first trams appeared in Manchester, in 1877, it had gradually grown in size, becoming the Belle Vue Zoological Gardens and Pleasure Grounds, with a large collection of animals and a variety of attractions. The attractions included a music hall, lakes, maze, firework displays, band contests, boat races, fairground rides and so on, not to mention the amusement park's own brew of beer called Belle Vue Pale Ale, which it produced in its own brewery.

The Belle Vue railway station was opened on Hyde Road in 1875 to handle excursion traffic, and when the Manchester Carriage and Tramways Company started running horse trams along Hyde Road in 1880, a double-track tramway siding was laid near the main entrance, the wall of the gardens being taken down and rebuilt to make way for it. The horse trams ran every seven minutes along Hyde Road and every three minutes along Stockport Road, which was not too far away. The horse trams were parked on the sidings ready to take visitors home after firework displays and other events. When electric trams were

In the latter part of the nineteenth century a frequent service of horse trams was run every five and a half minutes from Manchester's Exchange Station to the Belle Vue pleasure gardens, with a car every minute on gala days. One of the cars on the Belle Vue run is seen in Piccadilly making its way to Exchange Station. There was a special siding for horse tramcars outside the gardens, which remained *in situ* long after the trams had gone.

One of Manchester's famous little red trams at the Hyde Road entrance to the Belle Vue amusement park and zoo. This illustration, by the transport artist G.S. Cooper, is from a series of postcards featuring trams and other transport, produced by Dawn Cover Productions of Stockport.

introduced along Hyde Road in 1902, the old horse tram siding fell out of use, but remained *in situ* until the 1980s, being a source of great fascination for those interested in tramway archaeology.

In 1904, the famous No. 53 circular route, with its single-deck combination cars, was inaugurated between Cheetham Hill and Seymour Grove in Chorlton. The circular cars approached Belle Vue's main entrance down Belle Vue Street (which, until the opening of the tramway, had been a private street under the ownership of Belle Vue), and encircled the greater part of the amusement park's walls on their circuitous journey to Longsight and beyond. The cars provided a frequent service every day of the week, especially at weekends. The service was very popular and became Manchester's busiest tram route, with cars well packed, especially when big events were held. A two-track siding was provided at Mount Road where, in 1926, a new greyhound race track was opened. There was, of course, also a frequent service of electric trams from the centre of Manchester, with cars passing every few minutes on their way to Gorton, Denton, Hyde and Reddish. After the firework display the home-going crowds would find tramcars bound for the city centre waiting for them in Hyde Road, as M. Evans discovered at the end of a day trip he made to Belle Vue from Colne in 1937. He recalls the scene in an article he wrote for the October 1966 edition of *Trams*, published by the Tramway Museum Society.

> We made our way through the gates and back into Hyde Road where the crowds were really becoming thick. I thought the return trip to Manchester would be a matter of waiting for a No. 19 or 33 tram, but this was not so as seven or eight 'specials' were lined up on the inward track ready for the Belle Vue day trippers.
>
> The thought struck me at once, whilst this was very welcome and proved that the trams played an important part in Manchester's transport, how foolish the authorities had been to put an end to what was a good reserved siding outside Belle Vue, and confine the Belle Vue special cars to the Hyde Road track. I understand that the Belle Vue specials continued through the war years and in 1944 *Picture Post*, in an article dealing with Belle Vue, referred to them and even published a picture of one. It may well be that the Belle Vue tramway tradition (apart from Mount Road) lasted until the Hyde Road services ceased in May 1948.
>
> For the return journey to Victoria Station we sat in the lower deck. The saloon had upholstered seating.... Glancing through the window the scene was Hyde Road by night – the tramlines shining in the reflected light of the street lamps.

Belle Vue continued to expand between the wars opening many more attractions (including a miniature railway). Belle Vue was open during the whole of the war and continued to flourish until the 1960s when it went into decline.

The circular tram route was replaced by buses in 1930, the Hyde Road trams by trolleybuses in 1948, and Belle Vue itself was gradually shut down between 1977 and 1982. The site now consists mainly

of housing and a cinema complex, with only the greyhound track and the bowling centre surviving.

To boost ridership on its newly opened route to Spiersbridge, the Paisley District Tramways opened tea gardens in 1910 on five acres of ground at Rouken Glen, close to the end of the line. The gardens consisted of tea rooms, an entertainment hall, a Bioscope display, a bandstand, a large pond on which models of ships were displayed and a nursery. The gardens, which were open from May to October, were advertised on posters. One printed in 1911 announced that a high-class company of artistes had been hired to perform from June until the end of summer, and pointed out that a tram ticket gave free admission to the gardens. The venture survived into the mid-1920s, when the entertainment hall became a film studio for a short while, but then the site was developed for industrial purposes. The tramway service to Spiersbridge lasted until 1956.

Rothesay, on the Isle of Bute, was another Scottish town where the tramway company provided a tea room and entertainment hall for its passengers at the terminus of its one and only line, which in fact was on the other side of the island at Ettrick Bay. The line, which started at Rothesay Pier, was popular with holidaymakers, giving an enjoyable return trip on open-sided single-deck cars. There was also a putting green and a soda fountain at the terminus, which was provided with a three-track layout allowing six cars to load or unload at the same time. The entertainments provided by the Rothesay Tramway Company at Ettrick Bay included a sand castle building competition for children, prompting one observer to describe it as 'the children's paradise and joy ground'. For adults, there was an ever-changing programme at the entertainment hall, ranging from concert parties to singers, dancers, pipers and even descriptive lectures. There were also illuminations for special events such as the Music Carnival in August 1908. The entertainment facilities survived until the tramway service was closed on 30 August 1936 and replaced by buses. (Sand castle competitions, Pierrot shows and band performances were also held by Hartlepool Electric Tramways at the end of its line to Seaton Carew.)

The Devonport and District Tramways Company operated a tramway service to St Budeaux and Saltash Passage, and to encourage more people to use the line the company opened tea gardens at Little Ash in 1909. The gardens became very popular, so much so that the company started to issue all-in tickets which enabled passengers to ride to the tea gardens by tram and make a return trip to Devonport by boat. The Saltash Passage line was very unusual because prior to 1903 the section from Camel's Head to Saltash Passage was physically isolated from the rest of the system by a swamp at Weston Mill. The cut-off section was operated as a shuttle service by two cars, which were shedded in a small depot on the Saltash side of the swamp. Passengers travelling all the way to Saltash had to alight at the swamp and cross it by a wooden footbridge before resuming their journey by tram. In 1903 an embankment was built, enabling the tracks to be connected up and a through service operated. The Devonport Company was taken over by Plymouth Corporation in 1914 and the route to St Budeaux and Saltash Passage closed in 1930.

In 1894, the Belfast Street Tramways Company took over the Bellevue Pleasure Gardens and Tea House, which it had been subsidising for some seven years. The gardens, where band concerts and firework displays were held in the tourist seasons, were located on the company's route to Glengormley. They were very popular for a day's outing and the company developed them, building a second refreshment room and a large hall.

After taking over the Belfast Street Tramways Company in 1910, the corporation continued to develop the gardens into a zoological garden and dance hall, making it a very popular destination for the family at weekends and bank holidays and giving its tramway coffers a considerable boost.

The Belfast Tramways Department was congratulated by the *Tramway and Railway World* in 1930 for its efforts in popularising Bellevue. The magazine said:

> This park and its gardens are situated on a pleasant tramway route, and their natural features alone are sufficient to attract visitors on fine evenings and at weekends. It is a verdant and extensive municipal possession rising in terraces to a considerable height and surrounded by mountainous country.
>
> The programme of attractions provided by the Tramways Department makes a strong appeal to the citizens. A bandstand, concert enclosure and tea rooms are prominent features, and on Saturdays and during holidays special provision is made for the 60,000 schoolchildren of the city. This extends even to setting apart a portion of the grounds for donkey rides, swings, roundabouts and other pastimes in which young folks delight. Cheap travelling for children is provided by the general manager's scheme for half-penny fares for any distance to and from Castle Junction....

Finally, there is the Manx Electric Railway, which, unlike other coastal tramways round Britain, was

very much involved in the 'Glen' business and ran tea rooms and hotels dotted along its scenic Riviera-like line between Douglas and Ramsey, and its mountain tramway from Laxey to Snaefell. The company's first acquisition was the Laxey Glen, gardens and refreshment rooms, where bands were engaged to play each summer, including HM Life Guards. This venture was successful and gave a considerable boost to tramway takings. For bringing tourists to the glens, like those at Groudle and Garwick, the company received a small payment for each passenger who bought a glen entrance ticket. Subsequently the company rented and owned some of the other glens like Ballaglass and Dhoon. It also owned the Strathallan hotel in Douglas, the café and hotel at Laxey, the Ramsey Palace concert hall, a refreshment kiosk at Ballaglass, and hotels and refreshment rooms at Dhoon, Snaefell Summit, the Bungalow and Tholt-y-Will at the head of Sulby Glen (reached by the railway's charabanc service from the Bungalow).

The original Laxey refreshment rooms were destroyed by fire in 1917 and not rebuilt, whereas the Snaefell Summit Hotel, which was destroyed by fire in 1982 (by then leased off) was rebuilt and opened two years later. The Dhoon hotel and refreshment rooms were also burnt down (1932) but never rebuilt. The Bungalow Hotel and refreshment room was closed and demolished in 1958. The Ramsey Palace concert hall, which the MER had always let, was sold off at the end of the 1930s. The peak year for the MER seems to have been 1921, when nearly 700,000 passengers were carried.

Like the Manx Electric Railway the scenic Hill of Howth line originally had a refreshment room at the Summit station. It was known as the Pavilion and served tea and light refreshments only (the Earl of Howth refusing to allow it to be licensed to sell alcohol). A band also provided music at the height of the season. Sadly, the Pavilion was burnt down in 1918 and houses now stand on the site. Last but not least, Reading Corporation also provided tea rooms at its Wokingham terminus when it was extended into an off-street siding.

Tramway operators were well aware of the value of laying tracks to parks and beauty spots, while some tramways, of course, were opened purely to serve pleasure seekers, the Douglas Head and Marine Drive Tramway in the Isle of Man and the Pwllheli horse tramway in Wales being prime examples.

Some corporations laid their tramways right into the parklands they owned, as at Heaton Park in Manchester, Temple Newsam Park in Leeds, Alexandra Park in London and Gosforth Park in Newcastle.

Heaton Park opened in 1902, and was served by trams running along Bury Old Road from 1903 and along Middleton Road from 1904. A two-track siding some 400 yards long was laid from Middleton Road into the park in 1905. The park has many attractions, including an 18-hole golf course, a pitch and putt course, three bowling greens, a boating lake, a children's play area and a collection of birds and animals. The tram tracks in Heaton Park were closed in 1934 when Manchester tramways started to contract, but they were never pulled up and lay covered with tar until Manchester tram enthusiasts applied to the corporation to use the track for a museum tramway. The corporation agreed to the scheme and the tramway was reopened by the Lord Mayor in 1980 and the line extended to the boating lake. The tramway is now one of the park's attractions.

The tramway that ran through Gosforth Park was part of an eleven-mile circular route, numbered '00', which ran from Newcastle up the Great North Road, through the park, and back via Benton Four Lane Ends and Byker Bridge. The line through the park was very beautiful and passed the racecourse, where there was a four-track station. In the summer months a frequent service of open-top cars was operated and on race days the cars were packed. The fare for the circular trip was sixpence. When the track through the park was opened a film of the occasion was made.

Birmingham took advantage of the Lickey Hills right on its doorstep by laying a two-pronged tramway to the area and running a frequent service of trams. Over the years the tram carried millions of visitors anxious to explore the hills and savour the attractions laid on for their benefit. The two forking lines (to Rednal and Rubery) were an attraction in themselves, being laid, for the most part, on tree-lined reservations.

Southend-on-Sea's tramcars, like Blackpool's, took day-trippers to the resort's amusement park, which was known as the Kursaal and billed as the greatest amusement centre in the south, with funfair attractions such as seaplanes, cyclone, tumble bug, water chute, whirlwind racer and Alpine ride. But the tramway soon became an attraction itself, for in 1914 the corporation opened two miles of track on shrub-lined reservations down the centre of the Southchurch and Thorpe Bay dual-carriageway boulevards and ran tours along them.

'Probably no municipal undertaking possesses a sleeper track tramway in more beautiful surroundings than Southend-on-Sea,' wrote the *Tramway and Railway World* in 1930. It is not too difficult to see why, for the tracks ran among a

One of Southend-on-Sea's popular 'observation' cars on the famous circular tour that took in the Southchurch and Thorpe Bay boulevards. The trams ran between hundreds of different colourful shrubs and trees down the centre of the carriageways, which made this section of line one of the most beautiful in Britain. The cars were actually dark green – a fact overlooked by the tinter of this early commercial view.

magnificent display of flowering shrubs and trees planted in the middle of the road. In fact, there were some 3,000 trees and shrubs, and the Tramways Department had to employ six gardeners full-time to look after them.

For the tours of the boulevards during the summer months, the corporation laid on eight-wheel single-deck open-sided toastrack-type observation cars festooned with coloured lights and flags. To meet the demand during peak periods, open-toppers would also be pressed into service.

'It was an exhilarating ride along the boulevards, and one afternoon I went round three times because I enjoyed it so much. It was certainly better than sitting in a deckchair,' one seasoned holidaymaker once told me.

The trams, alas, ceased to run down the boulevards in 1938, and the Kursaal ended funfair operations in 1986, but reopened in 1998, offering ten-pin bowling, live music and dining-out facilities.

While most of the scenic rides on tramways were well advertised with posters and leaflets, I know of only one that was publicised by a film produced by the tramway undertaking itself. This was the Kinver line of the Dudley and Stourbridge Tramways, which by all accounts was a joy to travel on. This tramway, one of the most attractive rural lines in Britain, was laid in the beautiful Stour Valley through meadows and thick woods, along an embankment between rows of fine silver birches, and alongside the towpath of a canal. As well as serving Kinver, an attractive village in itself, it passed the famous caves in the cliff face of Kinver Edge. There were also attractive pubs in the area, including the Stewponey at Stourton. The terminus at Kinver had a waiting room and booking office and a three-track siding capable of holding

Boating on the river Stour – one of the attractions that encouraged Midlanders to ride in their thousands by tram to the popular beauty spot of Kinver. The area also boasts rock dwellings set in the famous Kinver Edge, from the top of which it is possible to obtain views of the Clee Hills, the Malverns and the Welsh Marches. So popular were the tramcars, one of which is shown paused on the bridge, they carried more than 30,000 passengers over two Whitsuntide days in 1905.

eighteen cars. On summer weekends and bank holidays especially, the Kinver single-deck open-sided cars bulged with day trippers as they trundled along the tracks, 16,000 being carried on one of the first bank holidays, with cars having to be run in pairs to cope with the crowds. The record year appears to have been 1907, when the trams carried 850,000 passengers.

The film that was made of the line was shown at cinemas in the Black Country towns to attract more visitors. Stanley Webb described how the film was made in Volume One of his book *Black Country Tramways*, which he published himself in 1974.

> In the early autumn of 1904, preparatory to the winter's programme, New Century Pictures were commissioned to make a cinematograph film of a portion of the Kinver Light Railway. A portion of this film was of the journey to Kinver, for which a camera was mounted on the flat roof of one of the cars. This followed a toastrack loaded with children, which was filmed en route and was stopped, unloaded and reloaded at various points of interest. The film also showed places worth visiting in and around Kinver. It was shown during that autumn and winter twice daily for a run of seventeen or eighteen weeks at the Curzon Hall in Birmingham, and for short runs at many of the small halls throughout the West Midlands which were then being fitted up to show the new pictures. The film appears to have been very popular....

The only other tramways I can think of which were publicised by film are the Shipley Glen cable tramway, near Bradford, and the line through Gosforth Park in Newcastle. A film was made of the Shipley Glen line in 1910, showing visitors riding up the tramway to the top of the glen; here there were fairground amusements such as a switchback, roundabout, aerial ride, steam-powered miniature railway and other attractions. The Shipley Glen tramway is still in existence, and in the early 1990s dodgems were still operating not far from the terminus.

While many of the old amusement parks have closed down, it is interesting to note that changes in lifestyle have brought new attractions in the past two or three decades that were undreamt of pre-war. And in a reversal of fortunes instead of taking people to attractions, the old trams have now become one of the attractions themselves, running up and down streets or around the grounds at museums, garden festivals and transport festivals, enabling visitors to recapture the thrill of a tram ride. They run at a number of museums: East Anglia Transport Museum (Lowestoft), The National Tramway Museum (near Matlock), North of England Open-Air Museum (Beamish), Black Country Museum (Dudley), Summerlee Heritage Museum (Coatbridge), Bradford Industrial Museum (occasionally) and Birkenhead Heritage Tramway. Trams were also present in a big way at two garden festivals – Glasgow (1988) and Gateshead (2000) – while heritage trams have also been one of the main attractions at the Birkenhead and Fleetwood Tram Sunday events.

[1] Something similar is located at the Wakebridge halt on the tourist line of the National Tramway Museum at Crich.

A Glasgow tramcar, on loan from the National Tramway Museum, carries visitors in the grounds of the Glasgow Garden Festival on 26 September 1988.

Ran a Pasty Special and Ore Trains

By Fisher Barham

The only electric street tramway in Cornwall, and the most westerly in Britain, was that which connected Camborne with Redruth. It was a mere three miles long and ran for only a quarter of a century, but in that time its eight tramcars carried 32 million passengers. The tramway uniquely ran a pasty special and was also used by two mineral ore trains, which operated for twenty-eight years along a mile of the street track and carried in excess of 1,300,000 tons of ore. Special trams were also operated for the miners, leaving both termini each weekday morning at 5.30 a.m. Writing about the tramway in his book *Cornwall's Electric Tramcars* (published by Glasney Press in 1972), the West Country historian Fisher Barham quoted several

unusual facts and some amusing stories of life on the trams.

At 12 noon each working day, the tramcar leaving Redruth carried pasties and other food parcels which had been prepared by the men's wives, and special depots were set up at various places of employment to receive them, and woe betide any tram crew who mislaid a delicacy. This run was known as the 'Pasty Special', and there was a charge of a penny for this service and a flat rate of twopence per item for the transport of parcels. For the latter a basket was fitted to the tramcar which left on the hour from Redruth and on the half-hour from Camborne throughout the day, and young lads were employed as parcel boys....

Soon after the start of the tramway, a practice had grown up whereby conductors accepted letters for addresses in the other town if within one mile of the terminus. In September of 1903, the GPO ordered this to stop, as it was illegal, but the following February the official tram postal service was inaugurated. Each hour a car leaving Camborne was designated a postal car with a sign hung from the upper deck handrail, and a small letter box hooked on the rear dash. Passers-by could drop in mail for Redruth and at the end of the journey this was collected by a postal official and delivered in the usual way....

Another amenity was that a tramcar could be hired after midnight for a dance party or similar function, and the charge was ten shillings. It was also possible to board a tram at Redruth after 6 p.m., and for a sixpence return ticket the purchaser was also entitled to a seat at the Camborne Assembly Rooms for a film show. Bicycles could be carried on the front platform, but this was not encouraged by the sixpence charge.

The ore trains were drawn by two four-wheel tram-locos powered by two 25 hp motors identical to those fitted on the passenger cars.... The ore was carried in fourteen side-tipping wagons, eight of two and a half tons capacity and six of three tons capacity.... The average journey time for a mineral train (*between the East Pool Mine and the smelting works at Tolvaddon Stamps*) was one hour for the round trip, and it usually worked out at about nine journeys per day, per loco, each transporting about nine tons of ore....[1]

The road surface was of ash and dirt bound with water, and in dry spells grit lodged in the track groove and dust settled on the rail surface. In these conditions it was not unusual for a tram to lose earth return, and after a stop, refuse to move off. The driver then had to ask at a house on the route for a bucket of water, and pointsmen regularly carried a large watering can for damping down the track and washing out grit from the point blades. One evening at Rounding Wall stop, this loss of contact occurred and all the car lights went out. Inspector Ripper, who was on the tram, warned that no one should alight until they came on again, but one young lady shop assistant, in a hurry to get home, ignored his advice. The moment her foot touched the ground she received a mild shock and had difficulty in releasing her hold on the car. The inspector knocked her hand clear, but all he got for his trouble was a telling-off for holding her. In 1919, to overcome this type of hazard, a 250-gallon water tank was fitted to a bogie by the depot staff and towed behind a single-decker in dry periods....

The people on the tram route knew the crews well and many were related. There were fathers, sons, sisters, brothers and daughters who worked together and many had their homes alongside the tracks. At least one conductress married a motorman. The tram company and the people it catered for were one family, each well known to the other, and the buses which replaced them never engendered the same affection....

A lady passenger coming down the stairs at the wrong end was politely asked to come down the other way (*in other words 'go to the other end'*). She remounted the steps and again descended – backwards....

Miners were paid monthly and it was a favourite trick to tender a sovereign or half sovereign for a penny fare, well knowing the conductor would not have change, and thereby gaining a free ride. The staff got wise to this and accepted the coin, telling the miner to collect the change at the office, and after this the correct fare was soon found....

One lady, when asked why she hesitated at the terminus before boarding replied, 'Shall I get on 'un now or wait for 'ee to turn 'un round?' ...

The local postman delivered the mail to the depot in the evening and one night he entered through the tram shed, in darkness. The next thing he knew he was at the bottom of one of the inspection pits saying a few choice words....

At Pool, a gang of men were working on track maintenance when a farmer rounded the bend in his car and was excitedly waved down. He swung across the road and crashed into a tram pole. When asked why he did not just stop, he replied, 'That's the one thing that never entered my head....'

One Saturday night the street lamps dropped to a glow and the trams came to a halt. The engineer hurried to the depot and found the duty stoker asleep on the coals and much the worse for drink and impossible to rouse. The 'boss' had to take off his jacket and raise steam himself, and he still had

enough 'pressure' the next morning for the unfortunate stoker.

[1] The tram locomotives were specially built for this work by Milnes and carried tool boxes down each side.

Passengers Escaped Massacre

By Dennis Gill, with extracts by Philip Beck, Jean-Jacques Fouché and Jens Kruuse

In the Second World War almost all the inhabitants of the French village of Oradour-Sur-Glane were massacred by German soldiers. Two tramcars arrived at the village in the middle of the massacre, the second pulling a trailer and carrying passengers, a number of whom were ordered to dismount. For a few nerve-racking hours their fate hung in the balance.

One of the most monstrous atrocities in the Second World War was the appalling massacre of 642 men, women and children at Oradour-sur-Glane, a village 22 km to the north west of Limoges in the Haute-Vienne department of France, on 10 June 1944. They were shot or burnt to death by a battalion of some 200 German soldiers as a reprisal for the capture and killing by the Maquis (the French guerrilla resistance force) of Major Helmut Kampfe, commander of the Third Battalion of the SS Armoured Division 'Das Reich' and holder of the Iron Cross. Why the Germans wreaked their vengeance on Oradour-sur-Glane we shall never know. The most likely explanation is that they mistook it for Oradour-sur-Vayres, which is not far away and a place where the Maquis were very active.

Oradour-sur-Glane was connected to Limoges by a roadside interurban tramway, opened in 1911, and five trams in both directions passed through the village during the course of the day. Coming from Limoges they stopped just before the bridge over the River Glane and by the post office at the northern end of the village, before carrying on to Javerdat and St Junien, some 13 km further on to the southwest. In those days, when few people owned a motorcar, the tramway would be the only means of transport for the villagers. In fact, it would have been the lifeline for the village and the surrounding hamlets with passengers and goods arriving and departing by it. It would also have been of great benefit to the rural economy. So the five-times-a-day arrival of the tram was an important event, eagerly awaited and savoured, and probably greeted by a friendly wave of the hand. It was also an indication that all was well, and for those who did not possess the luxury of a watch a good indication of the time of day. Children probably ran after the tram as it weaved its way through the village, perhaps pinching a short ride by clinging to the back of it. The line was also well patronised by the citizens of Limoges, who liked to take the tram to Oradour, especially during the war, to shop for provisions that were not easily obtained in the city, or go fishing and picnicking on the banks of the river.

Two tramcars arrived in the village during the massacre, and what happened to them and their passengers is described in the many books and reports that have been published over the years about the tragedy. The first to arrive was a maintenance tram. It arrived right in the middle of the massacre and the driver, for reasons we will never know, was executed. In my book *Tramcar Treasury* (published by George Allen and Unwin in 1963) I wrote:

> Soldiers stopped the tram as it was about to enter the village, dragged the driver from the controls, and split his skull open before he knew what was happening. At the trial of twenty-one of the soldiers nearly nine years later, the conductor described the incident: 'His skull was cut this way,' he said, running his hands over his head, '… it was all open and blood was pouring out.' The conductor was extremely lucky. He was ordered to take the tram and its passengers back to Limoges.

When I wrote *Tramcar Treasury* more than forty-five years ago, there was not as much material available as there is today and I took in good faith the information published at that time. More recently published books, however, suggest there were only three people on the tram and give a different account of what happened when the tram was stopped. All of them state that an employee from the tram was shot and his body thrown into the river, but they differ on which employee was shot. Philip Beck in his book *Oradour – The Death of a Village* (published by Pen and Sword Books Ltd in 2004), says it was the driver.

> A small maintenance tram from Limoges, bearing company employees, stopped before crossing the bridge over the Glane and the driver, M. Chalard, got out to see what was happening. He was shot as he crossed the bridge and his body was thrown into the river. The tram was driven back hurriedly.

On the other hand, Jean-Jacques Fouché on page 112 of his book *Massacre at Oradour* (published in English by Northern Illinois University Press in 2005) says that the person who was shot was an employee who was going to a craftsman's shop in the village, and not the driver.

> The 'tram' stopped a little before the bridge and blocks had to be put in front of its wheels to keep it from rolling. At the same time a group that had been rounded up on the outskirts walked by, escorted by Waffen SS. An employee named Chalard, who was the 'passenger', got off the tramcar. Did the Waffen SS order him to join the group making its way toward the village? Did he make a gesture or a move toward his colleagues? He immediately was shot, then finished off, and his body was thrown into the riverbed in full view of the group and his workmates.

The second tram that arrived at Oradour-sur-Glane on that fateful day appears to have been a motorised unit with a trailer carrying a good complement of passengers. It left Limoges at about six in the evening, despite what had happened to the first tram in the afternoon. The driver was warned about three miles from the village that hostages were being shot and buildings burned, but nevertheless carried on with his journey until he was stopped by German soldiers as he neared the village. This extract describing the scene is from *Madness at Oradour* by Jens Kruuse (published by Secker and Warburg in 1969 and reprinted by permission of the Random House Group Ltd).

> The little trams clattered along slowly over the narrow-gauge track beside the main road. Four kilometres from Oradour a man came along on a bicycle and shouted: 'Oradour is on fire! The Germans are there! Don't go any farther!' It was Hyppolyte Senon.
>
> But the driver was a dutiful man. He had been told to proceed to Oradour, and to Oradour he would go....
>
> When, after leaving the Laplaud stop, they reached the stop just outside Oradour where the road from St Victurnien enters the town, they were halted by German sentries. Soldiers entered the trams and demanded to see papers. The terrified passengers saw the town and church burning, and soldiers running up to individual houses and tossing grenades into them.

The passengers on the tramcar and trailer included between sixteen and twenty-two people who lived in Oradour or who were bound for Oradour. They were ordered to alight, while the rest of the passengers were sent back on the tram to Limoges. They were then forced to stand by the tramway until somebody in higher authority decided what was to be done with them. One can hardly imagine the strain and the terror they were forced to endure as they awaited their fate. At about eight o'clock they were marched to a command post at Les Bordes where they were questioned further. As to what happened next, Jean-Jacques Fouché (on pages 135–6 of his book *Massacre at Oradour*) quotes from a report by railway engineer Jean Pallier, a partial transcript of which was preserved in the files of military justice.

> While we were in the command post the soldiers guarding us, all of them Germans, kept fooling with the women and showing the sort of cheerfulness that you have after a pleasant outing. None of the men was drunk. Around 10 p.m. the soldiers' attitude suddenly changed. The commanding officer had just arrived. I was told to line up with the other men along a wall, as if we were going to be shot. Another identity check was carried out. All of us were men who had come to see their families, and none of us lived in Oradour. Was that the reason? Or was it because it was late and the officer was in a hurry to get back? Whatever it may have been, we were told to get away from the village quickly. As we left, the non-com who had carried out the last identity check, and who spoke proper French, said to us: 'You can consider yourselves lucky.'

It wasn't until later, when the horrific details of the massacre became known, that they realised just how lucky they had been.

Five days after the massacre a sanitary team (composed of helpers from the Red Cross, the Jeunesse Secours and the Équipes Nationales) travelled to the village by tram to bury the dead and carry out urgent sanitary and cleaning work.

The ruins of the village, which was destroyed by fire, still stand to this day, more or less as they were left by the German troops. Today they are protected by a security wall which runs round the village, and the entrances are locked at night. The tramway network in Limoges closed in 1948, but the section of tramway which ran at the side of the road through the village is still *in situ*. The village has become a memorial centre to all those who died on that fateful day, and is called the 'Centre de la Mémoire'. It is open to visitors every day.

Last Tram Run in London

By G.S. Gale

London said goodbye to its trams on the night of Saturday 5 July 1952, amid scenes of great jubilation and sorrow. Londoners flocked to the Thames Embankment on the last day to savour a last ride on the remaining routes to Woolwich and Abbey Wood via Eltham or Charlton. The Chairman of London Transport, Lord Latham, and the mayors of nine London boroughs rode on the last car of all, appropriately numbered 1952, from Charlton Works to New Cross Depot, there to await the arrival from Woolwich of the last car in public service, No. 1951. This report by G.S. Gale of 1951's boisterous triumphant last journey appeared the following Monday in the *Manchester Guardian* (copyright Guardian News and Media Ltd 1952).

The journey from Woolwich to New Cross of the last tram in London was incomparable. No triumphal car this, yet it had more glory in its dying than it had in its living. Its passage through Greenwich and Deptford was neither that of king nor of clown, yet majesty was affronted and levity confounded. The ridiculous cortège prompted cheers, and tears and jeers were alike dispelled. It was Saturday night in south-east London, and the last tram had become a pretext for a Cockney bacchanalia.

Imagine a crowd along a prescribed route to see a king or queen pass by. Let it keep its squealing children about its knees and hoist up its infants with flags in their hands. Give it torn paper hats, flamboyant holiday-camp hats and ribbons, football rattles, tin trumpets, dustbin drums and scrubbing-board drums, real and tin-tray cymbals, piano-accordions, and a welter of whistles. Let it line up not in daylight but late at night, after all the public houses from the Old Kent Road to the free ferry at Woolwich and beyond to Abbey Wood have sent away their tens of thousands of customers filled with beer, their arms and pockets filled with bottles, and their throats in full voice. Take away most of the policemen a stately procession would command and then, at midnight, with the moon almost full and the night air hot, send out, to run this crazy gauntlet, a tram.

The tram had no name – only a number, 1951. Queuing up behind other trams at Woolwich free ferry, it looked like all the rest, dingy, mechanical, uncomfortable, certainly soulless. Woolwich at quarter to eleven seemed normal enough, until you realised that the soldiers and their giggling girls, moving into the dark alleys, had left a noisy crowd behind in the full light, jostling in the pies-and-peas, fish-and-chips, and jellied-eels stalls, that the stragglers outside the doss-house were waiting on the kerb before claiming their beds, that flags hung from a few windows and men in their vests and wives in their night-dresses from others, and that women were dancing reels of sorts on the pavements.

As soon as the tram moved off – to go to Abbey

Londoners hurry forward for a last tram ride during Last Tram Week in London in 1952. The tram, which appears to be packed upstairs, is covered with chalked tributes, such as 'Good-bye faithful old pal of mine', 'I feel as if I can't go any longer', 'I'm going to get lit up', and 'Rest in Peace'. Above the indicator box is the one word 'Desire'.

Wood and back before it began its last journey – you realised that it was no longer an ordinary tram but had been made by the crowd at Woolwich into more than an object of affectionate derision or a scrap-album relic. It had become a festival queen, and as the festival was rowdy, beery, middle-aged, and merry, so was its queen. The last tram was a fattish woman of fifty, her tubes a little wheezy, her joints choked with arthritis, with a little bright lipstick and dry powder, her hair dyed and thinning, her resolution and her vanity indomitable. The huge crowd from Abbey Wood through Woolwich to New Cross were celebrating themselves when they celebrated the tram.

Off it moved, filled with a noisy babble of passengers, and escorted by policemen on motor-cycles, hundreds of cyclists, scores of motor-cyclists, and dozens of cars. There was a great cheer, flares were lit, horns and whistles blown. A woman leaped on to the rear of the tram and clung there, her frock, underclothes, and blasphemies streaming out behind her. She fell off soon, but others clambered on the sides. By the end of the journey there were twenty youths sitting on the roof and dozens strung along the sides. There was singing all the way, and the tunes came easily to mind. 'Maybe It's Because I'm a Londoner', 'Any Old Iron', and so on to 'Auld Lang Syne'.

There were people dressed as monkeys, people dressed as gypsies, people sporting huge theatre bills, people wanting to pat the tram or break a bottle against it or have a penny squashed by it. There were people who stood in front of it waving wildly. The tram could hardly move at times, and the whole road was filled with this exuberant crowd. Patients at a hospital threw out bandages as it passed. Someone flung out a bundle of torn newspapers. The last tram was an hour late getting to New Cross, and it was exhausted.

Outside the depot the crowd was vast. The moment of triumph was at hand. There were only a few yards to go into the sheds. First, the boys on the roof had to be got off, and that took half a dozen policemen. Then the last paying passengers had to be cleared off. This was easier since they all scuttled off quickly so that no one would notice the mementoes they had torn off, unscrewed, and broken away from the tram. Then the people climbing up the sides had to be pulled down, and firemen had to be brought in to clear the tracks.

A great cheer went up. Another. And another. But the last tram did not move. She clung to life, so it seemed, but in truth she was deader than ever. A break had occurred in her electrical system. The glory was too much for her. And so, another tram came out of the shed and was tied to the last tram. It gave a jerk, the last tram shook and moved up to the sheds. Newsreels whirred, cameras flashed. The last tram had gone inside, so that the officials could receive it with official publicity.

It will come out again, unheralded, to make its last journey to the scrapyard. On its road of glory it had passed that of trams awaiting destruction. It did not shudder, although there were plenty of wits to remind it of its fate. But then the last tram, even if it had become more than a machine, was all the way supremely unsentimental.

Their days done, a batch of London tramcars, are broken up. The car about to hit the deck is ex-West Ham car No. 246, which was withdrawn from service in 1937. It still shows 'Stratford' on its indicator.

Not all London trams went for scrap when London said goodbye to its trams. Some went to Leeds for further service and this one was preserved by enthusiasts and now provides rides for visitors to the East Anglia Transport Museum at Lowestoft.

Tramophilia

By Paul Jennings

The post-war pro-tram lobby, especially those arch defenders of the tram, the Light Railway Transport League, came in for some ribbing in this piece by the satirical columnist Paul Jennings in the *Observer* on 24 July 1949. The article was subsequently reproduced in *Oddly Enough* (published by Reinhardt and Evans, 1950). Copyright Guardian News and Media Ltd 1949.

It must baffle tram enthusiasts, the way the public go on assuming without much serious thought at all that buses are more progressive.

There are thousands of tram enthusiasts. On the editorial page of their magazine, the *Modern Tramway*, it says they are affiliated to 'the NVBS (Holland); the Association Belge des Amis des Chemins de Fer (Belgium); the Electric Railroaders' Association (USA); the Association Française des Amis des Chemins de Fer (France); the Australasian Railway and Locomotive Society; the Central Electric Railroaders' Association and the Town and Country Planning Association and Stichting Tram-Archief (Holland)'. And in *50 Questions and Answers About Trams* it says that 'the Light Railway Transport League was founded by a number of men and women in all walks of life who felt that the tram was not receiving a fair deal'.

Their literature is full of every conceivable argument in favour of trams, not forgetting the help given by tramlines to fog-stranded motorists, and even the advantages of a tram system in air raids; for, says Answer No. 37 gravely, 'A heavy bomb would usually … cause severe damage to pipes and cables, all of which had to be repaired with weeks of labour before the surface could be replaced. On the other hand, it was the work of a few hours only to lay a length or two of new rail bridging over the crater, supported temporarily from below, and restore tram services at once. As a result it became a common sight, during the Blitz, to see road signs "TRAMS ONLY".

They point out, disconcertingly, that the rates always go up wherever there is a switch over to buses. Of course old-fashioned trams look silly, they say crossly; so do old-fashioned buses; but just you turn to page 23 and see our artist's conception of the trams of the future … and all the public does is to shift from one foot to the other, and grin uneasily, and go right on buying more buses. They give what Cardinal Newman calls a notional assent, not a real one, to the economic superiority of trams.

Perhaps the explanation lies in a fact which has been overlooked by all tram psychologists hitherto – the extraordinary similarity of a tram to a greenhouse. The trouble with trams is that they don't look like things intended to move at all. They look, as I say, like greenhouses – and double-fronted greenhouses at that. An old tram is an old greenhouse, and a streamlined tram is simply a streamlined greenhouse, and what the public is saying to itself in its subconscious is, 'Good heavens, it *moves!*' Whenever the wheels come to a join in the rails, they go over it with a dead-weight, heavy, unspeedy sound, like a piano being wheeled over a tiled kitchen floor. Indeed, when you consider the mountainous height of a tram, its wheels do seem as insignificant as

castors. A tram is the perfect, and probably only, justification for that phrase with which the writers of insurance policies and bye-laws love to describe everything from a lift to an express train – a 'moving platform'.

And what *makes* it move? It seems incredible to me, as I sit in the green, glassy space, feeling as if I were in a small Crystal Palace (or a greenhouse, in fact), that there should be powerful groaning motors, and gongs, and cowcatchers, and brake-shoes, and all the statutory apparatus of public motion underneath that platform which is already so near the ground. The public likes, in some obscure way, to be *associated* with its motion.

There is, no doubt, for instance, about the function of a bus. How this handrail throbs; what a nice, businesslike, enginey smell; look, there is the driver doing things we all understand – changing gear, pulling on the handbrake. It is very different from those meaningless handle-twirlings which seem to stop or start a tram without any visible logic. The bus possesses the enormous advantage of familiarity. If trams are all that good, we feel, why isn't the tram-pattern repeated in our individual lives as the bus-pattern is repeated in cars? Why aren't there showrooms full of family trams, and even little two-seater sports trams, eh? Where do we get this sad feeling that trams are going the way of dinosaurs?

These subconscious doubts of the public are prompted by that very spaciousness which the tram enthusiasts think is such an advantage ('To seat 70 Persons', they say proudly). They will not be got over, therefore, by mere streamlining; and in any case so many tramlines go through narrow streets where it always seems to be Saturday afternoon, with thousands of people shuffling past shop windows full of chromium kettles and radios and rather dreary-looking pink underwear. It is no good having trams designed for an autobahn, or at least for Blackpool Promenade, in these surroundings.

Yet, as the tram enthusiasts point out, it would be criminal to scrap the rails and poles, and of course, the trams, now that we have them. It seems to me the obvious solution lies in a compromise. Why not give up *fighting* this greenhouse idea? Why not accept it? We already have mobile canteens, and in a turning off Oxford Street there is even a mobile dental clinic, so why not mobile greenhouses? Think of it – the duckboard floor (there already in many trams), the drowsy, damp, ferny smell, the tropical heat, the great purple and orange blossoms, the little wooden tabs pointed at one end saying *Lycopodium clavatum* and *selaginella* – and all the time one could be rumbling solemnly along the street. Perhaps there could be specialisation, with tomato trams and palm trams. When enough trams had been converted to satisfy the demand for mobile greenhouses, the remainder could be stationed in loop lines strategically all over the city. Let buses go out to the green belt. The trams could provide one in themselves.[1]

[1] Whether Paul Jennings actually ever saw a tram being used as a greenhouse we will never know, but Stephen Lockwood in his book *Trams Across the Wear* mentions that when Sunderland Tramways withdrew one of its ex-Huddersfield cars in 1953 it was purchased for use as a greenhouse at the back of the Beehive Hotel at Earsdon.

This streamlined purpose-designed tram was introduced in the 1930s to save American tramways from extinction by enabling them to compete with private motorcars. Incorporating many revolutionary developments in technology, it provided Americans with an unparalleled form of speedy and comfortable travel. Ultimately thousands of tramcars like it were built under licence, incorporating the same technology. It was this type of tram that the Light Railway Transport League advocated should run in Britain's towns and cities.

Riding the Buffers

By Dennis Gill, with extracts by Jim Soper, George Hearse and John Knox

On most tramways, if not all of them, it was a fairly common practice for youngsters to grab free rides by clinging to the backs of the trams, usually with their feet on the bumpers or 'buffers' as they were known in some places. It was a highly dangerous stunt, sometimes ending tragically in death, and has been practised on the new trams that are running in some of our major cities. In Belfast, shipyard workers also dodged paying their tramcar fares by clinging to the outsides of the trams and riding free.

Children had all sorts of fun with trams – chasing them up the street, bombarding them with snowballs, flattening pennies on the tracks, swinging round the brass platform rails, pulling trolley booms off the wires, jumping on the sand pedals, knocking back seat rests, changing destination indicators and so on, but the one prank that worried managements most was riding on the rear bumpers and grabbing free rides. This was the one game, often practised for a bet or devilment, which could sometimes end in the youths being badly injured or, worse, killed.

There cannot have been many towns in these islands where boys (and girls in some cases) did not ride the bumpers or fenders of trams. Managements made many efforts to stamp out the practice, but usually they were fighting a losing battle. After the war, Liverpool launched an advertising campaign to warn youngsters of the dangers involved. One of these posters read: 'Buffer boys – be warned. ONLY DUFFERS RIDE ON BUFFERS. Don't do this for sport and be crippled for sport – for life!' The department also took a specially posed photograph of a boy falling off a tram bumper and a passing motorist swerving to avoid running over him. In reality, some boys who lost their hold fell under the wheels of passing trams or other traffic which had no chance of swerving. In Plymouth, a Morice Town schoolboy lost an arm when he fell off a tram, and in Leeds during the First World War, two boys were killed. It led to a clamp-down on bumper riding in Leeds, as architect Jim Soper records in the second volume of his extensive history *Leeds Transport*, published by the Leeds Transport Historical Society in 1996.

Two boys (Tom Swallow and Aiden McCathie) demonstrate, on the Birkenhead heritage tramway, how easy it was for young lads to secure a hold on the back fender of an old-type Liverpool tram.

Two boys stealing a ride on the bumper of a London United tram bound for Hammersmith in the years between the two world wars.

Stealing rides on the rear fenders of the more modern and faster Liverpool trams was not only more difficult but also a highly foolish and dangerous practice. To discourage young boys from risking life and limb, this posed picture was taken on Prince Albert Road, shortly after the Second World War, the tramcar in the scene being Green Goddess No. 936.

A number of boys and youths took advantage of the employment of women by stealing rides on the back buffer and steps of trams. Conductresses complained of boys 'spitting in their faces and that the language that the boys indulged in was indecent and disgraceful beyond expression'. Two boys were killed in falling off trams and the police were instructed to seize every boy they could lay their hands on who committed the offence. On 21 February 1916 a batch of boys was brought before the Children's Court at the Leeds Town Hall. They were bound over for 12 months in the sum of twenty shillings each and threatened that if they offended again they would each receive six strokes of the birch. They did not re-offend and the practice quickly died out.

In 1914 two youths appeared before magistrates in South Shields charged with riding on the outside of the trams. The case was recounted in *The Tramways of Jarrow and South Shields* by George Hearse (written and published by him in 1971).

The youths were prosecuted at the South Shields police court for offences against the tramway bye-laws. One of the delinquents was caught getting a surreptitious ride on the front end of a tramcar – a highly dangerous proceeding, it was pointed out to the magistrates, and much more so than the common practice of boys hanging on to the back of cars.

'If you had slipped you would probably have been run over and killed,' said the Chairman to the defendant.

'I had a good grip, Sir,' the young offender assured the Chairman.

'If you had a good grip of the birch rod it would cure you of doing things of that sort,' responded the Chairman.

The boy's excuse for his act was that he wanted to get home quickly. The motorman was unable to see him owing to the steps of the car shutting him from view, but the lad was caught by an inspector. Another boy, who when caught in the act of changing a route indicator on a tramcar, altering it from 'Market' to 'Westoe', gave the conductor the name of Jack Johnson, which aroused suspicion, and on inquiry proved to be false. The Town Clerk said that this sort of offence was becoming somewhat frequent, and was apt to mislead and inconvenience intending passengers. The Chairman said that the best punishment for these offences was a good 'jacketing' or birching, but unfortunately the bench were not able to award that punishment. They hoped, however, that the fathers would give the boys proper chastisement. Each of the defendants was fined five shillings and costs.

One instant punishment for boys riding on the back fenders was to have the slops of teacans poured over their heads. It may have been practised in one or two places, but I rather think it was a deterrent that was little used.

Tram surfing – today's equivalent of bumper riding – was practised in the early days of the new Metrolink trams in Manchester, children grabbing free rides by clinging to the back of the trams until the tram drivers or the police spotted them. In 2000 a national newspaper published a picture showing two boys clinging to the tapered end of one of the new Metrolink trams on the Eccles line. A police officer who patrolled the tramway told the newspaper that offenders would be put before the court – 'if they were still alive'.

A local newspaper the following year reported that over an eighteen-month period several youngsters had been injured and others prosecuted for tram surfing. One youth, aged seventeen, was found seriously injured on the tracks after having been knocked off a tram by, so it was thought, an overhanging tree branch. Following these incidents the Metrolink fitted CCTV cameras to the cars,

Harland and Wolff shipyard workers grab free rides home by clinging to the back of a Belfast tram on Queen's Road.

enabling drivers to spot any youngsters clinging to the back of their trams, and for some considerable while now the trams have ceased to be plagued by surfers.

In Dublin, new trams for the LUAS services have been made 'surfer proof' by designing the front in such a way that there are no footholds or protrusions for would-be surfers to cling to. The new nose of the trams has also been designed in such a way as to lessen the effect of impacts in crashes.

It was not only youngsters who rode on the bumpers of the first-generation tramcars. Their fathers were sometimes guilty of having a go, too, especially in Belfast, where some shipyard workers carried out the practice every evening on their way home. They were the bane of Belfast tram drivers and conductors, and are remembered by John Knox in the following paragraphs which he wrote for the July 2000 issue of *The Journal*, the magazine of the Tramway Museum Society.

> When I was old enough I would ride my bicycle to either Mount Pottinger or Knock depot and from about four o'clock observe the tram crews frantically prepare their trams for the journey to the Belfast shipyard of Harland and Wolff, builder of the ill-fated Titanic and many other fine ships. At its peak the shipyard of Harland and Wolff employed some 21,000 people, so it is understandable that a large number of trams were required to transport these men home via every route in the city. The trams would proceed to the terminus at Queens Island and head back to the shipyard entrance gates. There they would line up behind each other awaiting their passengers. At any one time there would be close on a hundred trams engaged on the operation of transporting the shipyard workers home.
>
> Many stories emerged about these trams and the difficulty conductors had in trying to collect fares. The problem was a number of men would jump onto the back bumper of the tram, the trams being 'Open Reds'. When the conductor had lifted the fares in the main body of the tram and approached them, they would simply jump off, and jump onto the next tram, and so on.
>
> One very true story as told to me by my father was of the driver of the leading tram awaiting to commence his journey to the city centre or its designated route refusing to move his tram until all the shipyard workers had vacated his driving platform. These men, known for their cloth caps and red lead overalls, were short on patience with a driver attempting to enforce the rule. This rule stated that 'no passengers are permitted on the driver's platform at any time', obviously for safety reasons. This poor unfortunate tram driver found himself ejected from the tram most unceremoniously, to put it mildly, and a shipyard worker known for his versatility then took over the controls. The temporary driver drove the tram to Castle Junction and left the tram standing without a driver, much to the bewilderment of a tram inspector.

Lost his Teeth among the Coppers

By R.W. Cramp

In the early days of electric tramcars, a North Country newspaper wondered in an editorial why well-behaved citizens became struggling monomaniacs, bereft of manners if not morals when boarding trams. The *Bet Gazette*, attempting to answer this, suggested that perhaps the evil lay in the tramcar itself and not in the people and that 'there is some mystic influence in the mechanism of an electric tramcar, some hypnotic attraction arising out of the way it is built, some esoteric charm in the floor boarding and glass windows, that tends to transform gentle Jekylls into hooligan Hydes'. These same cantankerous passengers would also write to tramway offices and local newspapers castigating conductors, on whose behalf R.W. Cramp, Traffic Manager for the City of Birmingham Tramways Company, took up cudgels in the following letter to the Editor of the *Bet Gazette* for 17 April 1906.

Dear Sir,

Tramway conductors as a rule are long-suffering individuals. In the course of their duties they meet with some most cantankerous people who seize the slightest peg on which to hang a complaint.

A person of this description boards a car. He delights to find the inside seemingly full, and will stand in the doorway and impede the conductor and everybody else, while he fixes a steely eye on every individual and counts them. He will not step inside and trust to the courtesy of the passengers to move up and find him a seat, but expects the conductor to make everyone generally uncomfortable, in order that the maximum amount of room shall be at his disposal. If the conductor does not do this, the passenger promptly complains, and wants to know by return what are the conductor's duties.

Then there is the passenger who squeezes himself into the seat nearest the door, so that he may be the last to pay his fare, and retain the interest on his penny until the last possible moment. If by any chance the conductor approaches him first, he searches through a multitude of pockets, as though he had mislaid the necessary coin, in order that the conductor may pass him by and not issue his ticket until he has issued the remainder.

Then we have the passenger who believes that a conductor is a walking encyclopaedia and directory rolled into one. He usually asks for the direct route to some place about two-and-three-quarter miles from the tramway track, and after the conductor, poor fellow, has directed him to the best of his ability, he does not follow the directions, but turns to the left instead of the right, and vice versa, eventually having to take a cab to arrive at his destination in time for an important appointment. Then follows a strong letter of complaint as to the thick-headedness of conductors generally, and a claim for a cab fare.

Then we have the lady of uncertain age and weight, who with a child in each arm and two parcels, pushes past the conductor into a crowded car. She looks appealingly at the meek man in the centre, who promptly offers her his seat, which without a 'Thank you' she tries to take, but accidentally sits on the knee of the person on the left instead, and offers no word of explanation. This person promptly sends a letter of complaint as to the conductor overcrowding the car.

If the conductor is of a philosophic turn of mind, he takes all these things good-humouredly. Unfortunately, however, he sometimes has to put up with a serious assault, and cases are on record where he has used a point bar with telling effect.

A case in point occurred on the 18th instant. A passenger named Spencer, King Edward's Road, Birmingham, boarded a car at New Street, West Bromwich, wishing to ride to New Inns, which is a twopenny fare, but only tendered one penny, and when asked by the conductor later on for the excess fare, struck him playfully in the mouth, causing two of his teeth to get lost among the coppers.

While the conductor was looking for his point bar, the passenger in question jumped from the car, and ran at full speed down a side street. Luckily another passenger had seen the occurrence and followed. The passenger who had committed the assault, however, proved fleet of foot, and his pursuer accordingly hailed a passing motorcar, and speedily overhauled him. The result was that a police constable who happened to be on the spot took the offender's name and address, and he was summoned at West Bromwich Police Court on the 26th instant, where much to his surprise fines of £5 and costs for assaulting the conductor, and five shillings and costs for using obscene language were imposed.

It is refreshing to see a passenger taking up the cudgels on behalf of a conductor in this manner, as in the majority of cases the boot is on the other leg.

We have suitably thanked the gentleman who was instrumental in obtaining this conviction, and sent him a small sum to cover his out-of-pocket expenses. No doubt the magistrates were influenced to some extent by the disinterested action of this gentleman, and made the fines exemplary.

Yours faithfully,
R.W. Cramp
Traffic Manager, City of Birmingham Tramways Company

A cheerful conductor climbs the stairs on a restored Liverpool Green Goddess preserved at the National Tramway Museum. In the early years of trams, conductors were often castigated by passengers – but the traffic manager of the City of Birmingham Tramways Company was one who jumped to their defence in 1906.

My Forty-Five-Mile Trip in Oldest Tram

By George Elgin

Journalist George Elgin took a forty-five-mile trip round Liverpool on board a special tour tram packed with tram lovers. His account of the trip appeared in the *Liverpool Evening Express* in March 1954 and is reproduced by permission of the *Liverpool Daily Post and Echo*.

Elgin has performed many exploits in search of stories, but never until yesterday had he undergone ordeal by tramcar. While you probably were enjoying your Sunday afternoon by the fire, Elgin was out and about in a blizzard, riding forty-five miles around Liverpool in a corporation tram. In the city's oldest tram in fact. And now he tells his story.

Some weeks ago, he says, I wrote critically about Liverpool Passenger Transport. That criticism made the Liverpool branch of the Light Railway Transport League see in me a kindred spirit, for they themselves are arch critics of the Committee's policies.

So the League invited me to join them on a £6 tram ride, a tour of every yard of tram-track in the city.

That was why, at 1 p.m. yesterday, I, with sixty Liverpool tramcar enthusiasts, was aboard No. 766 when she pulled away from the Old Haymarket for Utting Avenue East, Kirkby, Anfield, Green Lane, Page Moss and points north, east and south.

No. 766 carried us for mile after mile and hour after hour. We defied all tramcar regulations. We smoked on the lower deck. We rang the bell for the driver to stop and start. We held up the tram while we got off to take photographs. We had a conductor aboard, but we paid him no fares. And we even rode with the driver on his platform.

Driver Harry Tindale was told to go as fast or as slow as we liked. We tried speed bursts along Muirhead Avenue and No. 766 proved she could still skip along at 40 mph.

'She's a grand old tram,' said Liverpool solicitor Mr H.E. Piercy. 'Built in 1931 from a design of about 1901, she can still beat your buses for speed, comfort and carrying capacity.'

Solicitor Piercy is one of the Transport League's liveliest members; he has roamed the world in his passion for trams. In 1951 he went to South America to ride on Brazilian and Peruvian luxury trams. In 1952 he was riding trams in Toronto, Pittsburgh and San Francisco.

As No. 766 made a near-record run to Kirkby, Old Haymarket to the Trading Estate in twenty-three minutes, League members joined in telling me their opinion of Liverpool Transport.

Oh Mr Chancellor Bidston and your colleagues of the Transport Committee how your ears must have burned. You were accused of not giving trams a fair chance in Liverpool. League members say you went a step in the right direction with the Green Goddesses, and then got cold feet and refused to follow the modern trend in tramcars any farther.

Even now, when you have declared against trams, they challenge you to give the Liverpool public the

Uniquely, there were three turning circles for trams at Liverpool's Pier Head, which was the hub of the city's tramway network toured by reporter George Elgin and sixty tram enthusiasts in 1954.

chance to see and try one of the single-deck super tramcars, such as are running in practically every city in the world outside Britain.

As No. 766 skipped through the snow I learned things about trams I never knew before. Driver Tindale told me that the fewer trams there are on a route the faster they can go because each tram gets more current. So the illusion that the last tram back to town is the fastest of the day isn't an illusion at all. As for speed, I was assured that a Green Goddess is capable of 60 mph.

They were a knowledgeable lot these amateur transport experts. They included engineers, designers, teachers, architects, a chemist, and dockers. Mr Norman Forbes, master at Liverpool Institute, who spends his holidays wherever there are trams he can study – he has been to Canada, the United States, and most European countries – told me that one reason why our public transport is in a mess is that too many of us insist on sitting down on buses and trams.

'Our conception of public transport is wrong,' he said. 'While we demand seats other people put speed and carrying capacity first, and passengers willingly stand. And because they prefer safety, other countries have turned to single-deck vehicles with automatic doors and separate exits and entrances.'

Trams in Literature

By Dennis Gill

There are some fascinating narratives on trams in biographies and works of fiction, depicting them in trouble, in childhood excursions, in times of war, in extremes of weather; in fact, in all kinds of situations. Some are included at length in this anthology; some of those that are not, but which are worth a mention, are touched on briefly in this chapter.

Trams crop up in literature when you least expect them. Sometimes they appear right at the end of a book, as in Thomas Armstrong's *The Crowthers of Bankdam*, when the mill of Simeon Crowther is clearly lit up in the blue electric flash of a tramcar's trolley pole being swung round. And sometimes they appear right at the beginning, as in Henry Morton Robinson's novel *The Cardinal*, about the rise of a catholic priest to the eminent position of cardinal. The first chapter of this book opens in the year 1915 with a sketch of Boston trolleycar No. 3, an antiquated four-wheeler which Robinson calls a 'balky shrew'. The reader then follows the car's progress along the streets and into the depot, where it is put to bed. The driver, who has come to the end of his shift, is none other than the father of the priest who is destined for greater things.

Few novels contain descriptions of trams as evocative as that in *The Cardinal*, but one that does go into considerable detail, especially about driving a tram, is *Camberwell Beauty* by Ralph Harris, first published by Peter Davies as *Spring Call* in 1977. It's a book bound to be enjoyed more by tram enthusiasts than butterfly fanatics. For this Camberwell Beauty is, in fact, not the large butterfly first recorded in England at Camberwell in 1748, but a London tramcar on the No. 35 route which ran from north to south of the metropolis. The tram is driven by Colin Feltham, the main character in the story, and there is a lengthy account of him at the controls on one of his trips. The narrative is a lusty saga of low-life in pre-war London, and Ralph Harris (actually S.P. Harris, a tram enthusiast who was one of the founder members of the Light Railway Transport League), pens an earthy story about Colin's amorous adventures. Written with a great deal of passion, observation and clearly a love of trams, this rumbustious bawdy no-holds-barred romp ends with Colin's death on a tramcar as he sets off on his honeymoon. The name Feltham, by the way, is of significance to those who have a love of London's trams, being the name given to a class of tramcar made at Feltham in Middlesex.

Another tramway murder, this time in a tram shed, occurs in Anne Baker's poignant novel *Goodbye Liverpool*. The murderer is a Liverpool Corporation tram driver, who turns out to be a violent man and a bigamist. At the end of one of his duties, as he parks his No. 33 tram in Dingle Depot, he receives a visit from his first wife and their son, Peter, whom he hasn't seen for a long time. The couple have a heated argument which ends with him strangling his wife. He flees the scene by the first available tram out of the depot.

Yet another novel featuring a murder on a tram is Ellery Queen's *The Tragedy of X*. A man boards a New York tram with colleagues, but it is very packed, so packed that he has to hold his fare above his head for the conductor to be able to grab hold of it. As the car approaches Ninth Avenue the man brings out his silver spectacle case from his pocket and notices the palm and underskin of his left hand have started to bleed. By the time the car has reached Ninth Avenue the man is panting and groaning and somewhere between Ninth Avenue and Tenth Avenue he collapses lifeless onto the lap of a young lady. Police reinforcements are sent for, nobody is allowed off the tram, and a jam of traffic builds up.

The film *Black Orpheus* was shot on the Santa Teresa tramway in Rio de Janeiro, Brazil, which crosses this abandoned eighteenth-century aqueduct some 45 m above ground between Santa Teresa and the Santo Antonio hills. The tramway's car barn was featured in the film, and today the tramway is a national monument and tourist attraction.

Death is much in evidence in the play *Orfeu da Conceicao* (*Black Orpheus*), written by Vinicius de Moraes, and loosely based on the classic tragedy of Orpheus and Eurydice. Orpheus is a tram driver on the Rio de Janeiro town tramway system and at the end of the day he returns his tram to the depot. His girlfriend, Eurydice, goes to meet him there. It is carnival time and a character dressed as Death follows her to the depot. To get away from him, Eurydice climbs a washing gantry, but Death continues his pursuit. Eurydice then screams, and is heard by Orpheus who, in order to see what is going on, switches on the depot lights which also energises the overhead. Finally, to get away from Death, Eurydice flings herself from the gantry but comes into contact with the live overhead and is killed.

Death on a tram also occurs in Boris Pasternak's romantic novel *Doctor Zhivago*, which traces the fortunes of a Moscow doctor, Yuri Zhivago, and his family, following the Russian revolution. Towards the end of the novel we find the doctor, broken in health and leading an anonymous life in the back streets of Moscow. He boards a Moscow tram to take him to a hospital where, that very day, he is starting a new job. From his seat on the tram, Yuri catches sight of a lady wearing a lilac dress walking on the pavement, but does not realise that she is a governess he had met at another hospital during the war. He catches sight of her several times because the tram, which is packed, has a defective motor and keeps breaking down. The driver has to alight now and then to do running repairs. It is a hot, stormy day and Yuri suddenly feels faint. He is seized by panic and then a stab of pain. He pushes through the solid mass of passengers to the platform, and manages to climb down from the car before collapsing and falling dead on the cobbles. The lady in lilac, catching up with the tram again, stops briefly to look at the body, but does not recognise Yuri and continues on her way. The film of the story, directed by David Lean in 1965, was filmed in Granada, and the sequence showing Yuri's last moments were shot on Madrid Tramways car No. 477, which now stands on a plinth in the Pinar de Chamartin metro station in Madrid. A plaque states that the car was built in Charleroi in 1908 and was featured in the film *Dr Zhivago*. It also reveals that the tram appeared in the film *Las bicicletas son para el verano* in 1984.

There are a number of novels covering the struggles in Ireland, one of the most famous of these being F.L. Green's *Odd Man Out*, which is set in Belfast. It starts with a militant revolutionary organisation's armed raid on a mill. During the raid a cashier is shot dead and members of the organisation are soon being hunted by the police. To elude capture by policemen hot on his heels, Seamus, an adjutant in the organisation, boards a crowded tramcar travelling from Belfast city centre to the Shankill Road. Unluckily for Seamus the tramcar becomes grossly overcrowded, so much so that the driver is forced to fetch a policeman to eject some of the passengers. Seeing the policeman, Seamus makes his escape via the front platform and disappears into the night. A film of the book was made starring James Mason, with Warren Beatty playing the part of Seamus, and the rowdy scene on the tram was filmed on board an old Belfast balcony tramcar (No. 59) within the confines of Sandy Row depot in 1946. Belfast Corporation did up the car specially for the film and although it got damaged (intentionally) in the film,

Liverpool trams have inspired or caught the imagination of many Merseyside writers, and entertainers, such as Helen Forrester, Frank Unwin and George Melly. The two cars on the right were known as 'Bellamy' cars and are standing at the Pier Head terminus. When this photograph was taken, in the mid-1930s, the two cars were nearing the end of their days.

the corporation afterwards found it in much better condition than its fellows and promptly returned it to service.

The hard times in Dublin before the First World War are vividly portrayed by James Plunkett in his novel *Strumpet City*. It touches on the struggle between Jim Larkin, leader of the Irish Transport and General Workers' Union, and William Martin Murphy, the chairman of the Dublin United Tramways. Larkin calls the tram workers out on strike on the day of the Dublin Horse Show. Only a few trams are running (guarded by policemen), and after having seen one that has been attacked by strikers, Father O'Connor, a junior parish priest in a Dublin slum, decides to walk home. He later boards a tram which becomes embroiled in a battle between strikers and the police. The dramatic scenes involving the tram make absorbing reading.

M.R. James, born in 1862, was a famous writer of ghost stories. In one of his stories, 'Casting the Runes', which appears in the book *The Ghost Stories of M.R. James*, a strange advertisement appears in a London tramcar one evening and then vanishes. It was seen by the tram driver, his conductor and one of the passengers, Edward Dunning, an authority on alchemy. All three are completely mystified by its disappearance later that evening, and have some difficulty convincing officials that they clearly saw it.

There are several mentions of trams in the novel *London Belongs to Me* by Norman Collins. The novel is about Londoners, in particular a mixed bag of people living in rented accommodation all under one roof at 10 Dulcimer Street. One of them is Frederick Josser, an office worker who struggles to take home on a tramcar the clock he received at his retirement presentation. He receives growls from his fellow passengers as he edges his marble clock past them towards an empty seat on the upper deck.

The art of jumping off a moving tram was perfected by Robert Douglas during his upbringing in the Maryhill district of Glasgow. It is one of many memories of journeys on Glasgow's trams recounted in his autobiography *Night Song of the Last Tram*. His alighting technique involved 'leaning backwards off the step, letting go the handrail and kicking against the step at the same time' as he jumped off. He appears to have made the feat look quite easy – as though he was walking off the tram.

Helen Forrester has written numerous books about Merseyside, a number of them being about her upbringing in the area. *Liverpool Miss* is the second volume about her poverty-stricken childhood in Liverpool during the Depression, and trams feature in it greatly. For example, she describes an adventurous journey by tram during a severe snowstorm which ends with the tram being abandoned at West Derby Road after being brought to a halt by deep snow. She bravely carries on by foot, and ultimately reaches the junction of Upper Parliament Street and Smithdown Road where she is able to wave down a tram that will get her home.

In *Lime Street at Two*, Helen Forrester continues the moving story of her early life, and describes what it was like to travel by tram through Liverpool on a foggy November day at the height of the Blitz in the Second World War, with buildings ablaze, timber crackling and waves of heat sweeping through the lower saloon.

Another authoress who writes descriptively about Merseyside is Anne Baker. In her book *Like Father, Like*

Visiting trams at the Liverpool tram races which captured the imagination of race-goers in Liverpool and which were recalled by Philip Purser in the *Liverpool Echo*. The trams (from left) are from Leeds, Sunderland and Birmingham. The Birmingham tram must have been re-gauged to enable it to compete. One of the favourite dates for the races was 1 April.

Trams in Manchester are featured in the works of regional writer Howard Spring. In this view, Market Street is packed with trams and people as a No. 11A tram to Alexandra Park turns into Cross Street on a clear but cold day.

Daughter she pens a picture of what life was like in Birkenhead between the 1920s and 1950s. To the mother in the story the most amazing thing about the town is the electric trams. Before her arrival in Birkenhead she had never set eyes on one, let alone ridden in one, the Welsh town where she had grown up having had no electricity whatsoever.

Liverpool trams feature again in a story by Philip Purser which appeared in the *Liverpool Echo* on 1 April 1963. The story, *The Last Great Tram Race*, is about the tram races which were held at the Tramadrome just off the main Southport Road. The races were almost as popular as the Grand National at Aintree. Apparently the competing trams had to be double deck and stripped of their top deck fittings to reduce the chances of them overturning on the curves, which they entered at 30 mph. According to Mr Purser, trams from as far as Dundee, Bristol and London took part.

Liverpool trams are recalled yet again in Frank Unwin's *Reflections on the Mersey*. Frank gives a vivid account of what happened when a trolley wheel fell off a Liverpool tram and landed at the feet of a policeman. Apparently the policeman picked it up and, as it was red hot, received severe burns. According to Frank, the unfortunate policeman, 'screaming like a Dervish, flung the object away from him and disappeared with the speed of an Olympic Games sprinter in the direction of the Pier Head'.

The Last Days of Dolwyn, a true story written by Emlyn Williams and filmed by him in 1949, is set in mid-Wales. A young man, played by Richard Burton, goes to Liverpool for a job interview. He returns complaining of the noise made by the trams, which had kept him awake all night. His unworldly grandmother, played by Dame Edith Evans, has never heard the word before and speculates about what a tram is, concluding that it is probably some sort of prostitute!

Richard Church, the London novelist and essayist, watched London's trams grow and disappear. In his autobiography *The Golden Sovereign*, he described at some length how the London County Council trams became his 'secret university' when he took to studying on them to and from his work. His cloister stretched from Camberwell Green to the Elephant and Castle. It was not the most celebrated of universities, but it served his purpose. Very unkindly, he called the LCC tram 'this Caliban' and 'an expressionless land-ark', and the track it ran on 'an armoury of razor-edged rails'.

Many famous regional writers have written about trams in their novels. Extracts from D.H. Lawrence and Arnold Bennett are reproduced elsewhere in this anthology (see pages 23, 27, 79 and 184). Also worth reading are J.B. Priestley and Thomas Armstrong, who write about Yorkshire; Howard Spring, who writes on Manchester; and James Joyce, on Dublin.

The Good Companions by J.B. Priestley is an

nostalgic trip on a Cheetham Hill tram, she is not enamoured by it, especially its upper deck, where the atmosphere is thick with tobacco smoke. She quickly alights, wondering how she stood that sort of thing day in and day out. The tramway sequences for the film of *Shabby Tiger* were shot at the National Tramway Museum, where part of the museum site was made to look like a Manchester street scene, and a double-deck Johannesburg tram doctored to look like a Manchester tram of the 1930s.

Two colourful incidents about trams are to be found in Joseph Quaney's biography of his father, Kerr (Kyran) Quaney. Entitled *A Penny to Nelson's Pillar*, it tells about his father's experiences while working on the construction of the Dublin to Clontarf tramway, and how once, while inspecting the overhead wires, he was left dangling from one when the tram ran away from under him, leaving him with no alternative but to drop into an overcoat stretched out by four workmen. He also recounts the time his father gave up his seat in a New Orleans tram to an African-American lady carrying a baby, in the days when trams were segregated. Kerr Quaney's courteous act didn't meet with the approval of the white passengers and very quickly led to a riot.

In his autobiography *A London Boyhood*, Ian Niall gives an account of how a London policeman had his own methods of dealing with violent individuals. Apparently, instead of waiting for a paddy wagon to cart culprits to the local police station, he commandeered an Uxbridge Road tram instead. The driver was given strict instructions to drive straight to the police station and not to stop for anybody.

Malcolm is an Australian film about a Melbourne tram driver who plans a bank robbery and gets away with it using modern technology and a mock tram. He flees to Portugal and is seen at the end of the film enjoying his fortune in Lisbon by watching trams pass. The film appeared in 1986, and was the first to be made by Nadia Tass and David Parker, who wrote the script.

A Manchester street scene recreated at the National Tramway Museum in 1973 for ITV's seven-part dramatised production of *Shabby Tiger* by Howard Spring. The tram is actually Johannesburg No. 66, one of the overseas vehicles in the museum's collection, in the guise of Manchester car No. 717.

enjoyable novel about a concert party's exploits in England between the two world wars. It is one of J.B. Priestley's most popular works, and has been turned into a film and television musical. The concert party's engagements take it to several towns well served by trams. One of these towns is Luddenstall, and a member of the party writes to a former fellow-teacher about the trams there, telling him how they seem to climb the hills vertically, like mountain railways. There is also a fascinating portrayal of the party's handyman, Jess Oakroyd, suffering 'two-pennorth o' misery' on the upper deck of a tram in Bruddersford, a name that conjures up visions of Bradford and Huddersfield.

Howard Spring, a former *Manchester Guardian* reporter who became the author of fourteen highly acclaimed bestsellers, wrote two novels tracing the fortunes of Rachel Rosing, a Jewess of great beauty born in the Cheetham Hill district of Manchester. The two books, *Shabby Tiger* and its sequel *Rachel Rosing*, give Rachel's impressions of the city's red trams and some of the districts they served. When she takes a

A Vanished Tram Comes Back to Life

By James Kilroy

When he was a lad, James Kilroy, the son of a journalist with the *Irish Press* newspaper, was old enough to remember the green Dublin trams, operated by Córas Iompair Éireann, and the blue

and cream Hill of Howth trams, which were operated by the Great Northern Railway of Ireland. He recalls his first encounter with the hill trams, and in an article he contributed to the magazine *Tramway Review* in Spring 2003 relates how he eventually came to help restore one.

I was first struck by the great differences between the Hill trams and the Dublin city trams. To begin with, the city trams were all enclosed, and covered from stem to stern with advertisements, whereas the Hill trams were all open-toppers and had no advertisements, apart from the occasional church notice about the parish fête. The livery of the Dublin tram was a dull green and cream, whereas the Hill trams were bright blue and white with red lettering. The Dublin trams were packed with silent and sombre-looking people on their way to work or shopping expeditions, whereas the Hill trams were packed with tourists and holidaymakers, bustling merrily, chatting excitedly and laughing out loud. The Dublin trams passed between dark forbidding buildings and ran on cobbled streets, while the Hill trams trundled over sleepers and gravel.

But the greatest departure of all was that the Hill trams sailed by some of the most magnificent scenery in Ireland. The rugged gorse-clad hills, the wind-swept valleys, the tumbling rocks and surging seas. To be on the open upper deck was like floating along on a magic wooden carpet at treetop level. The views across Dublin Bay were breathtaking, and, as the blue and white tramcars rolled powerlessly downhill from the summit to the harbour, on a clear day one could see the Mountains of Mourne, so famous in song and story. I say 'powerlessly', because it was the practice of the company to lower the trolley-boom and allow the cars to make the descent by gravity to Howth station. This was a money-saving measure, but could not be practised after dark, as the power would be needed to operate the lights. The tram passed close by megalithic tombs, wooded glens, early Christian oratories, Danish ramparts and two medieval castles. I recall the many stories my father would tell about this historic peninsular; it became a place of magic and intrigue for me, and the most magic part of all to a little boy were the trams themselves. As with the older Dublin trams, the Hill trams also embedded themselves deeply in my mind and memory. No wonder that, many years later, I became a willing slave to the restoration of these fine machines.

I was at boarding school when the system was closed down, and, being something of a recluse, I knew nothing about its demise. At the time I used to fish a lot in Howth, in both her quarries and her seas. Every weekend I would cycle to Howth from the little village of Artane, and, no matter where I went, I was never very far from my beloved tramway. I would stop and watch the trams at Sutton Cross, as they passed on the level, and here there was always a magnificent shower of sparks each time the trolley pole passed over the *dead* section of overhead power cable, where the city trams once crossed over. At Howth Harbour I loved the hollow, rumbling groans when the trams passed over the ageing steel viaduct as they descended into Howth Station....

The closure[1] of such an ancient mode of transport, which passed through such a scenic wilderness, was, in my opinion, nothing short of public vandalism. What a tourist attraction it would be today had it survived, and how short-sighted it all was!

Seen in service in happier days, Hill of Howth tramcar No. 9, which has been restored by James Kilroy and others, passes car No. 4, another survivor which is now preserved in the Ulster Folk and Transport Museum at Cultra.

I continued with my life, qualified as an architect in 1968, married my wife Helen the following year, and went to work in London. After about five years, we returned and bought a house in Howth. It wasn't long before I began remembering the trams and their passing. One evening, when out walking with my elder daughter, Claire, I tripped over something hidden in the long grass, adjacent to the old trackbed at the summit. It was the remains of an old traction pole. This stirred deep feelings within me about the trams and I resolved to discover what had happened to them. I learnt that one of these fine cars had survived, and could be seen at Castleruddery in County Wicklow, at the premises of the Transport Museum Society of Ireland.

I was not prepared for what I found when I visited there in 1976. There, in the open, was poor No. 9, *Ireland's last tram*, decayed beyond recognition, stripped to skeletal remains by vandals, and hardly recognisable as a tram. I remembered her glorious past and resolved there and then to save her. I joined the Museum Society and set about the slow task of her restoration. I had no idea what lay ahead of me, and if I had fully understood the pitfalls and the pains, I doubt if I would have had the courage to take on such an onerous commitment. It was probably my ignorance more than anything else that saved No. 9....

Together with 'An Taisce', the National Heritage Society, I organised a sponsored walk round Howth Hill to raise the necessary capital.... We raised enough money to place No. 9 under cover, and the serious work of restoration could then begin....

After raising the capital, the second task was to carefully strip down the tram to its bones, so to speak, to enable it to dry out, and ascertain how deeply the rot had gone. It is critical to measure everything with great precision, and, as an architect, this part I found easy. I was never bad at woodwork, and soon new components were being turned out in my garage. The truth is that I love working with wood. You have heard of the famous *Kilroy Silk*; well, I have been called *Kilroy Wood* by those who know me. Same name, different material. On the other hand, I had little or no knowledge of steel working at the time, and I had to find someone to help me. I was fortunate in having the support of two museum colleagues, John Wheatly and John Kelleher. Without their inexhaustible efforts and shared enthusiasm I simply could not have continued. Then there were the many helping hands who scraped, sanded and scratched endlessly, each with their own special skills, and all with the most vital requirement of all – *patience*!...

The most *patient* chap of all was Kevin Carleton (whose grandfather worked on the Hill trams). On his first day of arrival we put him to work scraping the under-belly of No. 9. Well, just like Michelangelo, Kevin stayed on his back under the tram for three long months, scratching and scraping and painting incessantly. We would completely forget about him for hours at a time, and all we could see of him was his feet sticking out. I believe that there were some short-time members of the team who never saw his face. Kevin vanished as silently as he appeared when he married and left to raise his family.

The Hill of Howth tramcar No. 9 was finally completed around 1990, and had the distinction of entering the St Patrick's Day parade on 17 March 1992. She was paraded down our nation's main street, O'Connell Street, the haunt of the old Dublin tram, led by a pipe band in a moment of great triumph for all concerned. It took many years to complete, and a great deal of money, not one penny of which came from the state or any government office....

[1] In 1959.

Hill of Howth tramcar No. 9, with its bodywork fully restored, returns from the St Patrick's Day parade in Dublin. It is now being re-motored at the National Transport Museum's premises at Howth Castle Demesne, Dublin. In front of the tram are Bill Garrioch, vice-chairman; James Kilroy, team leader; and Brian Greene, painter.

Trackwork was his Passion

By Dennis Gill and Andrew Grimes

Stanley Swift of Manchester was unique in the annals of collecting. He collected not stamps or bottles of wine or football programmes, but tramway rail, spending thousands of hours cutting off sections of it with a hacksaw. His hobby brought him considerable fame, especially in the Manchester area, where he was regularly interviewed by the media. I profiled him in my book *Tramcar Treasury* (published by Allen and Unwin in 1963), and again in 1991 when I was invited to give the Walter Gratwicke Memorial Lecture to members of the Tramway and Light Railway Society at the Charing Cross Hotel in London. My subject for the lecture was 'The Tram Enthusiast', and Stanley was given more than a passing mention. The following is a condensed version of what I had to say about him on that occasion, and it is followed by a profile of him written by Manchester newspaper reporter Andrew Grimes.

> When it comes to collecting, nobody can match the late lamented Stanley Swift's passion for trackwork. Dear Stanley! He first came clinking and clanking into our lives on a Sheffield tramway tour way back in 1957. By the time of his death in 1986 he had amassed a collection of tram rail weighing many tons, ranging from small shims or slices which he cut off with a hacksaw to a complete Glasgow tramway crossing.
>
> He travelled the length and breadth of Britain collecting them from every tramway there ever was, including remote or little-known lines like Cruden Bay, in Scotland, and Aldershot. His pride and joy was a section of 1767 rail from the South Staffordshire Ironworks – a find surely of some archaeological significance. He also treasured an 1898 shim of rail from Glasgow on which the makers, Phoenix Ironworks, had incorrectly spelt their name 'Phoneix'.
>
> Stanley was a mine of information on trackwork, and tramway historians regularly consulted him. From Stanley we learnt, for instance, that horse tram track was laid on George Stephenson's system of fish-belly railway rails chaired to sleepers and paved up with setts and with no guard rail.
>
> From Stanley we learnt that before the British Standard Specification for track was introduced in 1902, one manufacturer was supplying as many as 200 different rail sections to his customers. And I shouldn't be surprised if Stanley had every one of them. If we didn't know the difference between a 'Dicker' end and a fish bolt before we met Stanley we certainly do now.
>
> I think Stanley scaled heights of enthusiasm that none of us can ever to hope reach. He spent so much time at Glasgow Tramways' Barrland Street permanent way yard that they gave him his own workbench there. In the public's eye, the grey stooping bespectacled and bemedalled figure of Stanley Swift was the most famous tramway enthusiast of all time. They loved him everywhere, and they still recall him today. Reporters and radio and TV interviewers prized him as others would an expensive antique or curio. He made good headlines for them. They dubbed him 'King of the Tramways' and 'Stan the Tram', tributes he well deserved.

Andrew Grimes of the *Manchester Evening News* was a reporter who profiled Stanley more than once. This extract is from an article he wrote about Stanley on 30 May 1972, under the headline 'The Life that Runs on Rails'.

> Stanley Swift lives in cubicle 240 on the top floor of the Salvation Army hostel just round the corner from Strangeways Jail. There is just room for a bookshelf on which he keeps all the literature he needs for pleasure and research – Winston's Simplified Dictionary, Larousse's classical encyclopaedia, Our Boys' Best Annual, a history of the railways, and a 1917 catalogue of the Lorraine Steel Company's tramway track. Stored behind his bed are thirty-odd classical records which have been of no use to him since his gramophone was stolen when he wasn't looking, and a pile of symphonic and operatic scores, including a complete one of *La Traviata* which he has

Stanley Swift cutting off a section of tram rail for his collection, which included pieces from many corners of the globe.

annotated with his own stage directions. Over one stave he's put the word 'Pow!' to make it look more dramatic.

But the main decor of his cubicle, and the first thing he sees every morning when he wakes up, is a huge piece of hardboard to which are fixed rows and rows of what look like shiny new spanners. They are in fact slices of tram rail....

I met Mr Swift in the hostel's reception hall. The lapels of his jacket were emblazoned with tram-drivers' badges and his suit and hair were powdered with rust from his hacking operations in the workshop.

'Come down and see,' he said excitedly. I followed him down two flights of stairs and by the time we'd reached the bottom he had tried to explain varying nuances of a Lancashire tramline, a Flemish tramline, a horse-drawn tramline, a Derby tramline, and thrown in a witty quotation from *Don Giovanni* for good measure. He talks fast.

Down in the workshop he donned a plastic eye-shield, stuck a great hunk of metal into a vice, and started sawing away. 'I wear this thing,' he shouted over the scraping and the sparking, 'so that no ill fate will befall me. Before I made the mask it cost me £4.50 for a new pair of specs. A chip flew out and hit me right in the lens.'

He was sawing up a piece of tram-rail from Tottington. 'Don't you know,' he suddenly shouted, whirling round on me with fire in his eyes, 'what happened at Hazel Grove in 1910?'

No I don't know.

'Well some wag told the women that they had to blacklead the tramlines by Act of Parliament. And if they didn't the lines would be torn up and the tram service taken away. So there they all were every morning, forty women on their knees blackleading the tramlines....'[1]

The point of the story, he explained, was that in Tottington, where the rail he was working on came from, all the women blackleaded the tramlines as a matter of course, just like they scoured the flagstones ... 'But it didn't half upset the tram drivers. They were sliding all over the place. All over the place.'

We went up six flights of stairs to his cubicle. From the bookshelf he took down a ledger in which he has painstakingly recorded 1,500 pieces of tram rail, each one excavated by himself from the highways of Britain and Europe. 'I wouldn't swear that I'm the only one who collects tram rails,' he said, 'but I'm certain I'm the only one who collects them seriously. Naturally, I have to obtain permission from the authorities to get them. Sometimes they let me dig up the road to find a piece. Sometimes they're digging the road themselves and all I have to do is to take along my hacksaw. It takes about an hour to saw through a piece.'

Last year he went on a track finding tour of the continent. He trundled a trolley through Germany, France, Belgium and Holland, stopping to gouge up bits of rail wherever the authorities would let him. He lugged the junk back to the boat on a trolley and in a hold-all slung over his shoulder. 'I was greatly laden,' he says, delightedly. The trip was partly financed by savings from his £7.10 a week social security

A comic postcard showing a housewife blackleading the tramlines in Hazel Grove in the days when it was called Bullock Smithy.

A display at the Greater Manchester Museum of Transport showing some of the shims of local tram rails cut by Stanley Swift.

allowance (of which £5.25 is deducted for his keep at the hostel). A tram enthusiast friend in Oldham paid the boat fare.

When Mr Swift first began collecting rails in 1958, Glasgow, Sheffield and Leeds still operated tramway systems. Now they are all gone. He was on the last tram procession in Sheffield and on the last service tram in Leeds....

Still, he's greatly appreciated at the Salvation Army hostel, where he plays the piano at the Sunday services. 'I wouldn't say that Stanley's a concert pianist,' a friend of his told me, 'but he's certainly a loud pianist. If you look at the piano, you'll see there's a bend in the keyboard.'

[1] Hazel Grove (formerly called Bullock Smithy) is part of Stockport, and the blackleading of tramlines is part of its folklore. Whether it is true or apocryphal is left for us to decide. It is said the Grovers also put 't' pig on t' wall to watch the Grove Band turn out' and 'put wire-nettin' up ter keep the smallpox out'! These stories are recorded in verse and on comic postcards.

Another World

By John H. Price

John H. Price, former editor of *Cook's Continental Timetable*, was one of the country's leading tramway enthusiasts, and what he didn't know about tramways wasn't worth knowing. In the summer of 1955, when he was secretary of the Light Railway Transport League, he accompanied a party of members on a tour of the Scottish Tramways. His report of the tour appeared later that year in the League's magazine *Modern Tramway*, and in it he penned a wonderful tribute to the Glasgow tram. A prolific writer on tramways, he considered the report to be one of his finest descriptive pieces.

Before we get down to the serious business of visiting Scotland's fourth and largest tramway – Glasgow – there are two side-trips to be described. The first we made from Aberdeen, an hour's journey north to Cruden Bay, which once had Britain's only *hoteleigene Strassenbahn*, a now-vanished affair which ran from a railway station to a big hotel. So much we knew, but we found that the railway and big hotel had vanished as well as the tramway, leaving only a golf course, a derelict laundry, two poles and a narrow curving trail of weeds and dead rabbits; we wandered around disconsolately and came away, only to find later that the two car bodies still exist as summer-houses a few miles inland, and we had missed them. Heigh-ho, such is life.

The other excursion was that of 5 August to Kinlochleven and Fort William. Who said Scotland had no narrow gauge? In these Highland fastnesses are two aluminium works with real 3 ft-gauge railways, the Kinlochleven one a brief electric affair

with rather Continental pantographs and bowstring bracket arms, the Fort William one twenty-one miles long with steam traction (and chime whistles) in the lower reaches and diesel locomotives beyond. Both ran special trains for us, the Fort William one thoughtfully inscribed 'LRTL Special Visit', black lettering on yellow boards. This line runs through the bracken below Ben Nevis, and the scenery rivals that of the better-known West Highland line of British Railways just across the glen.

Which brings us down to Glasgow and another world. Forget the glens, forget the sad culture of Edinburgh, the bonhomie of Dundee, the quiet pride of Aberdeen; Glasgow, for all its engineering and commerce, is the world of the pub, the dance hall and the super cinema, neatly portrayed for tram students by the Standard Car, the Cunarder and the Coronation. The likeness is inescapable; the Cunarder is a vision of aisles, soft lights and waltzing-on-air; the Coronation has smart usherettes, moquette seats and a familiar ritzy decor, and the most typical Glaswegian of them all is the immortal Standard Car, fifty years old, all dark wood and brass fittings and blue pipe-smoke in the (upper) saloon, rolling home with a slight inebriated four-wheel motion that belongs to Will Fyfe's Glasgow as surely as do the late night crowds singing on the upper deck. Half a century hard at work, bruised, battered and patched, a lifetime's savings gone with no sign of a pension, defying every known theory of vehicle life; no wonder they are loth to go, they know that Glasgow would never be the same without them. They run in sett-paved streets on double 4 ft 7¾ in-gauge tracks, and since even pubs get television now they all carry Fischer bow collectors as aerials; they are the oldest working double-deckers in the world, but if you dared to call them obsolete, why, they would throw you downstairs. Or so one imagines, after renewing acquaintance.

When you think of the slaughter at Birmingham, Manchester and London, it seems incredible that there should still be in Britain a tramway to compare with the giants of the Continent, a tramway of 117 route miles, twenty-eight services, eleven depots and 1,000 cars, a quarter of the world's double-deck total. But there it is, and for the present generation it is likely to remain, for Glasgow is the one place in Britain where buses, trams and trolleybuses all get a fair trial and only the proportions change, a theory common abroad but so rare in Britain that the commercial transport press smugly describes its adherents as having 'no policy'. Nothing could better illustrate Glasgow's independence of London; trams like these don't care what anyone in London says, not even a Royal Commission.

To be honest, some of them are getting on a bit; the days when delegations came from all over the world to see them are gone, perhaps never to return. But if by chance a delegation did escape from London and arrived at Bath Street, they would find plenty to report on; the Dutch would like the cheap fares, the Belgians would like the *pavé* and the sidings that are laid in a weekend, the Swiss would like the neat overhead crossings and the insistence on electricity, the French would perversely like the PAYE single-deck trolleybuses, the Germans would like the technical staff library, the pointsmen's towers, the green uniforms and the slings and arrows that mark the electric points, the Italians would like the noise, the Americans would like the slickness and grid-pattern streets, the Russians would find the girl drivers twice as decorative as their own, and they would all go home full of enthusiasm for the splendid modern cars with their glass roofs (why is it that of short-stage vehicles this excellent feature only appears in trams?) and would write in glowing terms of the majestic Coronation bogie cars and their post-

Glasgow standard tramcar No. 416. It was this type of tram, with dark wood and brass fittings and defying every known theory of vehicle life, which captured John Price's imagination during the summer of 1959.

war cousins which are officially Coronations Mark Two but unofficially Cunarders, the only double-deckers to wear the kilt and leave their wheels all exposed to view like a PCC car. They would also report on the buses and trolleybuses; but unless you told them, they would never even find the Underground.

Caught Up in Conflict

By Dennis Gill, with extracts from Michael Corcoran and Mike Maybin

The Irish Troubles cover a long period of British history, and the battles for Home Rule have resulted in thousands of deaths and injuries. They also placed an intolerable burden on the tramways, particularly those in Dublin and Belfast.

The Easter Rising in 1916 was one of the bloodiest conflicts during the Troubles. It left 450 people dead and nearly 3,000 injured, almost all in Dublin. During the rebellion, tramcars were fired upon and some were commandeered and overturned by revolutionaries to make barricades. Several miles of overhead tram wire were brought down by rifle fire and the trolley standards supporting the wires were damaged by shells. Tram crews demonstrated remarkable courage during the shooting, like the driver who was chased and fired on after he had immobilised his tram by throwing away the controller key, and like the crew who reversed their tram and drove away at speed despite having a fusillade of bullets fired over their heads. But not everybody was so lucky, as was revealed in the 8 June 1916 issue of the *Tramway and Railway World*, which gave a detailed report of the fate of two cars and tramwaymen caught up in the conflict.

In Sackville Street one of the Howth cars was stopped and the motorman and conductor were covered with revolvers and ordered to leave. An endeavour was made to upset this car by hand to form a barricade for Earl Street, but the attempt failed. Then a charge of dynamite was put beneath it and exploded, but it did little or no harm. Eventually this car was burnt owing to the adjoining houses having caught fire and fallen upon it. Another car was caught on the South Quay and was also burnt in the same way.... One motorman, in running his car out of the danger zone, was seriously wounded, while another employee, who was coming from a city depot, was killed by rifle fire from the General Post Office. Several tramwaymen were wounded by stray bullets in the vicinity of their homes.... Sniping was very prevalent throughout the whole of the tramways, which made it uncomfortable for the men repairing the overhead wires, but by 5 May practically every feeder was temporarily repaired and the full car service was restored as far as the military authorities would allow it to run.

The struggle for independence carried on unabated in the years immediately following the Easter Rising until the establishment of the Irish Free State in 1923. Tram crews worked in extremely difficult conditions, never knowing when their trams would be boarded by terrorists or armed police. They were at risk from

Dublin tramcars and an overturned private carriage which have been seized with austere impartiality and used as barricades in the Irish Easter rebellion of 1916.

both sides in the conflict, as were the passengers. In 1920 an elderly magistrate who had been tracking down and confiscating Sinn Fein funds was dragged off a packed tram bound for Dun Laoghaire, and executed in the street in full view of the passengers, none of whom attempted to save him.

The Black and Tans, so called because they wore khaki uniforms and black hats, were formed shortly after this incident to suppress the IRA. They were recruited and armed by the Royal Irish Constabulary, and were joined a few months later by a new military or Auxiliary Division. The Black and Tans were greatly feared, roaring through the streets on Crossley tenders, armed with rifles ready to fire on anybody who dared to lob a grenade at them. They created considerable alarm among the populace, regularly stopping passing trams to search them for terrorist suspects or hidden arms. On these occasions it was not unknown for a terrorist to desperately slip his revolver down the front of his girlfriend's dress. In his history of Dublin trams, *Through Streets Broad and Narrow* (published by Midland Publishing in 2000), Michael Corcoran describes one of the searches aboard a tram.

> The late Joe Greally recalled that he was collecting fares on the top deck of a crowded tram in South Great George's Street on a summer day in 1920 when they were stopped by a patrol. Making his way towards the stairs to get to the platform as quickly as possible, he was horrified to see a pistol suddenly land in his cash bag. Thinking fast, he managed to hide it in the destination box as he started down the stairs.
>
> Trying to appear normal, he was petrified while he accompanied the raiders through the tram. After getting the Black and Tans off the car without further incident, Joe returned to the destination box, intending to retrieve the pistol and address some strong words to the inconsiderate coward who had put him in such danger. As he opened the box, two pistols fell out. The passengers stared at him impassively so he turned both weapons in as lost property and heard no more about them.
>
> Subsequently, he learned that the gun-in-the-destination-box trick was a speciality of Michael Collins, who often travelled on the Dalkey line. On these occasions, Collins usually rode on the front balcony, thus having a good view of the road ahead and close to the destination box in the event of a raid.

One of the worst atrocities in the Irish Troubles occurred on the night of Saturday 11 December 1920, when Cork's entire shopping centre and the City Hall, half a mile away, not to mention a Cork tramcar, were set on fire by armed, trigger-happy Auxiliaries and Black and Tans during a wild orgy of looting, wrecking, burning and drinking. They were seeking revenge for the deaths of sixteen Auxiliaries killed in an ambush earlier that day. The damage to the city was later estimated to be three million pounds. In the autumn 1969 issue of *Tramway Review*, Cork journalist Walter McGrath reports how the police and Auxiliaries held up the tram, ordered all the passengers off, searched and roughly handled them, fired into the tram and ordered the driver and conductor to drive it into the centre of Cork, where it was set on fire.

Terrorism did not cease after the Southern counties of Ireland gained independence. The Nationalists in the north were bitterly opposed to the partition of Ireland (which took place early in 1922) and the IRA launched a campaign of terrorism which was ongoing through most of the last century. Public transport was a prime target for the bombers and the gunmen, and the trams and buses in Belfast suffered considerable damage. In *Tramway Review* for autumn 1979, Mike Maybin, writing about Belfast trams, reports:

> On 11 May 1922 a bomb in an attaché case was found in a car in Ardoyne depot by Conductor Mansfield. It exploded without warning, causing him injuries from which he later died. Two other conductors and a cash receiver also sustained severe injuries. In a separate incident on the same day Motorman Hawthorne was shot in the foot while passing the entrance to Butler Street in the Ardoyne district. Four days later the general manager reported that a bomb had been planted on car No. 231 at Castle Junction. It had been found and rendered harmless by Henry Smith, a flower seller at the City Hall and an ex-soldier.
>
> On 18 May a man shot and fatally wounded two passengers aboard a Crumlin Road car. The murderer unfortunately escaped. On the same day a man was shot and wounded aboard a Greencastle car.
>
> Later the same month a car was set on fire at the Falls Road end of Donegall Road. It was then set in motion and careered down the hill towards a district known as 'the village'. Fortunately no injuries were caused by this action and the blazing car came to rest further down the road.
>
> Numerous acts of destruction occurred to the vehicles themselves, and conductors were frequently relieved of their takings by armed robbers. Terrorism reached such proportions as to necessitate the withdrawal of services from some routes.

Famous Cartoonist's Confession

From 600 Magazine

Rowland Emett, the famous cartoonist, best known for his drawings of fantastic trams and trains, once confessed that when he was a young man he was very unkind to trams. He made the confession at a luncheon held in his honour by George Cohen's at the Trocadero Restaurant in London in July 1952, which is the month London's trams disappeared from the city's streets. At the luncheon he was presented with a bell which bore the inscription 'To Emett, who has done more for trams than anyone in this country, from George Cohen Sons and Co. Ltd, who have done in more trams than anyone in this country'. It was presented to Mr Emett by Felix Levy, director of George Cohen's. These extracts are from the report of the luncheon, which appeared under the title 'The Emetts Come to Lunch' in the *600 Magazine*, **published by George Cohen, now the 600 Group PLC.**

This Birmingham tram, rolling sedately along the reserved track on the Bristol Road, might have fallen apart one afternoon in 1929 had not Rowland Emett, the famous cartoonist, embraced art. He confessed how it would have happened in the accompanying story. The photograph was taken in 1952 at Pebble Mill, a spot since made famous by BBC Television.

Before making the presentation, Mr Levy made a short speech welcoming the principal guests:

Ladies and Gentlemen … Mr Emett, as you know, is our leading authority on Transport, land and sea and air – and sometimes all at once. We have not in George Cohen's perhaps studied the subject, but we have taken a deep interest in it for some time. In fact, my wife and I have just come back from the United States and I hope that Mr Emett and his wife will go there sometime and be more successful than we were in finding the *Streetcar Named Desire*.

We in George Cohen's are a fairly hard-boiled lot – case-hardened, as you might say – and we do break up power stations, gas works, Domes of Discovery – things like that generally – and sometimes we can even bring ourselves to do it without shedding a tear. But it is noticeable that the more sensitive members of our Board – those who are here today – are really disinclined to go near the 'tramatorium' where we conduct the trams with suitable ceremonies to their last honourable pyre. Really we are only driven to go there by a strong sense of duty to our shareholders and possibly the thought in the back of our minds that there may be a few souvenirs left.

We have all been told in the spate of articles in the press on the 'Last London Tram' how it was a Mr Train who started trams on their way and it is a little curious that nobody had looked any further. But it is a fact that a Mr Outram first started trains on their way and why we should have got so mixed up is strange. Mr Train did not start so very long ago, but it is an extraordinary thing how the tram has woven its way into the life of this country. There are very few places where we have not heard its bell and if we may judge by Mr Emett's drawings, it seems to have got into some very queer situations.

We are tram conscious as a nation, and the tram bell has even got into our poetry. You will remember those stirring lines written by the greatest of all Secretaries of the Union of Tram Drivers and Trolley Pole Replacers, Alfred, Lord Tennyson:

Ring out the old
Ring in the new
Ring, happy bells, across the snow.

Generally, the bell of the tram is the thing we remember, so we feel that, Mr Emett having shown us what trams really ought to look like, we ought to present him with something as a memento; from a firm to whom, if I may say so, all things must come in the end, to Mr Emett for the most faithful portraiture of trams we have ever had.

Mr Emett, may I present you with this bell. Ladies and Gentlemen, may I ask you to drink the health of the Emetts. May their peace of mind be long disturbed by 'the Bell'.

Then Mr Felix turned around to a large box standing on a trolley just behind him. He lifted the lid of the box; the sides fell apart and revealed – 'the Bell'. It looked very imposing on its rich mahogany stand, shining brightly under the lights. It had been burnished and chromium-plated by the machine tool department of George Cohen's, and suddenly became the centre of attraction in the room.

Mr Emett rose to thank Mr Levy:

Mr Levy, ladies and gentlemen: I cannot begin to tell you how thrilled and fascinated and even electrified I feel on being the recipient of this monstrous and marvellous Bell. I have never seen anything like it.

In eleven years we have occupied thirteen furnished houses and we feel that it is getting towards high time that we had a home of our own. It is not as though we are unprepared: yes, we have all our own teaspoons and lampshades, and I can tell you we have our eye on the sweetest little tram, which the agent tells me is ripe for conversion, and I can think of no more fitting front door bell than this. It is absolutely perfect.

It is rather strange but I have always thought of Cohen's in the light of the old Cornish wreckers – sinister, evil wreckers who shoot stealthily out on the Victoria Embankment, set up false beacons and lure tramcars to their doom – but this afternoon I am most agreeably surprised and there is absolutely no one with cutlasses, or even cutlery, in their mouths.

I am told that the inscription on this bell implies that I have done things for trams. It is true that I have of late years carried a torch for tramcars. I hope that this does not sound too bad, in view of what goes on at Charlton, but really I must tell you – much as I don't like doing this – I must tell you that when I was young I was unkind to trams. The sort of trams I used to tease only had four wheels and a stairway on which the risers were embellished with beautiful pictures depicting things like Mazawattee Tea and Cattle Cake. These enamel plates were very full-bodied and curved outwards. Now when I ascended this stairway I would wilfully punch them, which caused the Mazawattee Grandmother and her spectacles to crack all over the tram.

Well, having gained the top deck one would then proceed to drive the tram. On this type of tram, up on the front end, there were usually two nicely curved stems which terminated in cast iron blossoms concealing bulbs to light the destination board. One would kneel on the curved front seat, hang out over the prow and grasp the blossoms and twist and turn so much that if the electricity was unable to light the bulbs so much the better.

The trolley pole I left alone: I was frightened. If you placed your ear against the upright you could actually hear the volts twisting and bending the molecules in the overhead wire. Coming downstairs the thing to do was to land as heavily as possible on the sand pedal: this was to ensure that at least a hundred weight was released on the rails.

These are rather nasty things to have to confess, but I must say that the thing I am going to tell you now is the most dreadful thing I ever did. In my pocket I always carried a folding screwdriver, and it was a point of honour never to leave a tram without having removed at least six round-headed screws off vital parts of the structure. I had it all worked out that the entire tramway system in Birmingham would fall apart at four o'clock on the afternoon of 14 July 1929. It is really only due to the fact that about this period I forgot screws and embraced art that the tramcars are running today.

Well now, Mr Levy, in the hope that this may induce some change of heart of George Cohen's in their attitude towards tramcars – unfortunately I had to add a postscript.

At this point Mr Emett produced a large drawing of the scene at the 'Tramatorium' to which was attached his 'postscript' in the form of a small illustrated adaptation of a tram ticket.

He presented both these pictures to Mr Levy in return for 'The Bell', thus completing – as the menu indicated as the main reason for the luncheon – 'the exchange of appropriately Emettious Presentations'.

All Dressed Up

By Ian Yearsley

Tramway men were once proud of their uniform and in the early days of electric tramcars were regarded with the same awe now reserved for space explorers. In this article, which appeared in the former *Old Motor* magazine in the early 1960s, tramway historian Ian Yearsley traces the changes in platform fashion down the years.

Tall and erect, short and portly, large or small, the tramwaymen stood to their tasks. In the horse-era

A driver, conductor and inspector on the Chester Tramways show off their smart high-buttoned uniforms as they pose in front of car No. 2 on Grosvenor Road.

they were somewhat looked down upon, working incredibly long hours for little pay, constantly at war with cab drivers and others who regarded the tramway as an unwarrantable intrusion into what they considered their own province. The steam tram shaped public opinion to accept mechanical traction on the roads – and became the scapegoat for the death of the horse. Steam tramwaymen were clannish, overalled and jealous of their craft as if it were a medieval mystery, yet the public regarded them merely as second-rate railwaymen.

Electric trams, when they came, had the popularity of speed without the stigma of having ousted the horse. They were cleaner and larger than either horse or steam trams, and for some while they were the fastest vehicles on the road. Today, with public transport somewhat in the doldrums, it is hard to imagine it, but in a smaller way the men who drove the electric trams of the early 1900s were regarded with the same awe which we now reserve for space explorers. The industry was growing at such a rate that trained men were hard to come by, and several newly fledged tramways used 'talent scouts' to entice qualified men away from other companies.

The tram driver on his platform was the captain of his ship; he had power enough to overtake anything else on wheels on the road and with his gong and often by word of mouth he could order lesser craft out of the way. His predecessor on the horse trams had been content with the dignity of a bowler hat; now in these changed circumstances it was not surprising that he was given a uniform.

The time was right for uniforms; German influence in this country was strong and jingoism at its height. If your enthusiasm was lacking, sixpence would buy you a bundle of Kipling's ballads, or a seat at the music-hall to hear Sable Fern's patriotic songs. It is not really surprising that tramwaymen's uniforms followed the naval and military styles of the period.

The tram driver's uniform identified him as a servant of the company or undertaking; it also served as a protection against the weather. Trousers were cut rather narrow, often with blue or red piping up the seams, and no creases. Jackets were either the single-breasted army-style tunic, with patch pockets and a high tight-fastening dog-collar (ask your nearest clergyman what this must have been like to work in), or else the double-breasted naval reefer, with large lapels which could be worn open with collar and tie or buttoned across.

Southend-on-Sea tram crews, all dressed in army-style uniforms and caps, pose for a group photograph in front of the car sheds in London Road in the days when German influence in Britain was strong. A large percentage of the men are sporting moustaches and officials are wearing boaters.

Reefer jackets seem to have been more common, probably because they gave better protection; this is borne out by several places where drivers had double-breasted jackets but conductors had army-style tunics. Drivers and conductors also had overcoats, and the design of these has changed very little down the years. But in wet weather, drivers on their exposed platforms needed more than overcoats, and most had heavy waterproof coats as well, usually of rubber or oilskin material, and often with a built-in cape round the shoulders. Sometimes this cape was large enough to reach down and cover the controller top as well; another idea was to have a waterproof sheet tied to the rail at the top of the dash plate and extending up to just below chin level.

Caps, too, had waterproof covers, usually made of black rubber. Tramwaymen's caps around 1900 were small-crowned, like the naval officers' caps of the period, and some even looked like the hats that the Bluebell Railway staff sport today. By the beginning of the Great War, the design of the hats began to look something very near its present form, with a large crown and down-tilted peak. Perhaps a relic of the naval inspiration is the white crown-cover still used by many towns in the summer.

Tramwaymen were proud of their uniforms; their managements included that pride in the rule books. Staff were not allowed to enter public houses in the uniform of the Tramways Department; they were forbidden to play football or even to 'skylark' when wearing it. Stockport had a peculiar rule about men 'appearing completely dressed in uniform' – perhaps someone had reported for duty in his pyjama trousers. And it was only a few years ago that I found still in position a tall mirror, just inside the entrance to Bury's Rochdale Road Depot, with the words 'All Uniforms Must be Close-Buttoned' in gold transfer letters above it.

The Great War destroyed the German influence and left no taste for jingoism. It also brought the conductress complete with girls' high-school hat and enormous skirt (in Glasgow, these skirts were tartan). Nobody seemed quite sure what a woman conductor's uniform should look like, but high-buttoned boots and breeches appeared in several cities, as well as every variety of long and unsuitable skirt.

After the Great War the bus made itself more and more felt. Early motor-bus drivers in mufti had envied

A Bolton conductor checks his appearance in a mirror, in deference to the notice warning him that 'all uniforms must be close buttoned'.

A Chesterfield conductress in the First World War, wearing a long coat and skirt, high-laced boots and a cap with a large crown and down-tilted peak. Her ticket punch, whistle and large fare bag are also clearly shown. The photograph was given to me by former Chesterfield tram driver Lily Hebblethwaite.

the tram drivers with their uniforms, but eventually the bus produced its own uniform traditions. Chauffeurs' leggings did not remain, but the white or light-coloured dust coat survives to this day. Tramwaymen before 1914 had begun to wear collars and ties, though high-collared uniforms lasted until the thirties. I myself can remember seeing a Manchester inspector with a dog-collared jacket, braided round the edge like a bandsman's, as late as 1947.

The real change was that the tramwayman was becoming an indoor worker. In 1909 one tramway manager had written to another: 'Dear Sir, Do you enclose your motormen in a glass case?' – to which the reply had been: 'This is a tramway department, not a museum.' Windscreens and vestibules came, however, and though the old hands complained that they caught colds from the draughts they now no longer needed the enormous waterproof coats and cap covers.

Came the Second World War, and with it clothes rationing. Tramwaymen were supposed to hand in clothing coupons for their uniforms, though it was often a hard job to persuade them to do so. At Stockport early in 1943, two conductresses and a conductor were each fined twenty shillings, with a guinea costs, for failing to hand in coupons. Uniforms, like all clothing during the war, were precious items, and overcoats, too worn for further use by platform staff, were passed on to the engineering staff, who were not so much in the public eye.

Early in 1943, too, the transport press recorded the death of Mr Harry Lotery, whose name had been long associated with tramway and transport uniforms. The firm of H. Lotery and Co. was, and is, one of the largest suppliers of uniforms, and during the early part of the war their advertisements featured the grey tunics and slacks which were then worn by London Transport conductresses. As a result of wartime shortages, the firms making uniforms had to keep to a few standard designs. This often put an end to the

Some of the uniforms worn today by the drivers and conductors on the heritage tramways are more in keeping with today's comfortable styles, as seen here on the 2 ft 9 in-gauge tramway at Seaton in Devon.

A lady driver at the controls of a modern coronation car in Glasgow in 1956 proudly wears the stylish green uniform of the 1950s.

local style and, in consequence, today you can see practically identical uniforms being worn in widely separated parts of the country. At present the accent seems to be on uniform drabness; even such individual features as the famous Blackpool 'lion-tamer' jackets have now disappeared.

If you want to see good, stylish tramway uniforms today go to Germany. Or Holland, for that matter. And if you want to see what British Tramway uniforms looked like in their heyday, try Lisbon. Nearer home, the inspectors and stationmasters of the Manx Electric, with their vast green lapels, cut a fine pre-war figure.

Heritage Tramways

There are some dozen or so heritage tramways in the British Isles (more than half of them run by museums), where it is possible to experience a tram ride. Some have already been pictured in these pages, including those at Crich, Beamish, Birkenhead, Seaton, Lowestoft, Heaton Park and Bradford. Here are some views of the heritage lines at Fleetwood, Beamish, Dudley, Birkenhead and Douglas on the Isle of Man, as well as one overseas – at Christchurch.

Restored Wolverhampton tramcar No. 49 is about to depart on its inaugural passenger-carrying trip at the Black Country Living Museum in Dudley, on the day of its public launch, 19 August 2004, with driver and restoration team member Don Phipps at the controls.

At Douglas on the Isle of Man is to be found the last fully operational horse tramway in the world. Opened in 1876, it runs along the Douglas promenade, providing a regular service between May and October. The open-top double-decker, carrying tramway fans from Europe, is followed by an enclosed saloon car.

138 | Trams: An Illustrated Anthology

Restored Stockport open-topper No. 5 pauses for a photoshoot at Fleetwood during an enthusiasts' tour of Blackpool's tramway. The car took sixteen years to restore after being rescued from the moors above Marple, where it was being used as a bird watcher's hide.

Newcastle No. 114 is popular with visitors to the Beamish Open-Air Museum. Restored in 1996, it is one of six trams that run round the museum's grounds on 2 km of circular track. Here it is leaving the museum's recreated shopping street bound for Pockley Manor on 10 July 1998.

Christchurch in New Zealand is one of a growing number of cities in the world operating a tourist tramway in its city centre streets. The line is one way, single track and circular, and is worked by vintage cars, including these two – No. 152, built in 1910, and trailer No. 115, built in 1915 and known as 'The Duck House'.

Restored Birkenhead tramcar No. 20 picks up passengers at the Woodside Ferry terminal of the Birkenhead waterfront heritage tramway. Offering a helping hand to a mother and child who are about to board the car is driver Mike Mercer, while the conductor, right, is busy communicating by radio, something unheard of on all the tramways which had vanished by the outbreak of the Second World War.

Record-Carrying Tramcars

By Dennis Gill, with an extract by Steve Palmer and Brian Turner

Today's streamlined trams can comfortably carry over 200 people, compared with around seventy on the old trams But there has been the odd occasion when the old trams carried far more then their official capacity, with passengers packed in like sardines.

Which tramcar held the record for carrying the most passengers is probably one question we will never be able to answer with any confidence. For the overloading of a car, strictly speaking, was not allowed, although in the early days of tramways, restrictions on standing passengers were undreamt of, and conductors considered it their duty to clear queues as quickly as possible. Unlimited standing was tolerated on both decks and balconies, and even hangers-on on the rear fenders were not always turned away. Tramcars carrying football crowds away from matches were often packed to the seams, with some supporters hanging on to whatever part of the tram they could grasp on the outside. Similar scenes were witnessed when workers left shipyards or other complexes of intense industrial activity. A blind eye would be turned by inspectors, especially at special events which drew huge crowds, in an effort to get crowds away.

On these occasions the capacity of tramcars might well have been doubled, but for obvious reasons wouldn't have been officially recorded. One loading, however, that is on record and appears to be the biggest total for a car in service, would seem to be the 216 passengers carried on a Blackpool eight-wheel 'standard' tram on its last run from Talbot Square to Marton one night during the Second World War. According to Steve Palmer and Brian Turner in their book *Blackpool by Tram*, published in 1968, the conductress of the tram remembers the occasion well.

> We had just gone to get a brew and left the inspector loading our car in Talbot Square where there was a great crowd, since we were the last car round Marton that night. When I came back the 'standard' was jammed packed with people; I even had to ask a passenger to get off so that I could get a foot-hold on the step. I shouted to someone to pull the bell rope, and we set off slowly up Clifton Street. I couldn't move from where I was standing as the passengers filled the platform. They were standing two abreast up the stairs, and hanging over the edge of the balconies. I shouted for all penny fares to pass them along. I punched tickets and passed them back. At Palatine Road when the penny fares got off, I called for the twopenny fares, and after the Preston Old Road I collected the threepennies. Back at the depot, the traffic superintendent took one look at my way bill and sent me straight to the top of the paying-in queue. I never carried such a load again.

The Blackpool figure just pips the 214 passengers carried on a Nelson bogie car taking fans to a match at Colne Cricket Ground when Learie Constantine played there. The figure was clocked on his waybill by Conductor Jack Eccles who issued tickets to 214 passengers – not once, but twice, as all passengers had to re-book at the Nelson and Colne boundary. It would be interesting to know if higher figures have been recorded for a car in service, especially, say, on the Swansea and Mumbles line, which operated cars seating as many as 106 passengers. I suspect, though, that somewhere around the 220 mark may be the finite number.

What a pity nobody has made an attempt, for *The Guinness Book of Records*, to see how many people can be squeezed into a tramcar like the Metropolitan Electric vehicle at the National Tramway Museum. It would be a big draw if it was done on a fine day in the summer, and we might well be looking at a figure in excess of 400 when you consider that 350 or more Staffordshire pupils managed to get themselves packed into a London bus some years ago.

The Blackpool and Nelson figures I have quoted are not isolated examples of overcrowding. A few others are worth a mention:

Warrington's last tram (No. 1), which ran on 28

As many as 170 people managed to cram on car No. 1 – the last to run in Warrington on 28 August 1935. At least seventy-five are peering through the windows at the photographer; presumably others are hidden and some have yet to board.

August 1935, is a contender, perhaps, for a place in the record books for carrying more people than any other last car. Although only a four-wheeler, it was packed with 170 people, including corporation officials and councillors, many tramway employees and members of the public. Like many last cars before the Second World War it was not decorated, but it was also unusual in that it was driven by a long-serving driver (H. Smith) with his son conducting.

A Kidderminster and Stourport four-wheeler carried 140 passengers on one occasion, but one of the shareholders was not unduly concerned, especially when he heard that all of them had paid their fares. And, according to Colin Maggs in his book *Bath Tramways*, a last car of the evening bound for Bathford (a mere open-top four-wheeler) carried 121 passengers.

As many as 130 passengers were being carried on a steam-drawn tramcar which overturned at Newton in Wigan in 1889. At the subsequent inquest, the Wigan Tramways Company was warned not to allow overcrowding on its cars in future. There were only forty-two seats on the car (No. 9), which left eighty-eight standing. There were two rows of passengers standing in the lower saloon, some standing upstairs, at least eighteen on the stairs, platform and step, with one passenger riding on the coupling and another (a former driver) on the engine. Those on the top deck and standing on the platform were thrown out of the car onto the pavement. Twenty passengers were injured, one of them dying later from her injuries. The conductor claimed it was raining and that he was powerless to stop the passengers cramming into the car, some of whom threatened to assault him if he tried. It was stated at the inquest that overcrowding was not the cause of the accident; it was caused through two axles breaking. However, the coroner did emphasise that if the car had not been overloaded, there would have been no passengers standing on the platform step to be thrown off and trapped under the car. A verdict of accidental death was returned.

On 6 May 1908, again in Wigan, single-deck electric tram No. 25 was stopped by police at 5.10 p.m. for being grossly overloaded. The Chief Constable complained that eighty-two passengers were on board, thirty-six more than the normal load.

Shortly before the Christmas of 1906, Tom Myers, a Thornhill councillor, travelled on a Dewsbury car carrying seventy-five passengers. The passengers included all the members of the Thornhill Prize Band, with all their instruments. Mr Myers reported the overloading to the Council and went on to state sarcastically that the council 'would judge that the car was in a very "comfortable" state'.

Finding her Sealegs

By Zelma Katin (in collaboration with Louis Katin)

Zelma Katin was a Sheffield tram conductress during World War Two, and in this extract from her autobiography, *Clippie* **(written in collaboration with Louis Katin, first published by John Gifford in 1944, and reprinted by Adam Gordon in 1995), she describes her first day conducting on board a tram after initial training. Accompanying her was a fully fledged conductor, whom she called her conductor-teacher, who offered her guidance and advice where it was needed.**

At 7.20 with my conductor-teacher I went to the town centre to pick up a tram at 7.25. We were late. Half running, I hurried to the assignment, weighted down by my several bundles and carrying my official black ticket box under one arm. Suppose we missed the tram, I put to myself as I hurried. The answer came in the form of a remembered music-hall joke: 'A man should never worry about losing a woman, because women are like trams: there'll always be another one along in a minute.' But in wartime women are probably scarcer than trams.

By now the morning light was chasing the blueness from the streets and, standing upon a traffic island, I scanned the numbers and destination boards as the trams moved towards me. There was a fleeting moment of panic and a pit-a-pat as I recognised my tram. MY tram! Those two words would now bear a different significance. I stepped on the platform.

'You take the fares,' said my teacher. 'I'll ring off.'

This was it, then.

I went into the saloon and lurched. 'Fares please,' I shouted. My voice rather took me aback. It sounded like a busker's. But I clutched my coloured tickets and went forward. The first customer of my transport career was a pale gaunt young workman in a cloth cap. He held out a penny. It felt hot and wet. The tram swung round a bend and I doubled over towards the workman, who eyed me anticipatorily and put his feet under the seat. Sharply I bent backwards and nearly lost the penny. Then I placed my feet thirty inches apart and stood my ground while I extracted a white ticket and squeezed the punch. Would the clang come? It came, a gladsome resonant clang, and I moved on. 'Fares, please!' The saloon was filling up and I began punching wildly at the tickets because I hadn't time to look for the fare stage numbers.

'Never mind,' said the conductor when I joined

Sheffield trams conveyed thousands to and from their daily toils, and it may have been on a car like this one (operating at the Beamish Open Air Museum) that Zelma Katin found her sealegs as a conductress during the Second World War.

him on the platform, 'so long as you punch the right side of the ticket – "From City" or "To City". That's all that really matters, until you get used to it….'

The pennies were getting hotter and grimier, and my hands had become black with their dirt. On the top deck I lost my balance and sprawled across an old man's lap.

'Hast tha not fahnd tha sealegs yet, miss?' he chuckled….

The indicator had told me our route would lie through the factory area but I had no time to look about me. I'd only a vague idea of buildings, gates, streets and traffic. All my world, for several hours together, was a narrow passage in a moving domicile – 'a flying house' as Chesterton calls a tramcar – with the men and women and children seated either side or strap-hanging in the middle. What a theme for a saga a tram might be: its endless load of human drama, laughter and tragedy sitting silently on its plush seats. Thousands of people sit and stand there, never saying what is on their consciences or in their souls, they pay their penny and go off at the fare stage taking with them the raw material for great novels, symphonies and great pictures.

At the city terminus there was a mobile canteen. The motorman – he is not a 'driver' on the trams – the conductor, and myself, sat down inside it and drank tea and ate cakes. The brief relaxation was pleasant and I was glad the transport workers had in the past pressed for so welcome a concession….

We three resumed our positions in the tram. This time the conductor collected the fares and I stood on the platform to ring on and off. At the first stage a crowd of working people surged towards my platform…. The upturned faces of many people in a state of urgency can be an alarming sight. With my chain in my hand I stood in the middle of the platform, keyed up, and let the men and women fill the tram. 'Full up,' I said, adding in compensation, 'another one behind,' and quickly hooked the chain in place. A stout middle-aged woman, with her hatless hair in curlers, stepped back hurriedly into the road, looking angry, having failed to get in by a short head. 'You've plenty of bloody room you bitch,' she said….

At the next halt a passenger alighted, and an elderly woman with a shopping basket laboriously hoisted herself up the step. I took the basket and helped her on to the platform.

'Tisn't often a lass 'elps me like that,' she said, surprised, 'ere, 'ave these.'

She handed me a paper package and told me they were cowheels. Gracefully I refused them, pleading that I was not addicted to cowheels and would not know what to do with them anyway.

Assassination at the No. 14 Tram Stop

By Dennis Gill

Over the course of history world leaders and famous people, such as President John F. Kennedy, Gandhi, Lord Louis Mountbatten and John Lennon, have been assassinated. But only one, Reinhard

Heydrich, Reichsprotector of Bohemia and Moravia, has been assassinated in full view of passengers on a tram.

Prague, capital of the Czech Republic, is one of Europe's most attractive cities, with many historic and beautiful buildings, and an extensive and progressive tramway system with thirty-four routes and 900 tramcars. The tramway is well-patronised by hordes of tourists that visit the city each year, many of them riding on the historic trams that offer a tour of the city in summer months. But Prague hasn't always enjoyed such popularity. It has seen darker days, especially during the years of German occupation. Imagine what it must have been like taking a tram ride in the city during the Second World War, when all of a sudden you might be caught in crossfire between resistance fighters and occupying troops, dragged off a tram to face interrogation or torture, deportation to a concentration camp, imprisonment or, worst of all, death from a firing squad. Imagine how terrifying it must have been if you were travelling in a tram which arrived in the middle of an assassination attempt on the life of one of Hitler's top henchmen. This is the nightmare that faced tram passengers in a quiet Prague suburb on 27 May 1942. It was one of the blackest days in Czech history, for it led shortly afterwards to the arrest, imprisonment or execution of thousands of Czechs and the extermination of two whole villages. The man who was the target for the assassins was Reinhard Tristan Eugen Heydrich, a highly decorated SS General, who had been appointed by Hitler as Reichsprotector of Bohemia and Moravia in 1941.

Hitler had long had his eye on Bohemia especially because of its great industrial wealth; it was because he wanted greater output from Bohemia's giant industrial plants, which included Skoda, that he appointed Heydrich as Reichsprotector. He was not to be disappointed. Heydrich increased the output of tanks, weapons and trucks considerably. However, he was greatly feared by some Czechs, and the Czech government in exile desired nothing more than to see him removed from office or assassinated. For these reasons, in December 1941, members of the Czech Free Army, who had been undergoing training in England, were flown across the channel in a Halifax bomber and parachuted into Bohemia to bring an end to Heydrich and his reign. In the exiled Czech government's view, it was essential for the salvation of the Czech people that they succeeded in their quest.

When Heydrich took up his post it was expected he would live in Hradschin Castle, overlooking Prague, but instead he very soon moved into a large country mansion, Panenske Brezany, on the outskirts of the city, which better suited his wife Lina and their family. Their country seat was well guarded, like Hradschin Castle, and was not the place to attempt an assassination. The route the Reichsprotector took from his home to the castle every day was also guarded, but not on the days when he travelled to Prague to fly to Berlin. The assassins noticed this and drew up plans to find the ideal spot for their mission on one of those days. The assassins carefully surveyed the whole length of the route Heydrich took from his home and eventually decided the best place to carry out the assassination would be on a bend at a road junction near Liben, not far from the Traja Bridge, which crossed the famous Vltava river. At this junction, Heydrich's car, coming down a hill to the junction, would have to slow down to negotiate the bend. There were also a number of tram stops at the junction for the various trams passing at that point, which meant that the assassins could loiter without raising suspicion. To all intents and purpose it would appear they were merely waiting for their tram to arrive; nobody would give them a second glance. Finally, there were no police or military establishments nearby, which meant they had a greater chance of escaping from the scene once their deed had been done. The only fly in the ointment was the possibility that a tram might arrive on the bend at the same moment as their intended victim, perhaps obscuring their view of Heydrich as he passed and preventing them from assassinating him. It was a risk, however that they were prepared to take.

The day chosen for the assassination attempt was

Prague trams today are popular with tourists – many of whom will have little idea of the dramatic and momentous incident that took place at one of the city's tram stops on 27 May 1942. This tram in the city centre is about to cross over a Grand Union junction, which is a right-angled intersection with double-track connections around all four corners, so that tramcars, no matter from which direction they are approaching, can go straight ahead or turn left or right.

27 May 1942. On that day Heydrich was being driven into Prague prior to flying to Berlin, and from all accounts it appeared it might be the assassins' last chance, because it was rumoured the Reichsprotector was about to be offered a more prominent position. Three men had been selected to carry out the assassination. They were Jan Kubis, Josef Gabcik and Josef Valcik. Gabcik's task was to kill Heydrich by firing a sten gun; if he failed Kubis would be standing by ready to hurl a grenade at the car. Valcik was assigned to hide further back up the road and warn his compatriots of the approach of the car by flashing them a signal using a pocket mirror. The plan was simple, but, as events proved, not everything went quite according to plan.

On the appointed morning the three men took up their positions and awaited the arrival of Heydrich's car. They seemed to wait an eternity, but as arranged, when the Mercedes came into view, Valcik flashed the agreed signal. Gabcik immediately took out his sten gun and as the Mercedes slowed down to negotiate the bend, he pointed it at the uniformed figure of Heydrich and fired. But nothing happened. The firing mechanism had jammed. Spotting Gabcik with his raised gun, Heydrich took out his pistol and ordered his chauffeur to stop. This, however, was a fatal mistake, for Heydrich had not spotted Kubis, who at that moment sprang forward and hurled his grenade toward the stopping car. The grenade (some reports say it was a converted anti-tank bomb) hit the back of the car and exploded, sending shrapnel in all directions, and blowing out the windows of a No. 14 tram, which had arrived at the tram stop at that very moment. The effect this had on the passengers must have been one of sheer terror. They hit the deck and, when it was safe, stared out of the windows in sheer disbelief, horror written on their faces, unable to accept that something like this could happen in a sedate suburb of the city. The event was even more traumatic for those individuals waiting at the stop for the tram, at least one of whom suffered shrapnel wounds from the blast, as did Jan Kubis.

At first, the attempt on Heydrich's life appeared to have failed, for Heydrich and his chauffeur climbed out of the car and set off in pursuit of the assassins, firing their guns as they went. The tram driver and his passengers, fearing for their lives, cowered inside the tram. Some fled from the scene, to escape the crossfire and reprisals. The assassins managed to escape, after using the tram and another tram that arrived shortly afterwards, as cover. But the pursuing Heydrich hadn't gone far before he collapsed in agony from the wounds inflicted on him by the shrapnel. He was rushed to hospital in the back of a passing vehicle which had been flagged down. Doctors operated on him immediately, but the blast had damaged his spleen and other vital organs, which resulted in an agonising death from septicaemia little more than a week later on 4 June.

Meanwhile, a massive hunt for the assassins had been launched. They were eventually discovered hiding with other compatriots involved in the plot in the crypt of a church in the centre of Prague, where their lives were heroically ended. They lived long enough, however, to learn that their assassination attempt had succeeded, bringing to an end the life of one of Hitler's most feared men.

In retaliation for the assassination, the Germans tortured, imprisoned and executed hundreds of Czechs and razed the villages of Lidice and Ležáky, executing the menfolk and sending the women and children to concentration camps. It was one of the most outrageous atrocities of the Second World War.

The site of the assassination is today a relatively quiet suburb of the Czech capital, but one of the roads in the area is named Kubisova in recognition of Jan Kubis's part in the assassination.

Out of Control

By John Disley, Harry Underwood and Tony Spit

In the history of tramways there have been many cases of tramcars getting into difficulties on hills and running away out of control, especially in some of the industrial towns nestling in the Pennines, like Halifax, which had more steep tramway gradients than any other town. Two of the incidents were vividly described by eyewitnesses. One was a carter, who saw one of the worst incidents involving a Halifax runaway; the other was an author who was born in Ossett and witnessed a spectacular accident in Dewsbury when he was a boy. Neither of these runaways, however, was as spectacular as one in Johannesburg, which occurred almost exactly half a century after the one in Halifax.

The carter, John Disley was returning home on 15 October 1907 when he saw the Halifax open-top tram come to grief on Bolton Brow, Sowerby Bridge, after running out of control down Pye Nest Road. Four passengers and the conductor were killed, and forty-seven were injured.[1] John Disley's dramatic and moving account was published in the weekly *Halifax Guardian* four days later, and is reproduced here by courtesy of the Halifax Courier Ltd.

It was somewhere about 5.45 in the morning when I was going up home with the horse and cart, after a spell of night-work. I had got almost as far as the Bolton Brow bend and turned the corner, when the tram which ought to have been going up on that line was coming down at a very quick rate. At once I guessed that something was wrong, but what was really the matter I could not guess then. I was very much afraid when I saw that its speed gained every second as it slid down the metals. I noticed then that the trolley was off the car, and that it was whizzing along over the rails without any electric current. And then the rest was plain. It was the conductor who was facing me as the car rushed headlong towards me, and the car was wrong way about. I was too busy to get my horse and myself out of the reach of the advancing car to notice anything else particularly. When it reached the loop where the cars generally stop, there was no saving the situation. The car was altogether beyond control after that.

The passengers inside were put about, I can tell you. Some of them were screaming, others moaning, and the scene was very upsetting. Several of them had just before tried to get out of the car, but one or two failed, and one managed, I think, to do it, though this was a risky business when the tram was careering along backwards way. The conductor, poor fellow, he stuck to his work well, so far as I could see, and was exerting himself in putting on the brake. But in another minute it was over. The tram gave a very violent jump, or lurch, at the points here, to the left side as I looked at it, and then crashed to the earth with a shock like a thunderbolt. It was in a flash that the car was on the ground, and I at once left my horse and cart and gave a helping hand. Only another three short seconds, and I and my horse and cart would have been part of the wreckage you see out there, and we should have been flattened as easily as possible.

I took some of the wounded into the Shepherd's Rest, and some in the house of Mr Atkinson and other Bolton Brow houses. But don't ask me to describe the scene on the road. It was dreadful. I have seen accidents and smashes, and heard of them, but never one that was so shocking to those that saw it. Everyone, you see, was helpless from the start. I fairly tremble yet, when I think of the sights that could be seen. What with the narrow escape of myself, and the frightful suddenness of the thing, I was taken aback, and it was with strange feelings that I set to work among the ugly fragments of the ruined car to help the wounded or fetch out the dead. The groans were something painful to hear, and the cries of the women. Those who were not too injured to move gradually crawled out of the wreck, and it was a pity to see them beckoning to their neighbours, who were 'doing all they could for the poor things'.

In the Dewsbury incident, witnessed by Harry Underwood, the runaway tram finished up in a boot shop adjoining the Scarbro Hotel in the centre of the town on 12 October 1915. The sight of the tram embedded in the shop attracted a large crowd, which grew even bigger when the upper storey later caved in on top of the car. Harry Underwood is the author of *Locos I Have Loved.* He was born at Ossett, near Dewsbury, in the early years of the last century and lived through the heyday of the electric tram. He came to know all the West Yorkshire tramway

This runaway Dewsbury and Ossett tramcar finished up embedded in Hilton's boot shop on 12 October 1915. Unhappily, the Scarbro Hotel building collapsed on top of it shortly after the photograph was taken.

systems very well. In his boyhood he often made circular trips by tram from Dewsbury to Ossett, and then on to Wakefield, Leeds, Bradford, Birkenshaw and back to Dewsbury, changing cars five times. In a letter to me in 1978, after having read my book *Tramcar Treasury*, he reminisced about the Dewsbury and Ossett tramway, which he rode on almost every day, and told me about the runaway he witnessed.

The Dewsbury and Ossett tramway was a most sedate line. The two and a half miles between Dewsbury and Ossett took the best part of eighteen minutes as a rule. All the drivers were familiar to me, and they varied most remarkably in their techniques. Most were painfully careful at their approach to loops and curves and to the descent of the long steep gradients. Two were noticeably brisker and one, 'Mad Mick', a wild Irishman, was positively reckless by comparison. He accelerated quicker and only appeared to brake when he had to, allowing much more free-running downhill. Mick could chip five minutes off anyone else's time if so disposed – or indeed, urged to do so by some familiar passengers in a hurry. Incidentally, if my memory serves me right, there were twenty-six sets of points (facing and trailing) in that two and a half miles, so it was no speed track.

On 12 October 1915, when I was six, my mother came to meet me from school at four o'clock and we did some shopping in Dewsbury. That over, we stood at the terminus in the Market Place waiting for the Earlsheaton (branch from the main line) car. Suddenly, there was shouting and a great commotion. Our tram was descending the long 1-in-12 of Wakefield Road, but certainly not in its usual sedate way, making a compulsory stop 200 yards before the terminus.

Instead, the first thing I noticed was flashing blue lights as the overhead was torn down by a wildly gyrating and near-vertical trolley boom. Next the dash of the car was suddenly smothered in a burst of firewood and the car was racing past us at a quite fantastic speed. Looking back, I think it could well have been at least 30 mph. I still have the most vivid recollection of seeing the driver, who had lost his uniform cap, struggling with the handbrake and stamping on his gong continuously. If ever I saw a man look terrified.... Just then, what appeared to be a black bundle of rags rolled across the setts in front of us – the conductress baling out, to be quickly followed by another similar bundle as the driver followed suit. Needless to say, the latter, in particular, was grievously injured, but miraculously lived to tell the tale. By then the car was but feet from the tall three-storey stone wall of the Scarbro Hotel and Hilton's shoe shop next door. And into this the car plunged with a sickening crash.

I have a most vivid recollection of the window rectangles suddenly turning into parallelograms, and of a cloud of dust and blue smoke. In a few moments the fire brigade was on the spot from their station but 200 yards away and there followed an ambulance. I believe there were only four passengers aboard [*there were in fact only three*] yet no one was seriously hurt. My mother told me that I was as white as a sheet, and I don't suppose she was too pink, either. Needless to say, we walked home up the hill....

Regarding the firewood, it seemed that right in the path of the runaway was a donkey carefully putting one hoof after another as it held back a small two-wheel cart piled high with firewood 'chips'. The hawker, apparently, was sitting atop this pile and being stone deaf failed to hear the gong and clatter of the flailing tram bearing down upon him from behind. Somebody, they tell me, had the presence of mind to reach up and literally drag him off his perch only seconds before the tram hit the cart. Hence the shower of firewood. And hence, also, my first and only sight of a dead donkey.

The most serious of all the accidents in Dewsbury, however, occurred eleven years before, on 20 May 1904, when a Yorkshire Woollen tramcar ran away, leaving a trail of mayhem and wreckage behind it. It happened on the Heckmondwike line (which has steep gradients varying from 1-in-8 to 1-in-10) when the driver of car No. 7 lost control of his brakes while descending Halifax Road. The car careered down the hill, colliding in turn with a cart laden with mineral water, a coal cart, a wagon carrying vitriol carboys, and two tramcars in the town centre, before coming to rest, badly battered and a partial wreck. The driver of the runaway bravely stuck to his controls, but was flung off the car just before it reached the Market Place, sustaining serious head injuries. The driver of the coal cart was flung into a shop window, and the drivers of the wagon and the second tramcar were also injured, as was the conductor of the runaway, who was later commended for his gallant action in preventing passengers from jumping off and sustaining serious injuries during the car's headlong descent.

A runaway that probably has a good claim to causing the most mayhem in tramway history, however, was tram No. 220 of the Johannesburg Tramways in South Africa, which hit at least a dozen vehicles in October 1957 before coming to rest. Tony Spit, in his book *Johannesburg Tramways* (published by the Light Railway Transport League in 1976) wrote:

Left unattended it moved off down Market Street and claimed its first victim, a carload of detectives, at the Sauer Street intersection. After that it smashed anything in its path; six private cars were claimed as direct hits, while several others were hit by ricochets. After nearly a mile of this, No. 220 approached the bottom of Fordsburg Dip, according to an eye-witness cruising at some twenty-five miles per hour, and bore down on car 149 which had been stopped at a traffic light. Fortunately for the occupants of this car, No. 220 was slowed down by an impact with a lorry loaded with sand, which was struck with such force that it was flung across the road, and through the parapet of a bridge, ending up in the bed of a stream some twenty yards away from the point of collision. The end of the run came immediately afterwards when No. 220 struck the rear end of No. 149 with such force that the latter car was forced more than halfway across the intersection and derailed. No. 220, however, remained on the rails, its headlights still on. Fifteen people were detained in hospital, of whom eleven were soon discharged. Of the remaining four, one later died from his injuries. Both trams were extensively damaged and withdrawn from service.

[1] Surprisingly the Pye Nest accident in Halifax, tragic though it was, was not the worst in human terms in Britain. The worst by far occurred at Dover on 19 August 1917, when an over-laden car ran away down Crabble Hill and overturned at the bottom, killing eleven passengers and injuring fifty-nine.

Stripped by Exuberant Well-Wishers

By William Rocke

Dublin's last trams, watched by an exuberant and over-zealous crowd of well-wishers, were stripped of their fittings and even parts of their woodwork by souvenir hunters and hooligans. As they limped their way back from Nelson's Pillar to the depot in 1949, their progress was at times slowed almost to a standstill by the unruly mob.[1] This article, recalling the scenes on that extraordinary night, was written by William Rocke in Dublin's *Evening Press* on 23 July 1963.

There is a streak of sentimentality inherent in all Irish people – and in Dubliners in particular. Little wonder then that as the midnight bells tolled over the city on that July night of 1949, a great mass of people should have assembled in O'Connell Street. They had come, young and old alike, to bid a glorious farewell to a tramcar. Within minutes No. 252 would arrive from Dalkey, as it had been doing for over fifty years now, at the Pillar. When it clanged away a few minutes later, it would be moving into history as the last tramcar on Dublin's streets. Time, like the city's bells, was tolling a death-knell for these rolling, rumbling lovable monsters.

The windows of Darwen tramcar No. 11 changed from rectangles to parallelograms when it hit this building after running out of control down Sudell Hill during a thunderstorm on 26 September 1926. Sadly, two passengers were killed and seven injured.

There was a riotous as well as a rousing send-off for Dublin's last trams, one car at least being completely stripped of most of its fittings by boisterous well-wishers.

For many of the people lining O'Connell Street that Saturday night the passing into obscurity of Dublin's trams was not only the ending of an era, it was the finishing blow to a way of life itself. With them went fond memories of open-air, wind-blown journeys to Dollymount and Dun Laoghaire; of irritating delays as points were changed; of the thrills entailed climbing a spiral staircase while the tramcar lurched and rolled like a living thing; of the noise, the incessant bumping on hard wooden seats and a 101 other joys of a tramcar ride....

Thousands of people packed into O'Connell Street that night, eager for excitement. Despite the sad occasion, the air tingled with expectancy. One could almost sense the drama about to take place. As midnight approached the crowd became more unruly and high-spirited. They felt that more than verbal expressions of feeling were necessary on this particular night. Caution was thrown to the winds. Sentiment became secondary. The time for action was at hand.

It was unfortunate that just at that particular moment, two of the vehicles which were causing all the excitement should appear in Westmoreland Street on the last stage of their journey to the Pillar. It is extremely doubtful if they completed that short distance. Half-way to the terminus, the mob converged, and what should have been a triumphal procession became instead one of complete disorder and violence.

Before the startled gaze of the more staid citizens, both trams literally disappeared under a heaving mass of humanity. The small force of *gardai* on duty were brushed contemptuously aside. Helpless, they watched as hordes of people scrambled aboard. One brash young fellow climbed on to the roof of one of the trams and entertained the crowd with a song.

Under his feet, the vehicle was rapidly disappearing. In the quest for keepsakes, eager hands pried destination boards loose, ripped up seats, tore light fittings from their sockets and cut trolley ropes. Enthusiasts even dismantled portions of the iron framework and carried it away. Within a matter of minutes only the bodywork, badly scarred, was all that remained of one of Dublin's prized trams.

Meanwhile No. 252 from Dalkey was just entering O'Connell Street. Mindful of what had happened earlier officials hurriedly stopped it and prepared to send it back to the sanctuary of the station at Blackrock. By now, all plans for ceremonial processions had been cancelled. The band engaged to lead the last tram from the Pillar were told their services would not, under the circumstances, be required. Radio Éireann's scheduled broadcast of the event was also scrapped.

Before it could be removed, Dublin's No. 252 tram was surrounded by a cheering boisterous mob. As fireworks exploded, extra *gardai* and officials fought to keep it intact. It was a losing battle.

The last cars in some towns were besieged by exuberant well-wishers, but probably not quite as much as the last Colne car to Nelson shown in this 'Last Car' comic card.

Finally at 12.40 a.m., with a police car in front and a flotilla of private cars at the rear, the last tram departed from O'Connell Street. Despite its battered appearance, there was something regal-like in its exit. A burst of cheering sent it on its way.

Twenty minutes later, the overhead current was switched off. The life-line of tramways in Dublin was severed forever.... Silent now, O'Connell Street lay under a mantle of shattered glass and broken woodwork. They were inglorious symbols of what could have been a very famous night.

[1] Some of Bristol's last tram ceremonies, commemorating the closure of certain routes before the outbreak of war in 1939, were marred by rowdy over-zealous souvenir hunters going on the rampage. On the closure of the route to Brislington, on 3 September 1938, crowds went on an orgy of tram-wrecking, tearing off the hats and coats of the crew men and stripping the last tram of practically all its fittings. The last tram from Knowle received similar treatment, one man tearing off the curtains from the lower saloon for his greenhouse, another cutting off the platform chains, which he said would make 'a fine lead for his dog'. Those sections of the crowd that sang, let off fireworks, sounded bicycle bells and car horns, and beat out tattoos on the sides of the trams were mild in comparison.

In comparison with the closures at Dublin and Bristol, and a few other towns where well-wishers went on the rampage, the farewell for the last Stockport tramcar to leave Hazel Grove was fairly low key.

According to Jekyll and Hyde

By Dennis Gill, with extracts by *Zelma Katin*, *D.M. Friend, Alan Brotchie and Robert Grieves*, *Bill Tollan, Keith Stretch and Edwin Elsley*

Misbehaving passengers were the bane of yesterday's tramway operators, and many of those who offended against the tramway's bye-laws and regulations were taken to court. Their misdemeanours make interesting reading. Sadly, the new tramway systems suffer as much from trouble makers.

Jekyll and Hyde played an important part in the history of Stockport's tramways. And woe betide any passenger who didn't take note of what they had to say, way back in 1903. For the two men were the signatories to Stockport's tramway bye-laws and regulations. But this Jekyll and Hyde were separate individuals and not the fictonal character created by Robert Louis Stevenson. They were, in fact, Herbert Jekyll, Assistant Secretary to the Board of Trade, and Robert Hyde, Stockport's Town Clerk. When the two officials signed the bye-laws they must have been aware of the amusing connotations presented by the juxtaposition of their names. One can imagine the ribald comments that were made at the time – a pity some of them weren't written down for our enjoyment.

Every tramway had bye-laws and regulations that passengers were expected to abide by when travelling on the trams. These bye-laws were a glorified list of 'do's and don'ts', which everybody, presumably, was expected to read. The list was usually displayed in a glass-fronted panel by the side of the sliding doors which gave access to the lower saloons.

Stockport's tramway had some thirty bye-laws, which came into force on 1 January 1903. According to Mr Jekyll and Mr Hyde, you were not allowed to smoke, swear, spit, carry firearms or be under the influence of drink. Nor were you allowed to scratch the windows, tear seating, wilfully damage tramcars or interfere with the equipment; soil seats, play musical instruments or take a dog or other animal on the cars with you. Nor were you permitted to travel on the steps of the cars, or stand on the roof, or sit on the outside rail of the roof. (The 'roof' in this case must surely have been the floor of the top deck, for when the bye-laws first appeared, the trams didn't have a roof over the top deck.) You were also not allowed to impede or obstruct the conductors, drivers or inspectors.

I can't remember ever seeing a tram passenger reading the bye-laws. But this is hardly surprising, for instead of being written in plain English, they were written in legal jargon which clearly would have put people off reading them. For instance, what would the tram passenger of 1903 have made of the following, which is quite a mouthful in anybody's language!

A PERSON WHOSE DRESS OR CLOTHING MIGHT, IN THE OPINION OF THE CONDUCTOR OF A CAR, SOIL OR INJURE THE SEATS, LININGS, OR CUSHIONS OF THE CAR, OR THE DRESS OR CLOTHING OF ANY PASSENGER, OR A PERSON WHO, IN THE OPINION OF THE CONDUCTOR MIGHT FOR ANY OTHER REASON BE OFFENSIVE TO PASSENGERS, SHALL NOT BE ENTITLED TO ENTER, MOUNT, OR REMAIN IN OR UPON ANY CAR, and may be prevented from entering, mounting or remaining in or upon any car, and shall not enter,

All Stockport's trams, like this one in Prince's Street, carried bye-laws signed by Jekyll and Hyde.

MAURICE MARSHALL

mount, or be or remain in or upon any car, or any part thereof after having been requested not to do so by the conductor, and, if found in or upon any car shall, on the request of the conductor, leave the car upon the fare, if previously paid, being returned.

Try to get your head round that if you can! Compare it with the bye-law below seen at the National Tramway Museum, the wording of which is somewhat shorter and a little easier to read.

No person shall travel on the steps, footboards, stairs, platforms, cabs, fenders, couplings or roof of any tramcar or hang from or by any part of the exterior of any tramcar while it is in motion but shall travel on a seat provided for passengers.

Despite these bye-laws, though, the trams, like trains, aeroplanes and ships, have never been quite free of troublemakers, and thousands of passengers who broke the rules were taken to court by the tramway operators. Sheffield Tramways took 166 passengers to court one year for breaking regulations. According to the *Tramway and Railway World* there were 161 convictions.

The various cases were as follows: Being drunk and disorderly 83; riding on car steps (boys) 20; assault 14; obscene and offensive language 10; obstructions 9; refusing to pay fare 8; offensive conduct 7; smoking and spitting on cars 5; larceny 3; committing nuisance 2; failing to produce a tram ticket 2; various 3. One conductor was also charged with embezzling fares.

As will be seen from these figures, being drunk or disorderly on a car seems to have been the most common offence committed by passengers. You would have been very lucky if you had travelled by tram, or indeed any other public service vehicle, all your life and never been troubled or disgusted by the abhorrent behaviour of drunkards who were unable to hold their liquor. Imagine, though, what it must have been like for the crews, especially the conductors, who regularly had to put up with this kind of misbehaviour, especially after closing time on a Saturday night. Zelma Katin gives some idea of what the conductor had to endure in her book *Clippie* (published by John Gifford in 1944).

With the closing of the public houses the tram became smellier, noisier and more repellent. Each passenger gave forth his or her distinctive smell. Upstairs a sot had vomited. His vomit covered half the gangway, and in an effort to avoid it, the more sober ones, when alighting, tried to pass down the stairs and out at the end where the motorman was working. He refused to

Policemen were often called to disturbances on tramcars, especially to remove drunkards and ruffians, but these policemen are more interested in the spanking new tramcar delivered for the opening of Northampton's new electric tram service on 21 July 1904. With their white gloves, these policemen were obviously on traffic point duty. In 1927, after an accident involving a constable, tram drivers were warned that cars should not pass each other with a constable in between. Note the meter under the stairs and the holes in the riser below it, which allowed drivers to see overtaking vehicles on the nearside. The photograph is taken from an early 3D view.

let them pass, and they turned back and waded as best they could through the slime. After I refused to take any fares on the upper deck, the motorman poured sand on the mess and smothered it.

I was struck by the number of young boys and girls who were drunk at closing time. From their mouths and the mouths of their elders came a stench of stale liquor which lunged against me as I bent to collect their fares. Altogether on this Saturday night I had seen enough of the fluid side of Merrie England to put me off intoxicants for ever.

Spitting on tramcars was another offence that was equally abhorrent to the travelling public and to tram crews. In 1909 in Glasgow, determined efforts were made to stamp out the nasty habit. Plain clothes men were employed to book people who offended in this way. Over a six-week period in November and December that year they booked more than 1,500 offenders.

More surprising is the unfortunate experience of a London tram driver who was at the receiving end of a different, and fortunately not very common, offence. His daughter, Mrs D.M. Friend of St Paul's Cray in Kent, wrote to tell me about it.

Years ago, of course, the men were not allowed meal-breaks. They worked eight hours at a stretch, so my father had his sandwiches handy for eating. Just as he put one to his mouth, he felt water dripping onto the top of his cap, down his peak and onto his sandwich. He stopped the tram and his conductor went upstairs to investigate. What had happened was that there was a mother with a small boy upstairs and the child needed to spend a penny. Instead of getting off the tram she had let him perform on the vehicle. Of course, the obvious happened and unfortunately just as my father was about to eat. When told off by the conductor, the irate mother threatened to report the man for swearing at her; not surprising he did, is it?

Another bye-law often broken was one warning not to damage the cars. I have ridden on old and new tramcars on which the saloon windows have been blatantly and defiantly scratched. This was particularly noticeable on the new supertrams in Sheffield not long after they had entered service. Wilful damage has taken many forms, but one of the most unusual cases was publicised in Liverpool during the First World War, when twenty boys were birched for stealing headlamps off tramcars and throwing them violently to the ground in imitation of bomb throwing.

In Torquay, a petty officer from a torpedo boat lying in the bay was accused of pulling down the trolley arm of a tramcar by the guy rope and letting it spring back with such force that it broke the overhead line. He convinced the bench that, being a seafaring man, he had attempted to tighten a loose line, but had made it too taut so that it had later left the traction wire and sprung up.

At the other end of the scale a passenger was fined six shillings in 1923 at Stalybridge for damaging a poster in a tramcar. He admitted tearing down a notice which, he said, prevented him from seeing where he was going. The Stalybridge, Hyde, Mossley and Dukinfield Joint Tramways Board said that the notices in its windows were a good source of revenue.

One of the most despicable of crimes committed on tramcars was that of picking pockets. It was rife at one time on tramcars, particularly when passengers were scrambling to get on, such as when departing from football matches. In Bolton gangs of pick-pockets fleeced unsuspecting passengers leaving Bolton Wanderers' Burnden Park ground. Detectives on duty in the ground for one match saw four men acting strangely as the crowd made their way to the trams. They followed the men and saw them pushing their way through the crowd, jostling supporters and putting their hands in other people's pockets. They then saw the men board the trams and attempt to dispose of their ill-gotten gains among several accomplices. They were then arrested and subsequently appeared in court, where they were severely punished.

Far worse crimes than these, however, were those committed by robbers and burglars, especially those intent on stealing the cash from takings, as illustrated by a case at Paisley's Elderslie tram depot in 1930. The following newspaper report of the incident is taken from *Paisley's Trams and Buses – Twenties to Eighties* by Alan Brotchie and Robert Grieves.

At two o'clock in the morning Mr Robert Drummond, one of the oldest employees, was in the cash office alone. He had been receiving the drawings of the conductors who were in charge of the late cars, and most of the money was placed in lockfast boxes ready to be taken to the bank.

Mr Drummond felt a draught behind him, and suspecting that the wind had blown open a door went to close it. He had almost reached the door when he received two heavy blows, and a man sprang out at him. Mr Drummond made a fight of it, and the two men struggled violently – the tramway official all the while becoming weaker, but anxious to lead his adversary near to the alarm bell.

The burglar was forcing Mr Drummond to the

floor when, with great presence of mind, Mr Drummond seized a ledger and hurled it through a window. Immediately, several men from the sheds rushed to the office. The burglar grabbed one money bag and ran off. He rushed through the door at the rear by which he had entered, and was last seen scaling a high wall behind the depot. The bag contained £8 in small silver, and a search of the path revealed some silver coins. The county police quickly made an arrest, but the Fiscal decided that there was not sufficient evidence to prosecute.

Happily not every robbery was pulled off with success, as Bill Tollan, son of a Glasgow tram conductor, revealed in the July 1993 issue of *Kontakt*, the magazine of the Scottish International Tramway Association. Bill, who is a keen writer on the subject of Glasgow trams, described how his father, with the help of a friend, prevented robbers from grabbing his takings.

One night my father was conducting on an open-top standard car coming into town from Uddingston. In those days, this would have been in the darkness of the night, largely through open country until Mount Vernon was reached. On the tram's upper deck was a family friend – one Gerry Reynolds, who had been a much-feared full-back with Celtic FC. Shortly after passing Uddingston Station, he came downstairs with the news that two toughs on the top-deck were planning to come downstairs, cut the leather strap of my father's cash-bag, and jump off with the money. This was serious stuff, as the loss of the money could have meant instant dismissal for my father. Bag theft was always a danger for a Glasgow Corporation tramway conductor!

So a plot was hatched downstairs. The motorman would make a sudden and unexpected stop. He would then climb the front stairs with the very long point-shifter, carried in those days to allow the motorman to change the points without leaving the front platform. Gerry Reynolds and my father would at the same time come up the back stairs together. When the two brave fellows realised what was about to hit them, they jumped over the side of the open-top tram, and disappeared into the fields. So the cash was saved.

I don't remember the old bye-laws prohibiting passengers from boarding trams 'in the altogether'. But on the new Metrolink tramcars in Manchester, one evening in October 2003, passengers couldn't believe their eyes when a man wearing nothing more than a woolly hat was bundled onto their tram. The man, it appears, was on his stag night and, in the age-old tradition, had been stripped naked and tied up by his friends. A passenger quickly restored the unfortunate victim's dignity with the help of the woolly hat and then untied him so that he could pick up his scattered clothing from the floor of the tram and get dressed.

Back in the 1920s, passengers attempting to board a Manchester tram one day might have imagined they were about to witness something similar when a young lady on the platform shouted at them, 'Wait, I'm going to take my clothes off.' Her comments certainly stopped them in their tracks for they assumed she was about to strip. But the stop was

Passengers on Halifax trams enjoyed many trips down scenic roads like this one, but on one tram in 1901 their enjoyment was rudely interrupted when a man on the upper deck picked up a snake from the floor and declared that he was carrying a box full of them, which was strictly against the bye-laws and regulations. Their surprise turned to horror when he then revealed that another snake had escaped and that it was still missing.

opposite a public wash-house, and she explained that she was referring to the bundle of washing she had left under the platform stairs. Nobody sighed more with relief than the conductor.

Upper-deck passengers on a Halifax tram in August 1901 received an even bigger surprise when a man picked up a snake from the floor and declared that he was carrying a box full of them. Their surprise turned to horror when he then revealed that another snake had escaped and that it was still missing on the top deck. On most tramways it was against the regulations to take strange and exotic creatures on cars without the express permission of the conductor.

Probably the bye-law broken more than any other is the one stating that the passenger shall pay the conductor the fare legally demandable. The total number of people who have avoided paying their fare down the years must be astronomical. Some of the lengths they go to are unbelievable. When I was walking out of the Haymarket Station of the Newcastle Metro one day in 1997, a youth running at speed leapt past me over a turnstile and disappeared into the bowels of the station before I could say Jack Robinson! This was certainly a spectacular demonstration of fare dodging, but the youth could easily have broken his leg or even his neck in the process. In 2003, Manchester's Metrolink was catching 800 people a week who were travelling on the trams without a ticket. The number of fare dodgers taken to court each week averaged 240. The inspectors heard all kinds of excuses for not having a ticket, such as 'I've chewed it up', or 'the wind blew it away'.

In Wigan in May 1902 a number of passengers appeared in court for fighting and refusing to pay their fares. One man was also charged with assaulting the driver. The local paper headlined their story 'Tramway Dodgery and Ruffians'. Two years later, in the same town, Philip Hains, a 77-year-old vicar, was taken to court for avoiding payment of his fare. What was said in court is recounted by Keith Stretch in his detailed history *The Tramways of Wigan* (published by Manchester Transport Museum Society in 1978).

In 2003, Manchester's Metrolink was catching 800 fare dodgers a week, with an average of 240 being taken to court each week. Yet every station has ticket machines, most of them on the platforms. This one was photographed in St Peter's Square in the opening year.

The vicar first disputed the charge, arguing that he had not 'avoided' paying, but had 'refused' to pay, because he had not received the service the tram was supposed to provide.

Apparently he had been waiting at Coppull Lane stop on the Boar's Head line for an inward-bound car, but was waiting on the wrong side of the road. He gave no signal, and the driver did not stop; the conductor, however, looking back, thought perhaps Mr Hains wanted to board, and rang the bell. Mr Hains then ran after the car and got on. In court, Mr Hains said he gave no signal because the trams were supposed to stop anyway if someone was waiting, and asked rhetorically what sort of signal was one supposed to give; ought one to whistle, or jump about, or leap into the road?

He cross-examined the driver and conductor at great length, most of the questions being totally irrelevant. James Slevin was also called as a witness, and it came out that Mr Hains was in the habit of writing letters of complaint about the tram services. Mr Hains then dwelt at length on the management of the Wigan trams, and also on what he claimed was the poor standard of driving – he said he absolutely refused to travel on any tram driven by Mr Dewse (though as Mr Dewse was the accountant and assistant manager, it hardly seems likely that he drove very often!).

Finally, he said that apparently, 'there were four things a man had to understand before he could stop a Wigan tramcar. He had to stand against a pole; secondly he had to shout; thirdly he had to blow a

trumpet like the ancient Pharisee; fourthly he had to place four fingers in his mouth, pulling it like a post-office pillar-box opening, and then whistle. A man in such a pose could only be compared to a sailor in his dying agony.'

Mr Hains' eloquence, though it provided much entertainment, did not carry much weight with the magistrates: they fined him ten shillings. The issue of the *Wigan Examiner* which carried a report of the case also contained a letter from the irrepressible Mr Hains complaining that the whole affair was a miscarriage of justice; he argued that as the magistrate's bench was made up entirely of members of the Borough Council, they should all have been disqualified from sitting on this case as the Council was the plaintiff.

The vicar would have found an ally in an irate Reading tram passenger who also had difficulty in requesting tramcars to stop for him only the year before. His letter of complaint to the *Reading Standard* in 1903 made the following observations:

> Would it not be well to make the appointment of motormen dependent upon a simple side sight test? Being desirous the other evening of boarding an east-bound car I planted myself within two feet of the rails immediately opposite the pole and held up my right hand. This, not having the desired effect, I held up everything I possessed of a liftable character, and then still noting an absence of response, began to execute a sword dance and to wave my hat, umbrella and parcels about in a manner which must have been highly amusing to watchers on. Notwithstanding all this the car passed me without slackening speed, and on the face of the controlling official was a look of stony superiority which struck me as being exaggerated even for an electric car driver in a brand new uniform!

One thing the bye-laws and regulations didn't protect employees from was the trouble caused by devious road users. This was brought out in Edwin Elsley's pocket-size book *How to Drive a Tram*, which was reprinted under the auspices of the Manchester Transport Historical Collection in 1964. Mr Elsley warned tram drivers to beware of the class of person who was always on the look-out for a chance to obtain money from tramway operators by underhand means.

> There is one class of person to be always aware of, when your alertness and cunning cannot be too keen – for example, the person who after an accident to either himself or his vehicle says, 'Oh, it's nothing; off you go,' leading you to believe that neither he nor his horse is hurt, and that there will be no more said about it, but who after he has got you out of the way, speculates in a few names and addresses on his own; and when you think it has nicely blown over, the engineer or manager wants to know why you did not report the accident you had on such-and-such a date, and for which there is a claim of so-and-so, generally about four times the amount expected by the person who told you a few days since, 'Oh, it's nothing; off you go,' but who was crafty enough to notice the number of your car as you were driving away, then got his witnesses, and now means to be set up in a good business by the tramway concern.
>
> What nice soft things we look now, standing in front of the manager, telling him we know nothing about it, while all the time he knows we are lying to him, and it is just beginning to dawn on us that we have not done justice to either him or ourselves. The moral to this is, don't be 'gulled or disarmed' by anyone where you or your employers stand to lose anything.
>
> The member of society here described is known as 'one of the forty' and each town generally has its own gang, although I have known one gang to be working two towns at one and the same time.
>
> In all cases of accidents, collisions, damage to persons or property, etc., never assume any authoritative air and 'demand' the name and address of anyone who may be held responsible, but offer to exchange your own for theirs – you will stand a much better chance of getting it – and in obtaining names of persons as witnesses, ask them a favour; and if you can point out to anyone a wheel mark on the road showing that the party who has collided with your car has come in front of you suddenly without giving you due notice to do so, it may be a help to you; but beyond this do not argue or squabble as to whose fault it is – that can be decided another day, in calmer moments, and with less delay to the car.

Glittering Spectacle

By Dennis Gill, with extracts by Steve Palmer, Richard Passmore, Mark Pearson and Ian Yearsley

Town streets once enjoyed the spectacle of tramcars illuminated by a myriad of coloured bulbs, usually to celebrate some special occasion, and crowds stood on the pavements to gape in wonder as they passed by.

Blackpool's Western train is probably the most ambitious of all illuminated tramcars, and in this view outshines Blackpool's famous tower. It entered service in time for the 1962 illuminations and was immediately popular with visitors. It seated ninety-four passengers.

One of the most attractive features of tramway systems was the illuminated tram. There were few towns which did not have one, and they roamed the streets, decorated with hundreds of electric bulbs of many hues during special events, such as coronations, jubilees, victory celebrations, royal visits and shopping weeks. Thousands of people lined the streets to see them pass by. The glittering spectacle they presented was described in glowing terms, such as a 'mass of splendid iridescence', 'shimmering waves of light moving back and forth', and 'a picture out of the fairyland of youth'. Blackpool, in 1897, was the first town to run illuminated trams (for Queen Victoria's jubilee) and they have been part of the Blackpool scene, running in conjunction with the resort's crowd-pulling illuminations, virtually continuously since 1913, apart from breaks (1914–25 and 1939–49) caused by wartime disruptions. How it all started was described by Steve Palmer, the productive author of books on Blackpool trams, in his book *Blackpool's Century of Trams*, which was published by the Blackpool Transport Department in 1985.

> Of all the trams operated by Blackpool during the century, it is the galaxy of illuminated cars which make the most lasting and vivid impression. Who can ever forget their first impression of an illuminated tram gliding over the rails in a halo of coloured light? The writer's own experience was seeing the Progress car in the first post-war illuminations of 1949: sheer magic as it swept by, playing music while its myriad bulbs radiated heat and light. Today's children are still enraptured by the approach of the illuminated cars along the promenade, just as they were by the Gondola and Lifeboat in days gone by. The feature cars, as they are known in the Department, are one of the tramway's brightest assets. The story of illuminated trams began with the Diamond Jubilee of Queen Victoria in 1897, when the Tramways Department equipped five trams with lights and patriotic slogans to mark the occasion, and operated them after nightfall on a packed promenade. The effect was tremendous and the *Gazette* commented: 'This first experiment with illuminated trams was a huge success. No doubt the idea will be elaborated when the occasion offers.' This was a portent of future events, and for the Coronation of 1902 no less than twenty-five trams were decorated, illuminations being added in the evening while the cars were in service. The *Gazette* reported: 'Red, white and blue incandescent lamps were rapidly fitted in position, and when the trolley kissed the wire, a brilliant design of stars burst forth and the car was outlined in national colours.' The Tramroad Company,[1] not to be outdone, illuminated some of their own cars both

Frigate 736, one of Blackpool's popular illuminated trams, as rebuilt in 2004.

inside and out. The *Gazette* reported their arrival in Fleetwood's main street: 'The car, with its brilliantly illuminated electrical devices, was a sight which overwhelmed the people in the street with astonishment, broken later by applause as the car passed slowly through the town to the terminus.' The enthusiastic reception of the illuminated cars was such that any future occasion was bound to be graced by their presence.

Blackpool continued to produce illuminated tramcars for special occasions in the years immediately following, including the visit of Princess Louise in 1912 to open the Princess Parade round the Metropole Hotel, and the visit by King George V and Queen Mary in 1913. After the 1912 visit, strings of light were hung along the Princess Parade for the rest of the season, which paved the way for the illuminations which appeared regularly thereafter.

Leeds claims to be the first large city to have an illuminated tram (for the end of the Boer War in 1902) and subsequently ran illuminated trams to celebrate some fourteen special events.

Perhaps the most famous illuminated tram was built by Liverpool in 1923. It boasted 7,000 bulbs of many colours, sixteen changing patterns of light, and an illuminated panel featuring the Liver Bird. When it appeared on the streets it was an immediate success and one lady, Mary Pickering, writing in the *Liverpool Echo* in 1949, recalled it being like 'a great sparkling birthday cake … with a glorious blaze of colour … a living rippling thing like a fountain of flame'. The car consumed nine times more current than other trams; indeed, as it loomed into view, other tram drivers noticed the reduction in power to their own vehicles. Onlookers gathered on the pavements noticed the warm glow from all the bulbs as the car passed by.

Towns like Bolton, Ashton, Stockport, Wigan and St Helens were all bowled over by Liverpool's new illuminated tram and hired it to tour their own tracks to advertise special events, such as the local shopping week. The tram was able to travel to these places

The Cevic Trawler, launched in time for Blackpool's 2001 illuminations season, can be driven from either end.

An illuminated Leeds tramcar decorated for the visit to the city by King Edward VII and Queen Alexandra on 7 July 1908. As well as a crown in the middle window, the tramcar carried a shield on the end panels upstairs, and a Maltese Cross on one dash and a star on the other. It toured all the routes in Leeds during the course of a week.

Many tramways illuminated or decorated tramcars for special events. Portsmouth illuminated their toastrack tram in support of the local football team's triumphs in reaching the FA Cup final, either 1929 or 1934.

under its own steam, so to speak, because they were connected with Liverpool by a continuous line of tramways that stretched across South Lancashire. But the arrangement for most towns was ended in 1930 when the connecting tracks were severed by the abandonment of the Atherton to Ashton-in-Makerfield section and its replacement by trolleybuses. As a result some of the hiring towns were forced to build their own illuminated trams for subsequent events, not that they lacked the experience. Bolton, for example, had built an illuminated tram as far back as 1907 to celebrate through-running with neighbouring Bury.

The illuminated trams are remembered with much affection by many people. Richard Passmore recalls Liverpool's famous illuminated tram in his autobiography, *Thursday Is Missing* (published by Thomas Harmsworth Publishing Company of Beaminster in 1984). Trams were inextricably part of his childhood in the back streets of Liverpool between the wars, but it is the illuminated tram that he remembers most.

> Chiefly, I suppose, I remember the Illuminated Car, well worthy of its capitals. The sides were huge fields of electric bulbs on which unknown artists constructed magical patterns in coloured light – often the municipal coat of arms. On the top deck a band, invisible behind that radiance, played for us. Is heaven itself hidden from us by the glory of its own radiance, I wonder? The tram would process – no lesser word is adequate – to Lime Street, where it would be parked in a siding between the entrance to the station on the one side and Professor Codman's Punch and Judy Show on the other, the brilliance illuminating the tall columns of St George's Hall. Inside sat a few fortunate, unspeakably privileged mortals. On special occasions the tram came out from its shed, next to Wavertree Park, to delight the citizenry, and on its return, late at night, it would pass up the recently laid line in North View, separated from our bedroom only by the Green. The extravagance of light would pluck us out of our shared bed like hooked fish; mute with wonder we would watch, glorifying in every full second, and then scamper back to bed and snuggle down, turning over and over the memory of that unexpected bonus.

In his book *Leicester's Trams in Retrospect* (published by the Tramway Museum Society in 1970), Mark Pearson recalls the concert party and band which turned out with Leicester's illuminated tram (like Liverpool's, also built in 1923) in aid of local charities.

In February 1923, open-top car No. 50 was festooned

Blackpool's illuminated 'Progress' car with the addition of all-over advertising for the electrical manufacturer Compton.

TRAVEL LENS PHOTOGRAPHIC

with decorative panels, drapes and 2,000 coloured lights. This illuminated car toured the various routes after dark in aid of charities, the first of which was the Lord Mayor's Distress Fund for the unemployed. Postcards of the tram were sold at the termini. A band occupied the top deck, and a converted maintenance truck, which was coupled up behind, housed a piano, a potted frond palm and a lady contralto in a warm fur coat, who sang a solo. I remember that one of her songs was 'Keep the Home Fires Burning'. The concert party, of which she was a member, was drawn from the rank and file of the staff. On one occasion over 200 turned out in fancy dress....

The formation of the concert party and the design and decoration of the car were largely due to the efforts of Mr Charles A. Herbert, who joined the staff in 1913, became Claims Superintendent in 1937 and retired in 1959. He appointed himself pathfinder, capering in front of the car and brandishing a stick to control the hordes of small boys who milled around the procession.

The illuminated car made several other sorties, and in 1925 it was kept going until £500 had been raised to endow a cot in the children's ward at the Royal Infirmary.

Ian Yearsley describes the vivid impression Manchester's illuminated tram had on him when he was a boy in his book *The Manchester Tram* (published by Advertiser Press in 1962).

Of my childhood memories, one of the most vivid, is of being held up to the bedroom window to see my first Illuminated Tram, a tram all decked out in coloured electric lights. The occasion was the 1937 Coronation, and I can still remember my excitement at seeing this gorgeous display of coloured lights appear at the end of our road and pass slowly down Alexandra Road, looking like something out of a fairy-tale. All the other trams flew flags on the trolley ropes, and there were decorations on the buildings in town, but it was the Illuminated Tram that stole the show for me.

Manchester Corporation differed from many other towns in not having a permanent decorated or illuminated tram, preferring, when an 'occasion' came along, to deck out one of the ordinary passenger cars. The tradition of decorated trams for special occasions dated right back to the beginning of the electric tramways, when on 6 June 1901 a large crowd watched a procession of ten open-top electric cars decorated with flags and potted palms set out from Albert Square on its way to Queens Road, where the Lord Mayor opened the doors of the new tramway car shed with a golden key. The tradition was maintained by cars that were decorated for the opening of each new route, for national celebrations such as the 1911 Coronation, and for local occasions such as the 1926 Civic Week. The Civic Week car had so many bulbs and decorations that it looked as though a swarm of bees had settled on it.

As tramways started to close down, illuminated trams had their final fling, making tours to commemorate the final closures, but not in as many towns as one might have imagined. The few towns running last trams bedecked with coloured light bulbs included Birkenhead, Blackburn, Bolton, Bradford, Cardiff,

Seaburn seaside resort, being part of Sunderland, enjoyed the benefit of illuminated trams, like this one, provided by the town's tramway department.

Hull, Leeds, Oldham, Rothesay, Sheffield, Southampton and Stockport. Proudly, Stockport's last tram acknowledged the fact that the trams had run in the town for exactly fifty years, but pitifully was illuminated with a miserly 200 bulbs. Many people who had lined the streets to see it pass were disappointed with the meagre display. 'Stockport's illuminated trams have always been a treat to see, but this one was a disgrace,' said one spectator. Well-wishers who turned out to see the last trams in the country's major cities must have been even more disappointed. London, Manchester, Birmingham, Glasgow and Liverpool had no illuminations whatsoever on their last cars.

[1] Operating between Blackpool and Fleetwood.

Crisis on the Top Deck

By Alastair Phillips

Alastair Phillips recalls the never-to-be-forgotten occasion when he took a tram ride in Glasgow and could not find his fare. His story about that journey (reproduced by kind permission of the *Herald*, Glasgow) appeared in the then *Glasgow Herald* on 12 February 1958.

We lurched the other night to the top of our Partick-bound tramway-car with the conductor following close behind us. We were the only unserved passenger and he was at our elbow with that blank look that conductors have when, as the car rocked over the Jamaica Street crossing, we stumbled into the seat, saying: 'Fourpenny.'

His automatic machine clicked as we reached into our pocket and brought out four halfpennies. When we glanced up before investigating our other pockets the hand was out, with the ticket gripped firmly in his fingers, an expression of indifference on his face as he stood with experienced patience, with his eyes on the roof and his other hand stirring the coins in his money bag.

We were still relaxed when we yoked back our overcoat to try the left-hand trouser pocket, and we began to command the special attention of the conductor and a flicker of interest in the passenger across the aisle only when we brought out two penknives, an India rubber and four leather buttons. At that we began to apologise and search with increasing frenzy in our other pockets – of which, when we counted them later in tranquillity, we discovered we had seventeen.

The conductor let his shoulders sag, dropped the hand holding the ticket, and said: 'Now jist take it easy, mate.'

His voice was soothing but not subdued, so other

How embarrassing can it be when you can't find your fare and the tram conductor is waiting to give you your ticket? Alastair Phillips' nightmare is re-enacted in this view taken on board one of Birkenhead's Hong Kong cars.

passengers heard and watched. They were silent and just grinned a little, and the transaction might have passed off discreetly but that one of them at the back of the car was a little drunk, petulantly inquisitive, and could not see what was happening.

He started to ask aloud: 'Hi Mac ... Oh Mac ... Whit's gawn oan up there? Are ye gonny pi'm aff?'

This created an atmosphere of sympathy, and while the conductor turned to silence the interrupter we tried to settle down and search our pockets systematically. When we had produced two boxes of matches, two cigarette packets, an old red handkerchief, three brass hooks and a screw driver, we looked up in some embarrassment and caught the eye of the man across the aisle, who was nodding confidentially at us at the same time as he was making gestures towards his own pocket. The offer was kind but it made us only the more uneasy, so we shook our head back at him, and dug out a spectacle case, a broken propelling pencil, two cigarette cases and a long knife with a curved blade for scraping leather.

By this time the conductor had eased his stance and had one knee on the cushion and his hand resting on the back of the seat in front. We took out the spare rubber tube for an old-fashioned fountain pen, another pocket knife and a leather-covered diary for 1934 given away by a Newcastle upon Tyne firm that manufacture switchgear for marine engines.

Then the passenger sitting immediately in front of us turned round – in the direction of the window so that the others would not overhear – and murmured out of the corner of his mouth: 'Are you short? Here, I can help you.'

We said: 'No, no. It's quite all right,' and produced the case of an old gold watch with no works in it, a nutmeg, a small china plover, and twelve inches of heavy fishing line.

The man at the back of the car was calling: 'Get the polis.'

By this time we had reached our last pocket but one. From it we brought a brass token for the Cape Town horse tramway system, dated 1895, an Egyptian piastre, and a lead communion token engraved 'Free Church, Fearn, 1846'.

When at last we took out an ingenious little mechanism for winding up old-fashioned pocket watches the conductor straightened himself, and, saying, 'Ach, here', he thrust the fourpenny ticket into our hand, and went back to the lower deck.

When, still out of countenance, we came down the stairs at Peel Street, he was standing on the platform, and when we muttered our apology and thanks, he said: 'Not at all, mate. Now, are you sure you're all right to get home?'

Good-Humoured Belfast Banter

By Mike Maybin

Mike Maybin recalls some of the good-humoured banter he came across on Belfast trams in his book *A Nostalgic Look At Belfast Trams Since 1945* (published by Silver Link Publishing in 1994) from which the following extract is taken. Mike is the Belfast representative of the Light Rail Transit Association, and is currently campaigning to bring back trams to Belfast.

My own memory of Belfast trams is limited to their last few years of operation in the 1950s, when as a child we visited my grandmother and travelled by

trolleybus from the Ormeau Road to the City Centre, then by tram to Bray Street on the Crumlin Road.… I have other memories of riding the Crumlin Road cars in the rush hour, full of shipyard men in damp coats, the ringing of the bell to stop or start, the good-humoured banter of the conductors, the careful counting out of pennies and halfpennies to make up the correct fare, and the occasional dispute about a youth's age and therefore his right to travel half-fare.

Apart from the McCreary cars,[1] Belfast trams had no platform doors. On the platform beside the motorman there was a leather-covered chain designed to deter passengers from getting on or off, and the strict rule was that the chain should be kept across at all times. On one occasion on a cold and windy day a tram was passing Castle Junction with the chain not in place. It was stopped by the duty inspector and the motorman loudly told in front of all the other passengers to 'put that ****** chain on'. Quick as a flash the motorman replied, equally loudly, 'Thanks, Billy, I wondered where the draught was coming from!'

In the early days of trams, fares were a penny and two-pence and conductors were required to carry a certain amount of change for a shilling, or occasionally, a half-crown. There was a gentleman who lived on the Malone Road route who got into the habit of offering a ten-shilling note for his penny fare into town in the morning. Remembering that ten shillings might be a week's wages for a working man, few conductors could change this amount first thing in the morning. There was no choice but to let him travel free. One conductor, becoming fed up with this behaviour, decided to deal with matter in his own way. The next time he was faced with the 'Sorry, I've only got a ten-bob note,' he replied, 'No problem, sir, I've got some change this morning,' and handed the passenger 119 penny coins. He did not have any more trouble from that particular gentleman!

Although working on the trams was considered relatively secure employment, especially at a time when casual labour was widespread, conductors and drivers were not particularly well paid. Tickets came in packs and were held by elastic bands in a rack carried by the conductor. As the serial numbers were recorded on issue at the depot in the morning and again at pay-in in the evening, the cash due was easily calculated. On occasions, when short of money, conductors would sell tickets from the middle of the rack, where the loss was not immediately noticed. However, the money had to be found by the time the tickets had been sold as far down as the 'gap'. The practice could result in disciplinary action, but was often regarded as 'borrowing' rather than theft, and was referred to by the crews as 'selling on the futures market'.…

There were several ways in which Belfast trams were unusual as compared to other cities. Belfast conductors wore their ticket machines and cash bags around the same shoulder – usually the right – whereas in most other places they were worn on opposite shoulders with the strap crossing the chest. By 1945 tram routes that crossed the City Centre showed a different route number in each direction, which was changed at the terminus. It was partly for this reason that Belfast people almost always defined routes by their name and not the number. The other reason was that many of the Standard Reds[2] never carried route numbers.

There were a couple of other things of which I was

Standard Reds (right and fourth from left) are included in this view of Belfast trams at the junction of Crumlin Road and Oldpark Road in September 1938. Mike Maybin enjoyed the good-humoured banter of the conductors working on these trams.

aware; I don't know whether they were unique or just unusual. Boys selling the local evening paper – the *Belfast Telegraph* – were allowed to travel free while so engaged. According to the rule book, newspapers were the only item allowed to be sold on the trams. Old people from Nazareth Lodge on the Ravenhill Road were allowed to travel up and down on the trams and buses free outside the rush-hour. I remember this particularly as it was the first time I had seen a man smoking a pipe with what seemed to be a metal lid. I must have been about eight at the time.

[1] The city's most modern trams, named after the manager who introduced them.
[2] The city's older trams.

Wonderful Asset in Fog

By Ian Yearsley

One often-quoted advantage of trams was their ability to keep going in fog when everything else on the roads had come to a stop. When visibility was bad other road users would follow the tram lines. In very bad fogs, bus services would be withdrawn, whereas tram services would continue to operate. 'You could get on a tram in a pea-souper, confident that it would get you home safely. It was a solid haven of refuge, as sound as the Rock of Gibraltar. You knew it wouldn't take the wrong turning or land you in a ditch,' said an office worker who travelled on Manchester's trams for thirty years. So bad was a Manchester fog in 1931, the Manchester Tramways decided to withdraw its all-night bus service and instead run all-night tramcars.

The same year the Leeds Tramways manager, Robert Lund Horsfield, reported that he had had to withdraw buses from the streets during a bad fog, but not trams. There was only a three per cent loss of mileage on the trams compared with about thirty-five per cent on the buses. In his opinion the tramcar was the safest vehicle on the streets.

Following another thick Manchester fog in 1937, the *Empire News* commented: 'While private cars have been mounting pavements, while buses have been left in side streets by disgusted drivers, and while bicycles have been skidding all over the road, tramcars have been carrying on work as usual.'

Tramway historian Ian Yearsley was brought up in the Whalley Range district of Manchester, not far from the city's No. 11 tram route, and quickly came to appreciate the tramcar's versatility, especially in times of fog. By the time he reached adulthood, he had become an expert on the tramways of Manchester and surrounding towns and went on to write a book on the subject, *The Manchester Tram* (published by the Advertiser Press in 1962) which is acknowledged as a classic of its kind. Mr Yearsley's fascination for trams shines throughout the book and in this extract he recalls how cheerful the sounds of the tram's motors were in fog.

You knew precisely where the tram was going, and where it was not going, and never could be going. Most of all, the tramlines, and the trams, were a wonderful asset in a fog, and the trams kept going long after everything else had come to a stop. I remember how one afternoon we went into town for

A Leeds tram shrouded in fog at the terminus of the Elland tram route on 25 October 1951.

Trams operating in fog were very much a part of the tramway era, as captured in this evocative scene of Bolton trams painted by artist Ashley Best.

a shopping expedition in Lewis's store, and emerged to find the city shrouded in close, noise-deadening fog. The bus service had completely stopped, and we set off to walk home, following the tram lines, but after some way we caught up with a dark shape studded with pools of yellow light slowly cleaving the fog beside us, a lighted No. 23 tram running very slowly through the murk with visibility down to about three yards. It was packed to the very steps, and we didn't try to board it but walked alongside as the driver applied the first notch for a few yards, then coasted, and so on.

The wartime blackout of street lamps didn't help, for the glass globes had been replaced by a metal box with holes, letting through only a few pinpoints of 'starlight'. Today there are more powerful streetlamps to help penetrate a fog, but if it becomes really thick, the Transport Department's only hope is to run the buses in convoys, each one headed by a motorcycle carrying a board of electric bulbs, lit from batteries, and driven by a senior bus-driver or inspector picked for his ability as a trailblazer. But the fog often wins, or did until Manchester introduced the Smokeless Zone....

In the refectory of Chorlton High School there hung a fine painting of a Manchester street on a foggy day, complete with a No. 12 tram, which always reminded me of that evening; it was one of the Rutherston collection of paintings loaned to the city and displayed in the various schools. Pictures like this, of Manchester trams looming through the fog, are comparatively rare, and yet these scenes are the very essence of the Manchester scene in winter. It was as if fog was a tram's natural element; it was at home in it, as nothing else on wheels could be, and the sound of its motors was a very cheerful one indeed on a night like that. You felt that the tram, steered by its rails, would never get lost or have to give up, though in a city of complicated track layouts like Manchester the first did occasionally happen. The fog would often be particularly thick down by the Irwell, and Bob Berwick, my tram-driver friend, told me how one day, in a fog, he had passed a Salford Corporation tram groping its way down Chester Road near Old Trafford, when it should have turned off to the right at the junction of Liverpool Road and Deansgate.

Bombed off the Face of the Earth

By Dennis Gill, with extracts by John Appleby, Dr H.A. Vreedenberg, Stanley Guildford Collins and Harold Carliczek

Hitler's bombs put paid to two of Britain's tramways in the Second World War, but failed to put others out of action. Indeed, many of the large tramway operators showed considerable resilience at the height of the Blitz in getting cars running, even where tracks had been blown apart.

Despite the countless number of bombs dropped on Britain in the Second World War, most of the country's tramways did remarkably well to keep their tramcars on the road, especially when one considers the

thousands of people killed and injured, and the large number of fine public buildings, churches, hospitals, factories, hotels, cinemas and stores destroyed. Tramways in most of the country's large cities suffered bomb damage; few of them escaped unscathed. Not surprisingly the worst affected tramway was that in London, which lost forty-eight tram and trolleybus operatives, had more than seventy cars destroyed and very many others severely damaged. Three other tramway systems to be badly hit were Birmingham, which lost nearly forty cars; Sheffield, with fifteen cars destroyed; and Liverpool, which, while it had only four tramcars destroyed, had more than 230 damaged. Apart from Sheffield, which closed for a day after the raid which destroyed much of the tramway infrastructure in December 1940, all these systems kept their services running throughout the bombing, quickly repairing damaged track.

This was not the case, however, in Coventry and Bristol, which suffered very severe damage to their infrastructure. Managements in both these towns took the decision to suspend tramcar operation for good, the raids putting the finishing touches to tramway abandonment programmes that had started before the war. Likewise, in the battle for Arnhem later in the war, the town's tramway system was virtually wiped out, never to run again.

Coventry Tramways were put out of action by a number of raids culminating in the catastrophic raid of 14 November 1940. Some 500 bombers, in wave after wave, dropped in the region of 500 tons of high explosives and 30,000 incendiary bombs on the city, killing nearly 600 civilians, injuring almost 900 and leaving thousands homeless. The attack was in retaliation for the RAF bombing of Munich six nights before, and the fires could be seen fifty miles away. The percentage of the population killed in Coventry on that one night was greater than in any other British city throughout the whole of the war. The city's tram and bus system suffered severe damage, with severed and twisted tram track left pointing skywards in many places. Bomb-blasted pieces of track were flung great distances, some even into rooms of houses, one landing in a bathroom and another heavy piece rocketing into a boy's bedroom and landing on his bed. Oddly enough, few tramcars were damaged, although half the bus fleet needed repairing or rebuilding. In his history of Coventry's tramways published in the magazine *Tramway Review* in 1961, Ken Farrell reproduced a map showing the fifteen craters that severed the tracks. The craters left five tramcars marooned until they could be towed back to the depot. The operation involved derailing the cars to haul them round the craters. There were several places where the wires had been brought down, and the power station and repair shops were also hit. The decision to close the lines for good did not go down well with *Modern Tramway*, the campaigning magazine of the Light Railway Transport League. In their April 1941 issue they commented:

> We learn that the Coventry City Council have definitely decided that the tramways, which were damaged in the famous raid, are not to be operated again. We have every sympathy for this gallant Midland city in its difficulties, but we cannot help feeling that a mistake has been made. The tramways, though in need of urgent improvements, could with a little ingenuity have been made over into a quite useful and modern system, and the air raid damage,

Fourteen of Sheffield's trams were destroyed or badly damaged by Hitler's bombers in December 1940. This view shows two cars (Nos. 201 and 228) which suffered considerably when bombs landed at West Bar on the night of 12/13 December. Nobody on the trams was injured, the passengers and crews presumably having fled to the shelters. The two cars were rebuilt.

Night view of Coventry trams in Broadgate – the street which disappeared in just one night during the Blitz in November 1940. To help the photographer get this scene the tram drivers switched on their lights for one second and then off for four.

though severe, was by no means irreparable. Indeed there are other systems which (though larger) have probably had a total amount of damage since the war started quite equal to Coventry's, but this was promptly repaired as it occurred and services were in no case interrupted for more than a few days. The raid damage at Coventry might, indeed, have facilitated a bold modernisation plan. Is there no hope of a reconsideration after the war?

There was no hope, of course, whereas in Dresden, a German town which British bombers practically blasted out of existence, the destroyed tramways were rebuilt to become one of the finest in the world today. According to Falk Lösch, press officer of the Dresden Tramways, the raids in February 1945 left 191 cars completely destroyed, 121 cars damaged, only nine kilometres of track operable (out of a total of 186 km), the power equipment completely out of action and many parts of the lines blocked by numerous craters and rubble from ruins. Herr Lösch told me that none of the trams had been parked on dispersal sidings because nobody in Dresden, of course, had expected raids of such magnitude. A few trams started running again on 12 May 1945, and three trams were borrowed from Cologne the following September, but it took three years to reconstruct the main lines and for services to be restored stage by stage. On the other hand, it took Coventry four years to dig up its tram tracks, but how much of the resulting scrap metal (estimated to be sufficient to make 180 heavy tanks) was actually used for the war effort is not clear.

Bristol Tramways were left crippled by a bombing raid on 24 November 1940, with the final blow coming the following year. The 24 November raid destroyed the Bedminster tramway depot, severing the approach tracks, damaging most of the rolling stock within it and killing a driver about to take out a tram on early workmen's duty. In his book *Bristol's Trams Remembered* (which he published himself in 1969) John Appleby describes a very unusual incident that night, which left a tram in a never-to-be-forgotten contrary situation.

> This was the occasion of the city's fourth severe night raid, and, known as the 'freeze-Blitz', it lasted from dusk till dawn. Water that night froze to the firemen's hoses and at Redcliff Hill a direct hit burst a large water main which then gushed its contents down the slope toward Redcliff Street, covering the road with a sheet of thick ice. Earlier, when the sirens had sent everybody scuttling for shelter, a tramcar had been abandoned on the incline by St Mary Redcliffe Church. The tram was soon overcome by the freezing torrent and became firmly frozen to its tracks. Mr Harold Slocombe passed by the stranded vehicle at the height of the raid and could hardly believe the quite incredible scene of an empty tram, still with its lights burning, iced to the axle boxes and draped with overhead wires which sagged with the heat from blazing buildings nearby!

It was a raid on Good Friday the following year that brought about the demise of the Bristol tram service, the *coup de grâce* being given by a bomb dropped on St Philip's Bridge, which disconnected the power station from the remaining trams. All the trams out on the road, denied the use of electricity, came to a sudden halt. John Appleby describes how the crew of one tram on the Kingswood service managed to get their vehicle safely back to the Kingswood depot.

> Left without power the driver and conductor decided that a push from behind might just get the car to the beginning of the next downward slope which led directly to the depot. One or two helpful onlookers joined in and the dead tram was soon sailing down Hill Street, Driver Webster not applying the handbrake until the car had swung in through the depot gates and come to a halt… outside the main shed.… It soon became apparent that power for the tramways could not be restored.… Thus ended Bristol's trams. Their demise, in fact, marked the end of Bristol's Blitzes which had destroyed so much of the city that was. The old trams had outlived all reasonable expectations and finally met their Valhalla among the weeds of the Kingswood sidings, victims of Hitler's war.

In Europe, the classic instance of a tramway being put completely out of action, never to run again, was the Dutch town of Arnhem, made famous by its strategic role in the invasion of Europe, and especially by the film *A Bridge Too Far*. Writing in *Modern Tramway* for April 1946, Dr H.A. Vreedenberg said:

> The tragic history of Arnhem is well known.… At the start of the battle of Arnhem in September 1944, the depot, workshops, power station and nearly all the rolling stock were destroyed by allied bombardments. A part of the remainder was carried to the enemy's country during the following months of evacuation, just like most of the properties of the inhabitants. The liberation of April 1945 was accompanied by heavy fighting for quite a few days. Nothing was left in the ruins of the houses of the population, and only a few wrecks were found on the remains of the rails.… The overhead equipment had disappeared altogether.… A sad death of a network which deserved a better fate. There is some analogy to the case of Coventry.

The window panes of this tram in Birmingham were all shattered during an air raid on the city in 1941. But it is shown here back in service with temporary sheeting over the windows.

In May 1941, *Modern Tramway* praised British tramway workers for the way they kept services running even while bombs were falling around them.

Great ingenuity has been shown in all parts of the country by tramway officials and permanent way men who have worked to restore services, very often under adverse conditions before the 'All Clear' has been sounded and while bombs have been falling nearby. Debris on the track was frequently cleared by the time the morning services were due to start, while the overhead gear was also repaired at the same time. This called in all cases for superhuman efforts on the part of the staff. In one town in the Midlands a heavy bomb fell on the tram tracks and actually blew a tramcar in two, the top deck being blown some distance from the lower part of the car. A huge crater was made on one of the tracks and surrounding roadways, yet a normal tram service was in operation within forty-eight hours. During a recent raid on a north-west town, two tramcars were blown over and craters were caused in the roadways, yet next day tram routes were operating for early morning workers as usual.

In London, a certain route had a considerable length of one track torn up; here temporary crossovers were speedily laid, so that normal services were maintained on the single remaining track during the time the road was completely closed to all other traffic. At another part where similar conditions applied and there was no satisfactory alternative route for other road vehicles, the trams deputised for the buses and trolleybuses normally traversing this section until the road surface was restored.

London's trams, unlike Coventry's, kept running throughout the Blitz and the doodlebug raids that followed later. According to a news item in the June 1941 issue of *Modern Tramway*, the all-night trams in London never ceased running throughout the Blitz, and the spirit of the tram drivers and conductors was appreciated by the public. One of the drivers, 56-year-old Mr Sydney Ball, who had been driving trams every night since the war started, said that it would take more than bombs to frighten him.

Bombs have fallen close to his trams on many occasions and several times Mr Ball helped to save buildings by putting out incendiary bombs. One night he saw an incendiary bomb roll under the outer door of a large building. There was just space under the door to admit the bomb, but not space enough for him to crawl under. He and some passengers tried to batter the door down without success and soon the building was blazing. Much worse than the bombs is the black-out. It is difficult to judge distances and in the darkness his eyes play odd tricks. Mr Ball has often pulled up his tram, believing that a vehicle had stopped on the track, only to find that what he thought was a red rear lamp was a glowing cigarette end, sticking upon the road.

Mr Ball takes an interest in his passengers and they take an interest in him. Before the war they were a colourful and often gay crowd – cabaret girls, dance girls, music hall performers, newspaper men, waiters, market workers and cleaners. Now that entertainments end much earlier, Mr Ball's passengers are mostly newspaper men and soldiers on leave who have stayed in the West End as late as possible. Mr

Bomb-damaged Birmingham trams stand forlornly in Moseley Depot.

Ball says that during a 'rough' night passengers frequently come to his cab, shake him by the hand and thank him for having got them home. This pleases Mr Ball, who is known to many of his passengers by his Christian name of Sid. He is not always able to run as strictly to timetable as in peace time, but he still tries to keep passengers waiting in the blacked-out and often dangerous streets as little as possible and he never leaves anyone behind.

Mr Ball has no nerves. He feels happier and safer in his large Feltham-type tramcar than in a house or in the street. His passengers, too, seem to be content in the car, but he has one interesting and perhaps surprising comment to make – elderly people withstand bombing much better than do young people. He has yet to see an elderly person, man or woman, give the slightest sign of being frightened.

London tramway driver Stanley Guildford Collins, talking to Terry Cooper in his book *The Wheels Used to Talk To Us* (published by Sheaf Publishing in 1977) recalls in great detail his tram driving experiences through the Blitz – how he narrowly avoided being hit by a bomb and the diversions he made when bombs were falling. On one occasion the siren sounded when he was driving on the No.18 route to Croydon.

I stopped the tram and turned round. 'Ladies and Gentlemen,' I said, 'the sirens are going. Anyone who wants to go down the shelter, there's one just up the road.' I forget now exactly where it was. That was orders, we had to do that. One old boy standing near me asked me if I was going down the shelter. 'I am not,' I said, 'I'm going to fight my way home.'

'Good,' he said, 'the driver's going on, the driver's going on,' he tells everyone, he was ever so excited, just like a little schoolboy. Nobody got off, so we tootled on down Brixton Road, dropping them off. When I stopped at the bottom of Brixton Hill the old chap asked me if he could get out of the front door. He wasn't supposed to in the blackout, but the tram was still full and he couldn't get through to the back, so I opened the air-door and let him off the front. Just as he's getting off he puts a pound note in my hand and says, 'There you are, driver, this is for a drink, and thank you for fetching me home.' When we were reversing at the end of that journey I told Alf and gave him ten bob, but he told me that the old chap had run round the back and given him a pound as well. They used to be pleased to get home. You see, the service used to get a bit irregular at times. Routes would be short-turned or diverted around bomb damage, and the situation would change almost from day to day.

To give an example, a bomb fell on the corner of Christchurch Road and set a gas main alight. For a while we worked single line between Upper Tulse Hill, past Brixton Hill Depot to Telford Avenue, but then a temporary single track was laid round the crater, and that lasted several weeks....

The trams got into a shocking state. They didn't get painted. Windows got blown out and trams were running round with the windows boarded up – they couldn't get the glass you see – sometimes for weeks. The buses were the same.

When he started blowing the tram-track out we used to have to find our own way home. Sometimes you might be two or three hours late back into the Depot. No one took any notice of timekeeping in the

blackout, we used to let it right out and away we went. As long as the trams were running, that was all they were worried about. I don't know how we kept going, but we did.

During air raids, Londoners were usually far happier in a tram than any other vehicle on the road, probably because it was cosier and friendlier than any other vehicle and partly because the noise of the tram cut out the fearsome sounds of bombs falling. It was said that the familiar sounds made by the trams were reassuring in those days, as was the sight of trams still running without glass in their windows – a welcome sign of defiance against the enemy. Despite heavy bombing, Berlin's tramways did not suffer as badly as Coventry's or Bristol's, and were able to continue running. Writing in *Modern Tramway* for June 1956, Harold Carliczek said:

> The trams were not left in their depots, but were parked singly, well apart, along the avenues, where the densely growing trees sheltered them from view. If a tramcar caught fire, the flames were attacked at once by the company's fire brigade; its neighbours were not affected and damage was thus kept to a minimum.
>
> A similar plan was adopted for the bus fleet, but with less success as the petrol tanks had to be left full in case the buses had to be driven away; full petrol tanks and underparts thickly coated with soot from the exhaust made a fierce torch-like blaze once a bus caught fire and they burned out rapidly, in almost every case a total loss. If the tram tracks were cut by high-explosive bombs, temporary rails were laid around the crater; these rails were of a type normally employed during track and street repairs, and other road vehicles could pass over them without difficulty. Overhead wires were also easily adapted for such diversions.
>
> So it was that after the bombing attacks had begun to cause serious damage and the city was suffering heavy punishment, the tramways were the only means of transport offering anything approaching an adequate service.

The practice of parking trams out in the suburbs, and hiding them from enemy view, was carried out at a number of towns in this country at the request of the Ministry of Transport. Leeds parked its trams on several routes, including those to Headingley, Roundhay, Stanningley, Middleton and Temple Newsam Park. The last mentioned was one of the places where a tram was also used as a firewatcher's hut. Southampton laid special sidings under the trees on Southampton Common, where the overhead wires were strung from branches, but while this might have made the trams safe from enemy air attacks, it did little to protect them from the 'enemy within'! (See 'Lorry Driver Averted Tragedy' page 170.)

During the bombing raids on Britain, tramcars were dispersed in the suburbs and hidden under trees and in woods and parks, like Middleton Woods in Leeds. This modern bogie car, en route through the woods, was one of seventeen introduced in 1935 to serve the new housing estate at Middleton. Not one of them was damaged in the bombing. It is in a special turquoise livery.

Bedtime Story

From **The Times**

A correspondent, writing in *The Times* in April 1956, recalls the times he and his brother turned their bed into a tramcar after lights out, taking it in turns to be driver and conductor.

My parents never knew there was a tramcar in the boys' bedroom. It was a secret which my brother Gordon and I kept to ourselves. Not even our sisters knew about it, although they may have wondered at the strange sounds coming from our room during the winter evenings. In the summer-time the tramcar looked very much like an ordinary iron bedstead, with shiny brass knobs at the corners and the usual sheets, bolster, blankets, and a patchwork counterpane covering it. It was only during the dark nights, after the candle which lit us to bed had been taken away, that the tramcar materialised.

It was the rule in the pre-television pre-British Summer Time era for children to go to bed at half-past seven. It did us no harm. During the summer evenings we read our books, or played draughts or snakes and ladders, and provided that we were fairly quiet, nobody minded. The dark, cold, winter evenings were different. It was very pleasant to snuggle down into bed and chatter, but suitable games were hard to devise.

We discovered that our bed was a tramcar quite by accident. It was Gordon who found that underneath the mattress were the springs and the iron framework and, riveted to the iron members, two little pieces of metal which could be twirled round. They made a very satisfactory sound – something like that which a tram conductor made when he tweaked the metal rod which passed through the tram and rang the bell at the driver's end. Thus was our idea born.

We lived about a mile outside the town. It wasn't a very big town – just big enough to have corporation tramways in the streets. When I think back I realise that those trams (they have long since disappeared) were rather small, not very impressive trams. But to two small boys, who only rode in them when our parents took us into town, they were magnificent, rumbling, thundering monsters. Everything about them was fascinating. To have seen the driver unhook the chain which guarded his end of the tram, step down and push over the points with an iron bar so that his tram could take the right turning at a junction was a matter for lengthy discussion between Gordon and me.

We never ceased envying the conductors who ran up and down the stairs, calling out something which sounded like 'Fez peas!' or who, swaying in important fashion on the rear platform, jingled the money in their leather bags on shoulder straps. We delighted to hear them call out the names of the streets when the tram ground to a noisy stand-still or to watch them punching a hole in exactly the right place on a ticket, making a pleasing little tinkling sound with their punching machines as they did so. It didn't matter that the seats were hard plywood or that our trams had no roof on top.

So our bed became a tramcar on those long winter evenings. It must have been Gordon's idea in the first place for he always had more imagination than I had. Anyway, he took the best job. He was the conductor while I, even though I was the elder, had to content myself with being driver.

Now you may think that being the driver of a tram would be a tremendous thrill for a nine-year-old boy. But you can't manage much excitement out of driving a bedstead tram! All I had to do was to make the right noises – 'Dummmm, dum-dummm dum-dum-dummmmm', when we were bumping and swaying along the lines and something like 'Beee-urgh!' when we stopped with a jerk. Occasionally I had to clang my bell when a horse and cart got in the way. That was done with a violent kick down the bed (all tram drivers had a foot bell) and saying, 'Clang, clang!' – but that was the most exciting part of my job.

But Gordon had plenty to do. There were the names of the stops to be called out – sometimes before I thought we had got so far, but I couldn't do anything about it. Passengers would have thought it an odd tram if the conductor shouted 'West Street' and the driver shouted back, 'No it isn't. We haven't got to St Mary's Butts yet!' Gordon had many other things to say; things like 'Hurry along, please!' and, 'Mind the step, lady!' with any amount of backchat, which had evidently been his special study when riding on the real trams.

When we got our tram to the terminus, there was the most difficult business of swinging round the trolley-pole. This was the conductor's job. But, in our tram, it meant getting out and walking round to the foot of the bed and, as Gordon slept nearest the wall, I was permitted to do this important job. I made the most of it! After all, nothing could happen till that little wheel was safely on the overhead wire – no fares to collect, no streets to call out, the tram wouldn't even move nor would its lights go on. So, even if the nights were cold and my feet got nearly frozen, I took my time, ignoring even the derisive remarks of my conductor! Once I was snugly back in bed, Gordon would twirl the little piece of metal under the bed and

we were off on another journey across town.

We had disagreements how our tram should be run, of course. Then, with a driver's strike facing him, Gordon would agree to swap jobs. But it was no good. I didn't know half the things a good conductor should say and, even if I could give the right change, I once got my stops in the wrong order and had my driver appear through the door which shut him off to ask what I thought I was doing!

But I had one great triumph. It was on a night when I had driven across town with a particularly vociferous conductor, when passengers never stopped getting on and off the tram and when my throat was quite dried-up with making those tram sounds. Able to stand it no longer I drove the tram absolutely crammed with passengers straight into the car sheds and then went off duty, leaving my conductor to talk his way out of that one!

Lorry Driver Averted Tragedy

From the Southern Daily Echo

How a lorry driver stopped two runaway Southampton trams was reported by the *Southern Daily Echo* for 4 November 1942. Apparently, during the Second World War, Southampton Corporation parked its trams and buses away from depots to avoid them being damaged in air raids from the enemy above. The trams were parked on two special sidings laid in the woods on Southampton Common, where they wouldn't be spotted by enemy aircraft. Extra precautions were also taken to protect them from the enemy on the ground (for example, vandals and prowlers). The controller keys were removed and locked in the watchman's hut. The power switches were turned off, and the trolley poles pulled off the wires and tied securely down. Every precaution was taken to make the cars safe. So it was quite surprising when, on Tuesday 3 November 1942, three of the trams suddenly emerged from the shadows and set off driverless in the direction of the city centre. The following account of what subsequently happened is reproduced by the kind permission of the *Southern Daily Echo*.

A few minutes before noon, Jesse Clark, a lorry driver, was waiting at Bassett cross-roads for the traffic lights to change when two of the parked trams suddenly began to nose out on to the down tracks.

'See that? There's nobody aboard 'em!' shouted the driver of a tram just coming out of Burgess Road.

Clark let in the clutch of his five-ton lorry, which was loaded with six tons of sand, and set off after the runaways. Before he could catch up with them they were rolling wildly down The Avenue[1] at over forty miles an hour. Their trolley poles swung off the overhead wires and knocked off several street lamps suspended over the middle of the road. Springing up and down as they struck the stretcher wires of the overhead system, the trolley wheels flew off one after the other. Then the trolley poles snapped off and fell in the path of the lorry.

Blaring on his horn and waving wildly to oncoming traffic to get out of the way, Clark kept on the tail of his strange quarry. Every time he tried to overtake, oncoming traffic made him swerve behind the trams. They flashed past several parked vehicles, missing them by inches…. The cars rattled violently over the points with Clark and his lorry almost alongside. In the lower part of The Avenue he saw his chance.

The road was clear ahead. He jammed his foot down on the accelerator, and got past the two trams, which were almost touching each other. Then with a brilliant manoeuvre he got his lorry on to the down tracks, and watching the oncoming trams in his driving mirror, braked gradually until they were touching his lorry. He stood on his brakes, pulled on his hand brake, and after the lorry had been pushed along for some distance with its wheels locked all three vehicles came to a stop.

Clark got out unruffled to see what damage had been done. The only mark on his vehicle was a smear of paint which had been scraped off the first tram as he used his lorry to brake 16 tons of runaway trams.

While he had been doing what he later described as 'just what anyone else would have done', the third car had been launched on its wild but much shorter career. At the Rest Camp stopping place it crashed violently into a tram that had stopped to pick up passengers. The conductress of the stationary car saw the runaway coming, gave a warning shout and leapt off the platform. Had she not done so she would almost certainly have been killed, for the platform was completely smashed, as was the front of the runaway….

'It was absolute sabotage,' declared Mr Baker[2] to an *Echo* reporter. 'It was little short of a miracle that nobody was killed. This desperate business was the work of somebody who understood tramcars very thoroughly. They knew just how to set the controls and must have used a spanner to do it, as all the keys had been removed and locked up.

'On examining the three cars we found that they

Southampton trams, painted grey, parked up on a wartime dispersal siding on Southampton Common. It was from this siding that three trams set off driverless one day in 1942.

all had their direction controllers set in the forward position and their power controllers set on various notches. The one that hit the service car had four power notches on. We thought we had taken every precaution that could be taken to prevent anybody tampering with the cars on the sleeper tracks, but somebody has found a way of overcoming these precautions.'[3]

[1] One of Southampton's main thoroughfares.
[2] The transport manager.
[3] A month later a fifteen-year-old boy appeared at Southampton Juvenile Court and admitted he had set the cars in motion. He told the court he was very keen on electricity. He was bound over for twelve months under the supervision of the probation officer.

Snowploughs Kept Tracks Open

By Dennis Gill, with extracts by Richard Wiseman and Charles Hall, Stanley Guildford Collins and W.T. Robinson

Trams have kept going when all other traffic has come to a standstill because of heavy falls of snow, thanks to the special equipment and men sent out by many tramway operators to keep tracks clear. But there were some tramway systems in the early years that were ill-prepared, and forced to abandon rolling stock stuck in drifts.

When two feet of snow fell on Bolton in January 1940 all the roads were blocked and trams were brought to a halt. Five trams were stranded in ten-foot-high snow drifts at Snydale on the Westhoughton route. It took almost a fortnight to rescue them. Hundreds of men had to be taken on to clear the snow, and it took several days to restore tramway services. Over a third of the tram fleet was temporarily put out of action through snow damage to their electric motors. In addition, a hundred members of staff were absent from work. It was a miracle any tram ran at all.

A Bradford tram passes through deep drifts of snow on the Queensbury route in the severe winter of 1947.

At that time, and all the years before, and all the years since, snow has managed to paralyse Britain's transport system. We have fighting forces ready to defend us against attack from our enemies, but we are not so well equipped to defend ourselves from heavy falls of snow. Why is it that we are not well prepared? Why, when it snows heavily, do we grind to a halt? Strangely enough, these questions were being asked at the beginning of the twentieth century. It appears we haven't progressed much. But it is not all doom and gloom. For then, as now, there were, in fact, some towns which were ready for snow. When it fell they were fully geared and equipped to get it all moved away, not several days later, but within a short space of time, or, at the worst, by morning, so that tramway services could continue to run, enabling school children, workers and shoppers to reach their destinations.

Leeds and Sheffield, for example, two cities often covered with deep snow, were rarely brought to a complete halt by heavy falls because they both had sufficient numbers of snow-clearing cars to keep tracks clear. Sheffield had fourteen snowploughs and Leeds had fourteen snow-clearing cars, five fitted with brooms and nine with ploughs. The first three snow sweepers brought into use in Leeds in the early years of the system coped well with falls, particularly in the bad winter of 1909–10, prompting the manager to comment that they had been of 'immense value'.

But despite the preparedness of some tramway undertakings, there were plenty that had no appliances for clearing snow quickly, which led the *Tramway and Railway World*, after heavy falls of snow at Christmas in 1903, to make the following criticism of their short-sightedness.

Snow falls of any magnitude are so rare an occurrence in England that the temptation to neglect making sufficient provision for dealing with them is considerable, and there are tramways which would be absolutely blocked in falls of a few inches because they have no means of fighting a storm. Probably the experience of the past few days has convinced some tramway committees that they would have acted more prudently had they adopted more completely the suggestions of their managers in regard to the matter. A few hours disorganisation of traffic is a far more costly business than has, perhaps, been appreciated by some local authorities that are comparatively new to tramway working.

Heavy snowfalls three years later, on Christmas Day in 1906, went a long way to proving the magazine's point, when the South Lancashire Tramways' lines became more interrupted than any other, with some twenty to thirty cars having to be abandoned on the road. It took all of Boxing Day to remove some of the cars and it was several days before all the tramway lines were again in operation. The magazine reported:

These lines are of course largely interurban, and on many roads where population is sparse little is done by local authorities to remove snow, except in the case, perhaps, of heavy drifts. These were numerous enough and caused great trouble. The tramway worked very hard, but despite their efforts the snow in many places got the better of them for several days. Great inconvenience was caused, particularly to the working classes, who largely use the tramways between adjacent towns for going to and returning from their work....

A Sheffield supertram provides a much-needed service on 25 January 1995 – a day when no buses at all were running – as it speeds along snow-covered tracks on Ridgeway Road on its way to Halfway.

Great drifts had accumulated at many places, and after the ploughs had got through the snow was piled up several feet high on each side of the road. The trouble was the greater because the company are prohibited by one of their Acts from using salt for the removal of snow. The local road authorities also took no steps to clear the sides of the roads, so that even when the company got their track clear the snow was either brought back again on the tracks by carts, or was drifted back by the high wind. On the question of the use of salt, the company are in a very disadvantageous position compared with most tramway authorities. We are reminded that ten years ago the House of Lords decided, on appeal, that the Aberdeen Tramway Company was not entitled to use salt, as its use constituted a nuisance.

Notwithstanding, Aberdeen, one of the hardest hit towns when it comes to snowfalls, managed to keep its lines open without salt. In the heavy falls of 1909, when the snow reached a depth of three feet, the whole of the tramway staff, numbering 250, was employed in shovelling snow off the tracks to great effect. Salt was certainly a nuisance in London, because trams in the capital picked up their current from a conduit in the road. When salt found its way into the conduits it created trouble, impairing the working of the current collectors (known as ploughs) and corroding them. Following the Christmas 1906 falls great quantities of slush and mud seeped into the conduits, and for two days after the cars ran very irregularly, being frequently stalled for want of power. Fortunately, London has not been too troubled with heavy falls of snow, but the London County Council and its successor the London Passenger Transport Board, who operated the conduit system, went to great pains to warn local authorities of the salt problem and obtained twenty snowbroom cars and seventeen snowploughs to keep tracks clear of snow.

In Leeds, when nearly five feet of snow fell on the city in the winter of 1947, salt thrown up from the roads played havoc with the electrical equipment on the trams. It put nearly eighty trams out of action and electricians had to work at full stretch to repair the damage.

It begs the question as to why there was no act prohibiting the use of salt in all our major cities, and why snowploughs and snowbrooms have not been used to a greater extent. I imagine there must be many motorists whose motorcars have been badly corroded by salt, who might well be wondering why salt is still not considered a nuisance today! It seems that even if salt is put down, roads still become blocked by heavy falls of snow, as in February 2009, when schools and businesses by the thousand were forced to shut down because roads were blocked or very slippery.

After the Christmas 1906 blizzard, the management of the South Lancashire system (which didn't get snowploughs until the 1920s) must have looked enviously at towns like Bury and Rochdale, which were able to demonstrate the value of their snow clearing appliances that winter by keeping nearly all their lines open. They must also have looked in wonder at Newcastle, where about 130 men worked all through Boxing Day night to clear away fifteen inches of snow from the tracks, their efforts earning them an extra day's pay and enabling tram services to operate on time from 4.30 a.m. onwards.

Belfast and Sheffield were two of the tramways

Well and truly stuck! Blackburn tram No. 36, hauling a salt car, went out to clear the tracks of snow in late February during the severe winter of 1947, and became stranded for more than a week near the Redcap Hotel on the Accrington Road. Its motors had burnt out through its wheels constantly slipping in the snow, and then its wheels had become frozen to the tracks. Until it could be moved a watchman, complete with hut, coke brazier and lamps, was put on duty to guard the tram and keep passing traffic out of danger. In the same snowfall a second tram became stuck on the Boulevard and another was stranded on the Whalley New Road route.

Named 'Snoweagle', this streamlined Romanian tram is used on snow clearing duties in Iasi. It is fitted with a snowbroom which is just visible.

PETER GEMEINHARDT

most efficient at clearing snow. In Belfast, ploughs were always at the ready, each one going over fifteen miles of route every two hours while snow fell. In the 1918 storms, the ploughs travelled roughly 1,150 miles and sixty tons of salt were spread. In Sheffield, too, the fourteen snowploughs were always ready to roll. Each depot detailed twenty drivers and twenty conductors for snow clearing duties and each car was manned by a crew of two or three men. As soon as snow started falling each gang reported to its depot to await instructions. Once on the road the cars each followed a specific route so as to cover all the tracks in the shortest possible time with as little shunting as possible. After the first round trip, each car returned to a central siding for further instructions and to replenish salt hoppers.

Writing in the January 1962 issue of the magazine *Trams* (published by the Tramway Museum Society) Richard Wiseman and Charles Hall described Sheffield's campaign plan.

> At maximum strength there were fourteen snowplough cars, they had a plough at each end and were equipped with a telephone box key, rubber gloves, two jumping irons, four shovels, two brooms, two buckets and one tow rope. They also carried wedges and point-cleaning tools for ordinary and automatic points, and a good supply of sand. The 'saloon' was filled with salt; this could be distributed through a small shoot in the rocker panel or by men with shovels through the unglazed middle windows.
>
> In order to obtain maximum efficiency and to ensure that there was adequate protection for the motors, etc., against snow and salt, the cars were overhauled at Queens Road during the summer or autumn, and from the first week in November all ploughs were to be kept in readiness and fully equipped. There was a detailed list of men on the snow emergency gang and they had to make arrangements for being called by day or night.... The control centre was the office in Fitzalan Square [*in the centre of Sheffield*] where the inspector on duty would decide the number of snow-ploughs required.
>
> The depot foreman was responsible for keeping clear all the points, junctions and crossings in the immediate vicinity of his depot, and also the adjoining footpaths. The inspector in charge at each depot had to telephone the Fitzalan Square Office immediately after a plough left the depot and state the route taken together with the motorman and conductor's names. The conductor had to keep a record of the route taken and of the time they entered the various sections.
>
> As each plough cleared the running lines, the crew salted the pavement at stops, and cleared all the snow and salted the road at junctions, termini and crossovers on the way. With the increase in motor traffic it was often necessary to have extra men on duty at junctions to keep points clear of snow and slush deposited there by passing vehicles.

Every member of the gang received a special grant for showing up at the depot in addition to the ordinary rate of pay. The gang was also well provided with refreshments when kept out for any lengthy period. Casual labour was also employed to keep junctions clear.

'We get a lot of snow in Sheffield and the buses have never been able to cope as well as the trams. As soon as flakes start falling the buses start slithering,

The crew manning snowplough No. 360 keep tracks clear of snow in the centre of Sheffield on 7 February 1954.

whereas the trams sailed up the hills as easy as pie,' remarked one regular Sheffield commuter.

London's snow-clearing equipment was always at the ready and according to Stanley Guildford Collins in the book *The Wheels Used to Talk to Us* (edited by Terry Cooper and published by Sheaf Publishing in 1977) every depot had one or two snow brooms. At Telford Avenue depot, where he was based, there were two. In the following extracts, Mr Collins gives a description of the snowploughs and describes what it was like to work on one.

> They were like a small single-deck tram, donkeys years old, with no seats or anything in them. At one time they'd been double-deckers, but the tops had been taken off them and the bodies were raised up from the track to make room for the brooms.... The broom swept the snow out on the nearside. Inside the saloon we kept tools, bags of sand, ropes, freezing salt and God above knows what.
>
> Whenever it snowed during the night, if I was on early turn I'd go up early on my own and report to Telford, or else they'd send someone down to get me out of bed, because I was on one of the snow crews. It wasn't the sort of job you could put any old Tom, Dick or Harry on. Every depot had its own snow crews, and they covered their regular jobs with spare men. I remember one night I came home about eleven-thirty, it was snowing a little bit, but I had a wash and a bit of bread and cheese and a cup of tea for my supper, and I was just going to get into bed when someone knocked at the front door. I opened the front room window; it was someone from the Depot.
>
> 'Come on,' he said, 'get your clobber on, we want you to take the snow-broom out.' It was snowing like blazes, whacking great flakes. I had to get dressed and go back up again.
>
> We used to take out bags of salt and, unofficially, perhaps a lump of rope and some paraffin. We had to keep the moving parts of points from getting so packed out with frozen snow that they jammed or wouldn't close properly. We'd soak the length of rope in paraffin and lay it in the track and light it to melt the ice first. Then we'd brush it all out with a point-brush and leave plenty of salt on it to keep it free of ice. The most important thing was to keep crossovers and single-track points clear....
>
> I used to like the snow-broom. It was cold, but you'd get stuck into the work and very soon get warmed up. There was an all-night coffee stall at Tooting Broadway and another at Brixton Church, so you could always get a cup of coffee. We used to love it. I'd say to my mate sometimes, 'Do you want to have a go at the handles?' and I'd go inside the saloon for a bit of a warm up ... we made sure that all the tracks were clear and the service kept going. There were no night inspectors on the road, they knew we'd do the job and we did.

When it came to clearing snow from tracks, however, nobody could beat the tramway systems in Canada. The Toronto Transport Commission's magazine *The Coupler*, in May 1926, sang the praises of the commission's permanent way gangs in keeping tracks open.

> It makes no difference, winter, spring, summer or fall, whatever the season, there is always plenty to do to keep the tracks in order so that the cars may run without delays. It may have been snowing and

freezing all night, and yet in the morning the crowds are brought down-town without a hitch, electric switches operate smoothly, intersections are clear of snow and the tracks are clean. All night long Permanent Way Department employees have been busy thawing out the switches, shovelling the snow and making everything ready for the morning rush.

The Montreal Tramways in Canada were also well prepared to deal with falls of snow so that the tramcars could keep running. Montreal is called 'Our Lady of the Snows', and with falls averaging 120 inches between December and March, snow-clearing equipment on a grand scale was necessary. The following extracts are from an article by W.T. Robinson, in the *Tramway and Railway World* in 1920.

Looking like something out of a science-fiction movie, this awesome snowplough was part of the Montreal Tramways snow-clearing fleet.
Photo: Société de Transport de Montreal

It is obvious that a wonderfully efficient organisation is required to maintain the proud record of never having snowed up.... The equipment is necessarily on a grand scale and consists of thirty-nine sweepers, seven ploughs, twelve levellers and ten salt cars. In addition, all service cars are fitted with rail scrapers, which do invaluable service in preventing the accumulation of snow that falls during running hours. The sweepers themselves are provided with wings which clear the roadway six feet from the rail, but owing to an obligation to assist in snow removal from the road altogether, these are followed by levellers – freight cars fitted with heavy iron wings – which push the snow still further back, practically to the edge of the pavement, from where it is carted away on sleighs after the storm is over....

Each motorman retains his own particular unit for the season and also follows the same route, thus becoming familiar with any danger point and any good or bad feature of his equipment. Each sweeper completes its circuit in roughly forty-five minutes....

Before the snow season starts, a meeting is called by the superintendent, at which district superintendents and sweeper drivers are asked to offer suggestions for consideration, and the plan of action is clearly defined, each man knowing what he has to do without wasting time at a critical moment asking for instructions....

If snow is expected, call boys are held in readiness at each depot, and with the first flakes the crews are called out to their respective posts.... The city is divided into four districts and each of these has its own self-contained operations of sweeping, levelling, salting, point clearing and fender and vestibule glass clearing. The superintendent takes entire charge and directs operations from snow headquarters. Divisional superintendents control the work in their particular areas, telephoning frequently to headquarters to report progress, and all these reports are systematically entered in a log-book, so that the superintendent can see at a glance how things are going and divert a sweeper from one route to another when necessary. The men in charge of the sweepers also report by telephone at certain points, and altogether calls average seventy to eighty per hour, so it will be seen the log is a comprehensive one....

The fullest arrangements are made for the comfort of all the men engaged in the work, and cars fitted up as coffee vans are sent out to provide for their material needs. As storms sometimes continue for thirty-six hours, the need for these is obvious.

The most wonderful thing of all is the intense loyalty and *esprit de corps* of the whole snow-fighting department. It is not sufficient for each man to do his duty and no more; there are times when it is necessary to be a superman, and the joy and pride of being a part of a perfectly organised and conquering fighting force is clearly displayed by everyone, from the superintendent to the pointsman. Extra payment is, of course, made, but the real reward clearly lies in the piled up snow at the sides of the roads and the practically uninterrupted car service.

Most Damnable Outrage
By Geoffrey Skelsey

At the age of forty-two, Theodore Roosevelt became the youngest man ever to be installed as president of the USA in 1901, following the assassination of William McKinley. The following year he was on a

campaign tour of New England ahead of the impending Congressional elections, when, on 3 September, he was thrown out of his horse-drawn carriage in a collision with a streetcar between the towns of Pittsfield and Lenox, Massachusetts. One report of the accident said the president received a bruise on his cheek, a banged knee, a cut lip and a severe shaking up. In addition, his glasses were knocked flying, his silk hat was frazzled, and his frock coat torn at one elbow An account of the incident, researched and written by Geoffrey Skelsey, appeared in the December 2007 issue of the magazine *Tramway Review*, from which this extract is taken.

The president had addressed a large crowd that morning in a Pittsfield park and had then set off down South Street towards the nearby town of Lenox. Riding in an open landau drawn by four fine white horses, he was accompanied by the Governor of Massachusetts, Winthrop Murray Crane; the US Commerce and Labour Secretary, George Cortelyou; a coachman, David Pratt; and a single protection officer, William Craig. The main road (now US7) was shared with the rails of the Country Club route of the Pittsfield Electric Street Railway (PESR), a line only completed in September the previous year. At the foot of a gentle hill in the country about a mile and a half south of the city the single track crossed from the centre to the west side of the straight road, requiring southbound traffic, such as the president's, to deviate from the right towards the centre of the highway so as to keep off the rails. This coachman Pratt did.

Proceeding in the same direction as the president's carriage was streetcar 29 of the PESR.... The car was carrying prominent local members of the exclusive Pittsfield Country Club including the district attorney, a director of the neighbouring Berkshire Street Railway, and a director of the PESR. The motorman was Euclid Madden and the conductor James Kelly.

Carriage and streetcar reached almost simultaneously the point where the track crossed the road obliquely, and the streetcar coming from behind and the left, grazed the right hand side of the landau just after it crossed the rails. However, the coachman's protruding front right-hand wheel was smashed and, as the vehicle tipped sideways, the occupants were hurled out. One of the horses was killed. Agent Craig fell from the box of the carriage beneath the still-moving streetcar and died instantly. The roadside verge was soft with soil washed down the hill, and the president and Secretary Cortelyou fell into the damp ground. The right hand side of the president's face was bruised, and his left hip and shin cut from collision with the splintered woodwork of the carriage. The coachman suffered cuts and a dislocated shoulder. Mr Cortelyou was slightly hurt, and the governor unharmed.

In the immediate aftermath the president, clearly shocked, his clothes torn and his lip bleeding, berated the motorman. 'Who has charge of this car,' he shouted. 'This is the most damnable outrage I ever knew,' and he was helped away. Motorman and conductor were arrested and detained overnight in custody. Madden was charged with manslaughter, and bailed to appear later....

Coachman Pratt, if he saw the overtaking streetcar at all, may simply have assumed (in the absence of any instructions) that he had precedence, given the eminence of his passengers and the authority of his entourage. As it was, he nearly made it clear of the tracks, but the front of his coach was still just within the swept path of the car.

Motorman Madden, who claimed to have been travelling at under ten miles per hour with power off and to have had his car under control, was in the dilemma every street tramway motorman faces a dozen times daily. He assumed that the landau would continue to move at an even pace and in a predictable direction, and would be out of the way just in time for him to overtake it. In the event coachman Pratt turned his horses slightly earlier than expected....

'I had the right of way – you don't suppose I wanted to do it?' claimed Madden crossly afterwards....

The Commissioners say that he tried the motorman's readiest weapon, his gong, but no-one heard it. The security detail also claim to have signalled the motorman to stop, but their signals can hardly have been resolute or Madden would have surely braked. The final responsibility was surely theirs, even if contemporary inquiries found otherwise.

With whatever inducement, Madden pleaded guilty to the charge of manslaughter and was sentenced in January 1903 to the sizeable fine of $300 and a term of six months' imprisonment for failing to control his car....

Despite his evident discomfort, President Roosevelt continued with his campaign tour which eventually took him into West Virginia and South Carolina. But his damaged leg grew worse, with the risk of then-fatal blood-poisoning, and in the late September he underwent what was a serious operation, being subsequently confined to a wheelchair for several weeks. He recovered, and in 1904 received the Republican nomination for the presidency, to be elected in November with a higher number of

electoral college votes than any of his twenty-five predecessors. He served until 1909, but failed in his attempt to secure re-election in 1912, and never held public office again.

The Pittsfield Electric Street Railway Company was absorbed by the Berkshire Street Railway Company in 1910, and streetcar operation eventually ended in 1932.

Veritable Chariots of Fire

By Geoffrey Claydon

Geoffrey Claydon, President of the Light Rail Transit Association, has visited tramways all over the world. Nothing in his lifetime's experience, however, prepared him for the scenes that met him when he toured the tramways of Hanoi, capital of Vietnam, with some of his friends at the end of 1989. The system was on its last legs and it amazed him that some tramcars were still running, when by all accounts they should have fallen apart long ago. He wrote an account of his visit in the July 1990 issue of Modern Tramway **(published jointly by the LRTA and Ian Allan Ltd). It was offered to the magazine's readers as a tribute to human ingenuity and persistence and, coupled with awed respect, to the boundless endurability of the tramcar and its component parts. The following extract from the article describes some of the incredible sights that greeted the party.**

Hanoi has a current population of almost three million. At the time of our visit, public urban transport to convey this number consisted of about twenty motor buses, five trams and three trolleybuses. There are also cyclos (a species of pedal-operated rickshaw). Most people use bicycles or scooters. These vehicles swarm in vast numbers and, like the trams, are usually unlit at night. The only passengers travelling by tram tend, therefore, to be the elderly, the handicapped and the encumbered. Market produce, carried in wide baskets, often takes up much space on the cars. The writer found a basket of live hens lodged at his feet in one instance. A certain amount of detritus accumulates as a consequence of this traffic, encouraging the presence of other fauna. One noticed on one occasion, for example, a mouse sharing the driving platform with the motorman.

But it is the rolling-stock which rivets attention. The comments could be legion. All cars in operation sustain corroded or battered external body panels. The presence of glazing is spasmodic, and when present is often severely cracked. The absence of glass is sometimes compensated for by the presence of wooden shutters, but the louvres of these are not infrequently broken or missing. The rotted remains of a window pillar hang stalactite-like from the cantrail. Even in repose, bodies incline at rakish angles. From one car a fender hangs obliquely, the victim of some devastating past encounter. Flooring is so worn that wide gaps yawn beneath the feet. In one instance, a wooden shutter has been nailed over a more than usually spacious hole. The bench-like longitudinal

On its last legs, a Hanoi tram trundles carefully past hucksters' stalls, some of which occasionally spread-eagle its path. Geoffrey Claydon's visit to this tramway was a never-to-be-forgotten experience.

seats have few slats; the backs of most of the transverse seating have only the perimeter steel framework to offer support.

The electrics are in character with the bodies. The cars have but one motor apiece. Many loose wires dangle from odd points on the framework. Circuit breakers have been dispensed with, the resulting ends of the traction cables having been brought together and crudely taped. Controller covers are loosely held in place by rope, and controller fingers are apparently in such short supply that in at least one instance they had to be extracted at each terminus from the leading controller, carried to the other end, and reinserted into the controller at that end for the return journey.

Interior lighting is a rare luxury and there is no external lighting: in place of the headlamp is a simple circular aperture in the dash. Progress at night is accordingly fraught, especially given the meagre street lighting, with lorries and buses bearing down on the near-invisible tram making its faltering way along the centre of the highway. In one case, the car was also without its gong, the desperate driver having to announce its presence by leaning through the unglazed window and beating the dash panel.

The cars in their static mode are dreadful enough; experienced in motion they are horrendous. They proceed in a succession of lurches, made inevitable by the absence of any resistance notches between 'off' and 'top series'. Application of the rheostatic brake is equally abrupt. The bodywork assumes ever-changing rhomboid profiles and, if one is sitting against structural members, care has to be taken to avoid getting parts of one's anatomy trapped by the convulsions of the joints. One of the party felt a disturbance at his heel, only to discover the revolving flange of a wheel protruding through the floor. The cars proceed to a cacophony of sounds: to the howl of the motor, the grinding of the gears, the roar of the wheels and the creaking of the bodywork there is added the thunder-like rumble of metal ceiling panels adrift from the roof.

Night-time brings a new dimension. Lack of formal lighting is made up for by illumination from unintended sources. The intermittent cascade of sparks from the trolley-wheel is supplemented by more persistent arcing emerging through the gaps in the control casing. Particularly striking are the pyrotechnics caused by the periodic grounding of the car as a result of dust and dirt overlaying the rails. The resultant flashes from the wheels, leaping through the many apertures in the floor around one's feet and vividly lighting up the interior, make the tram a veritable chariot of fire. The drama of the journey is further heightened by the many obstacles in the path of the vehicle. Introduction of the free economy has spawned a profusion of little hucksters' stalls which spread-eagle the path of the tramcar. So infrequent and erratic is the service that the stallholders, taken by surprise by the appearance of the tram, grudgingly pull their wares out of its way, only to regroup immediately in its wake.

Fired on by Snipers
By Steve Hewitt

Tramway operatives, whether working on the new generation of trams or on the old tramway systems, have had to endure attacks from members of the public, the only difference being that today the attacks have become more violent. On the old trams passengers and crews would sometimes become embroiled in drunken brawls, but they were rarely mugged or threatened with knives and handguns. In February 1949, three London trams on the No. 68 Dockland route to Greenwich via Bermondsey and the Surrey Docks were fired on by snipers from a block of flats. Windows on the upper decks of the cars were broken, but luckily only one passenger was slightly injured. Sheffield's new Supertrams, on the other hand, have had to endure attacks not only from snipers, but also from saboteurs and particularly vandals. This report by Steve Hewitt, writing in Sheffield's newspaper, the *Star*, on 23 March 1995, describes some of the attacks made on the Supertrams during a night of madness.

Saboteurs have put the entire future of Supertram on the line today after a night of madness. Two trams were sabotaged and engineers working on the tracks in Sheffield were shot at from nearby flats. One tram was derailed by a large wooden slab and a second ran into a block of concrete laid across the track. Engineers then fled for cover as shots were fired at them from around Castle Court flats, Hyde Park.

Detectives and transport officials described the incident as 'a very serious, mindless act'. Sergeant Steve Smith said: 'A potential disaster has been narrowly averted. Fortunately no one has been injured, but it could have been very serious....'

Chief Executive John Bigate said: 'We will do everything to keep Supertram safe. At the moment we are in discussion with the police about what can be done. I can't comment further, but we do have something up our sleeve. We don't believe this will put people off using the system. It is safe for passengers....'

Last night's sabotage is the latest in a catalogue of incidents – mainly around the Norfolk Park area. Shooting at engineers and blocking tracks are a frightening echo of previous attacks. Two Balfour Beatty Supertram workmen were injured when a gunman took pot shots at them with a high-powered air rifle from high-rise flats at Norfolk Park in August 1993. Both needed hospital treatment – one for a leg wound and the other for a grazed arm – following the shootings in Park Grange Road and Park Spring Drive area.

Other attacks include:

Last April a car was set on fire and sent rolling across Supertram tracks behind Midland Station – a carbon copy of an earlier incident on the same stretch.

Windows were shattered by vandals hurling missiles while trams were being tested on the Norfolk Park line in August last year.

Two men were sentenced to community service last year after wrecking vital equipment used to keep traffic and Supertram road-works apart. Only prompt action by police averted the danger.

Later, after gaining its first court prosecution, Supertram vowed to continue a hard-line stance against vandals. The *Star* wrote:

Supertram bosses have declared war on vandals and thieves who have caused more than £20,000 worth of damage to tram stops and ticket machines since the system opened.... The company issued the warning after Sheffield magistrates ordered one vandal to pay £1,000 compensation to Supertram after breaking into a ticket machine.

Supertram spokesman Peter Gross said: 'We have been tightening up security and the message is that people who damage Supertram property will be prosecuted. Hopefully this will deter others, but if damage continues we will prosecute again.'

Bosses admit that they are surprised by the amount of damage and say if it continues in the long term it could put up ticket prices. But they have stepped up security, including putting closed circuit TV across the tram system in a bid to stop the rot.

Mr Gross added: 'The first successful prosecution is a signal to anyone who tries to damage Supertram that they risk being dealt with severely. We will continue our strong line working with the police and community to help cut crime and vandalism.'

Golfing Fun on the Mitcham Run

By Dennis Gill

Golfers and trams have one thing in common. They both have bogies. And Mitcham Golf Club in Surrey is one of the courses where players, if they hooked or sliced their shots, could hit a tramcar 'bogie' and score a golfing 'bogey' at the same time. There were a number of other courses, which, like Mitcham, were on or near tram routes, while the Cruden Bay course, in Scotland, had its own tramway.

Golfers have all sorts of hazards to contend with – bunkers, streams, lakes, ditches, ravines and trees to mention but a few – but not many of them have had to take tramcars into their reckoning as much as the members of Mitcham Golf Club in Surrey. London's No. 30 tram service, from West Croydon to Willesden Junction, ran past the Mitcham course, and if players on the dog-leg second hole weren't accurate with their shots, there was every chance a stray ball might rebound off passing trams. The clubhouse had a painting depicting a golfer attempting to get his ball back into play from off the tram tracks, while a tram waits patiently for him to take his shot.

The No. 30 tram route was replaced by trolleybuses in 1937, but since the new Croydon Tramlink was opened in 2000 (replacing trains that once ran between Croydon and Wimbledon via Mitcham Junction) trams are once more in view. In fact, the tram lines bisect the golf course, cutting off four holes from the rest, but both sections of the course are

A Sheffield supertram on its way to Norfolk Park, where in 1993 men working on the laying of new tracks were fired on by snipers in high-rise flats along the route.

There don't appear to be many scars from flying golf balls on this No. 30 tram as it stops to pick up passengers on its run from West Croydon via Mitcham and Putney Bridge to Willesden.

connected by a crossing. The line runs adjacent to four holes and in some places is a mere sand iron away from a badly hit shot off the shank, so I wouldn't be surprised if a few if not all of the German-built trams have been hit by a wayward ball.

George Blake of Carshalton, who played the Mitcham course for many years, wrote the following poem entitled *Mitcham Golfers (or Against the Odds)*, about the effect trams, trolleybuses, trains and the Croydon Tramlink have had on play:

Some years ago they used to have fun
Missing the trams on the Croydon run
Came their demise and the trolleybus grew
To be the target of the unfortunate few,
Who sliced or hooked from the fairways green
To rattle the traffic, before, unseen.

Around the course the railway goes,
This keeps most golfers on their toes.
A slice from the fourth, you're two shots down,
A lost ball as well, no wonder you frown.
The fifth tee also, placed out on that wing,
Solicits train whistles at the top of your swing.

The West Croydon–Wimbledon line ran through,
A slice from the seventh and that was you.
But a shot from the tee as the signal went clear
Struck the raised arm giving rise to a cheer
For the ball came back and on to the green
The luckiest shot ever – believed only if seen!

Leave us alone? No, now it's Tramlink.
We've enough distractions, wouldn't you think?
But the golfer true only sees the ball
And playing this game, gives it his all.
So when he comes in to check his card
He can blame public transport for making it hard.

Many other tramway operators had routes that served golf courses. At Southend-on-Sea, trams ran past the clubhouse gates of the Thorpe Hall course at Thorpe Bay. And in Cheltenham the Cleeve Hill trams were a boon to golfers heading for a game on the Cleeve Hill course.

A narrow-gauge open-topper at Penrhynside on the Llandudno and Colwyn Bay Tramway in May 1955. This tramway ran past the Rhos golf club, where a trophy presented by the tramway is still competed for annually. The open-topper was one of ten bought from Bournemouth Corporation in 1936.

There was a special sixpenny return ticket for golfers using the five courses served by the Dundee and Broughty Ferry trams, one of which is shown in Dundee's Seagate on 15 May 1931, the last day of operation.

In Wales, trams on the Llandudno to Colwyn Bay line ran past the gates of the Rhos-on-Sea Golf Club until they were withdrawn in 1956. In fact, the club, which celebrated its centenary in 1999, has a Challenge Trophy which was presented by the tramway management in 1913 and which is currently awarded to the winner of the annual Captain's Day competition.

In Scotland, at Edinburgh, the trams to Port Seton ran past the Royal Musselburgh Golf Club at Prestonpans, while in Leith an early morning tramway service specially for golfers was operated during the summer months. The Dundee, Broughty Ferry and District Tramway served a number of courses and offered golfers travelling on the trams a special sixpenny return ticket, but for the return trip the golfers had to get their ticket stamped at their golf club – either Monifieth, Grange, Broughty, Dundee Ladies or Press, all of which, apart from the Ladies' course in Dundee, are still open.

In Northern Ireland, at the Belle Vue pleasure gardens owned by the Belfast Tramways Department, visitors were able to obtain golfing lessons from an instructor.

Golfers who travelled by tram, however, and took their golf clubs with them, were not always the most welcome of passengers. A correspondent in the magazine *Justice of the Peace* recalls the time in 1910 when he travelled with his father from Shepley Bridge to Dewsbury Market Place on a single-deck tramcar of the Yorkshire Woollen District Tramways. They both had golf bags, having played a round of golf at Whitley, and when the conductor asked them for their fare, he insisted they also paid a fare for their golf bags. When his father refused to pay for the golf bags, the conductor said 'Then ah'll put thee and thy son off!' But his father was a legal adviser to the tramway company, and the conductor soon found he was unable to carry out his threat. Father and son were able to carry on with their journey – complete with golf bags.

There are, however, at least two golf courses which once ran trams especially for golfers. In America, the Hyatt Grand Cypress Resort near Orlando, Florida,

Golfers alight from the Cruden Bay Hotel's tramcar, in the days when it was owned by the LNER, as they make their way for a challenging round on the links course, which today is ranked among the top fifty golfing gems in the British Isles.

ran a tram service linking the hotel complex with its golf course several miles away using second-hand single-truck Brussels trams. And on Scotland's Buchan Coast, some twenty-five miles north of Aberdeen, a narrow-gauge electric tramway was constructed for the benefit of hotel guests and golfers at the Cruden Bay Hotel. This hotel, owned by the Great North of Scotland Railway, boasted a magnificent eighteen-hole links course, a nine-hole course for ladies (the St Olaf) and a putting course, all designed by the railway company with the highest professional advice. It was the first railway-owned hotel to have its own golf course, and the first to have a tramway. The tramway was two thirds of a mile long and ran from the Cruden Bay station on the Ellon to Boddam branch line to the front door of the hotel, which also served as the railway company's central laundry for all its hotels and restaurants.

The tramway was opened on 15 June 1899 and the rolling stock included two four-wheel single-deck passenger cars, both with an open compartment at one end which was used to carry luggage, laundry baskets and, of course, golf bags. The saloon had comfortable upholstered seating, while the doors, wrought ironwork and glass were all of ornate design. Uniquely, for such a small tramway, there was a turntable at the back of the hotel which gave cars access to the car shed and laundry. The trams met trains at the station to pick up hotel guests, golfers and visitors. Hotel guests travelled on the tramway free, but non-residents paid threepence, and another threepence for their luggage.

The history of this unique line is told in Keith Jones's book *The Cruden Bay Hotel and Its Tramway*, published jointly by the Grampian Transport Museum and the Great North of Scotland Railway Association. According to Mr Jones, from the outset the hotel and its course attracted the famous of the land, including prime ministers Lloyd George and Asquith, the contralto Clara Butt and the American millionaire Pierpoint Morgan.

Within a month of its opening, the course staged a professional tournament which attracted some of the game's legendary figures, such as Ben Sayers, James Braid and the then Open Champion Harry Vardon, who took the first prize of £30.

Sadly, over the years, the hotel's fortunes declined, primarily because of the shortness of its season, and from 1932, when the railway branch line to Boddam ceased to carry passengers, the tramway carried only goods to the hotel. Two years after the outbreak of war in 1939 the tramway closed altogether when the army requisitioned the hotel, the two passenger cars becoming summer houses for the Simmers bakery family in the nearby village of Hatton. Happily, both of these cars were rescued in 1987, and ultimately one was restored (using parts from the other) for the Grampian Transport Museum in Alford, the project being financed by various bodies in Scotland, including the Heritage Lottery Fund. Through the efforts of tramway historian Ian Souter an appropriate 'Peckham Cantilever' truck for the tram was obtained from Tram Museum Zurich in Switzerland. The car is now on show at the Grampian Museum.

The hotel was never reopened and was sold for demolition by the newly created British Railways. The par-seventy golf course was taken over by local interests in 1951 and has been redeveloped. Today it is one of the finest links courses in Scotland, and some years ago one golfing magazine ranked it among the top fifty golfing gems of the British Isles. It is within view of Slains Castle, which is said to have inspired Bram Stoker's *Dracula*.

Another big treat for tram-loving golfers was the Giant's Causeway Tramway in Northern Ireland. For this line – one of the most dramatic and scenic of coastal tramways – served not one but two golf courses. At the start of the journey from Portrush to the causeway, the line passed the Royal Portrush, a championship links course set amid huge sand dunes commanding spectacular views of the Atlantic coastline and with a history that goes back almost as far as the tramway itself. At the other end of the line, between Bushmills and the geological attraction of the Giant's Causeway, the tramway passed through the nine-hole Bushfoot golf links course where there was a special stop for golfers, complete with a red corrugated-iron waiting shelter. The tramway closed in 1949, but in 2002 a 3 ft-gauge railway was opened, following exactly the route of the old tramway between Bushmills and the causeway. Not surprisingly, its passenger cars are not allowed to have glazed windows – in case they are hit by golf balls!

Immediately north of Aberdeen, was a 3 ft-gauge steam-operated light railway (opened in 1899), which ran for three and a quarter miles from the Bridge of Don, Aberdeen, to the Strabathie brickworks of the Seaton Brick and Tile Company. Known as the Strabathie Light Railway (and in its later days as the Murcar Railway), its rolling stock included four of Aberdeen's old double-deck horse trams, which had run on the city's Woodside route until the line was electrified in 1899. Cut down to single-deck and re-gauged, they were used to convey workers to the brickworks, usually being attached to the back of the brick-wagon trains. The railway ran along links for the whole of its length, passing in turn the Royal Aberdeen Golf Club, the Aberdeen Ladies Golf Club

and, from 1909, the newly opened Murcar Golf Links Club, just over halfway along the line. Unfortunately, access to the Murcar links was difficult by road, and the club entered into an agreement with the Strabathie railway for golf trains to be operated for the benefit of its members until it could obtain a railcar which the club would operate itself between brick trains.

The petrol-driven railcar, which looked like an open-ended tramcar, was locally built and was known as the Murcar Buggy. Drivers of the railcar were expected to take no less than eight minutes for the journey, but could not leave the Bridge of Don terminus until golfers travelling there on the corporation tramcars had arrived. The Buggy provided a service for golfers until 1932 when it was replaced by a new vehicle built by Wickham of Ware. The brickworks went into liquidation in 1924, and from that date the golf club uniquely took over ownership of the railway, the track being cut back from the brickworks as far as the Murcar Golf Club halt. The railcar could carry up to thirty-five golfers and caddies, but caddies had to ride at the back of the car. It was also used by golfers on the other two courses, and additionally provided a service for local farmers living alongside the route. It ran all through the Second World War and survived until 1950, when it was forced to close through lack of patronage, primarily because the end of petrol rationing that year meant members could run their own private cars.

When the Manchester Metrolink opens its planned new line to Wythenshawe it will run alongside the Sale Golf Course before it crosses the M60 orbital motorway. To make way for the new tramway, the golf course has had to part with the green and a portion of the fairway of its old 380-yard par-four third hole, which as a result has now shrunk to a 190-yard par-three hole. The course, needless to say, has been compensated for its loss.

Sheffield's Supertram route to Halfway passes the Birley municipal golf course. The trams stop outside the course, near the appropriately named Fairway public house, and consequently are well patronised by golfers who do not have any private transport.

The Heroism of Thomas Chadwick

By Arnold Bennett

Arnold Bennett (1867–1931), famous for his novels of the Five Towns, was probably one of the country's first tram fans, for he wrote quite descriptively and with great enthusiasm about horse, steam and electric tramcars in many of his works. This story about a Five Towns tram conductor appeared in *The Matador of the Five Towns*, **a collection of twenty-two short stories first published in 1912.**

'Have you heard about Tommy Chadwick?' one gossip asked another in Bursley.

'No.'

'He's a tram-conductor now.'

This information occasioned surprise, as it was meant to do, the expression on the faces of both gossips indicating a pleasant curiosity as to what Tommy Chadwick would be doing next.

Thomas Chadwick was a 'character' in the Five Towns, and of a somewhat unusual sort. 'Characters' in the Five Towns are generally either very grim or very jolly, either exceptionally shrewd or exceptionally simple; and they nearly always, in their outward aspect, depart from the conventional. Chadwick was not thus. Aged fifty or so, he was a portly and ceremonious man with an official gait. He had been a policeman in his youth, and he never afterwards ceased to look like a policeman in plain clothes. The authoritative mien of the policeman refused to quit his face. Yet beneath that mien, few men (of his size) were less capable of exerting authority than Chadwick. He was, at bottom, a weak fellow. He knew it himself, and everybody knew it. He had left the police force because he had considered that the strain was beyond his strength. He had the constitution of a she-ass, and the calm, terrific appetite of an elephant; but he maintained that night duty in January was too much for him. He was then twenty-seven, with a wife and two small girls. He abandoned the uniform with dignity. He did everything with dignity. He looked for a situation with dignity, saw his wife and children go hungry with dignity, and even went short himself with dignity. He continually got fatter, waxing on misfortune. And – another curious thing – he could always bring out, when advisable, a shining suit of dark blue broadcloth, a clean collar and a fancy necktie. He was not a consistent dandy, but he could be a dandy when he liked....

And now he was a tram-conductor. Things had come to that.

In the old days of the steam trams, where there were only about a score of tram-conductors and eight miles of line in all the Five Towns, the profession of tram-conductor had still some individuality in it, and a conductor was something more than a number. But since the British Electric Traction Company had invaded the Five Towns, and formed a subsidiary

Thomas Chadwick was a conductor on the short tramway branch line between Bursley and Moorthorne in the Five Towns of Arnold Bennett. The famous novelist may have had in mind the Burslem to Smallthorne line, which ran along Moorland Road, when he wrote the tale about the conductor. He may also have imagined Chadwick working on a small tram like this one, which was originally a trailer car in the fleet of vehicles owned by the Potteries Electric Traction Company.

local company, and constructed dozens of miles of new line, and electrified everything, and raised prices, and abolished season tickets, and quickened services, and built hundreds of cars and engaged hundreds of conductors – since then a tram-conductor had been naught but an inhuman automaton in a vast machine-like organisation. And passengers no longer had their favourite conductors.

Gossips did not precisely see Thomas Chadwick as an inhuman automaton for the punching of tickets and the ringing of bells and the ejaculation of street names. He was never meant by nature to be part of a system. Gossips hoped for the best. That Chadwick, at his age and with his girth, had been able, in his extremity, to obtain a conductorship was proof that he could bring influences to bear in high quarters. Moreover, he was made conductor of one of two cars that ran on a little branch line between Bursley and Moorthorne, so that to the village of Moorthorne he was still somebody, and the chances were just one to two that persons who travelled by car from or to Moorthorne did so under the majestic wing of Thomas Chadwick. His manner of starting a car was unique and stupendous. He might have been signalling 'full speed ahead' from the bridge of an Atlantic liner.

II

Chadwick's hours aboard his Atlantic liner were so long as to interfere seriously, not only with his leisure, but with his political activities. And this irked him the more for the reason that at that period local politics in the Five Towns were extremely agitated and interesting. People became politicians who had never been politicians before. The question was whether the Five Towns, being already one town in practice, should not become one town in theory – indeed, the twelfth largest town in the United Kingdom! And the district was divided into Federationists and anti-Federationists. Chadwick was a convinced anti-Federationist. Chadwick, with many others, pointed to the history of Bursley, 'the mother of the Five Towns', a history which spread over a thousand years and more; and he asked whether 'old Bursley' was to lose her identity merely because Hanbridge had insolently outgrown her. A poll was soon to be taken on the subject, and feelings were growing hotter every day, and rosettes of different colours flowered thicker and thicker in the streets, until nothing but a strong sense of politeness prevented members of the opposing parties from breaking each other's noses in St Luke's Square.

Now on a certain Tuesday afternoon in spring Tommy Chadwick's car stood waiting, opposite the Conservative Club, to depart to Moorthorne. And Tommy Chadwick stood in all his portliness on the platform. The driver, a mere nobody, was of course at the front of the car. The driver held the power, but he could not use it until Tommy Chadwick gave him permission; and somehow Tommy's imperial attitude seemed to indicate this important fact.

There was not a soul in the car.

Then Mrs Clayton Vernon came hurrying up the slope of Duck Bank and signalled to Chadwick to wait for her. He gave her a wave of the arm, kindly and yet deferential, as if to say, 'Be at ease, noble dame! You are in the hands of a man of the world, who knows what is due to your position. This car shall stay here till you reach it, even if Thomas Chadwick loses his situation for failing to keep time.'

And Mrs Clayton Vernon puffed into the car. And Thomas Chadwick gave her a helping hand, and raised his official cap to her with a dignified sweep; and his glance seemed to be saying to the world,

'There, you see what happens when *I* design to conduct a car! Even Mrs Clayton Vernon travels by car then.' And the whole social level of the electric tramway system was apparently uplifted, and conductors became fine, portly court-chamberlains.

For Mrs Clayton Vernon really was a personage in the town – perhaps, socially, the leading personage. A widow, portly as Tommy himself, wealthy, with a family tradition behind her, and the true grand manner in every gesture! Her entertainments at her house at Hillport were unsurpassed, and those who had been invited to them seldom forgot to mention the fact. Thomas, a person not easily staggered, was nevertheless staggered to see her travelling by car to Moorthorne – even in his car, which to him in some subtle way was not like common cars – for she was seldom seen abroad apart from her carriage. She kept two horses. Assuredly both horses must be laid up together, or her coachman ill. Anyhow, there she was, in Thomas's car, splendidly dressed in a new spring gown of flowered silk.

'Thank you,' she said very sweetly to Chadwick, in acknowledgment of his assistance.

Then three men of no particular quality mounted the car.

'How do, Tommy?' one of them carelessly greeted the august conductor. This impertinent youth was Paul Ford, a solicitor's clerk, who often went to Moorthorne because his employer had a branch office there, open twice a week.

Tommy did not respond, but rather showed his displeasure. He hated to be called Tommy, except by a few intimate coevals.

'Now then, hurry up, please!' he said coldly.

'Right oh! your majesty,' said another of the men, and they all three laughed.

What was still worse, they all three wore the Federationist rosette, which was red to the bull in Thomas Chadwick. It was part of Tommy's political creed that Federationists were the 'rag, tag and bob-tail' of the town. But as he was a tram-conductor, though not an ordinary tram-conductor, his mouth was sealed, and he could not tell his passengers what he thought of them.

Just as he was about to pull the starting bell, Mrs Clayton Vernon sprang up with a little 'Oh, I was quite forgetting!' and almost darted out of the car. It was not quite a dart, for she was of full habit, but the alacrity of her movement was astonishing. She must have forgotten something very important.

An idea in the nature of a political argument suddenly popped into Tommy's head, and it was too much for him. He was obliged to let it out. To the winds with that impartiality which a tram company expects from its conductors!

'Ah!' he remarked, jerking his elbow in the direction of Mrs Clayton Vernon and pointedly addressing his three Federationist passengers. 'She's a lady, she is! *She* won't travel with anybody, she won't! *She chooses her company – and quite right too, I say!*'

And then he started the car. He felt himself richly avenged by this sally for the 'Tommy' and the 'your majesty' and the sneering laughter.

Paul Ford winked very visibly at his companions, but made no answering remark. And Thomas Chadwick entered the interior of the car to collect fares. In his hands this operation became a rite. His gestures seemed to say, 'No one ever appreciated the importance of the vocation of tram-conductor until I came. We will do this business solemnly and meticulously. Mind what money you give me, count your change, and don't lose, destroy or deface this indispensable ticket that I hand to you. Do you hear the ting of my bell? It is a sign of my high office. I am fully authorised.'

When he had taken his toll he stood at the door of the car, which was now jolting and climbing past the loop-line railway station, and continued his address to the company about the aristocratic and exclusive excellences of his friend Mrs Clayton Vernon. He proceeded to explain the demerits and wickedness of federation, and to descant on the absurdity of those who publicly wore the rosettes of the Federation party, thus branding themselves as imbeciles and knaves; in fact, his tongue was loosed. Although he stooped to accept the wages of a tram-conductor, he was not going to sacrifice the great political right of absolutely free speech.

'If I wasn't the most good-natured man on earth, Tommy Chadwick,' said Paul Ford, 'I should write to the tram company to-night, and you'd get the boot tomorrow.'

'All I say is,' persisted the singular conductor – 'all I say is – she's a lady, she is – a regular real lady! She chooses her company – and quite right too! That I do say, and nobody's going to stop my mouth.' His manner was the least in the world heated.

'What's that?' asked Paul Ford, with a sudden start, not inquiring what Thomas Chadwick's mouth was, but pointing to an object which was lying on the seat in the corner which Mrs Clayton Vernon had too briefly occupied.

He rose and picked up the object, which had the glitter of gold.

'Give it here,' said Thomas Chadwick, commandingly. 'It's none of your business to touch findings in my car;' and he snatched the object from Paul Ford's hands.

It was so brilliant and so obviously costly, however,

that he was somehow obliged to share the wonder of it with his passengers. The find levelled all distinctions between them. A purse of gold chain-work, it indiscreetly revealed that it was gorged with riches. When you shook it the rustle of banknotes was heard, and the chink of sovereigns, and through the meshes of the purse could be seen the white of valuable paper and the tawny orange discs for which mankind is so ready to commit all sorts of sin. Thomas Chadwick could not forbear to open the contrivance, and having opened it he could not forbear to count its contents. There were, in that purse, seven five-pound notes, fifteen sovereigns, and half a sovereign, and the purse itself was probably worth twelve or fifteen pounds as mere gold.

'There's some that would leave their heads behind 'em if they could!' observed Paul Ford.

Thomas Chadwick glowered at him, as if to warn him that in the presence of Thomas Chadwick noble dames could not be insulted with impunity.

'Didn't I say she was a lady?' said Chadwick, holding up the purse as proof. 'It's lucky it's *me* as has laid hands on it!' he added, plainly implying that the other occupants of the car were thieves whenever they had the chance.

'Well,' said Paul Ford, 'no doubt you'll get your reward all right!'

'It's not –,' Chadwick began; but at that moment the driver stopped the car with a jerk, in obedience to a waving umbrella. The conductor, who had not yet got what would have been his sea-legs if he had been captain of an Atlantic liner, lurched forward, and then went out on to the platform to greet a new fare, and his sentence was never finished.

III

That day happened to be the day of Thomas Chadwick's afternoon off; at least, of what the tram company called an afternoon off. That is to say, instead of ceasing work at eleven-thirty p.m. he finished at six-thirty p.m. In the ordinary way the company housed its last Moorthorne car at eleven-thirty (Moorthorne not being a very nocturnal village), and gave the conductors the rest of the evening to spend exactly as they liked; but once a week, in turn, it generously allowed them a complete afternoon beginning at six-thirty.

Now on this afternoon, instead of going home for tea, Thomas Chadwick, having delivered over his insignia and takings to the inspector in Bursley market-place, rushed away towards a car bound for Hillport. A policeman called out to him:

'Hi! Chadwick!'

'What's up?' asked Chadwick, unwillingly stopping.

'Mrs Clayton Vernon's been to the station an hour ago or hardly, about a purse as she says she thinks she must have left in your car. I was just coming across to tell your inspector.'

'Tell him, then, my lad,' said Chadwick, curtly, and hurried on towards the Hillport car. His manner to policemen always mingled the veteran with the comrade, and most of them indeed regarded him as an initiate of the craft. Still, his behaviour on this occasion did somewhat surprise the young policeman who had accosted him. And undoubtedly Thomas Chadwick was scarcely acting according to the letter of the law. His proper duty was to hand over all articles found in his car instantly to the police – certainly not to keep them concealed on his person with a view to restoring them with his own hands to their owners. But Thomas Chadwick felt that, having once been a policeman, he was at liberty to interpret the law to suit his own convenience. He caught the Hillport car, and nodded the professional nod to its conductor, asking him a technical question, and generally showing to the other passengers on the platform that he was not as they, and that he had important official privileges. Of course, he travelled free; and of course he stopped the car when, its conductor being inside, two ladies signalled to it at the bottom of Oldcastle Street. He had meant to say nothing whatever about his treasure and his errand to the other conductor; but somehow, when fares had been duly collected, and these two stood chatting on the platform, the gold purse got itself into the conversation, and presently the other conductor knew the entire history, and had even had a glimpse of the purse itself.

Opposite the entrance to Mrs Clayton Vernon's grounds at Hillport, Thomas Chadwick slipped neatly, for all his vast bulk, off the swiftly gliding car. (A conductor on a car but not on duty would sooner perish by a heavy fall than have a car stopped in order that he might descend from it.) And Thomas Chadwick heavily crunched the gravel of the drive leading up to Mrs Clayton Vernon's house, and imperiously rang the bell.

'Mrs Clayton Vernon in?' he officially asked the responding servant.

'She's *in*,' said the servant. Had Thomas Chadwick been wearing his broadcloth she would have probably added 'sir.'

'Well, will you please tell her that Mr Chadwick – Thomas Chadwick – wants to speak to her?'

'Is it about the purse?' the servant questioned, suddenly brightening into eager curiosity.

'Never you mind what it's about, miss,' said

Thomas Chadwick, sternly.

At the same moment Mrs Clayton Vernon's grey-curled head appeared behind the white cap of the servant. Probably she had happened to catch some echo of Thomas Chadwick's great rolling voice. The servant retired.

'Good-evening, m'm,' said Thomas Chadwick, raising his hat airily. 'Good-evening.' He beamed

'So you did find it?' said Mrs Vernon, calmly smiling. 'I felt sure it would be all right.'

'Oh, yes, m'm.' He tried to persuade himself that this sublime confidence was characteristic of great ladies, and a laudable symptom of aristocracy. But he would have preferred her to be a little less confident. After all, in the hands of a conductor less honourable than himself, of a common conductor, the purse might not have been so 'all right' as all that! He would have preferred to witness the change on Mrs Vernon's features from desperate anxiety to glad relief. After all, £50 10s. was money, however rich you were!

'Have you got it with you?' asked Mrs Vernon.

'Yes'm,' said he. 'I thought I'd just step up with it myself, so as to be sure.'

'It's very good of you!'

'Not at all,' said he; and he produced the purse. 'I think you'll find it as it should be.'

Mrs Vernon gave him a courtly smile as she thanked him.

'I'd like ye to count it, ma'am,' said Chadwick, as she showed no intention of even opening the purse.

'If you wish it,' said she, and counted her wealth and restored it to the purse.

'*Quite* right – *quite* right! Fifty pounds and ten shillings,' she said pleasantly. 'I'm very much obliged to you, Chadwick,'

'Not at all, m'm!' He was still standing in the sheltered porch.

An idea seemed to strike Mrs Clayton Vernon.

'Would you like something to drink?' she asked.

'Well, thank ye, m'm,' said Thomas.

'Maria,' said Mrs Vernon, calling to someone within the house, 'bring this man a glass of beer.' And she turned again to Chadwick, smitten with another idea. 'Let me see. Your eldest daughter has two little boys, hasn't she?'

'Yes'm,' said Thomas – 'twins.'

'I thought so. Her husband is my cook's cousin. Well, here's two threepenny bits – one for each of them.' With some trouble she extracted the coins from a rather shabby leather purse – evidently her household purse. She bestowed them upon the honest conductor with another grateful and condescending smile. 'I hope you don't *mind* taking them for the chicks,' she said. 'I *do* like giving things to children.

It's so much *nicer*, isn't it?'

'Certainly, m'm.'

Then the servant brought the glass of beer, and Mrs Vernon, with yet another winning smile, and yet more thanks, left him to toss it off on the mat, while the servant waited for the empty glass.

IV

On the following Friday afternoon young Paul Ford was again on the Moorthorne car, and subject to the official ministrations of Thomas Chadwick. Paul Ford was a man who never bore malice when the bearing of malice might interfere with the gratification of his sense of humour. Many men – perhaps most men – after being so grossly insulted by a tram conductor as Paul Ford had been insulted by Chadwick, would at the next meeting have either knocked the insulter down or coldly ignored him. But Paul Ford did neither. (In any case, Thomas Chadwick would have wanted a deal of knocking down.) For some reason, everything that Thomas Chadwick said gave immense amusement to Paul Ford. So the young man commenced the conversation in the usual way:

'How do, Tommy?'

The car on this occasion was coming down from Moorthorne into Bursley, with its usual bump and rattle of windows. As Thomas Chadwick made no reply, Paul Ford continued:

'How much did she give you – the perfect lady, I mean?'

Paul Ford was sitting near the open door. Thomas Chadwick gazed absently at the Town Park, with its terra-cotta fountains and terraces, and beyond the Park, at the smoke rising from the distant furnaces of Red Cow. He might have been lost in deep meditation upon the meanings of life; he might have been prevented from hearing Paul Ford's question by the tremendous noise of the car. He made no sign. Then all of a sudden he turned almost fiercely on Paul Ford and glared at him.

'Ye want to know how much she gave me, do ye?' he demanded hotly.

'Yes,' said Paul Ford.

'How much she gave me for taking her that there purse?' Tommy Chadwick temporized.

He was obliged to temporize, because he could not quite resolve to seize the situation and deal with it once for all in a manner favourable to his dignity and to the ideals which he cherished.

'Yes,' said Paul Ford.

'Well, I'll tell ye,' said Thomas Chadwick – 'though I don't know as it's any business of yours. But, as you're so curious! … She didn't give me anything. She asked me to have a little refreshment like the lady she

is. But she knew better than to offer Thomas Chadwick any pecooniary reward for giving her back something as she'd happened to drop. She's a lady, she is!'

'Oh!' said Paul Ford. 'It don't cost much, being a lady!'

'But I'll tell you what she *did* do,' Thomas Chadwick went on, anxious, now that he had begun so well, to bring the matter to an artistic conclusion – 'I'll tell ye what she did do. She gave me a sovereign apiece for my grandsons – my eldest daughter's twins.' Then after an effective pause: 'Ye can put that in your pipe and smoke it! … A sovereign apiece!'

'And have you handed it over?' Paul Ford inquired mildly, after a period of soft whistling.

'I've started two post-office savings bank accounts for 'em,' said Thomas Chadwick, with ferocity.

The talk stopped, and nothing whatever occurred until the car halted at the railway station to take up passengers. The heart of Thomas Chadwick gave a curious little jump when he saw Mrs Clayton Vernon coming out of the station and towards his car. (Her horses must have been still lame or her coachman still laid aside.) She boarded the car, smiling with a quite particular effulgence upon Thomas Chadwick, and he greeted her with what he imagined to be the true antique chivalry. And she sat down in the corner opposite to Paul Ford, beaming.

When Thomas Chadwick came, with great respect, to demand her fare, she said:

'By the way, Chadwick, it's such a short distance from the station to the town, I think I should have walked and saved a penny. But I wanted to speak to you. I wasn't aware, last Tuesday, that your other daughter got married last year and now has a dear little baby. I gave you threepenny bits each for those dear little twins. Here's another one for the other baby. I think I ought to treat all your grandchildren alike – otherwise your daughters might be jealous of each other' – she smiled archly, to indicate that this passage was humorous – 'and there's no knowing what might happen!'

Mrs Clayton Vernon always enunciated her remarks in a loud and clear voice, so that Paul Ford could not have failed to hear every word. A faint but beatific smile concealed itself roguishly about Paul Ford's mouth, and he looked with a rapt expression on an advertisement above Mrs Clayton Vernon's head, which assured him that, with a certain soap, washing-day became a pleasure.

Thomas Chadwick might have flung the threepenny bit into the road. He might have gone off into language unseemly in a tram-conductor and a grandfather. He might have snatched Mrs Clayton Vernon's bonnet off and stamped on it. He might have killed Paul Ford (for it was certainly Paul Ford with whom he was the most angry). But he did none of these things. He said, in his best unctuous voice:

'Thank you, m'm, I'm sure!'

And at the journey's end, when the passengers descended, he stared a harsh stare, without winking, full in the face of Paul Ford, and he courteously came to the aid of Mrs Clayton Vernon. He had proclaimed Mrs Clayton Vernon to be his ideal of a true lady, and he was heroically loyal to his ideal, a martyr to the cause he had espoused. Such a man was not fitted to be a tram-conductor, and the Five Towns Electric Traction Company soon discovered his unfitness – so that he was again thrown upon the world.

Trams for the Twenty-First Century

Man is constantly re-inventing the wheel, especially in the case of tramcars, which are now enjoying an unprecedented revival, incorporating all the latest advances in technology. And as new lines are built, the demand for even more lines grows; but the revival in this country, primarily because of political and financial constraints, has been painfully slow.

In Britain, which once upon a time had more than 200 tramways, only five new tramways have opened since 1992 – Manchester, Sheffield, Birmingham, Croydon and Nottingham, with another one under construction in Edinburgh. Compare this with our nearest neighbour, France, where some twenty towns have opened new tramway systems since 1985, with half-a-dozen more to open by 2012 and many more beyond that. And some of France's systems have been built in a quarter of the time it takes us in this country! Tramway development in Spain has also been breathtaking, with a dozen new systems having opened by 2009 and another eight expected to by 2020.

Tramway development in America has been even more dramatic, with some forty tramway and light railway systems opening since 1981 and a good number more to come, while Turkey has now surpassed us in bringing back trams. Around the world some 130 new tramways have opened since Edmonton started the ball rolling in 1978. And 2,000 new trams will be delivered in the period 2009–12, very few to Britain, while in the period 2010–14 France alone will be spending €6 bn on more than 250 km of new tramway lines.

190 | Trams: An Illustrated Anthology

A Tramlink articulated unit in its smart new livery passes through a pedestrianised area in the centre of Croydon.

Nottingham Express Transit runs state-of-the-art trams like this one passing through Old Market Square in the heart of Nottingham.

For the expansion of Manchester's Metrolink service, forty new trams have been ordered, one of the first of which is shown here in Market Street. The cars, built in Vienna by global transit company Bombardier, sport bright new colours and have spacious interiors with extra room in circulation areas, such as in and around doorways and aisles.

Trams for the Twenty-First Century | 191

An impression of what the new trams for Blackpool will look like. They will replace, not before time, most of the streamlined trams built for the resort in the 1930s.

The West Midlands 'Metro', opened by Princess Anne in 1999, has a fleet of streamlined cars – like this one picking up passengers at West Bromwich. The car was photographed in the first year of operation and is in the original livery of red, yellow and blue.

Strasbourg, seat of the European Parliament, has a tramway that is the envy of many towns. Very impressive are the city's first low-floor trams, made in England and delivered in 1994.

Montpellier opened its new tramway in 2000, and since then has been expanding it. These trams, in an eye-catching artistic livery, were among the first to be delivered to the town.

Grenoble, the university city in the south-east of France, was one of the first European cities to bring back trams. It set a high standard with cars like this one crossing the Pont du Drac, with the Alps in the background. Since it was opened in 1987, the tramway has continued to expand (with new lines opening, one serving the university) and is well patronised by the city's inhabitants.

Southport's famous pier is the first in the world to get itself in on the tramway revival act by running this avant-garde, sophisticated and smart vehicle. It runs from one end of the pier to the other – a distance of three quarters of a mile.

Volunteer Driver

By Sir Jimmy Savile and John H. Price

In the autumn of 1945, Leeds tramway workers went on strike over a number of grievances, including time schedules and long working hours, which were not helped by a shortage of conductors following six hard war years. Members of the public were recruited to keep the trams and buses running. They were known as volunteers and included servicemen on leave, ex-servicemen, students and members of the public.

Among those who welcomed the idea of becoming a volunteer tram driver was Sir Jimmy Savile, the famous disc jockey and entertainer, who had been conscripted into the coal mines as a Bevin boy. In his autobiography *As It Happens* (published by Barrie and Jenkins in 1974, and later reprinted under the title of *Love Is an Uphill Thing*) he recalls what happened when he took over the controls of Leeds tram No. 39. (See 'Memories of the Famous' to find out how Sir Jimmy came to pull a horse tram, page 87.) This extract is reproduced with Sir Jimmy's kind permission.

A break in my molelike life came one day with the breathtaking announcement that the buses and trams

Sir Jimmy Savile 'on camera' on the platform of a tram at the National Tramway Museum.

were on strike twenty-five miles away in Leeds and there was an appeal for volunteer drivers and conductors. In those days such strikes were good-humoured affairs and no one was bothered over a crowd of pit lads all giving false ages in order to drive such tempting juggernauts....

A tram-driver I wanted to be and at 8 a.m. the next morning a dozen of us piled aboard an empty tram and took off for a straight piece of track with preferably not too many pedestrians about. Driven by an inspector who was going to explain the glorious intricacies, we were like a bunch of paroled lifers.

The now almost extinct tram was a thing of joy to drive. Like a friendly elephant it would lumber along. Other road-users understood it. On corners it needed a thirty-foot arc of clear space, and it got it, for no one would argue with an actual moving friendly neighbourhood tram. If only because it weighed twenty tons.

After half a day's stopping and starting we all finished up back in the tram depot praying that the strike would last long enough for us to realize this incredible windfall....

I was given a chit that said I was the legal driver of tram 39. It was love at first sight. We emerged daintily from the shed into the sunlight at the regulation five miles an hour. My conductor was a local layabout with a fine sense of occasion. For this occasion he had donned full Royal Navy uniform....

Seating regulations were not for us and if 150 people wanted to climb aboard a tram designed for seventy, who were we to argue. It gave the city a decided atmosphere, with travellers much preferring to hang on, or off, versus walking two or three miles home. Thereby arose my first disaster.

The weight difference between the empty tram we had trained on and one full of souls was just over double. *Ergo*, it takes longer to stop. This never occurred to me, and when I spied the railway cart in the distance, pulled by one of those noble shire horses, in theory a gentle application of the handbrake would allow the fine beast of burden plenty of time to get out of the way. It didn't work out like that.

The wagon was loaded with garden and field produce, in boxes. We caught it a smart crack ... and several things happened at the same time. The potatoes and carrots rose out of the boxes like Lazarus from the dead. The driver rose also into the air in a perfect sitting position, at the same time letting go a cry of fear. The magnificent shire horse didn't leave the ground at all, but having had a good belt up the backside from the cart and unable to get a grip on the road with its metal shoes executed a carthorse-on-ice sequence which left its head and shoulders in the doorway of a tobacconist's shop. Piercing screams from within told all that she who was inside was no lover of horses. All this was dwarfed by the cheer which came from our passengers.

Some yards farther along the cheers changed to loud cries of correction as I shot up the wrong road. It was necessary to change the points, at a junction, with a short metal bar, but not having recovered from the horse and cart saga my mind had been elsewhere. A tram takes its power from the bow on its roof which runs along the live overhead wire. If you have to reverse you have to alter the angle of the bow. This is impossible except at certain slack points on the overhead cable. Needless to say I couldn't pull the bow over so we had to navigate the junction with the bow the wrong way.

All went well until we hit the collection of high-voltage wires which make up the overhead junction, when there was a spitting sound from above our heads. Large balls of incandescent material fell all around us. Loud cries of fear came from all aboard. Other trams up and down the same line suddenly went all anaemic and slowed abruptly. Two cars shunted into the back of one, and a lively altercation ensued. This instantly heated discussion was cut somewhat short by my tram clearing the junction and restoring full power down the line, which left two motorists looking at an empty spot where before was a large tram. That particular driver had left his power on full and on resumption of supply had taken off like a dog out of No. 1 box. This was to be our first, and only, day.

On Kirkstall Road one of my pit colleagues, also misjudging his weight-to-stopping ratio, had serenely borne down upon a coal lorry which was waiting in the middle of the traffic lights to do a right turn. Alarmed by the sight of the tram-driver leaving his clanking charge, together with the more observant of his passengers, the coal-lorry driver (feeling that his end was too nigh for comfort) also left the scene at the double. As the bull gathers the unwary matador so the tram picked up the lorry, turned it on its side and deposited seven tons of coal right across Kirkstall Road, bringing the life of that great artery to a halt. But not for long. Coal was rationed in those days. The sturdy people of the area credited the Good Lord for this manna with loud cries of acclaim; not only had they the road free of coal and into their houses, but they had also righted the lorry, and disappeared.

It was too good to last. The cost and carnage of the volunteer scheme made the dispute resolve itself that very day. Off we went, back to the pit, with memories and cash to sustain us for many a day.

John H. Price, an eminent tramway historian and preservationist, was in khaki in 1945 and spent some months at a training camp in Yorkshire. On 29 September, during one of his free weekends, he visited Leeds and found the tramwaymen on strike. John gave his impressions of the strike in the spring 1999 issue of *Tramway Review*, from which the following extracts are taken.

If you wanted to drive a tram, they sized you up for brain and brawn and put you on an air-braked Horsfield or a hand-braked Chamberlain or an ex-Hull car. The students from Leeds University, who were in the first category, were allocated in pairs to the Horsfield cars and sent out on the northern and eastern routes, to run, say, between Briggate and Roundhay. All cross-town services were cut out and the cars turned back in the centre. On some of these cars the combined ages of the crew cannot have been more than thirty-three years. The soldiers were in the second class, and were given a handbrake car to drive, especially the Hull cars, which they drove up and down the Compton Road, and Dewsbury Road with the handbrakes half-applied, and the grinding noise even worse than usual....

The collision between a coal lorry and volunteer-driven Leeds tram which is recalled in Sir Jimmy Savile's autobiography.

Unfortunately the public seemed to enjoy it, and some of them travelled more for the fun than to go places, netting a fund of stories that would last them for many a year. The volunteers enjoyed it too, but there were some wry faces among the maintenance men, as tram after tram came in with flat wheels, twisted bows, jammed windows, broken lifeguards or any of a dozen other faults. By the end of the strike, seventy-five trams were out of action and probably as many buses.

Three days later the strike collapsed. The strikers were reinstated, services resumed, and all was forgiven. I could not have known at the time, but my brief visit to Leeds coincided with the last occasion when a municipal transport undertaking in Britain, faced with a strike, would ever appeal to the public and the army to come and drive the trams. When Manchester had a strike in 1946 no trams ran at all and the few volunteer buses brought ugly scenes such as stone-throwing, broken widows and the letting down of tyres.... Leeds in September 1945 was something we shall never see again, but I am glad I was there.

Toastracks – A British Phenomenon

By Brian Turner

Tramcars which were open at the side or open on top were once a popular feature of seaside towns in this country. They ran in some thirty resorts, enabling visitors to take a leisurely trip along the promenade and at the same time to enjoy the sea breezes, the sunshine and the spectacular views. The trams that were particularly popular with holidaymakers were the single-deck toastrack cars – open-sided and with no roof – and the single-deck crossbench cars – open-sided but with the addition of a roof. There were also combination (or California) cars, which had open and enclosed sections. Nowhere outside of Britain, it seems, could you ride on a toastrack tram.[1] And nowhere else is the toastrack tram given as much coverage as it is in Brian Turner's brilliant and entertaining book *Circular Tour*, which he published and distributed himself in 1999. The following extracts come from his chapter, 'The Great British Toastrack'.

The *Oxford English Dictionary*'s definition of a toastrack is suitably crisp: 'a contrivance for holding dry toast, keeping each piece on edge and separate; also a vehicle, especially a tram, having full-width seats and (usually) open sides'.[2] The *OED* cites 1801 for the word's first vehicular use in Germany ('*ein Tohstgestell*') and 1905 for its first in English, but it was certainly in common usage before then. In 1898 the *Blackpool Herald* described the Fleetwood Tramroad's winter saloons as a 'big improvement on the toastrack cars', and presumably its readers knew what it was talking about....

The electric toastrack tram was a peculiarly British phenomenon. As far as is known – it's impossible to be absolutely sure – the genuine electric toastrack existed nowhere else in the world. This was odd because horse-drawn toastracks were once quite common, being cheaper to build, easier to pull and quicker to load than enclosed trams. And since there were no motors to fit under the floor, horse-drawn toastracks were lower and easier to board than their electric counterparts.

Having your photograph taken on a toastrack car was something not to be missed in the years between the wars. A photographer was on hand for most of the toastrack tours run at seaside resorts, as illustrated by this view of a packed car at Llandudno.

In the electric era, however, the roofed crossbench cars rapidly became the standard open vehicle in the USA, perhaps because electric trams needed support for the trolley. Crossbench cars were amazingly popular in America; there were 3,500 in the state of Massachusetts alone. Britain had nothing on that scale. But since the first electric tramways tended to follow American practice and import American equipment, the crossbench car gained a tenuous foothold over here. Several early systems – not all of them holiday resorts – bought crossbench cars. But the climate was much less suitable than in America, and the crossbench car had fallen from favour by the turn of the century. Altogether only thirty-four double-deck and ninety-nine single-deck crossbench cars ran in Britain, most of them on the Fylde Coast or the Isle of Man.[3]

Although seaside tramways still bought the occasional new crossbench car, most other tramways with a taste for the open air turned instead to combination cars, sometimes known as 'California cars' from the state where the idea originated. These combined one or two open sections with one or two short saloons, and seemed to offer the best of both worlds. In practice the passengers usually all wanted to be outside or all inside. Combination cars were surprisingly popular with operators, if not passengers, and nearly 400 were built for twenty-eight different British tramways in some fairly un-Californian locations. Operators in Lancashire and the north-east seemed to have a particularly rosy view of their climate, the largest users being Manchester (with sixty-two), followed by such exotic places as Newcastle, Wigan, Rochdale, Middleton, Cardiff, Darlington, Gateshead, Rothesay and Southport, in that order. The last two were the only seaside resorts in the list.

The combination car in turn went out of fashion when the open toastrack began its brief heyday just before and after the First World War.... But Blackpool had set the standard for the British toastrack in 1911, and thereafter they stuck to it. Indeed there was a strong family resemblance to all the forty-five toastracks that ever ran in Britain. This was partly because most were built at Preston, but also because the toastrack, being such a primitive vehicle, didn't lend itself to variations on the theme....

One of the toastrack's greatest advantages was its speed of loading. Charles Furness[4] reckoned that Blackpool could reload a toastrack in 90 seconds; as the old passengers got off at one side, the new ones got on at the other. It may have seemed efficient to the management, but for the individual passenger the getting-on was rarely easy and the getting-off harder still. The *Blackpool Gazette* wrote in 1934 that 'to get aboard the toastracks with their high awkward steps and narrow seats, has been an ordeal to everybody, and to elderly ladies has been a positive nightmare. There have been innumerable instances of these folk getting wedged fast and having to be dragged out by force....'

To mount the steps, passengers were provided with handles on the ends of each seat.... The grab handles were attached to cast iron seat frames. These were perforated, presumably to save weight, with a pattern which was one of the few decorative elements on the entire tram....

Once passengers had hauled themselves aboard,

Holidaymakers arriving at Ettrick Bay after an enjoyable ride on one of Rothesay's famous toastrack cars. The poster on the car's dash is probably advertising one of the attractions at the bay.

they would find very similar seating arrangements on all the toastracks – long wooden benches with reversible backs, seating five passengers on standard gauge cars, and four on the narrow gauge (except for Rothesay, who managed five)....

Wartime conductresses everywhere were unhappy with the gymnastics required to collect fares on a toastrack. In March 1917, Southampton, with a touch of southern chivalry, divided its bench seats down the middle to 'enable the girls to remain on the car away from any risk of accident'. The capacity fell from fifty to forty, which was no doubt why conductresses at Blackpool, Southport and Rothesay had to make the best of things. It was twenty years before Blackpool followed Southampton's example, and the other two never did....

In vehicular terms the toastrack tram was the ultimate triumph of function over form – the elemental public transport vehicle, consisting of a platform full of seats, mounted on wheels, with something to make it go and something to make it stop.

The driving position of a toastrack reflected this basic simplicity. It's difficult to imagine any powered vehicle having fewer controls – no gears, no steering wheel, no pedals in the normal sense, other than one to sound the gong and another to drop sand on the rails if they were wet.

To start the tram, the driver simply set the controller key to forward or reverse, and turned the controller handle. To stop it, he turned the brake handle. To keep it stopped he kicked the ratchet in. To immobilise it, he removed the controller key.

[1] Only one toastrack – Blackpool 166 – is preserved. It is at the National Tramway Museum at Crich in Derbyshire, where it has been driven by royalty (the Duke of Gloucester) and where it was used in 1985 as a hearse to convey the body of the museum's oldest officer, Richard Fairburn (still working until his death at the age of eighty-one), on a last tram ride in accordance with his wishes. (See 'What a Lovely Way to Go', page 227.)

[2] *Chambers Dictionary* doesn't mention the vehicular meaning of toastrack at all, but nor does it give the tramway meanings for crossbench and combination, although it does give as one meaning for combination 'a motorcycle with sidecar'.

[3] Southend-on-Sea operated four crossbench cars on its circular tour round the Southchurch Boulevards. The last crossbench cars to be built in this country, they were always referred to in Southend as 'toastracks'.

[4] Blackpool's transport manager.

Record-Setting Driver

By Dennis Gill

A German tram fan has driven 200 trams in some 150 different places, as far north as Archangel and as far south as Melbourne.

A former Frankfurt tram driver must surely hold the record for driving trams in more different towns in the world than anybody else. By 2009 he had driven 200 tramcars on some 150 different tramways (including museum lines) in some thirty-two countries dotted round the globe. He is Peter Gemeinhardt, aged sixty-three, of Offenbach, who

Waiting for passengers at Blackpool's North Station is one of the Blackpool and Fleetwood crossbench cars, which offered a breezy and exhilarating ride along ten miles of Fylde coastline.

Record-breaker Peter Gemeinhardt drives the preserved Montreal 'Golden Chariot' sight-seeing tramcar on 30 May 2001 at the Connecticut Trolley Museum at East Windsor – one of the 150 or so different places round the world where he has driven tramcars.

was born in Plauen, in the former East Germany.

It was while studying in Plauen to become a teacher that the tram bug first bit him. He needed to find employment to help pay for his studies and so in 1967 became a weekend tram driver after only ten days' instruction. He qualified as a teacher two years later, but soon found that teaching in a socialist system was not his vocation, and instead became a full-time tram driver first in Plauen, and subsequently in Frankfurt some while after moving to West Germany in 1983.

His passion for trams during this period grew to the extent that he soon found himself globetrotting to see the fascinating variety of trams running in different cities and on operating museum lines. And almost everywhere he went he asked to drive a tram. Some undertakings flatly refused to let him take over the controls. But there were many that agreed. Even authorities in Russia, China and Ukraine were co-operative. Some let him drive their trams for a considerable distance. Rostov-on-Don in Russia, for example, let him take a car for six kilometres. But some would let him drive for only a short way, as for example in New Orleans, where he was allowed to drive only a works car, and only in the confines of the depot. The three Chinese tramways (Changchun, Anshan and Dalian) were happy for him to drive a car, but he found their controls quite different from those he was used to, especially as they were the first he drove with air brakes.

'I remember my drive in Changchun,' said Peter. 'After a few metres we passed over a crossover, and I wanted to switch off, but I turned the controller off over "zero" onto the first braking notch … and the controller blocked. A locksmith had to repair it.'

He also found the older Melbourne trams not the easiest in the world to drive. 'You have to watch the line-breaker. It works at the first notch if you switch too fast. It was strange for me.'

At the National Capital Trolley Museum near Washington in America, where they have nearly two miles of track, he drove both a production and prototype model of the PCC car, a revolutionary type of streetcar developed in the 1930s to save American tramway systems from total annihilation.

'I asked the motorman if he would take the Düsseldorf four-wheeler out to the first passing loop on the track so that I could take photographs of it,' explained Peter. 'He asked me if I would like to have a go at the controls, too. I said "yes" to him and he explained to me how to drive the car. When I took over the controls from him he was amazed at my tram driving skills, so I then told him I was a qualified driver in Frankfurt. He called to his conductor on the rear platform: "Did you hear it. He is a motorman, and I gave him instructions!"'

Driving the PCC cars was one of Peter's most enjoyable experiences because they are pedal-controlled cars, as are the cars made under PCC licence by Tatra of Czechoslovakia, once the largest tramcar manufacturer in the world. One of the fastest trams he was allowed to handle was, in fact, a Kiev three-car set made by Tatra. 'You have to take into consideration the speed limit of each system,' said Peter, 'but both route No. 1 and No. 3 in Kiev are high speed lines with regular service speeds of 65 km/h.' The fastest car he has driven, though, is one of the former South Shore cars that once ran between Chicago and South Shore, and which is now preserved at the Illinois Railway Museum near Union, Illinois. On the line's five-mile track he was allowed to take it up to 80 km/h, but with the controller only in 'series' (half speed).

He thinks Grenoble, in France, with its stylish low-floor blue and grey trams, is the finest tramway

system in the world, and he considers Karlsruhe in Germany to be the most efficient by far, primarily because its trams serve a wide area through sharing tracks with trains. In fact, Karlsruhe has the longest light rail line in the world – from Freudenstadt in the Black Forest via Karlsruhe and Heilbronn to Öehringen-Cappel, a distance of some 180 km.

He also likes the Tuen Mun system in the Hong Kong area, but when it comes to landscapes one of his favourites was the Ust-Katav tramway in the Southern Urals region of Russia, where he had the pleasure of driving a brand new tramcar over part of the test track of the Ust-Katav tramcar manufacturer (abandoned for regular passenger service in 1995). He drove the same car a year later in Kemerovo. It is the one and only tram he has driven in two different towns.

In Russia he was also able to drive a tram in Archangel, which until its closure in 2004 was the most northerly system in the world. Also in Russia he drove a three-car set in Magnitogorsk and a single tramcar in Orsk – both on the Ural River, which forms part of the border between Europe and Asia – the only two towns in the world where it is possible to drive a tram from continent to continent.

One of his most treasured memories is driving a tram at Itatinga in Brazil, which is one of the least-known lines in the world and can only be visited with permission from the Santos harbour administration. Another highlight for him was to drive a former Third Avenue car from New York at the Shoreline Trolley Museum near East Haven in Connecticut. 'These cars have a strange braking system,' said Peter. 'You have nothing to hold on to. While driving you have to press down the brake lever with the right foot, and lift it slowly to brake. It was one of my dreams come true.'

Peter is also one of the few tram fans in the world to have visited the metre-gauge Kumsusan tramway at Pyongyang, capital of North Korea. This is a new tramway, opened in 1995 and different to the standard-gauge city system. It is two and a half kilometres long and in very good condition. It provides a free service to and from the mausoleum where the great North Korean leader Kim Il Sung, who died in 1994, lies in state. The trams are second-hand vehicles from Zurich and are operated by military personnel only in 'series' control (at half speed) with a female military officer giving a commentary about the leader and the mausoleum. Western tram fans can only photograph the line after visiting the mausoleum, but they must wear a tie.

In the British Isles Peter drove his first double-deck trams, and I met him on one of his trips over here. He drove a tram at the National Tramway Museum in Derbyshire and an old London car at the East Anglia Transport Museum near Lowestoft. He also visited the Isle of Man to drive a car on the Manx Electric, which has the oldest tramcar fleet in the world and which in 1993 celebrated its centenary.

Peter's favourite tram is Plauen car No. 21, which, in 1965, became a preserved historic car, available for hire. Not surprisingly, Peter became the first tram fan to hire it. Sadly after the political change it broke down, its ninety years beginning to tell, and it was suspended from service. As there was a lack of specialists in the workshop, a local car builder made a new body for it. 'Equipped with refurbished truck, controllers, lamps, and so on, it is now a newborn old-timer par excellence. I like it very much,' beamed Peter. 'It was built in 1905, and now has open platforms, giving you a wonderful feeling when you are driving it in the summer.'

On his travels round the world Peter snapped this ex-Zurich tram running on the neatly laid out Kumsusan tramway at Pyongyang, capital of North Korea. This is a new tramway, opened in 1995, and provides a free service to and from the mausoleum where the great North Korean leader Kim Il Sung lies in state.

Beware! Cattle and Sheep on the Tracks

By Dennis Gill, with extracts by Mark Pearson, Stanley Webb and Jim Kilroy

Tramcar drivers faced many hazards on the tracks, but none as surprising as those created by animals, especially bulls and bullocks, which would have no hesitation in charging a tram, while cows and sheep would often hold up services by straying onto the tracks or by blocking them while being driven to market or the abattoirs.

In the early days of tramcars, it was a fairly common occurrence to meet sheep and cattle on the road. Quite often there was no bother; but on occasion trams suffered damage from charging cows or bulls, and there have been instances of trams running into flocks of sheep or herds of cattle with unhappy consequences. A shorthorn bull, for instance, took an instant dislike to a Burton and Ashby tramcar and butted it right in the side panelling. According to P.M. White in his book *Sixpenny Switchback*, the bull was being led to a butcher's slaughterhouse when the foolhardy driver of a passing tramcar, well known in the area as a prankster, deliberately clanged his bell to scare the creature. The bull's reaction was hardly surprising. It whipped its head round and the tram received the full force of its horns. The teenager, who was leading the bull to earn half-a-crown, incurred the wrath of not only his father (for agreeing to lead the bull in the first place) but also the butcher, who received a bill for repairs to the tramcar.

In Blackpool a bellowing heifer charged a tram head on. The fear-crazed animal had escaped from a slaughterhouse. After ramming the tram, it careered down a main road leading to the town centre with three police cars in pursuit, causing holidaymakers to scatter and cars and buses to swerve out of its way. Its pursuers managed to corner it in a car park, but it jumped over a chain that was thrown over the entrance. It was eventually trapped in an alleyway behind the central station, where slaughterhouse men finally lassoed it. In Torquay, a tram ran into a cow and the farmer took the Torquay Tramways to court. After a long legal battle he was awarded £15 – the amount a vet estimated the cow had suffered in depreciation.

When a Carlisle tram ran into cattle during darkness in 1917, two cattle dealers were awarded damages of £96 at the Carlisle County Court for injuries sustained by their animals. The driver of the tram turned out to be a lad of sixteen who had had only a week's training at the controls. A Bushmills farmer, though, lost his £35 claim against the Giant's Causeway line for the loss of his cow. After escaping from its field through a gap in the fence alongside the tramway, the cow had wandered along the road and plunged through a gap in a clifftop wall, unaware that there was nothing on the other side but a sheer drop onto rocks 15 ft below. The court held that the tramway was not responsible for maintaining the fence alongside its tram tracks. A luckier cow was one in Leicester that finished up under a tram. How it was released was related by Mark Pearson in *Leicester's*

A Leeds tram has to wait patiently while a pig is being driven down the tram tracks.

Trams in Retrospect (published by the Tramway Museum Society, 1970).

> Many people referred to the lifeguards as cow-catchers, a misnomer which appears to have been borrowed from railway engines which, of course, could expect to meet the odd cow now and then. Mr Hefford[1] tells me, however, that in 1915 the cow-catcher on a tram in Uppingham Road actually caught a cow. A herd of cattle was being driven into the yard of the Great Northern Station when one animal broke away and careered straight at the tram, finishing up well and truly underneath it. Mr Hefford had to take a breakdown lorry to the scene and jack the car up before the cow could be released. Remarkably, when it was freed, it seemed little the worse for its unpleasant experience!

One of the most frightening incidents occurred in Sunderland on 7 June 1898, when two horses pulling a tram were suddenly and unexpectedly terrorised by a bullock on Wearmouth Bridge. The *Sunderland Echo* the next day carried a full report of the astonishing scene.

> A most extraordinary sight was witnessed on the Wearmouth Bridge yesterday afternoon. About three o'clock two bullocks were being driven across the bridge from Monkwearmouth to the Sunderland side. At the same time a tramcar was coming across the bridge in the same direction. It was going very slowly at the time, and as anyone who has observed a tramcar may have noticed, when the horses are not drawing to any extent, the bar to which the traces are attached drops rather low down.
>
> As the car was passing, one of the bullocks stepped over the bar, and then forced itself along between the two horses. The horses were terrified at the unexpected presence of this unusual companion, and the bullock was not less frightened at the predicament in which he had placed himself. He could not turn back, and naturally, he tried to get out between the horses' heads. But the horses were furious and started away at a fast rate.
>
> The bullock increased his pace and away the wonderful trio went. Irritated by the constant prods which the horns of the bullock gave them, the fiery steads went faster and faster, and tried hard to kick the ox, but just as he was too close to them to hurt them much with his horns, so they were too close to him to kick him with any degree of force.
>
> And so the unwilling companions dashed along creating the greatest astonishment on the part of the spectators. The driver was trying hard to stop them, without avail, but a policeman and another man each ran forward and seized the horses, which were pulled up, the bullock then escaping. No particular damage was done, the horses only having been slightly grazed by the bullock's horns. But the sight of the three scampering along in a row was one to be remembered!

In the early days of tramways, some operators produced a list of charges for animals and goods that could be carried on the tramways. The Camborne and Redruth tramway had a scale of charges for the transport of horses, cows, bulls, calves, pigs, sheep, sand, iron and mineral ore, slate, compost, manure and so on. The South Staffordshire Tramways Company produced a schedule which listed a charge of sixpence per mile for every cow riding on its steam trams, and threepence per mile for every sheep, but gave no indication how the animals would be carried, although Lowestoft Corporation once made it possible for a visiting circus elephant to be carried on one of its electric trams by taking the seats out. One tramway, however, on which cattle were definitely carried is the Manx Electric Railway. A former open-sided car, No. 12, was converted into a cattle truck in 1903, and it ran until 1920.

In Middleton and Dublin, tram services have been held up by cows refusing to move from the lines. In Middleton, Lancashire, two cows blocked the path of the special trams carrying dignitaries on a tour of the town's tramways shortly after they had been opened. Despite much persuasion, the cows refused to budge until the cowman appeared on the scene. The Dublin incident was reported in the *Tramway and Railway World* for 16 January 1904 as follows:

> According to a story which comes from Dublin, the Irish cow resembles the Scotch Highland one in its laziness and disinclination to get out of the way. It appears that the electric tramway service on the Phoenix Park route in Dublin was brought to a standstill for about an hour by the perverse conduct of a cow. It was being driven along the street when it lay down on the tramway tracks to rest. Every effort short of violence was brought to bear on the cow, but without effect. Ultimately ropes were secured.… Just as a tall policeman was about to give the order 'Pull away', the cow rose to its feet, looked about in wonder, and calmly walked off.

There have also been quite a few instances of trams running into flocks of sheep, sometimes with disastrous results. In Bournemouth in 1904 four sheep were killed and others injured when a tram returning

A flock of sheep holds up an electric tram in Wanganui, New Zealand. The photograph was taken by Graham Stewart, founder of New Zealand's first transport museum, in September 1950, on the last Sunday trams ran in the town.

empty to its depot ran into a flock being driven along a road illuminated only by moonlight. Apparently the driver did not hear the drover's warning shouts. The tram had to be jacked up before the bodies of the sheep could be removed. Dudley and Stourbridge trams have also had unfortunate encounters with flocks of sheep. One tram ran into a flock at Cradley Heath on a Saturday night, killing several sheep, while in 1903, another tram ran into a flock near Wollaston. In *Black Country Tramways* (Volume One), which he published himself in 1974, Stanley Webb describes the scene.

> Towards the end of the year, a court action was brought against the Company for alleged negligence of a driver, whereby four sheep were killed; damages claimed were five pounds. Apparently, a flock of sheep was being driven along the country road beyond Wollaston, when, just round the bend at the bottom of The Ridge slope, they escaped over the tramway and through an open gateway into a field. As the drover was driving them out again, a tram came down from The Ridge, round the bend, and into the flock before the driver could stop, killing four sheep.
>
> Judgment was passed for the company, as it was claimed that the driver was only travelling at the regulation seven miles per hour for this hill, that he stopped within twelve yards of seeing the sheep, but that it was impossible to see the gateway in time, owing to the bend and the high hedge. One of the risks of country tram driving in those quiet days, one supposes!

By way of contrast, a Stockport tramcar which ran out of control down Lancashire Hill ploughed through a flock of sheep and some cows without injuring one of them before finishing up in a clog shop. An unusual story involving sheep appears in *Howth and Her Trams* by Jim Kilroy (published by Fingal Book Publishers in 1986).

> One little-known duty of each conductor and one taken very seriously indeed was related to me by Billy Rankin, reputed to be the most courteous conductor of all.
>
> The area now covered by Carrickbank and Offington estates was once lush meadowland used in spring for the fattening of lambs. Unlike their hardier mountain cousins, who foraged along cliff edges and rocky mountain streams, the Sutton sheep were thoroughly spoilt. Each lowering of the head provided rich mouthfuls of grass in abundance, so they became very fat.
>
> Now everybody knows that fat, self-indulgent sheep tend to become lazy and rather helpless and once they roll over on their backs, they are very often unable to roll back on their feet again. The rich pastures of Sutton were very conducive to this lethargic and helpless condition and many of the fatter sheep would lie for hours, waving their spindly feet in the air and bleating pathetically. They were

easy prey for any marauding dogs and many died in ditches in this manner.

It became the profound duty of all conductors to exercise vigilance from the vantage point of the upper deck to ensure that all woe-stricken sheep were up-righted. It was not uncommon for Billy to clank the emergency signal, scale a fence and roll over lethargic lambs to the cheers of an entranced upper deck. Occasionally stray lambs were carried on the tram back to their flock and it was, I am assured, not too uncommon to see sheep among the passengers; a rather confusing situation for the drowsy morning passengers, who were, so to speak, still counting sheep.

[1] Tramway Engineer for many years.

We Collect Trams

By John H. Price

John H. Price was involved with tram preservation in this country from its birth pangs – from the purchase by enthusiasts of their first tram to the formation of the Tramway Museum Society and the subsequent setting up of the National Tramway Museum at Crich, near Matlock. He became the first secretary of the society when it was formed at a meeting in Manchester late in 1955. He was a man with a dream, and he wasted no time and spared no effort in making it come true. Only a few weeks later the following article, written by him, was published in the *Model Engineer* for 5 January 1956, disclosing how it all started six years before, when tram enthusiasts set off on a tour of Southampton's tramways. It took another three years before a suitable site for the museum was found and a good few more years of back-breaking effort before the museum took shape and became the nationally recognised and much respected institution it is today, with more than fifty preserved trams and a working tramway bringing pleasure to thousands of visitors every year. It is an extraordinary success story in the face of great odds, and before his death in 1998 John could look back on the society's humble beginnings and its achievements with pride. His article about the early struggles to save trams from the scrap heap is reproduced by courtesy of the magazine's editor.

Did you know that there is a society that collects trams? There is, and I belong to it. Just as other people look after veteran cars or traction engines, so our society tries, in a small way, to salvage a few superannuated tramcars. So far we have six; their average age is fifty-two years, which is a lot higher than our own, for although some of us have been trying to do something like this for several years, our Tramway Museum Society has only just been formed.

Keeping trams is rather like modelling them, only at 12 in to 1 ft. I am no modeller myself, but I always think of a modeller as someone who would really prefer to run his own full-size railway, or tramway, or fairground, or whatever it is has captured his imagination, and only takes to modelling because the larger target is a bit beyond his reach or the size of his back garden. It was no surprise to me that when Talyllyn Railway Preservation Society was formed, railway modellers throughout Britain downed tools and converged on Towyn to realise their secret ambitions; even if they only found themselves painting the stations and weeding the track, there was a world of difference between doing that and painting the kitchen door or weeding the garden.

If your subject is trams, there is a fascination in

A poster promoting the National Tramway Museum's 'living tramway collection' in its growing years.

Before Southampton 45 (right), the first tram to be saved by enthusiasts, was moved to the National Tramway Museum it was stored at Blackpool. It contrasts vividly with a passing streamlined Blackpool car on 29 May 1955, the day it was handed over to the Tramway Museum Society.

handling them too, and I expect the tram-modellers will be glad to hear something of our efforts to keep a few prototypes. They can come and lend us a hand if they want to, there are only a few of us and there is a lot to do. But first let me tell you how it all began.

It started in August 1948, when some of us hired a tram for a day to have a trip round Southampton while there were still some rails left for it to run on. First they gave us a covered tram, almost modern in a pygmy sort of way, but it was such a nice day that we took it back and fetched out an old, half-forgotten open one from the back of the depot. It had seats like two benches leaning back-to-back in a park; it had not been dusted for months but it ran all right and so we cruised nostalgically around Southampton on the last open-top tram to run in the whole south of England.

When we took it back that night they said it would only make one more trip, to St Denys' yard; its fate would be the hammer, the torch and the funeral pyre. Perhaps, said the foreman, sensing our thoughts, some farmer with £10 to spare might take it off to his farm and let the chickens lay their eggs in it. Either way, the end was not far off and either way it seemed a shame. Trams deserve a better fate than that. We thought about it, talked about it, and finally wrote to the manager. If, we asked, *we* gave him £10, would he spare its life? We would look after it; it would be safe with us. He was surprised, but said we could have it if we really wanted it; what's more, he would dust it and give it a coat of paint as well. So he moved it into the paintshop and told the oldest hand to use up whatever tram-paint was left – it was enough for eight coats!

If you look in the darkest recesses of a Blackpool tram depot you will see the old lady there yet, a small crimson lake lodger in a family of green and cream, Southampton Corporation Knifeboard Tramcar No. 45. Or, if you look in my file, you will see 'Received with Thanks, to Supply of one Tramcar, the sum of Ten Pounds'.

I expect you are wondering why we took it all the way up to Blackpool. The short answer is that we knew the manager there and he had some spare room. That brings me to the big problem which you face if you try to collect trams: you cannot keep them in your back garden, they are too big; you really need something more like a factory, and even then it might not do for a double-decker.

None of us own a factory so our big headache has been to find somewhere to keep them; I cannot say I blame anyone for building models; it makes the storage easier. Regrets vanish, however, when you climb aboard. You cannot twirl the handbrake and ring the bell in a model, you cannot climb the stairs or sit on the seats and imagine yourself going down the Old Kent Road. A better justification is that there are so few trams left anywhere now that someone jolly ought to make an effort to keep one or two, even if there is not anywhere for them to run. So we carried on and got more.

Our second was a Geordie tram – from Newcastle. She was born in 1902 and took you not to Blaydon Races but to the more accessible ones in Gosforth Park. No. 102 is a battleship of a tram, she could lead a parade with the band playing on the quarter-deck; in fact she can shift 100 people. She is so large and awkward, though, that it takes 100 people to shift her too. Since we do not keep a private army it means hiring a mobile crane every time we move her; even then she is really too long for the lorry. But we shall keep her, if only to prove for evermore that trams could carry more people than those lifeless products of mass-production called 'buses'.

Of course, there are many types of tram and considering how hard up we were we thought we had better limit ourselves to one of each type: we could not afford duplication. We had a four-wheel 'open-topper' and bogie 'open-topper', but we did not have a single-decker, a covered-top car or a works car. To fill the last vacancy we chose a little Welsh water-wagon. It was a wooden one with chapel windows that used to pace the streets of Cardiff on a Sunday when everything was closed; for the covered

Visitors to the National Tramway Museum enjoying a ride on two open-top trams, the one nearest the camera from Paisley, the other Southampton 45, the first tram to be preserved by enthusiasts.

one, we chose a prosaic wooden affair from Leeds known to the locals as a kipper-box; the only single-decker that really took our fancy was a trailer tram from Liverpool, one that had seen better days but which, we felt, ought not to be broken up; it was only a little one. That made five; we thought we had better stop there for the moment, at least until we had somewhere better to put them than on other people's yards and tram-depots.

By this time the news had got around that someone was saving trams, and we began to get letters; sad letters, plaintive letters, pleading letters, letters from sentimental managers and from broken-hearted tram drivers, letters from repentant scrap-merchants, acquisitive schoolboys and people who just felt about trams as we did. While we could not take any more whole trams we did take bits of trams; a Peckham cantilever four-wheel truck, a Brill 21E swing link, a trolley-head, some panels and 20 yards of linen destination blind.

Then we had a letter that broke all our good resolutions, one with a story so strange that we knew no rest until we had rescued the car concerned. I suppose you would call it a 'ghost' story.

The story was set in the wild, rocky south coast of the Isle of Man, lashed by the waves and deserted by all but the sea-birds. Sixty years ago, some men set out to build a tramway along the rugged cliffs, the strangest tramway in Britain, a thin lifeline of Victorian civilisation suspended mid-way between sea and sky with a towering wall of rock on one hand and a sheer 200 ft drop to the breakers on the other. Defying nature, they cut a thin shelf in the rock and built their tramway; they also ran it for many a year until, in 1939, it closed and became a legend. The letter which contained this story went that if we walked the cliffs where no man went, and came to a headland which is known as Little Ness, we would find a complete depot full of old, forgotten open trams.

It was 21 June 1951, feeling like explorers in a lost world, that we climbed the cliff, walked along the deserted drive, and wondered what we would find at the end of it. The tramway had vanished, the rails torn up or thrown into the sea with, here and there, a gaunt, rusted pole to show where once the cars had run. The drive was closed to traffic, and we were alone in the silence, talking in whispers. We came to the depot, just as the letter had said, a rusty iron shed on the cliff-top, the only building for miles. The door creaked open at the first touch, and there they were – sixteen old, red, open trams of 1896 and 1897, standing there just as they were on that day in the autumn of 1939 when the men shut the doors and switched off the current for the last time.

Sixteen faded red and white double-deckers, complete in every detail, with wooden cross-benches below and open garden seats above, mounted on

Members of the Tramway Museum Society spend many of their leisure hours on voluntary work at the National Tramway Museum. Member Michael Gilks is working on the electrical equipment of preserved single-deck Leeds tram No. 602. The car, when it was introduced in 1953, was the prototype of a fleet of modern railcars which were to grace the streets of Leeds. But because of a change of policy the fleet never appeared and four years later the prototype was withdrawn from service, becoming a museum exhibit three years later.

Lord Baltimore's patent four-wheel trucks with real grease in the axle-boxes, and carrying notices headed 'Douglas Head Marine Drive Electric Tramways', informing passengers that 'on request to the conductor' they 'may alight from the car at any stage en route, including Pigeon's Stream, Rebog, Whing and Keristal'. It was almost incredible; we had to touch them to make sure we were not dreaming, but no, they were real enough. Their survival was so miraculous that we had no choice but to rescue one of them and keep it, so we set about moving No. 1 car and adding it to our collection. The staff had been signed off twelve years ago and the company wound up, but we knew they would have approved. We hired some gear and took No. 1 over the rough track to Douglas, where it now rests secure beneath frames and tarpaulins in the road-menders' yard until the time comes to install it in a proper museum. But we are not quite sure of it. Two years later we happened to walk again along the deserted drive, and the depot and the other fifteen trams had vanished so completely that they might never have been.

We could do with a bit of magic on this job; it would make things a lot easier when it comes to moving a tram from where it is to where it ought to be. Have you ever tried moving a tramcar? You need a lot of ingenuity, a lot of patience, and (worst of all) a lot of money. You cannot just tow it down the road; you leave two furrows and get a rude letter from the council. You cannot mark it *marchandise roulant* and send it in a goods train; it would derail at the first curve.

We did try and see whether a 4 ft 8½ in-gauge tram would run on a 4 ft 8½ in-gauge railway line, by towing the little Welsh car on a track in our chairman's timber yard, but at the very first bend it slipped down between the rails, sat on the sleepers and refused to move until we jacked it up onto a timber-wagon; tyres and tolerances sometimes mean more than track gauge.

No, to move a tram you have to have a big lorry, trailer and all sorts of gear which is very expensive to hire. The next thing we did was to buy a towing lorry and a trailer, the former from Bury Corporation Transport Department and the latter from a fairground in a Manchester slum. The trailer had a box body which had been the home of some performing dogs, but previously it had been a chilled-meat trailer and all the dogs died of pneumonia; we took it apart and it now has another life. The lorry has 'Tramway Museum Society' emblazoned on its cab; it is a bit temperamental but we are all set for our next move – when we find somewhere to put the tram.

Try as we might, we still cannot solve the storage problem. All the time really deserving trams are being broken up for scrap. At present our cars are old, but if we get any of the later models they will be tall, upstanding double-deckers; they are the trickiest of

Sunderland tramcar No. 100 (formerly MET 331) being delivered to the National Tramway Museum on a low-loader in 1961. The view illustrates well the problems involved in transporting trams, for it shows the difficulty the driver had in easing the low-loader through the entrance.

In half a century the National Tramway Museum has made great strides – from what the *Guardian* in 1959 called 'an amateur coach builders' yard' to a living museum where the public today can see more than fifty preserved trams and capture the thrill of a tram ride. Here, some of the preserved trams are taking part in a procession on 24 May 2009 to mark the museum's fiftieth anniversary.

all, to them a low bridge is anything less than 20 ft. It seems a pity to stop now with trams getting so scarce, but a tram has to have somewhere to live, you cannot just ignore its presence or put it in the attic. If any of you have space for one or two, even outdoors, we should be delighted to hear from you; the same applies if you want to join us and lend a hand.

Some Fell by the Wayside

By Dennis Gill, *with extracts by Eric Watts, Hugh McAuley and Alan Brotchie*

Normally tramway conductors and drivers behaved impeccably, but there were some that fell by the wayside. Managers had to contend with all kinds of inexcusable misconduct, such as fiddling tickets, threatening superiors or subordinates, and, in the case of Birmingham Tramways, shooting a colleague. But, on rare occasions, even some of those holding responsible positions did not exactly set a good example, either.

Generally speaking the employees of tramway undertakings were of upstanding character, performing their duties civilly, smartly, conscientiously, punctiliously and considerately. The London County Council Tramways, for example, required from them honesty, sobriety, obedience, punctuality and civility. Nothing less would do. And history shows that most tramway workers were a credit to their employers and were respected by the travelling public. To make sure no employee was in any doubt of what was expected from him, undertakings issued every employee with a book of rules and regulations, which were usually of a handy size so that they fitted easily into a uniform pocket. More often than not the books ran to more than 100 pages. The following extract is from the Salford City Tramways rule book, and appears to confirm that 'being polite at all times' was the foremost requirement from employees.

> Every employee must be firm, civil and obliging in the execution of his duty, and at all times answer civilly any enquiries by passengers to the best of his ability and discretion, and, if requested, give his name and number (if any), and when on duty must abstain from smoking. Employees must not visit public houses whilst in uniform, use improper language, nor misconduct themselves. It is the desire of the Tramways Committee that the Traffic Staff should earn and maintain a reputation for general smartness in conduct and appearance.

Sadly, there were some who came off the rails by breaking their rules of employment or abusing their position. Even one or two holding high office came to grief, as in the case of two managers employed by Keighley Tramways. The first of these was Arthur Kirton, previously traffic superintendent of Lancaster

City Tramways, who took up his appointment in 1904 and moved into a small wooden office built for him in Town Hall Square. It must have been the least inviting manager's office in the land, yet only eight months later he was summarily dismissed for having had an amorous affair in it. Society was much more alarmed by such goings-on in those days. Kirton was succeeded by John Bamber, the Halifax traffic superintendent, who managed to hold the post for four years before he too was sacked. His sin was to threaten the depot foreman, Eli Murgatroyd, whose services were highly valued and who was offered the position of manager in his place. (In the short space of twenty-one years, the small Keighley undertaking had no fewer than seven managers – a record no other municipal undertaking came anywhere near matching, although Wigan was not far behind, appointing seven managers in a period of twenty-seven years.)

The chief inspector of the Birmingham Corporation Tramways did not bring honour on Birmingham Corporation Tramways when he fired a loaded revolver at his superior, the traffic superintendent. It happened on an October day in 1925, when shots were heard in the tramways head office. The chief inspector, 60-year-old John Henry Cuttler, had been harbouring strong grudges over staffing levels against the traffic superintendent, 43-year-old Leonard Johnson, whom he considered to be a strict disciplinarian. He threatened to take the matter to the general manager. The issue came to a head when Johnson told Cuttler that he was arranging for someone else to do his work until the matter was resolved. 'That's it, is it?' exploded the chief inspector, whereupon he drew out an automatic pistol and fired it at the superintendent, wounding him in the groin. At Cuttler's subsequent trial for attempted murder, the prosecuting solicitor, Mr M.P. Pugh, described what happened next. His words were reported in the following extract from *The Birmingham Mail* for 10 November 1925:

> Mr Johnson saw blood coming from the place in which he had been hit, and found marks of a bullet having passed through his clothing. Hearing Mr Johnson's call for help, members of the staff rushed in. They saw Johnson in a crouching position against the wall and Cuttler standing up with the revolver in his hand. As one of the staff, Mr Smith, entered the room, Cuttler wheeled round and fired the revolver – Mr Smith could not say whether the shot was intended for him.
>
> Wheeling back, he again aimed the pistol at Mr Johnson. Other officials and clerks who had rushed in saw this. Luckily for the traffic superintendent, his assailant was overpowered. In the struggle some four further shots were fired. Before this Mr Johnson had said, 'He's shot me.'
>
> Cuttler was held down by a Mr Tickle till Mr Johnson was got out of the room, and the man now accused said, 'You'd better loose me, or I shall hurt some of you.' Later Cuttler said, 'I shot him and I shall say I shot him.'
>
> On the way to the station Tickle, who was one of those accompanying Cuttler in the vehicle, was nodding his head. This led the accused to say, 'It's no use shaking your head. I ought to have had one as well.' By this, Mr Pugh said, he did not know whether he meant he ought to have shot someone else or have put a bullet into his own body....
>
> In support of the contention that there was premeditation, Mr Pugh said that twenty-five cartridges were found about Cuttler and in a wallet handed by him to a Mr Fletcher, in addition to five or six discharged. This meant that Cuttler was armed with an automatic pistol and thirty to thirty-one cartridges when he went to see Johnson.

The case appeared to be clear cut, but Cuttler was fortunate in being defended by a keen young barrister, Norman Birkett, then virtually unknown but who went on to become a judge in the King's Bench Division and Lord Justice of Appeal. Birkett made much out of the fact that Cuttler had spent several years on the Gold Coast of Africa and during that time had become a crack shot. He asked the jury if they could really believe that a man who was a champion revolver shot could fail to kill a man six feet away, if it was his deliberate intention of doing so. 'He almost failed to wound, and yet he is a champion revolver shot,' said Mr Birkett. After an hour and a quarter's deliberation the jury found the chief inspector not guilty.

Another incident involving a pistol occurred at the Derby Corporation Tramway offices on 2 June 1907, when a former tram conductor went there with the intention of harming the tramways manager, Frank Harding. This report of the incident appeared in the *Tramway and Railway World* for 15 June 1907.

> At Derby Police Court on Tuesday, William Henry Fenton was charged with having been armed on 2 June with a loaded pistol with intent to inflict grievous bodily harm on Frank Harding, manager of Derby Corporation Tramways. He was also summoned for threatening on April 6 to blow out the brains of Frank Harding. For the prosecution it was stated that the accused was formerly a conductor on

the corporation tramways, but for various reasons his services were dispensed with in March last. He had on various occasions gone about with a loaded revolver in his pocket, and had threatened to do grievous bodily harm to the manager and the chief inspector, both of whom he thought were responsible for the circumstances which led to his dismissal. On 2 June he went to the tramway offices and announced to the caretaker that there were two he meant to put a bullet through. The chief inspector passed through the office, and the accused said to the caretaker that that was one of them. After evidence, it was stated for the defence that the accused had got into bad company and had too much to drink, and that the threats were simply swagger. He had always borne a good character. The Bench passed sentence of two months' imprisonment with hard labour on the charge, and on the summons he was bound over to keep the peace for six months, or, in default of finding sureties, one month's hard labour.

In 1908, a Wigan tram inspector was sentenced to three months' imprisonment for a fiddle involving tickets. Apparently the inspector stole bundles of tickets from the traffic office, and persuaded some of the conductors to sell the tickets, in place of the ones with which they were issued before going on duty, and share the proceeds. The inspector was earning as much as £2 a week through the scam, of which he gave half to the conductors. So that the crime would not be detected through the ticket punches (which recorded the total number of tickets punched) he had also stolen a punch, which he handed to whichever conductor was selling the stolen tickets. The fiddle had been going on for some time, and it was only because one of the conductors was willing to testify that the case was brought to court.

A Portsmouth tram conductor's unprofessional conduct cost him his job in 1900. Eric Watts in his book *Fares Please* (published by Milestone Publications in 1987) lists some of his offences.

In July 1901 he was cautioned for allowing a passenger to have a twopenny ride for a penny. In November he broke a dashlight glass that cost him a shilling for the repair. On Christmas Eve 1901 he received a day's suspension for moving the trolley pole before passengers had got off the tram. When Inspector Randall spoke to him about it, he was insolent. For neglecting to take a fare, he was cautioned in June 1902. The end finally came in September 1902. The record book reads: 'Inspector Ade saw a lady give this conductor something which he thought was her fare but he did not give a ticket.

When spoken to, he said she had given him a penny for himself. The inspector caught up to her and she stated that she got on at Fratton Bridge and paid the conductor as she was leaving the car. His excuse was on the return journey that he dropped a penny in giving change and did not stop to look for it; he thought the lady had picked it up.' The column headed Verdict shows: 'Dismissed 1 October 1902'.

In horse days, before the introduction of tickets, dishonesty among drivers and conductors was commonplace, and many a conductor made quite a bit on the side by pocketing for himself some of the fares that should have been handed in at the end of

David Hooker, dressed in the style of clothing worn by conductors in the Victorian era, is a volunteer on the Heaton Park tramway in Manchester and collects fares on the restored Manchester horse tram which occasionally runs in the park. He is holding a Kaye's Patent Fare Collection Box, which was used by the Manchester Carriage and Tramways Company on their vehicles to prevent fraud. Coins dropped by passengers into the top windowed compartment of the box could be checked by the conductor. If the amount was correct, the conductor then pressed a lever at the back of the box to drop the coins into the lower sealed compartment, which could only be opened by the cashier's office.

his duty. In 1888, in an attempt to stamp out fraud, the Manchester Carriage Company introduced a Patent Fare Collection Box invented by Joseph Kaye. This box had an upper and lower compartment, with a slot and window in the top half. Instead of handing their fare to the conductor, passengers simply dropped the correct amount of money into the top half of the box through the slot. The coins could be viewed through the window by both the passenger and conductor, and if correct the conductor then pressed a lever at the back of the box, causing the coins to drop into the bottom compartment which could only be opened by a key kept by the paying-in office. Even so, the box was not the answer to tramway operators' prayers, for the waybill system was primitive and there was still no way of knowing whether any fares had been missed.

In Budapest, in the early 1930s, a tram conductor shot himself shortly after coming off duty. He was still wearing his uniform. His suicide was not obviously greeted with heartfelt sorrow by the tramway management, as became clear from the warning which was given to all the conductors two weeks after his funeral. They had been ordered to assemble in front of one of the managers, who lectured them at length on the enormity of their former colleague's crime. It was made clear to them that it was not only a grave offence but also against the rules to shoot oneself while wearing the tramways' uniform; such dishonourable conduct could not be tolerated. It was inconsiderate to their employers, and furthermore the uniform was likely to become damaged or bloodstained to the extent that it could not be re-issued to somebody else. They were told in no uncertain terms that if the rule against committing suicide in uniform was broken again, the cost of replacing the uniform would be claimed from the deceased employee's next-of-kin.

Hugh McAuley, the editor of *Kontakt*, the magazine of the Scottish International Tramway Association, mentioned the Budapest suicide in his columns, in August 1997, adding the following note.

> Before we all think to ourselves that such a ridiculous incident could not have happened in the UK, I have an acquaintance whose grandfather, a Newcastle upon Tyne Corporation driver, died in the early 1930s as the result of injuries received when the tram he was driving collided with another vehicle. Although he was given a funeral by the transport department, his widow was informed that she was required to clean the blood-stained uniform and return it to the department! This she did, but one can well imagine her private opinion of the department.

An inspector on the Carlisle tramways was surprised to see rolls of tickets streaming out of the back of a tram one evening. He stopped the car and, to his surprise, found the conductor clinging to the brass grab rails on the back platform completely drunk. On most tramways, any employee found drunk while on duty faced instant dismissal.

Discipline was strict, but fair, on Falkirk's tramway system. Any employee committing an offence was graded with demerit marks – setting the trend, perhaps, for the points awarded to motoring offenders today. Some of the offences which earned demerit marks are described by Scotland's leading tramway historian, Alan Brotchie, in his book *The Tramways of Falkirk* (published by the N.B. Traction Group in 1975).

> Offences were many and varied, and punishment graded, with demerit marks being allocated to each offence and accumulated until some drastic action was taken.
>
> Failing to set the destination screen cost 10 marks, as did punching a ticket at the wrong fare stage; 20 demerit marks were given for each uncollected fare discovered by an inspector; for putting a car off the rails in New Market Street, Driver Inglis earned 50 demerit marks. A caution from the Chief Inspector was the next punishment, two cautions meaning dismissal.
>
> Offences which earned a caution included failing to observe Board of Trade stops and allowing a strange boy to turn the trolley and destination sign. A period of suspension from duty could be imposed, e.g. one day for running the car with the trolley in the wrong direction, three days for smoking on duty, five days for running the car on to the dead section at an open canal bridge, and derailing at the runaway points. For the most heinous offences the ultimate sentence was dismissal, which was not often invoked. However, it was applied to one motorman who entered a public house whilst in uniform, and to Motorman Haxton, who, in a hurry to get back to the depot to sign off, overtook another car going in the same direction at Camelon Station loop! The record does have its more humorous side, however, like the driver who resigned because he got wet one day; as his was one vocation where being wet and cold was the norm, he was obviously not cut out for this work. Or there was the conductress who received a caution for playing about in the street with the driver.

A similar scheme to Falkirk's was operated by the London United Tramways, but as well as giving

Two trams lie side by side on the windswept heights above Halifax after having been toppled by a very severe gale at Stocks Gate on the Queensbury route. They were left lying on their sides until the wind abated the next day. The incident led to a wind gauge being installed on the line.

demerit marks, the LUT also gave merit marks. For example if an employee was two minutes late when he arrived at a terminus, he was given one demerit mark. When an employee had 60 demerit marks on his record he was dismissed from the service. On the other hand, an employee bringing credit to the company, or helping the company improve its service in any way, would be awarded merit marks. One employee was known to have 300 merit marks when he retired.

Toppled by a Gale

By Eric Thornton and Stanley King

Gales and storms caused as much disruption in tramway days as they do today. In 1910, for instance, a gale caused the roof of Staffordshire Tramways depot to fall in, while in 1917, a gale that swept the north of England derailed tramcars in Leeds and Bradford and took the corrugated roof off the Falkirk tram sheds. Worse was to follow for Halifax in 1920, when a severe gale blew over tramcars on the windswept Queensbury line. This description of the event is taken from *Halifax Corporation Tramways*, written by Eric Thornton and Stanley King and published by the Light Rail Transit Association in 2006.

The morning of Friday 3 December 1920, was wild and windy, obliging Halifax folk to hold on to their hats as they struggled to their places of work. By early afternoon a full-scale gale was raging over the town and its surroundings, and on the encircling heights the force of the storm was terrific – nowhere more so than at Stocks Gate on the Queensbury route, where, to quote the *Halifax Courier*, 'this particular portion of the road is the most exposed on the whole of that bleak route. It is at the height of the hill and open to the full force of the wind from all directions. It forms a gap in which the gales collect and rush over it with the full might of their concentration.'

At about 2 p.m. top-covered tramcar No. 50 left Union Street for Queensbury, halting at intervals on the ascent of Haley Hill and Boothtown Road to allow passengers to alight, so that when it set off from the Boothtown fare stage only two adults and a boy remained on board. Partially sheltered by the glazed platform vestibules fitted to the tram only a few months earlier, Motorman Lumb and Conductor Midgley were at first unaware of the increasing violence around them.

However, when the tram came to rest in the Stocks Gate loop, waiting for a car from Queensbury to pass in the opposite direction, they were assailed by the shrieking and buffeting of the gale. A sudden tremendous blast rocked the car sideways, lifting one side off the rails, and before it had time to right itself, a second blast toppled it on its side across the down track. Wrenched from the overhead wires, the flailing trolley boom struck the nearest wall while the passengers and staff were flung across the saloon.

Both adult passengers lay injured, but the agile boy scrambled out of the tram and was not seen again. Summoned by the lineside telephone and scarcely able to believe that a ten-ton tramcar could be toppled by the elements, Mr Galloway[1] and Inspectors Drinkwater and Lumb hurried to the scene and sent for a breakdown gang, but not surprisingly it proved impossible to raise No. 50 in the teeth of the gale.

Meanwhile, on the Queensbury side of the loop, two Halifax-bound trams had been waiting for some time, and when the wind had abated somewhat, the first of these, No. 98, was allowed to venture over the points, using the outward track as a means of circumventing its capsized companion. At that moment another tram arrived from Halifax, but was promptly sent back whence it came, and as soon as it had moved off, No. 98 began to follow it. A malicious gust of wind then sprang up and blew the trolley off the wire – a very unusual occurrence – and before it could be retrieved, No. 98 too was blown over, to the astonishment of the tramway officials.

At that, the breakdown gang abandoned the unequal struggle, leaving the two tramcars lying side by side with the third tram standing in the shelter of the nearby houses until next day. Needless to say, no trams ventured beyond Boothtown until calmer weather returned, and when they did they were all open top cars which presented much less wind

resistance. This action was approved on behalf of the Board of Trade by Major G.L. Hall, RE, who advised the installation of an 'anemometer station' (wind gauge) which would automatically transmit wind velocities to the tramway offices at Skircoat Road. Suitable equipment was located in June 1921, and installed on one of the tram poles, and HM Meteorological Department (the Met Office) in London contracted to provide twenty-four hours' forewarning of winds likely to exceed 40 mph.

[1] The corporation's tramway engineer.

Historic Film Discovery a Boon for Tram Lovers

By Dennis Gill and Ian Yearsley

When 800 old films were discovered in a Blackburn cellar it caused great excitement among tram enthusiasts, for many of the films contained splendid sequences of tramcars on the move in many northern and midland towns in the early years of the twentieth century.

A momentous event in the first half of the twentieth century was the discovery of Tutankhamen's tomb by the archaeologist Howard Carter in 1922. Another eventful discovery in the second half of the twentieth century, remarkable in its own way, was the discovery in a Blackburn cellar in 1994 of 800 films taken in the early years of the twentieth century by local film makers Mitchell and Kenyon. The films, containing amongst other things a wealth of shots showing early trams on the move, were found in three metal drums by contractors who had been employed to strip the cellar. The films had probably been in the drums since 1922, the year Mitchell and Kenyon's partnership was dissolved and the very same year Carter uncovered Tutankhamen's tomb. Samples of the collection were taken to Blackburn film enthusiast Peter Worden, who realised their significance and took steps to preserve them before eventually handing them over to the British Film Institute so that they could be enjoyed forever by the nation. The films, unparalleled in the history of early British movie making, show everyday scenes and events, usually where large crowds were present. They were shown at local cinemas in the north of the country, especially the North West, giving local residents the opportunity of seeing themselves on the big screen.

The discovery of the films and its consequences, and particularly how the collection helps us to understand the history of early film-making, is fully explored in *The Lost World of Mitchell and Kenyon: Edwardian Britain on Film*, published by British Film Institute Publishing in 2004 and edited by Vanessa Toulmin, Simon Popple and Patrick Russell, with contributions from experts in widely differing fields benefiting from the discovery.

Many of the tram scenes that feature prominently in the Mitchell and Kenyon collection were filmed from the platforms of moving trams, some of the most fascinating being taken on trams in Lytham, Rochdale, Nottingham, Sheffield, Bradford, Halifax,

For the first time in almost a century, the Mitchell and Kenyon films give us a chance of seeing an Eades Patent Reversible horse tram being swivelled round on its truck in the streets – a sight most enthusiasts thought they would never see on film, let alone in reality. But, amazingly, one of these cars has recently been restored (early in 2009) and runs on special dates at the Heaton Park Tramway in Manchester, when visitors can see the swivelling device in action. This view of the restored car was taken in the summer of 2009.

Sunderland, Morecambe, the Isle of Man and Belfast. They present amazingly clear shots of the earliest tramcars, showing passengers enjoying the ride, crews at work, pedestrians waving to the cameraman and other traffic passing by. They vividly bring to life scenes from a long-gone age that many people never imagined, even in their wildest dreams, they would see from the comfort of their own armchairs. Scenes like a watching crowd being sprayed with water from a hosepipe by a Wigan steam-tram driver; the body of a Manchester horse tram being reversed on its truck; and a Liverpool tramcar illuminated with hundreds of bulbs for the visit of Boer War heroes Earl Roberts and Viscount Kitchener when they received the freedom of Liverpool in 1902. Even the opening of Accrington's municipal tramway is depicted, and shows trams, bearing civic dignitaries, arriving from the neighbouring towns of Darwen and Blackburn.[1] The auspicious occasion is described in the following paragraphs taken from the chapter 'On the Move in the Streets', which was written for the book by transport historian Ian Yearsley, and which is reproduced with permission of Palgrave Macmillan.

> The date is 2 August 1907 and both towns have sent their latest trams, delivered only a few months earlier. Darwen sent a small car, No. 17, designed to be operated by a driver alone, instead of a driver and conductor, and Blackburn's car is immediately identifiable by the curious destination 'Engaged Car', which was a local feature. But for the film, these municipal goodwill missions would never have come to light.
>
> This quite long sequence provides a study of a celebration of municipal enterprise, with the mayor not only giving a speech from the front platform of the inaugural tram, but also demonstrating the scope of the undertaking by winding through all the destinations on the front indicator blind. It also, at the beginning, gives a rare view of tramway construction with a horse-drawn reel wagon feeding the gleaming copper wire over the platform of a tower wagon behind it. And at the end of the film there is a long line of guests heading for the celebratory banquet at the town hall, finding their way through the stream of horse-drawn traffic.

The films record a time when people were increasing their mobility. The average person in 1891 was travelling no more than one and a quarter miles a day; by 1911, he would be travelling five miles a day; today he or she travels twenty-eight miles, of which nine are abroad by air. But the four-fold increase in travel came mostly in the Mitchell and Kenyon period, and much of it was made possible by the new electric tramcars.

Statistics like these are brought to life by these films. They enable us to contrast the teeming streets of the city centres and industrial districts with the tranquillity of the suburbs. They allow us to see how the streets, which one present-day commentator has described as 'sewers for traffic', were at that time places for meeting people and enjoying all kinds of passing entertainment, whether in the form of religious, political or philanthropic processions, or simply of a well-loaded tramcar, its open top-deck passengers looking like a basket of flowers on the move, or yet again in the gaudy displays of advertisements, at that time unrestricted by legislation.

The opening of Accrington's new electric tramway in 1907 was witnessed by many distinguished guests and by huge crowds of spectators, some of whom are seen here. The scene was captured in the films of Mitchell and Kenyon, which are now preserved at the British Film Institute.

They also enable us to see all sorts of skills being practised: driving vehicles in heavy horse-drawn traffic, riding a bicycle to avoid being caught in the tram tracks, driving an electric tram or a horse-drawn dray. They show us how a woman in a long skirt negotiated the steep stairs of a horse bus. It is not so clear how the men, so universally wearers of hats in the streets, managed to keep their headgear on in high winds. Besides the street scenes, there are glimpses of street traffic in films of sporting events and of people entering or leaving factories....

The Mitchell and Kenyon street sequences therefore turn myth into reality, statistics into experience, and the dry facts of history into the excitement of pageantry. They will form an animated illustrative benchmark against which future historians of street transport will be able to measure their own findings. They also offer a journey into streets of our family history; I found myself scanning the top-deck passengers of Manchester horse trams to see if I could see my father and grandfather. They would have been on top because top-deck fares were half those for travel inside the downstairs saloon; among the immediate benefits of electric trams were reduced fares for passengers, along with better pay and hours for drivers and conductors.

It was completely by chance the Mitchell and Kenyon films came to light. Nobody appears to have conducted a full-blooded search for them, so presumably their existence had been forgotten by most people before the outbreak of war in 1939.

Some 500 films of tramways as far back as the Victorian era are in the National Tramway Museum library, making it one of the biggest collections of its kind in the world. It was built up thanks to the efforts of film archivist Roger Benton, who has been at the museum for fifty years and is one of its longest-serving stalwarts. Roger started collecting the films very seriously in 1973, and within ten years had amassed some 250 films. The amazing collection, now double in size and the largest of its kind in the country, includes sequences from *First Cycle*, a road safety film made unusually in colour in 1942 and showing Salford tramcars; the weird-sounding *Dr Brian Pellie and the Secret Dispatch*, with chase sequences involving robbers and pursuing policemen on South Metropolitan tramcars; *Toonerville Picnic*, a cartoon version of the Toonerville Trolley series; and *Sailor Beware*, in which Bill Dooley stars as a sailor bringing home a guinea pig for his girl and causing a riot on a streetcar as a consequence.

Also included in the collection are British television films and programmes which feature the Tramway Museum's trams, such as *Paradigms*, *Blue Peter*, *Nationwide*, *Britain's Strongest Man*, *Treasure Hunt*, *Barbershop Picnic*, *Yesterday's World* and Howard Spring's *Shabby Tiger*. There are also films of tramways shot by amateurs (including enthusiasts) and documentaries of tramway undertakings, such as *The Elephant will Never Forget*, the British Transport Commission's affectionate eleven-minute look at the last tram week in London, and one of my favourites, *Paul Tomkowiz, Street Railway Switchman*, which is about a point cleaner in Canada. The oldest films in the library include a run on the San Francisco cable

Historic film footage of trams in action on the streets of Chester is included in a video of transport scenes issued by the North West Film Archive at the Manchester Metropolitan University in 1997. This pleasant scene of tramcar No. 11 was shot on Grosvenor Road. The driver at the controls, Mr Eagleton, is also pictured driving the horse car in 'Jobs for the Boys', see page 74.

cars from the top of Market Street to the Ferry Buildings in 1905, prior to the earthquake which demolished the city; a street scene in San Diego in 1898; and family films of Michael Holroyd Smith, who in 1885 completed the construction of Britain's first electric street tramway in Blackpool. The longest films in the collection include *Passing of the Tramcar*, a 95-minute look at Glasgow's trams, and two of Harold Lloyd's feature films – *Girl Shy* and *Speedy*, both over an hour long.

The films are housed in the John Price Library at the museum, which also houses some 25,000 books, brochures, leaflets and reports (including the Winstan Bond collection of 9,000 books and 250 boxes of papers, for which special shelving had to be installed), 100,000 photographs and postcards, 8,000 maps and drawings, and some 500 tramway-related artefacts.

[1] Tramway scenes from the Mitchell and Kenyon collection appear in videos by Online Video, especially *Trams In and Around Manchester* and *Trams in North Lancashire*.

Much to Be Said for Tramcars

From the Hawick Express and Roxburghshire Advertiser

In August 1955, at a time when the tramways in Edinburgh, Glasgow, Aberdeen and Dundee were beginning to diminish, the *Hawick Express and Roxburghshire Advertiser* **jumped to the defence of the much-maligned tramcar, pointing out some of the weaknesses in the arguments of the antagonists. This extract is reproduced by kind permission of the** *Southern Reporter***, Selkirk.**

Old orders are changing very rapidly nowadays; and a current change is the doom of the tramcar, for its days, it would seem, are numbered. Gradually they are disappearing from the streets of our cities. They have vanished from London; they are becoming few in Edinburgh; and even the stately tramcars of Glasgow (surely the most luxurious of all tramcars) are departing from one route and another. Their places are being taken partly by buses, partly by those queer hybrids, trolleybuses. And I for one am sorry to see them go, for in spite of their shortcomings, there is much to be said for tramcars.

The tramcar has had a shorter career than most vehicles, for it is still under a century since the first public tramcars trundled through the streets of Birkenhead. In those days, and for many years after, they were merely horse-drawn carriages running on rails. They were succeeded by steam-drawn vehicles, which were never really popular, for, apart from the disadvantage of their clouds of steam and smoke, they were regarded with the suspicion that had been accorded to the early railways. They were, in fact, miniature railways running through the streets, and so were looked upon, possibly rightly, as extremely dangerous.

Then came the era, in a few cities, of the cable car. It is not so very long ago since the cable cars disappeared from Edinburgh; probably many of my readers will remember them. They were the clowns among vehicles, and furnished material, not without justice, for many a music-hall joke.

A slot ran lengthwise between the rails; under this was a constantly moving cable, which supplied the motive power. A projecting arm underneath the car gripped this cable when the driver wished to move, and let go of it when he wanted to stop. The main characteristics of these cars were their noise and their comparative slowness. The speed of a cable-car was the speed of the cable, and under no circumstances could it be more. As for the noise, it went on whether a car was passing or not; Princes Street resounded permanently to the sound of the heavy cables running on their wheels under the open slot.

The typical tramcar of to-day (perhaps I should say of yesterday) is the electric tramcar; and it is the passing of this which I deplore. It had all sorts of advantages over its predecessors. It is reasonably quiet; it is, or given the opportunity, can be, fast; it can be comfortable; and, unlike the cable-car, it seldom

The *Hawick Express and Roxburghshire Advertiser* lamented the disappearance of tramcars from Edinburgh, but luckily one was preserved and the public were able to enjoy rides on it again when it ran during Blackpool Tramways' centenary celebrations in 1985.

breaks down. For short journeys in a city, it seems the ideal vehicle. It is easy to enter and leave, and it holds a great many people. And yet this paragon is doomed to extinction, mainly because it needs rails.

But that, to the pedestrian and to the user of other vehicles, is one of the great beauties of the tramcar. One knows, not merely where it is at any instant, but where it is not and never can be. It cannot, like a bus, pursue one all over the road. It is subject to the predestination of its rails, whereas the bus is a freelance, and can chase its victims everywhere except up trees. The whole roadway is at the mercy of a bus. The trolleybus is even worse, for although it cannot stray far from its parent wires, it has nevertheless the freedom of about half the road, which means that in its own bounds it is exactly twice as virulent as the bus, and as it creeps up on one even more silently than the quietest tramcar, it is all the more deadly. It may share certain good points with the bus, but it combines the faults of the bus with those of the tramcar, and adds a few of its own.

As for the question of rails, they certainly do not improve the surface of the roadway; but, properly looked after, they are not as bad as many other things. If one could be sure that, once they are removed, the roads would be better – and remain better – there might be more in the argument; but the rails had the advantage of discouraging people from digging holes in the road under them. And there is nothing surer than that, as soon as all rails have been removed and all roads have a beautiful smooth surface, the various authorities in charge of gas, electricity and water will dig strings of holes all over the city, and then the telephone people and the sewage people will add their quota to the mess; and every hole will be filled to a level either just above or just below the surrounding surface.

It has been pointed out, too, that electrically speaking the rails are alive. True, perhaps; but to receive a shock, one must not only have a foot on a rail, but also a hand on the overhead wire. And, human beings usually falling short of the necessary height for such a feat, this form of electrocution happens only at the longest intervals.

The arguments against tramcars, in fact, seem so weak that perhaps the change rests on a philosophical and religious basis – predestination against free-thinking and the free-thinkers have won. But there is a lot to be said for predestination, too.

Comic Postcards

Millions of comic postcards were sold at holiday resorts, a large proportion of them being produced by Bamforth's of Holmfirth in Yorkshire, where there is now a comic postcard museum. A few of them featured tramcars, six of which are reproduced here.

The press had much to say in praise of this South Shields tram when it was introduced to the press and the public in 1936. It had a wide entrance with folding doors, leather and moquette seating, chromium steel fittings, magnetic air-braking and greater power than other trams. It cost £2,500, but ten years later was sold to Sunderland for a tenth of that price. This superb colour montage of the tram is by Malcolm Fraser, incorporating official pictures taken at its press launch.

Comic Postcards | 217

'If I put my foot on the tram rail, Inspector, shall I get an electric shock?'
'Not unless you put yer other foot on the overhead wire Missus.'

The policeman said "Follow the Tram-Lines."

'Are they all yours, Missus, or is it a picnic?'
'They're mine all right, but it's NO PICNIC!'

'They're giving us a long ride in this dodgem car, Bert!'

You can go a long way for a penny at Manchester.

A humorous card marking the introduction of the electric tram.

Thrown in at the Deep End on the Blue Road

By Harold Ballantyne

Harold Ballantyne, a former Glasgow tram employee, describes his experiences on the road, first as a conductor and later as a driver, in Glasgow's *Evening Citizen* on 4 September 1962, the day Glasgow's trams ceased running.

I wonder who's wearing it today: Corporation Transport cap badge No. 6782. I have a personal interest in that relic because one day in 1937 it became a part of my history. Under this glittering symbol of authority, which had to be kept highly polished in memory of 'Daddy' Dalrymple[1] I entered the service of the City of Glasgow.

Now, getting a job on the cars in 1937 was about as easy as going into a space orbit is today. The queue in Bath Street in those days was almost as long as the Buroo[2] queues that fed it, and every man in that queue had to be married and a ratepayer. With both those hurdles already behind me, I faced the next one, a medical test that would have got me into the Scots Guards a couple of years later. I passed.

'Parade at Admiral Street for your uniform.' I obeyed and was fitted out with a cheese-cutter hat, a badge carefully tarnished to encourage spit-and-polish, a green top-coat and trousers with red piping down the seams. A black leather cashbag, a wooden ticket rack, a metal punch, a rule book, a cotton bag with three shillings and sixpence 'bag money' in it, a whistle and a small metal gadget for clearing the punch completed my outfit. I marched proudly home to the bosom of my family – a pupil conductor as green as his own uniform.

My tuition lasted for four days and then on Hogmanay night, 1937, they threw me in at the deep end on the blue road from Linthouse to Lambhill ... Route 31. Being a new conductor I didn't rate one of the new TIM's (ticket-issuing machines), so I had to do my own issuing with those long coloured pre-printed tickets that had to be snapped out of the ticket-rack and punched in the exact space for the previous fare-stage. Before long my fingers were numb, my new cap had become an iron band round my brain, and my passengers were mostly too drunk to know where they wanted to go to.

My driver was running late, which meant that I was making up the last journey's waybill for the first two stages on the way back, and trying to grab all my halfpenny fares before they dodged off for free. It ended at last, I staggered home, gasped out a 'Happy New Year' to my family, and fell into bed.

I was a fully fledged conductor but in accordance with the law of supply and demand in those days, I was only allowed to practise my art once a week, always on a Saturday and always on what tramwaymen called 'a deid late yin' [*very late one*], which meant I started about three in the afternoon and finished about one o'clock on Sunday morning.

My home depot was Govan, but invariably my Saturday stint was on 'foreign service', which meant anywhere from Coatbridge to Elderslie, from Maryhill to Dalmarnock or Dennistoun. For which I received one day's pay neatly halved by the Labour Exchange, so that my eight hours of ticket punching on Saturday night and Sunday morning brought me about five bob benefit.

After the Empire Exhibition I graduated to the ranks of the 'steady men' in Govan Depot, where I really got to grips with the philosophy of the green red-striped uniform. Among other things I learnt the world of difference that lay between 'conducting a tramcar' on the red road to Giffnock and 'conductin' a caur' along the 'yellow peril' route from Bellahouston to Millerston. When in Giffnock it was 'Fares, please' and 'Thank you', when in Brigton it was a cut-down edition which sounded like 'Spleece' and 'Ta'.

In both spheres the conductor had to watch his step, for the Giffnockians were the world's greatest Head Office complainers and the Brigtonians had a strong reputation for ankle-tapping and nose-punching. In Giffnock a tramcar was full when every seat was occupied and there was a line of standing passengers from front door to rear. In Brigton or

After service in the Tank Corps in the Second World War, Harold Ballantyne became a driver of faster vehicles when he took up tram driving in Glasgow, and may well have driven this tram, unloading passengers at the erstwhile Glasgow zoo.

Govan a 'caur' was full when the conductor was hanging on to the trolley-rope at the rear end and trying to get half of one foot on to his own platform.

Both worlds produced an alarming number of day-by-day travellers who never knew what the fare was but who could always tell the conductor when he charged them too much. Giffnock had more pound notes to change for tuppenny fares, and Govan had more Irish pennies to pass, and 'wooden money' (car tokens) which were offered for sale and which it was a sacking sin to buy.

One thing that was common to all my tramcar passengers, and which seems to be unknown to bus passengers, was a peculiar sense of ownership. Whether the passenger was taking a ha'penny run from Govan Cross to Linthouse or a tuppence ha'penny trip from Renfrew Ferry to Milngavie, he wore that same sense of proprietorship and pride of possession and every creature in a green uniform was his personally-hired servant.

In 1939 I went into the Army. I found the Tank Corps easy after the Caurs, but five years later I had to come back again and tackle the other end of the job … driving tramcars in Glasgow. I went to the Tramcar Motor School at Coplaw Street, and the man in the motor school told me I couldn't afford to take chances with some thirty tons of metal, wood and glass behind me, not to mention a few odd tons of Glaswegians. He also told me about my four braking systems, but when my air-brake died on me going up Hope Street on a bright and busy Saturday, I ignored the other three and kept on driving through green lights, amber lights, and red lights gonging away like a fire-engine and praying like a monk till I reached the flat pastures of Cowcaddens.

A skid, according to the motor inspector, was something you got out of in two easy moves, but the one I got into on a greasy-railed day on Garngad Hill stayed with me till I reached Townhead.

Electrically operated points were another sore point. The book and the motor inspector both stated that no car behind you could operate the point until you were through and clear, but one day at St George's Cross I proved the book and the expert both wrong by having my front two wheels pointing down New City Road and my rear ones trying to get down St George's Road. I was derailed, my passengers were deserting in a twittering body and behind me the real culprit was 'innocently' surveying the chaos from behind his control box.

I wasn't on the carpet for that one, but I did get sent 'upstairs' the day I drove from Lorne School to St Vincent Street without a conductor because some enterprising passenger had given me the two-bell signal for starting. A lot of gratified citizens got a free hurl that day before I discovered that my back-end was vacant and ran the car into St Vincent till I could get a spare conductor.

One of the great (unmentioned) essentials of good tram driving was to make life as easy as possible for your conductor, and that entailed making sure that the tram that ought to be in front of you *was* in front of you and not tailing along a towing-bar's length behind you while its driver made faces at your sweating conductor. That explains the once-familiar sight in Glasgow streets of two tram drivers leaning from their front vestibules and holding up two, three or four fingers as if they were bidding in a poker game. Believe me, the henpecked husband of a nagging wife was a very poor martyr compared to the caur-driver whose conductor (especially female) was doing the work of the car behind that should have been the car in front.

My other enemies were the jouking[3] drivers of small cars, pedestrians who strolled about like lovers in country lanes, and time-keepers who never saw you when you were ten minutes late, but were breathing down your neck every time you happened to be a minute and a half sharp. Sometimes it amazes me to think that in two years of driving I never killed one jouking car-driver, one jay-walking pedestrian or one eager time-keeper.

And all the wisdom I gained in my eight years on the 'caurs' can be summed up in the words of my first old driver, who said: 'Aye, it's a steady joab, but, man, it's gey sair[4] on the digestion.'

[1] Manager of the tramways, 1904–26.
[2] Employment exchange.
[3] Dodging.
[4] Very hard.

Gone, But Not Forgotten!

By Alan Brodrick, Edgar Jordan, Dorothy Lord, K.H. Rutherford, John V. Horn, Ted Haywood and David Holt

Tramcars appear to have been unforgettable, for no road public transport vehicle endeared itself to the travelling public or etched itself in the memory as much as the tram did. Most memories of the 'people's carriage', as the tram was first called, are tinged with a good deal of affection, and some with vivid recollection of detail, colourful observation or even amusement as is amply illustrated in the

following extracts covering Bolton, Reading, Cheltenham, Plymouth, Dover, Bournemouth and London.

Bolton's fleet of efficiently operated trams were recalled in an article written by Alan Brodrick for *Klaxon*, the magazine of the Preston and District Vintage Car Club in the 1970s. Mr Brodrick also described in detail the tramways' two electricity stations, in one of which was employed an engine room cleaner who had been one of the great characters on the Dunscar route.

> Bolton's fleet consisted mainly of long-bodied eight-wheelers, totally enclosed except for the driver's compartment, so that the driver suffered agonies in winter; a few cars had enclosed fronts, in which the driver rode in considerable state, like a captain on the bridge of a ship, but these trams ran only to such remote places as Doffcocker or Montserrat, and were never seen on any other route. In those days you could travel long distances by tramcar, if you had the time, changing trams at each borough boundary, and J.B. Priestley has pointed out that you could lose your way and die of exposure somewhere up on the Pennines, not ten miles from where the Bradford trams ended and the Burnley trams began.
>
> The rest of Bolton's fleet was made up of a dozen or so rather comic little short-wheelbase four-wheeled cars; the pronounced overhang of the long body on the little truck caused a violent, fore and aft, rocking-horse kind of motion which was very upsetting for the passengers, but these cars were the only ones which could be used on the winding, steeply graded routes, which ran through the older parts of Bolton; no long-wheelbase tram could have negotiated some of the acute corners and steep climbing turns on the Church Road route, for instance....
>
> Power for the tramcars came from two electricity stations; a very large one at Spa Road, and a much smaller one behind the tram sheds in Bradshawgate. Spa Road sub-station was a very important place indeed, as it provided electricity for about a third of the town, using the old direct current three-wire system, besides supplying most of the tram routes with power at 550 volts. It was also a very old-fashioned place, dating back to the nineties of the previous century, and working there was like working in the Science Museum; the engine room was filled with humming, rotating, spark-spitting electrical machinery, and there were long galleries of black marble switchboards, hung with gleaming, naked copper switches of enormous size, and huge instruments as big as soup plates. Very different from the miniature control rooms of today's power stations....
>
> Bradshawgate sub-station, tucked away behind the tram sheds, was a much more restful place, ideal if you were rebuilding a motor cycle or swotting for your Higher National Certificate. The equipment and machinery was even older than that at Spa Road, and this marvellous collection of antiques was looked after by a wonderful character named Benny Owen. Officially, Benny was only the engine room cleaner, but he knew more about the station than anybody else, chief engineer included, and it was as well, in any emergency, to retire to the office and let Benny pull all the right switches and make all the right telephone calls in order to get the place running again. Benny was an ex-Lancashire Fusilier who had been badly gassed in the First World War; he had been a tram conductor until his health failed and he had been given this lighter job, and generations of young engineers have reason to be grateful for the way in which Benny carried them during their time at Bradshawgate.
>
> During his tram conducting days, Benny had been one of the great 'characters' on the Dunscar route; he hated leaving anyone behind at a tram stop, and had been known to cram a tram with over 100 people, well above the safe load. This habit nearly landed him in trouble one fine Saturday lunch time, when the Wanderers were playing at home and everyone was in a hurry to get home and get changed. Benny had just packed his tram with 150 of Dobson and Barlow's workmen, who had just finished work at the Kay Street works, and was busy collecting fares on the lower deck. He thought the tram was rattling down Bridge Street rather quicker than usual, but took no notice until a tall thin man looked towards the front of the car and remarked, casually, 'Heigh, Benny, thy driver's not theer'.
>
> Benny jumped up onto a seat and peered over the heads of the passengers to see that the front platform was indeed unoccupied; unable to fight his way through the packed passengers, he ran upstairs to the front of the car and down the front steps to find his driver lying in a fit. By this time the tram was thundering past the Palais de Danse at heaven knows what speed, and the point-duty policeman at Bow Street had to jump for his life. Benny got the emergency brake hard on, and slowed down by the rise past the Fish Market, the runaway took the curve into Deansgate with sparks flying from its wheels, without toppling over.
>
> Next day Benny was called before the transport manager and severely censured for 'daring to meddle with the controls'. He was told that in this emergency

When Bolton Wanderers were playing at home Benny Owen would cram a hundred supporters onto the tramcar on which he was conducting. And one of the cars that would easily have held a hundred is No. 66, the restoration of which was nearing completion when it was photographed in 1981 at Back-o'the-Bank power station in Astley Bridge. At the controls are two of the stalwarts, Alan Ralphs and Derek Shepherd, who spent eighteen years bringing it back to life. The car has been running in Blackpool since 1981.

he should have 'tried to revive his driver'. Benny's reply to this piece of nonsense was typical: 'Aye, happen I should and if I hadn't revived him, we would all have gone straight in through t'shop front of Boots' on Deansgate, and I could have bought him some aspirins without getting off t'bloody tram!'

Reading was served for thirty-six years (1903–39) by trams which made a profit every year except one (1920–1). Edgar Jordan, author of *Tramways of Reading*, was the son of a tram driver and grew up with the trams. He recounted some of his earliest recollections of the trams in this article he wrote for *The Journal*, the magazine of the Tramway Museum Society, in April 1992.

> Not many members, I suspect, can boast that their birth certificate bears the word 'Tramway'; neither have they had the (doubtful) pleasure of driving a last car at an abandonment, albeit only for a short distance. I can lay claim to both. My father was a motorman with Reading Tramways, hence the notation under 'Father's Occupation' on the certificate. With trams in the blood, so to speak, it was not surprising that my interest in them should be aroused at an early age.
>
> I must have come into contact with trams literally from the first month of my life. When my mother met Dad's tram, at the end of our road, to convey refreshments to him, I would have been taken in my pram as part of the daily routine; I obviously cannot remember these early happenings. A few years later it became one of my regular errands, at an age tender enough to be told not to step off the kerb; Dad would leave the tram and come to me. The victuals consisted of tea or cocoa in a blue enamel can, with a lid which served as a cup, and I can recall that seven heaped teaspoons of sugar went into every can. There was also a small metal box shaped as an attaché case containing sandwiches more suited to the vicar's tea party than a tram driver. Mum skilfully cut them each to bite size to facilitate consumption on the front of a moving unvestibuled tram in rain, snow or tempest! She got it down to a fine art and even knitted a 'sock' to go over the tea can to keep the contents hot.
>
> An occasional treat for me was to be taken by Dad 'down the depot', if he had to call in there for some reason when off duty. I soon became familiar with the car sheds, repair shops and engine room – the latter being the name by which the power station was popularly known. In it, the huge, spinning, highly polished fly wheels used to fascinate me and the whole place was kept as spotlessly clean as a hospital ward. In my very young days we would also call in at the Tramways Parcels Express Office and I would be placed on the parcel scales to check my weight progress. In the course of these visits I got to know most of the staff and thus always got a wave of the hand from passing motormen if they saw me in the street. Many years later, one of my jobs was to hand these very men their weekly pensions. Thus a happy relationship was maintained well into my adult life.
>
> I soon became able to identify the cars from a distance by the adverts they carried and, in some cases, by the sound of the motors and the note of the gong even before they came into sight. They were all individuals to me, and it was a sad day when I lost them. This occurred on 20 May 1939, when by a lucky coincidence my dad was rostered on the very last car from the London Road terminus. So, while the mayor and corporation were having their official farewell amid thronging crowds in the town centre, a couple of friends and I held our own private ceremony in the seclusion of the London Road branch, where we all had a turn on the handles, thus providing me with an everlasting final memory of Reading's trams.

Mr Jordan could swing the can containing his father's

tea over his head in professional style, but not when his mother was looking. He could also identify a tram driver from a distance by his stance at the controls or by the angle at which he wore his cap. His father worked for Reading Transport Department for forty years and was successively a conductor, motorman, trolleybus driver and inspector.

In 1977, Dorothy Lord of Bell Green, Coventry, wrote to me with her reminiscences of the bright red and cream trams in Cheltenham, the town where she was born in 1905. She also described how she lost her father in a tragic accident on the four-mile line to Cleeve Hill, where the gradient was 1-in-9.

> My father was foreman of the track maintenance gang. His name was William Smith, and his brothers John and Harry also worked for the Company. My Uncle Harry is still alive and has told me many things about the tram system in Cheltenham, including his account of the accident which happened to the first tram to run up Cleeve Hill outside the town. He was on board, and while his two workmates jumped off (to their death) when the thing ran away, he sheltered under the stairs (and survived). He attained his ninety-seventh birthday last month. After that, special single-decker trams ran up and down the hill, and passengers from Cheltenham arriving at the foot of the hill had perforce to change from the double-decker which brought them from town to the single-decker. Later, double-deckers were allowed to ascend the hill, but all top-deck passengers had to sit inside for the climb.
>
> My maternal uncle, William Greengrass, later joined the company as a driver. Uncle Harry became foreman maintenance engineer, and he told me about the difficulty of devising efficient brakes for that hill. Finally he came up with the solution of soft wood blocks, which were operated from the driver's platform. They found some spruce trees growing in a village nearby and made an offer for them. The spruce brakes were found to be efficient in wet weather as the softwood held the road, where hardwood would not do so. They were primitive, but so were those trams, with the top decks open to the weather.[1]
>
> The drivers, too, had no protection from the weather, but strangely, as soon as newer models with enclosed fronts were brought into service the drivers suffered with colds and 'flu as they had never done before. My aunt and my sister were conductresses during the 1914–18 war.
>
> My father was not so fortunate as his brother. In 1907 he was working at the summit of Cleeve Hill. All materials and tools which the gang used were taken up on a bogie towed by one of the single-deckers, which was then withdrawn for the day. The bogie only had a handbrake, and when that failed it was my father's job to stop the thing as best as he could. It failed one day, and poor Dad was dragged along until he managed to clamber aboard and attempted to apply the brake hard – to no purpose. The bogie careered down the hill and at the bend in the road at the bottom left the rails and overturned. My father was dead when his workmates caught up with him. My mother was left with three of us to keep on nothing a week. Finally, the company made her an ex-gratia payment of £200. She was not allowed to handle the money, but it was paid at the County Court at the rate of ten shillings a week. My father was

For some years, double-deckers were not allowed up Cheltenham's Cleeve Hill after a car ran away causing two fatalities. Passengers wishing to go up the hill had to change at Southam onto a single-decker which ran a shuttle service up the hill. The single-decker can be seen in this view behind a double-decker which is about to return to town.

thirty-one when he died.

I suppose the trams must have been relatively cheap to run, although the wages paid at that time were very low. My Uncle William has often told me of the shocks experienced by the conductors when turning the trolley arm at the terminus in wet weather. He said that sometimes the metal parts of the vehicles were really dangerous. But in the fine summer weather nothing could have been more delightful than 'riding on top of the car' through Gloucestershire's leafy lanes. I loved the tramcars. To me they were part of my life, with memories I shall never forget.

Before the First World War, during his schooldays in Plymouth, K.H. Rutherford started to take a keen interest in the city's trams, which at that time consisted of three separate systems serving Plymouth, Devonport and Stonehouse. All his boyhood summer holidays were spent riding and studying the trams, and he came to know all their peculiarities, as well as being able to distinguish all the different types of car by their sound. He wrote about some of his memories in the spring 1964 issue of *Tramway Review*.

Memories! Memories! They crowd upon the mind … the thrill of arriving for the summer holidays and catching the first glimpse of a tram as the train passed through St Budeaux … standing outside the Theatre Royal and watching the endless coming and going of trams … the wonderful ride from Plymouth Hoe to Saltash Passage when Route 14 was extended at both ends … the low bridge at St Budeaux with the warning notice, 'Do not stand up or touch the wires' (which it would have been very easy to do) … the somewhat precarious single front seat at the top of the stairs of the uncanopied Devonport 1–20 class, where a schoolboy in shorts would sit watching the driver manipulate the controls, but never quite fathoming which lever did what … the Sunday afternoon at Milehouse depot when the friendly man on duty allowed me in, and let me go down into the inspection pits to see the trams from underneath and climb on to them to play with the roller destination blinds (I was never satisfied until I knew the order in which the names occurred on those blinds) … the day when a tram from Plymouth was called in at Milehouse and the passengers requested to change to the car waiting on the track in front, and a perfectly innocent small boy, in his eagerness to reach the upper deck of the waiting car, got mixed up with the voluminous skirts of an elderly lady, to be roundly accused of the utmost vulgarity!

And then there was the incident at Hyde Park Corner, at the end of Mutley Plain, where the track bore off to the left for Peverell while that for Compton went straight on. It was the conductor's duty at this point to guide the trolley over the turnout while the car took the Peverell track; but on this particular occasion the conductor on my tram failed to do so, with the result that while the tram proceeded towards Peverell the trolley continued its journey towards Compton. This was obviously a state of affairs which could not last for long, and I awaited the outcome with interest until finally the trolley admitted defeat, left the wire and swung back with considerable force through a window-pane of the house which stood at the corner!

Strange to say, it is of Hyde Park Corner too that I have my last-ever memory of a Plymouth tram. It must have been about 1938, and I was driving back to Tavistock one night with a friend as passenger, after an evening's entertainment in Plymouth. We reached

A view taken in the early 1930s of Plymouth trams at the Guildhall. K.H. Rutherford liked to stand in the centre of Plymouth and watch the comings and goings of trams, but these two (the one on the right an ex-Torquay car on a Dockyard Special) were both withdrawn by 1936.

This Dover tramcar, on its way to River, was one of five purchased from West Hartlepool in 1927 for the total sum of £850. John Horn had many memories of the trams that served the ancient town and port from 1897 until the end of 1936.

Hyde Park Corner to find the traffic lights at red, and I drew up on the inside of a Peverell tram (probably one of the 151–166 batch), also waiting for the lights. The lights went green and I politely waited for the tram to go, forgetting that my car was over the Peverell track! The driver looked at me. I still waited. 'If you don't get a move on,' said my friend, 'you'll be hearing some good old-fashioned English in a moment!' I realised the position, let in my clutch and we went off into the darkness. I never remember seeing a Plymouth tram again.

John V. Horn, editor of the magazine *Modern Tramway* from 1948 until 1952, lived in Dover from 1919 until 1935. Consequently he was well qualified to write a history of Dover's tramway, which he titled *Dover Corporation Tramways 1897–1936*. Published in 1955, it was one of the first tramway histories to be produced by the Light Railway Transport League, and the following extract, taken from the last chapter, highlights some of John's special memories.

We shall still remember with affection … the little old cars of the early period bowing and curtsying their way up and down the town on their short wheel-bases; the years of reliable service given by the first River cars…; the solid dignity, efficiency and

Members of the Palm Court Theatre Orchestra pose on Bournemouth's preserved tramcar for the sleeve of their long playing digital stereo record *Vintage Parade* issued by Chandos Records Ltd in 1984. The music on the LP is non-tram-related, but nevertheless evocative of holidays in Bournemouth like those spent by Ted Heywood when the tram was in its heyday. The record sleeve was designed by Patricia Godwin, widow of the conductor of the orchestra, Anthony Godwin. Note the destination indicator blind bears the lettering PCTO 3, standing of course for Palm Court Theatre Orchestra.

green-and-gold splendour of the English Electric cars.... We remember the coming of the first top-covered cars; and how West Hartlepool's trams went to River. Still vivid in our memory is the clean smell of concrete on the occasion of track renewals; the welcome sight of new rails of honest British steel fresh from the rolling-mill; new points and crossings in their protective coat of oxide red; the intriguing appearance of a new layout taking shape; and the firm, smooth, velvety movement of a car on new track.... There are no more exhilarating rides on a top deck or balcony end on a fresh morning; no more friendly crowding on to a late River car on a wet evening; no one was ever left behind, and there always seemed to be room for one more.

The forty years of tramway operation were only a brief spell in the history of the ancient Town and Port, but for members of that generation Dover can never be quite the same without the trams. They were far from perfect, indeed, by modern standards of tramway operation, they were already verging on the obsolete; but they were ours; they were, in a sense, Dover; in their individuality they were like old friends....

Ted Haywood, writing in *Tramway Review* for autumn 1999, gave the magazine's readers some vivid memories of Bournemouth's maroon-and-cream eight-wheel open-toppers which he rode while holidaying in the resort. Bournemouth ran trams from 1902–36, but from 1902–13 it was the only town, apart from London, where trams obtained their power from both conduit and overhead, while its eleven-mile cross-town route from Christchurch to Poole was the longest in southern England outside London. One of the trams (No. 85) is preserved in the town.

The first time I made the acquaintance of Bournemouth and its trams was in 1927, when I was only nine years old.... We stayed in Boscombe, rather than in Bournemouth itself, which meant a tram ride to and fro as much as twice a day....

At that age I was familiar with only two systems, that of Leicester and my home town Nottingham; both used the same livery of maroon and cream, so on seeing Bournemouth trams for the first time the colours looked almost the same (Bournemouth used maroon and primrose). However, everything else was much different; I realised at once that the Bournemouth trams were superior – there were no 'common' advertisements on the outsides, and there were even curtains (brown) at the windows of the lower saloons. All the trams had open tops (a thing new to me), and many of them were long bogie-cars....

Those who have never had a ride on an open-top tram do not know the pleasures they have missed. You climb the stairs and come out, not into a closed saloon like the one below, but into the fresh air – everything is open: above you are only the trolley pole, the overhead wires, and the wide sky. The sounds are different too – the singing of the trolley wheel, the rumble of the pole, and the hiss of the wire are much more noticeable (and are visible at the same time). The noises from below as the tram goes along have an ever-changing reflection from the passing buildings, and sound much louder and nearer in the open air, adding to the intimacy of it all....

During their holidays, visitors traversed the two halves of the main line at least once – going east to the ancient town of Christchurch to visit the old Priory and perhaps walking to Hengistbury Head, and going west to the equally ancient Poole to wander round the town and harbour. As we were staying in Boscombe, we used the trams nearly every day to get to Bournemouth; most evenings we went there so that I could sail my toy boat on the Bourne stream in the Lower Pleasure Gardens amidst all the other children's boats, on a stretch known as the 'Children's Corner'; sadly this custom died out many years ago. It was on one of these trips, when riding on the top deck on a bright evening after rain, that my father showed me the usefulness of the patent seats – how turning over the usual surface, still wet, revealed the dry underside, which we sat on instead....

Yes, there were odd wet days at Bournemouth – the rain drifting in over the empty beaches while the pine trees wept; the raincoated and umbrella'd visitors dodging from shop to shop in the town centre, crowding the tea places (such as Bobby's), or sitting in the cinemas; and the trams spraying along with the top decks empty and the lower ones full with the windows steamed up....

In summer, the tram conductors were very busy men – not only did they have to collect the fares and advise the driver when to start and stop, they had to deal with the visitors who (a) knew where they wanted to go but didn't know what it was called, or (b) knew what it was called but didn't know where it was; in consequence the conductors had to call out the names of all the stops....

Other memories come to mind. On the eastbound track east of Lansdowne there was a short length of rail; the rather stately 'di-dum-di-dum' rail beats of the bogie cars were suddenly interrupted by two 'di-dum-di-dums' in quick succession, to my delight. Other sounds I recall occurred on the westbound journeys to the Square on the Fir Vale Road to St Peter's Road single line section, where the long

sweeping curves caused the wheels to protest. To sit on the open top deck of a bogie tram in the brilliant sunlight of a warm summer's evening, and hear the prolonged ring of the flanges reflected from the buildings on either side, was another thing to look forward to. On the rare occasions when we sat in a lower saloon, two things impressed me – the curtains (mentioned already) and the double doors. In my home town the trams had no curtains, and the doors were single; here in Bournemouth the two halves of the doors opened and closed in unison, meeting in the middle. It all seemed rather superior.

David Holt, author of the book *Manchester Metrolink* and, like his father, a railwayman, has memories of London's tram from a very early age. He wrote about his childhood memories in *The Journal*, the Tramway Museum Society's magazine, in April 2008.

My maternal grandparents lived off Camberwell New Road in London and had a shop at Kennington Cross. Home and shop were linked by one of the most intensively used parts of London's huge tramway system, with two busy junctions, the Oval and the Horns, Kennington, in between.…

I rode on and observed London's trams up to the age of four and a half on family visits to my Nan and Granddad's from our home in Manchester. My Dad was a railwayman and we benefited from free train travel, so the visits were frequent. Walking or going by tram between the house at Treherne Road and the shop at Cleaver Street, the clamorous drama of the trams must have implanted something in me which has never gone away. It remains with me as an aching nostalgia born out of some of the happiest moments of my childhood.

The trams were plentiful and affordable. They seemed to go everywhere and they all seemed alike, the Felthams and No. 1 excepted. We used them a lot, exploring all of south London by tram. My Mum was proud of them as part of 'her' London where she had grown up, and her pleasure in sharing them with us must have rubbed off on me. I have a few vivid memories of the trams which must have been the seeds of my lifelong interest. These are the recollections I can call to mind all these years later.…

Standing at Boadicea's statue at Westminster and seeing one tram bump into the back of another as it came to a stop. This happened all the time. London trams often had to push each other off dead sections, and for that reason they didn't always have paint on the fronts of their bumpers. So why worry about nudging into the car in front, with no explaining to do? Most impressive to a small child!

Crossing the track to try to get on at the front and seeing the chain barring the way. At that moment I realised that trams were bidirectional, which intrigued me.

The lovely swaying motion of those big double-deckers on swing bolsters. The homely sound of the

An LCC trailer tram on the No. 4 service to Tooting and Merton turns off the Thames Embankment onto Blackfriars Bridge. London had 150 trailer cars in use from 1914 until 1924, when they were sold off, many becoming seaside homes. The trailers jazzed so much in service that some passengers found it hazardous descending their stairs.

gears in ascending and descending pitch. Melodious gongs liberally tolled, especially in fog. Power shut off and on again smartly at dead sections, part of the panache with which those conduit trams had to be driven. The sheer vitality of it all.

Looking down from the front of the top deck at the track flashing underneath as our tram was driven at high speed towards a junction, the points set for the sharp curve disappearing rapidly under the front of the tram, and a sudden great lurch as the leading wheels hit the curve, power shut off and on again and, at night, the lights going off and on again, as we swung round the corner seemingly on only four wheels out of eight. Thrilling stuff, part and parcel of the conduit system with its gaps in the tee rails. Better than any roller coaster, it was an everyday part of the hustle and bustle of a great city, never to be recaptured in quite the same way again. And the whole unified public transport system gave you a warm, comforting feeling of confidence which has long since been sacrificed.

The lovely texture of shiny conduit track embedded in lustrous granite setts, especially at complicated junctions with pointsmen controlling them. My Mum told me how when she was a schoolgirl the pointsman at Kennington Gate used to let her 'help' him pull the lever to send trams round into Camberwell New Road and Brixton Road. She also told me about the trailers. Apparently the only way to get down the stairs of a moving trailer was on your bottom, so violent was their motion.

[1] The Hastings tramway manager, Mr Holiday, preferred poplar for his brake shoes, claiming in 1917 that they lasted thirty days on heavy gradients without being changed. The town never had any runaways on its steep hills.

What a Lovely Way to Go!

By Dennis Gill, with an extract by Jill Byrne

Some tramwaymen have died while working on the trams they devoted their lives to, while others have expressed the wish to be carried to the last resting place by tram. At one time it was not unusual for trams to be used as hearses, some operators, especially in America and Italy, running special funeral trams to local cemeteries.

In the history of tramways there are a number of employees who have died from natural causes while in harness or on tramway business. But of these only two were managers, and they were Sir James Clifton Robinson and William Wharam.

Sir James, promoter, managing director and engineer of the London United Tramways, was a giant among tramway officials – a man who, according to one magazine, 'talked, thought and dreamt tramways'. Generally considered to be the greatest tramway manager this country has ever produced, and most certainly the manager most revered around the dawn of the twentieth century, he was instrumental in promoting tramways in Cork, Bristol, Edinburgh, Los Angeles, San Francisco, Dublin, Middlesbrough, Gloucester and Reading. It was fitting for such a tramway colossus, then, that his end should come while riding on a New York tram with his wife on 6 November 1910; for it was in New York that he learnt his craft as a young protégé of George Francis Train, the American who, in 1860, had opened Britain's first street tramway at Birkenhead. In fact, Sir James was born at Birkenhead in 1848 and started his illustrious tramway career as office boy to Train. His death in New York came while he and his wife were travelling by tram back to their hotel, after attending a dinner party given by his wife's brother. He collapsed on board the car, and was carried into a nearby drug store, but died within a few minutes. When news of his death reached the London United Tramways, which Robinson had managed until his resignation earlier that year, flags were flown at half mast on all the trams, and the company's preference shares fell by a farthing. They would have probably fallen much more had Robinson still been in control. On the day of his funeral, all the LUT trams stopped for a minute's silence as a token of respect. Crowds lined the funeral route and several hundred tramway officers and employees lined the drive to St Mary's Cemetery, Kensal Green, his last resting place.

William Wharam, the other manager whose life was ended suddenly while riding on the trams he loved, was at the helm of Leeds Tramways from 1894 until 1903. His death occurred on 24 February 1903, ten months before he was due to retire after serving the tramways for almost thirty years. In the habit of catching a tram daily to his office, he had just boarded a tram in Chapeltown Road when he died from heart failure.

There was actually a third official whose life was prematurely ended on a tram, but not through natural causes. He was William Love, manager of the Rossendale Valley Tramways Company, whose death was brought about as a result of an accident. He fell off the back of one of his steam tramcars at Waterfoot, Rawtenstall, on 10 January 1896, and was seriously

A car of the Lanarkshire Tramways is suitably draped for the funeral of a Lanarkshire Tramways inspector in Motherwell c.1914. His coffin, in the lower saloon, is accompanied by some of his tramway colleagues, who are riding on the upper deck.

injured, dying about an hour later without regaining consciousness.

None of the above managers was taken to his last resting place by tram, but some employees who died in tramway service were. One of these was Alexander Hollas, who died as a result of an accident at the main Blackpool Corporation tram depot. His coffin was conveyed to the cemetery at Layton in January 1912 on board a tramcar (No. 5) which was suitably draped in black. Another tram (No. 6), also draped in black, was used to carry the family mourners. A large crowd witnessed the sad rites as the cortège made its way from the depot, and tramway men formed a guard of honour at the cemetery.

In 1909, when W. Edwards, a popular driver of the Wrexham tramways, died suddenly, his coffin was conveyed to the cemetery from the Rhos terminus on board car No. 10, suitably draped for the occasion. Driven by Inspector Steen, it set off towards Wrexham in the wake of a normal service car, so that its journey could be made at a stately pace. It picked up mourners en route, and when the funeral service was over it ran back to the depot at Johnstown, almost non-stop. Similarly, when an inspector of the Lanarkshire Tramways died in service, his remains were conveyed on a tramcar suitably draped for the funeral, with colleagues riding on the top deck.

On 1 December 1920, a single-deck tram on the Camborne and Redruth tramway in Cornwall was used as a hearse. A storeman at the tramway works had died while on duty, and his wife requested that his body be brought home by tram. Her husband had previously been a track gang foreman working on the construction of the tramway between the two towns, and their house at Illogan Highway stood alongside the track he had helped lay.

Halifax tram conductor Walter Robinson, who was one of the five victims of the Pye Nest runaway disaster (see 'Out of Control', page 143), was given a very special funeral, the flower-decked coffin carrying his remains being conveyed to the parish church aboard a Halifax single-deck tramcar, while the mourners followed in four other trams. In fact, there are quite a few instances of tramcars being used as hearses in this country.

One of the more recent instances of a tramcar being used as a hearse was at the National Tramway Museum on 6 September 1985, when the coffin

Richard Fairburn's coffin is carried to the gates of the National Tramway Museum by one of the preserved trams – Blackpool toastrack No. 166 – on 6 September 1985.

bearing Richard Fairburn was carried on board one of the museum's preserved tramcars from the depot to the end of the line at the museum's gates, where it was transferred to a waiting hearse. Richard Fairburn is the only man, I think it can be safely said, who entered this world on tramway premises and left it on tramway premises. In fact he had left special instructions in his will for his departure from this world, expressing the wish that his remains 'be conveyed by special tramcar over the Society's tramway … so that I may take final leave of the form of transport with which I have been so closely linked from the moment of birth'.

Richard was born in January 1895 at the tram depot of the Worcester horse tramways, in fact in the tramway manager's house, his father having been appointed manager of the undertaking the year before. His birth certificate clearly records that he was born at the tramway depot. He was brought up with trams and was present, at the age of eight, at the closure of the horse tramway and the opening of the electric lines. The later years of his life were also spent with trams when, a few years after his retirement from the Worcester Treasurer's Department, he became resident security officer and traffic superintendent at the National Tramway Museum, and, in 1981, the first annually appointed president of the Tramway Museum Society.

The tramcar that carried Richard's coffin was preserved Blackpool toastrack No. 166. It was suitably draped in black, and on the coffin were flowers, Richard's inspector's cap, his medals and the whistle which he had used in performing his duties. The four bearers rode at the back of the car, which was driven by two of Richard's closest friends.

The National Tramway Museum again provided a tramcar for a funeral (for only the second time in its history) on 15 December 2008, when the coffin bearing the remains of Winstan Bond, a vice-president of the Tramway Museum Society, was placed on a suitably adapted flat wagon and towed by tram down the museum's main street before being transferred to an ordinary hearse for the journey to the local church.

A Manx Electric tram and trailer were used for the funeral of an eminent Manx tramway employee and enthusiast in 1999. When Mike Goodwyn, a motorman on the Manx Electric Railway, passed away on 5 October, his coffin was conveyed eleven days later by special tram and trailer from Ramsey (where the funeral was held) to Douglas on its way to Peel cemetery. The trailer served as a hearse, and the car pulling it was suitably fitted with black drapes. Mr Goodwyn was chairman of the Manx Electric Railway Society from 1978 until his death, and played a key role in the centenary celebrations of the tramway in 1993. He was also editor of the Manx Transport Review from 1980–91.

When tramway historian and modeller Eric Thornton passed away on 17 June 2007 at the age of eighty-nine, his family thought it would be fitting if he made his last journey in a Halifax 'tram'. So with the help of the undertaker they arranged for his coffin to be made to look like Halifax single-decker No. 105. They were pleased with the result, for the coffin was very realistic, bearing a trolley pole and the word 'terminus' on its destination blind. His daughter, Jill Byrne, writing in *Tramfare*, the house journal of the Tramway and Light Railway Society, said:

> For me, the rest of the family and indeed all the folks who attended the funeral, Dad's coffin could not have been a better way to go. Dad died on Sunday; by Tuesday I was smiling and showing everyone the proofs of the intended coffin. On the day everyone was smiling when they saw 'Dad' emerging from the hearse and it was a real and fitting celebration of everything that was him, the tram, white roses of Yorkshire and his flat cap, all of which went with him to his maker. It made the day very special. Even the funeral director said he was intending to go in a submarine, his passion. It eased the day for us. And even now I show people photos of the funeral and that keeps Dad's memory fresh.

Some tramway operators overseas actually ran funeral services, using tramcars specially designed to carry coffins and mourners to the local cemetery; examples of this practice were to be found in several countries, including America, South Africa and Italy. Milan tramways, for example, had several funeral cars, each doing three or four funerals a day, while the streetcar operator at Baltimore was noted for running very elegant funeral cars, including one called Dolores, which was very popular with the bereaved. Funerals by tram had the advantage that they were not only cheaper, but enabled the mourners to travel with the coffin. In Britain, funeral trams were run at Accrington to the crematorium on the Burnley Road route. They provided a valuable source of revenue – to the dismay of local funeral undertakers. Coffins were also carried on the Great Orme cable tramway at Llandudno. The Great Orme Tramways Act of 1898 provided for the conveyance of corpses for interment at St Tudno's churchyard. Three small vans, otherwise employed to convey coal to the power plant and supplies to the summit hotel, were used to carry the coffins.

If your coffin could not be conveyed by tram, or

made to look like a tram, perhaps the next best thing was to make your last journey with an accompaniment by the Tramways Band. This honour was accorded to Bradford tram driver John Edward Hornsby, the grandfather of Stanley King, tramway historian and former Lord Mayor of Bradford. Mr Hornsby died at Heaton in Bradford in May 1929, but wished his funeral to be held in Lincolnshire. When his cortège passed the Tramway Office at Hall Ings, the band was waiting and accompanied the cortège out of the city centre, playing music appropriate for the occasion.

When track expert Stanley Swift died in 1986, the wreath from all his Manchester tramway friends was in the shape of a shim of tram rail – a fitting tribute to a man who devoted his life to the study of tramway track. (See 'Trackwork Was His Passion', page 126.) When an Englishman died while laying track for the Clontarf and Hill of Howth tramway in Ireland, his workmates, not knowing his surname and consequently unable to contact his relatives, buried his remains by the side of the line in the Strangers Bank, opposite the terminus at St Mary's Abbey. They made a headstone out of grooved tram rail which is still there and which is known as the 'Unknown Tram Man's Grave.' There is also a fine headstone at the grave of Alfred Neild, a 26-year-old conductor who was among those killed in the 1911 tramway disaster at Stalybridge, when a runaway tram crashed onto railway track at Mossley Station. The headstone, in Mossley Crematorium, bears the Stalybridge, Hyde, Mossley and Dukinfield Joint Tramways crest and the wording 'To guard Alfred Neild, an appreciation from the employees of the SHM&D Tramways Board, October 20 1911.'

Would you Believe it

By Dennis Gill, with extracts by Edgar Jordan and Merlyn Bacon

In no particular order, here are some fascinating snippets of information about tramways:

Glasgow Corporation Tramways were fined in 1928 for allowing their tramcars to travel at excessive speeds. The police, giving evidence, said that they had timed the tramcars with stop watches, and clocked them covering 220 yards in fifteen seconds, which was equivalent to a speed of 30 mph. Furthermore, the speeding had occurred on a section of route where there was a speed limit of 16 mph. The corporation was fined £2 on each of three charges. It was said that cases of tramcars exceeding the speed limits had been persistent, and that during that time other road users had been frequently prosecuted. This speeding occurred over a short stretch, of course, and one wonders what the average speed might have been over the full length of the route. The highest journey speed recorded on London's tramcars in the post-war years before abandonment, was 12.57 mph, clocked (according to Julian Thompson in his book *London's Trams*) on a service tram running between Victoria and Grove Park on 9 December 1951.

In 1884 a conductor on a Leeds tramcar was suspended for a day for allowing a passenger to carry a bucket of blood on a tram. The report does not say whether the passenger was called Dracula!

The driver of a Gravesend single-deck car was thrown off his platform as he was negotiating a bend, but managed to pick himself up, chase after the car and jump aboard the rear platform. As he hurried through the saloon back to his controls, a surprised passenger looked up from his paper and said 'I thought you were supposed to be driving this car!'

When Portsmouth Tramways extended its services to Portsdown to link up with the privately operated tram service between Portsdown and Horndean, the connection proved to be a flop. Between 1 October and 5 December 1906, the corporation trams ran up Portsdown Hill 6,000 times without a single passenger being carried.

The muscles of strongmen are severely put to the test on television, but this strongman appears to be making light work of pulling an electric tramcar at Ghent in Belgium.

When their days as passenger-carrying vehicles were done, many trams were offered for sale as chalets, allotment sheds, greenhouses, tool sheds, tram and bus shelters, and even as chicken runs. A number ended their days as sporting pavilions, some as shops and one or two as cafes, like this car at Colchester.

In the early years of the last century a woman in America lost weight when the tramcar she was stepping onto moved off and left her lying in the street. The shock of the accident caused her to lose 200 lb in weight, and lessened her value as the 'fat woman' in a dime show in Jersey City. As she could no longer command the high salary she earned before the accident, she sued the streetcar operator for damages.

Throughout their history tramways have suffered from thefts. Thieves have thought nothing of cutting down sections of overhead wiring, and from time to time there have been cases of tramcars being stolen. Two men in Leeds stole a tramcar late one night to get them home. All went well until they spied a policeman in the distance. When one panicked, his mate said, 'Don't worry! He'll never believe anyone would pinch a tram'. But the other wasn't convinced and jumped off, so his mate quickly followed him, leaving the tram in the middle of the road. Similarly, in 1957, a Washington citizen jumped aboard a tram while its driver was having a coffee and made off

This London tram is heading back to the repair works after suffering damage to its upper deck. Would it have been allowed to run under its power over the roads in today's traffic conditions, I wonder?

The most tortuous tram route in the world is Line 12 of the Lisbon tramways. Barely a mile long, it climbs a steep hill on single track and loops in very narrow streets, demanding very skilled driving. Where it breasts the summit of the hill, the camber of the road changes dramatically, causing the trams to heel from one side to the other. On some of the streets passengers can touch buildings on either side, and the clearance between trams and parked cars can be 'measured in millimetres'.

with it at high speed. He was totally inebriated and in his mad escapade hit four motorcars, spinning one round and ramming another so badly the driver had to go to hospital. He eventually came to a halt when he careered off the rails in Pennsylvania Avenue. Upon being arrested he told the police that he thought he could fly a plane better than he could drive a tramcar!

In Philadelphia, a youth stole a tram and drove it five miles across the city. Stopping to pick up passengers he told them he wouldn't be charging them a fare, nor giving transfers.

According to Mr Codling of Stamford, Lincolnshire, the tramway overhead standards in Leicester carried a row of small hooks some five to six feet above the pavement. The hooks were for carrying enamelled tea-cans, all neatly labelled with the name of the driver or conductor. Knowing when their father would pass one of these collection points, children would take a fresh can of tea and hang it on the post in advance of his arrival. Mr Codling's father recalled the same practice in Lincoln, where he spent his early years.

A Bristol tram driver had the shock of his life when he was driving on the Fishponds route. A lorry passed him trailing a chain and hook from its tailboard, which caught in the ornate wrought ironwork on the side of the tram and pulled away the complete front of the tram, leaving nothing in front of him. Fortunately he was able to go to the other end of the tram to drive it back to the depot.

When Doncaster's tramways opened on 2 June 1902, the day after the Boer War ended, three special cars were run to carry the mayor, councillors and distinguished guests. Among those riding in the third car was a well-known Doncaster draper, Marshall Wagstaff, who scattered £2 of copper from the top deck to the watching crowd below, and later gave 700 pinafores to women with children who were in

The Sayano-Shushenskaya dam near Cheryomushki in Siberia is unusual in that it is the only dam in the world to be served by an electric tramway. The 5 km line was opened in 1991, and there are six cars, including these two photographed with the 220 m-high dam as backdrop in May 1996.

This American streetcar was converted to a fire engine in 1908 – to put out blazes where no other vehicle could reach. The only one of its kind in the world, it ran at Duluth in Minnesota and was provided to fight fires at Park Point, a suburb on a narrow strip of land on Lake Superior, where the only means of transport was the streetcar line. It had its own shed and motorman, and was in service until 1930, when the strip of land was opened to other road vehicles.

possession of opening-day tickets.

During the Second World War all-night riding on tramcars was widespread. Apparently, servicemen in London would buy a shilling all-day ticket and ride the No. 1 figure-eight all-night route for six hours, with refreshment pauses at Kennington. It was considered quite a satisfactory way of spending a night if the Union Jack Club was full.

The cutting at the foot of Ingles Hill on the interurban Burton and Ashby tramway was often blocked by deep snow, but the most amazing phenomenon to be encountered there was an 8 ft-high fog, which left the tram driver and lower-deck passengers struggling to see where they were going, while upper-deck passengers enjoyed clear views and glorious sunshine.

Cheltenham's trams carried an unusual cargo – manure! According to John Appleby in *Cheltenham's Trams and Buses Remembered*, the manure was conveyed between the town and Cleeve Hill on small ballast trucks hitched to the back of the trams, but the service was not popular with passengers. John said: 'Passengers were made constantly aware of an aroma of steaming dung being wafted through the saloon with every change of wind; worse still was the return journey when the truck, though by then emptied, somehow smelt even stronger!'

In Burton-upon-Trent, normally rich in aromas from brewing and chocolate manufacturing, unpleasant smells were not very welcome, but residents in the Winshill suburb had to contend with foul smells emanating from the tramway posts and bracket arms holding up the overhead wires. The posts doubled up as sewer ventilation tubes.

In 1896 Huddersfield's steam tram tracks were used by special trucks carrying 'sanitary refuse'. Each day about fifty tons of the stuff was collected from a central point in the town and conveyed along the tram tracks to a tip at the borough boundary.

In a good number of towns, trams had to negotiate railway level crossings, while on some systems trams had to cross lifting bridges, swing bridges or, in the case of Barking, a bascule bridge. But on only one system were trams required to cross a slipway. This unusual situation was to be found on the Rothesay tramway on the Isle of Bute, Scotland. The slipway crossed the narrow-gauge tram line to Ettrick Bay, enabling 40-ton yachts to be taken into Malcolm's boatyard at Port Bannatyne. A tube was laid under the tram tracks to carry the cable that was used to haul up boats, and a section of the overhead wire at that point was designed for easy removal whenever the occasion demanded, so that boat masts wouldn't become entangled in it.

The only ocean-to-sea tramway in the world was to be found in Auckland, New Zealand. It ran from the port of Auckland on the Pacific Ocean to the port of Onehunga on the Tasman Sea – a distance of a mere seven miles. The service was also the only one that crossed a country from one side to the other. It survived until 28 December 1956.

At Torquay in 1921 a petrol tank at the St Marychurch depot blew up, setting the middle shed on fire. A tram that happened to be passing the depot at the time felt the force of the blast, which blew the conductor off the rear platform into the road. He had to be taken to hospital suffering from concussion and cuts. In Greenock on 16 October 1924 an oxygen cylinder fell off a steam lorry, and exploded under a passing tram. The tram, owned by the Greenock and Port Glasgow Tramways, was lifted off the ground by the blast and completely wrecked, with not a pane of glass left in it. Some forty people were injured.

Fifty streamlined trams under construction for Madrid in 1944 were completely wrecked when the American Air Force bombed the works in Turin, Italy, where they were being made. Commendably, the factory rebuilt the cars and despatched them by train to Spain, but on the way they were all severely damaged for the second time when the train was dynamited by Spanish communists in France. The ill-fated cars were once again rebuilt, this time in Madrid, and eventually they all entered service in the Spanish capital. One, however, was gutted by

fire shortly afterwards and had to be rebuilt for the third time.

Several trams were damaged when the roof of a South Staffordshire Tramways car shed collapsed under the weight of snow in 1910.

During severe thunderstorms in May 1920, when heavy rain fell for nearly two hours, Wigan's central tramway depot at Seven Stars Bridge was completely flooded, and all the cars housed there had to be parked outside. It is estimated that nearly two million gallons of water were pumped out by the fire brigade over the course of twenty-four hours. The depot was out of action for two days.

Of all the accidents involving personnel on tramcars one of the most tragic occurred at West Croydon in 1923. The *Tramway and Railway World* carried this brief report in its columns:

> Whilst reversing the trolley arm of a tramcar at the West Croydon terminus of the South Metropolitan Tramways Company the conductor lost control of the pole, which fell across a passing motorcar. In trying to recover it he allowed the other end to knock the control handle of another car, which started with a jerk, with the result that he was crushed between the two cars. At the inquest in Croydon, on August 26, a verdict of 'death by misadventure' was recorded.

Another unusual accident occurred on a Derby tramcar in the same year when the brake handle on the rear platform swung round and struck a passenger in the mouth as he was boarding a car. The passenger was awarded compensation for the injuries he sustained.

Augustus Hugh Bryan of Pietermaritzburg, who was at one time assistant traffic manager on the United Railways of Havana, wrote to me in 1969 to tell me that the tramlines in the centre of Paris were used after midnight by trains carrying produce to the central markets. It used to astonish his friends when they sat outside the cafes on the Boulevard St Michel to see these trains drawn by steam engines coming in from the main line system in the suburbs and hurtling down the Boulevard enveloped in smoke and steam.

Homing pigeons, as we all know, are very reliable birds and over the centuries have flown millions of miles delivering important messages. Some have taken the easy way home, hitching lifts whenever they could, for instance, on the masts of ships. One pigeon, at least, is on record as having cadged lifts on Blackburn trams. When it was taken to the Old Mother Red Cap Inn and released there on timing trials over a mile, it would wait for the next tram to town and perch itself either on the upper deck safety rail (if it was an open-topper) or on the trolley mast (if it was a totally enclosed double-decker), only leaving the tram when it was close to its home.

On race days, Doncaster Tramways ran two special cars to take policemen to the racecourse. Both cars, which were open-toppers, were loaded with fifty-six policemen and a police inspector. Merlyn Bacon, first manager of the National Tramway Museum, writing in the magazine *Trams*, recalls seeing the specials:

> The sight of these cars, each with fifty-six policemen, each with his helmet tilted at the regulation angle, was something I, for one, will never forget. There was, of course, a return working each evening and at Station Road they passed under an advertisement which read, 'twenty-six coppers will bring this to your door!' I always thought it should have read 'fifty-six coppers'!

Wrexham Tramways maximised the amount of revenue it could obtain from advertisements by putting them on the front of the balcony, on the ventilator lights in the lower saloon, on stair risers and even on the outside of the panel above the truck (known, in tramway jargon, as the rocker panel). They were an early example of the overall advertising seen on new tramcars today. An advertisement in the cars also encouraged passengers to read the backs of their tickets, where more advertising was to be found.

Southend-on-Sea Tramways opened a rifle range for employees in the tram depot during the First World War. On the first day 1,500 rounds of ammunition were used. A tramway inspector and an alderman on the town's council were among those firing rounds. A number of tramway depots were requisitioned during the First World War for the manufacture of armaments, including depots at Atherton, Reading and Rochdale.

The annual report of the Bradford Tramways manager in 1918 showed that some very strange things were left behind on the trams. The lost property that year included twenty-six chains, three rifles, two gas ovens and a dog, as well as 328 handbags and 206 suitcases.

Dublin trams had a 'removable' or 'mobile' upholstered stool to give an extra seat in the lower saloon. It had only one leg which was stuck in a hole at the front of the saloon, behind the bulkhead door. Whenever a terminus was reached it was the driver's duty to remove the seat and stick it in the hole at the other end.

In St Petersburg, an electric tram service was operated over an iced-up river during the period 1895–1910. Trams crossed the frozen surface of the

A four-wheel open-sided tram in St Petersburg crossing the River Neva on tracks laid on the ice during a very cold winter about the beginning of the twentieth century.

Neva at four points, the longest crossing being from the Winter Palace (which overlooks the river) to the opposite side for a fare of three kopecks.

When a trolley pole on a Keighley tramcar came off the wires in 1912 it swung through the window of a public house, smashing the window into fragments and knocking a plant pot off a piano. The landlord received the princely sum of seven shillings and sixpence by way of compensation. When the head of a trolley pole flew off a tram in Cleethorpes it took the driver three days of persistent searching before he located it in the loft of a nearby house. He found it when, by chance, he noticed the slates of the house had been damaged. Had he not found it he would have lost his job.

The driver of a gas tram in Trafford Park rejoiced in the name of A. Bellringer, and actually rang a bell, like a ship's bell, which was placed just above his head on the driving platform of the car.

Lightning struck a South Shields tramcar in 1928 as it passed under Westoe Road bridge, causing the trolley pole to come off the overhead wire. Although no passengers were struck by the lightning, the conductor was knocked unconscious by it, but he was able to return to work the next day.

In 1917 two curates became part-time tram drivers on the Chatham and District Tramways. One sure way of cutting down the offensive language used by some passengers!

A Manchester trolley-boy on the platform of a No. 41 tram to West Didsbury put his hand out when the car, with a full load, pulled up at the All Saints stop. 'Sorry! We're full,' he said to a portly gentlemen who was about to board the car. Imagine his consternation when he saw that the gentlemen he had just turned away was his father.

Thieves used the noise of a passing tram to drown the sound of breaking glass when they robbed a shop in south London one day in the years immediately following the Second World War.

The only university in the world to have its own tramway was the Universidade Estadual do Maranhão in Brazil. For five years from 1978 it operated a tram service across an open field from a highway to the campus of the state agriculture school at Tirirical, a tiny village 15 km to the south-east of São Luís. The line, which was only 1.34 km long, ran a free ten-minute service for students, using an open-sided car rescued from the São Luís tramway system on its closure in 1966. The President of Brazil attended the opening of this unusual tramway, which was forced to close in 1983 because of sewer construction.

John Betjeman, who liked to work splendid sounding names into his poetry, would have had a field day with some tramway destinations – like Auchenshuggle (Glasgow), Fazakerley (Liverpool), Splott (Cardiff), Joppa (Edinburgh), Foggy Furze (West Hartlepool), Spital Tongues (Newcastle), Unthank Road (Norwich), Shelf (Bradford and Halifax), Elephant (London), Oystermouth (Swansea), Stewponey (Dudley and Stourbridge) and Fighting Cocks (Wolverhampton). There are many more, of course, but I can't refrain from adding that in Bradford you could ride on a tram to Idle (where, believe it or not, there is an Idle Working Men's Club) and that in Maidstone you could ride on a tram to Loose (where there is a Loose Women's Institute). Also worthy of note is the fact that in Cork trams went to Blackpool and Douglas without even crossing the Irish Sea; that trams went to Square in Bournemouth, Circle in Sunderland, and Triangle in Halifax; and that in London trams went to Tooting and Barking, while in Vienna they have been noted going to Grinzing, Simmering and Meidling.

A Bristol tram was decorated and illuminated each Christmas to help raise money for the Lord Mayor's fund to provide poor children with Christmas dinners. As it toured the city, tram drivers and conductors wearing fancy dress and carrying collection boxes followed it on foot. The driver at the controls of the illuminated tram was dressed as Santa Claus and held out a large net into which passers-by were invited to throw donations. The tram invariably held up service cars.

Souvenir tickets issued on 6 January 1934 to mark the closure of Colne's tramway service carried photographs of the trams on one side and the following poem on the other. For each ticket a donation was requested in aid of the Mayor's Unemployed Fund. The poem was a parody on Gray's 'Elegy'.

> The curfew tolls the knell of parting day,
> And now, at last, without unwanted fuss
> The tramcar homeward rolls its weary way,
> Displaced though not disgraced by the speedier bus.

In 1946 Salford tramcars carried a slogan which said: 'Travel by Tram and Save Rubber.' This notice appeared at a time when announcements were being made saying that the remaining tram routes would be replaced by omnibuses at the very earliest moment.

According to Alan Jackson, writing in *Tramway Review*, the inventor of the cat's eye got his idea from seeing the headlights of his car reflected in the tram rails that used to be found in the main streets of our cities. Apparently, he noticed that the reflection from the rails showed him the curves and gradients in the road.

Two men boarded a San Francisco cable car when it pulled up at a stop at midnight one day in 1893. They were wearing cowboy bandanas over their faces and carrying a pistol with which they held up the driver and conductor, relieving them, and also a passenger, of their cash. There were no phones on the cars in those days, and no mobiles, so it wasn't until the car reached the powerhouse that the alarm was raised.

Tram drivers in Plymouth were the only ones in Britain to be issued with truncheons. They were handed to them during the general strike of 1926, after two drivers had been dragged from their platforms and roughly treated.

When a new greyhound racing track was opened in Reading, close to the tram terminus in Oxford Road, the road outside the stadium became jammed with traffic and pedestrians. Having the tram terminus in the middle of the road didn't help matters, so a single-line kerbside loading terminus was constructed about 150 yards further west. The only trouble was that this new terminus was right outside a house, the front room of which was a doctor's surgery. And this brought a new problem, as H.E. Jordan disclosed in his book *Tramways Of Reading* (published by the Light Railway Transport League in 1957):

> Passengers sitting on the top deck of cars could now look down on proceedings in the consulting room, to which, quite naturally, both doctors and patients objected! This difficulty was overcome by painting a white line across the tram track, and instructing drivers to bring their cars to a stand clear of the line. Incidentally, the manner in which this was done always struck me as rather curious. Instead of painting the line in such a position that the leading end of the incoming car stopped by it, drivers were required to run right over the line and bring the rear ends of their cars to rest clear of the mark. This called for judgement, extra distance being required, of course, for a bogie car.

Clearly a case of muddled thinking, but at least Reading didn't come up with a solution as drastic as that on the Hill of Howth tramway in Northern Ireland, where a massive granite battlement wall was erected alongside the tracks at Stella Maris to prevent inquisitive passengers on the top decks from seeing into the grounds of the convent there.

When York Corporation ceased to run trams in 1935, it entered into an agreement with the West Yorkshire Road Car Company for a joint company to be formed to run bus services in the city. The new undertaking was called the York-West Yorkshire Joint Committee. At the ceremony marking the closure of the tramway system on 16 November, the last car was led into the depot by the Tramway Brass Band. In the depot a 'funeral service' was held and the following poem recited:

> Ashes to ashes,
> Dust to dust,
> The corporation won't have us,
> So the West Yorkshire must.

According to Ian Yearsley, a London policeman saw a tram moving slowly past Peckham Rye Common entirely on its own (with no driver on board) one frosty morning. Apparently, the tram driver was running alongside the car in the road to try and get warm. He was quite put out when told by the policeman that he did not have his vehicle under proper control.

In the 1918 influenza epidemic, London County Council tram crews were instructed to keep the doors of both saloons wide open for the last 100 yards of every journey in an effort to 'blow away the foul air'. On one day, 197 drivers and 410 conductors were off duty suffering from flu.

Early in 1914, tram track in the centre of Cradley Heath, in the Midlands, completely disappeared from view when a quarter-mile section of the High Street collapsed to a depth of several feet because of mining subsidence. Tram poles, shop and house fronts, lamps and overhead wires also came down and the whole street had to be roped off. Shops and buildings had to be shored up and it took many months to repair all the damage, to fill in the crater and re-lay all the tram tracks. Until the line could be re-opened trams had to turn back short of the High Street at a temporary

terminus near Corngreaves Road. When the track was re-laid it was resurfaced in tarmac instead of the usual setts in case of more subsidence. It wasn't until the end of the following year that the full service was restored. Subsidence caused by mining occurred on a number of other tramways, particularly those serving large coalfields, such as the South Lanarkshire lines in Scotland, where subsidence delayed the construction of the main depot in 1903.

The Track Record – For Trams in the British Isles

By Dennis Gill

Which tramway was the first to open, the last to close; which was the longest and the shortest, the largest and the smallest? The answers to these questions and many more are here, in this list of superlatives.

First street horse tramway
Birkenhead – opened on 30 August 1860 by American entrepreneur George Francis Train. The line, between Woodside Ferry and Birkenhead Park, was 1.25 miles long, and the four pioneer cars were double-deck vehicles seating about forty.

First rural steam tramway
Wantage – opened on 1 August 1876. An 8 hp car designed by John Grantham (1809–74) entered service (after trial trips in London) on a 2.5-mile line between Wantage town and Wantage railway station.

First urban steam tramway
Vale of Clyde Tramways – opened on 28 August 1877, cars running on a 4-mile line from Glasgow to Govan until 1893. The track was of the unusual 4 ft 7¾ in gauge.

First street cable tramway
Highgate Hill, London – opened on 29 May 1884 on a gradient of 1-in-12. Earlier, on 5 March 1866, a 0.6 mile cable tramway started carrying passengers on Southport Pier. It ran until converted to electricity in 1905.

First electric street tramway
Blackpool – opened on 29 September 1885 over a distance of 2 miles between Station Road and Cocker Street. The cars, designed by Michael Holroyd Smith, picked up the 200-volt current from a conduit (or 'central channel') between the rails. Two years earlier, on 4 August 1883, Magnus Volk opened an off-street electric railway on Brighton Beach, from Black Rock to the Aquarium, using a third rail for current collection while, on 5 November 1883, a six-mile electric roadside tramway, the first to use hydro-electric power, had started running in Northern Ireland between Portrush and Bushmills.

First electric street tramway with overhead wires
Roundhay, Leeds – opened on 11 November 1891, covering a distance of 2.5 miles.

The Roundhay Park to Sheepscar line in Leeds was the first street tramway in Britain to have overhead electric wires. Electrified under the auspices of the Thomson-Houston Company, it opened on 29 October 1891 with six cars, one of which is shown at Roundhay Park.

First municipal tramway operator
Huddersfield – on 16 November 1882, when no private company could be found to work the 10 miles of steam tramway track it had constructed. The first line, along Lockwood Road to Dungeon Cottages, was inspected on 16 November 1882 and a public service inaugurated on 11 January 1883 using one steam tram engine and one car.

First second-generation tramway
Manchester – opened on 6 April 1992.

First electric street system to close
Sheerness – on Saturday 7 July 1917. It was the only system in Britain to be operated by open-top cars with bow collectors instead of trolley poles.

First system to replace a tram route by trolleybuses
Birmingham – in 1922 on the Nechells route.

First tramway to introduce Pay As You Enter
Gateshead – in 1912. Also the first in Europe.

First British tramcar manufacturer
George Starbuck (an American) – in 1862. His first tramcar manufacturing premises were at Mahogany Shed, Vittoria Wharf, Birkenhead.

Last conventional electric street tramway to open
The Dearne District Light Railway – on 14 July 1924. Connected Wath upon Dearne, Thurnscoe and Wombwell, but was short-lived, closing on Saturday, 30 September 1933.

Last tramway system to be electrified
Swansea and Mumbles – on 2 March 1929.

A Dearne District tramcar bound for Wath in South Yorkshire. The tramway, which opened as late as 14 July 1924, connected Wath upon Dearne with Thurnscoe and Wombwell, and was the last of the first-generation electric street tramways to open.

Last tramway system to abolish halfpenny fares
Dundee – in 1949.

Last tramway undertaking to operate open-top tramcars
Hill of Howth, near Dublin – closed in 1959.

Last horse tramway to close
Fintona, Northern Ireland – on 30 September 1957. In England, the last horse tramway to close was at Morecambe on 10 October 1926, and in Wales the last was Pwllheli on 28 October 1927. Horse tramcars are still operating at Douglas in the Isle of Man. They celebrated their centenary in 1976.

Last cable tramway to close in England
Matlock – on 30 September 1927. In North Wales, cable trams still operate up the Great Orme at Llandudno.

Last British electric tramway to close
Glasgow – on 4 September 1962. The last route was Auchenshuggle to Dalmuir West. Blackpool still operates trams on the sea front on the original 1885 line.

Largest urban tramway system
London – with 328 miles of standard-gauge route and a maximum of some 2,630 cars. Birmingham was the largest narrow-gauge system, with 93 route miles and 843 cars.

Largest interurban system
South Lancashire – at its maximum it operated 89 cars over 39 miles of track connecting more than twenty towns and communities.

Largest-capacity street tramcar
Double-deck car on the Trafford Park system, near Manchester. It seated 132 passengers (66 on each deck) but it was only 37 ft 6 in long and 7 ft wide. It was built in 1903 and scrapped in 1907. The largest capacity steam tram trailer was a 44 ft 100-seater on the Wolverton and Stony Stratford line. The single-deckers with the largest seating capacity were Rothesay's narrow-gauge toastrack cars Nos. 11 and 12 which seated 80 (five abreast on sixteen seats). And the largest narrow-gauge trams were two bogie cars at West Hartlepools, both seating 84.

Largest tram depot
Manchester's Hyde Road – with capacity for 323 cars.

Smallest electric town system
Taunton – with only six single-deck cars (later replaced by six double-deck cars) and 1.66 route miles. Lincoln, with 11 trams and 1.84 route miles of track, was the smallest municipally owned system.

Smallest street tramcar
A horse car operated by the Middlesborough and Stockton Tramways Company – it seated 14 (7 on each side) and weighed only 24 cwt. The single car on the Carstairs House tramway seated only six, but this ran on private track.

Smallest tram depot
Devonport and District's two-car depot at Camels Head – used 1901–3 for service cars, and then as a store for defective trams awaiting repair.

Longest tramway service
Glasgow's Milngavie to Renfrew Ferry route – covering 22.72 miles.

Longest interurban service
The Manx Electric's Douglas to Ramsey line – almost 18 miles in length. In England, the longest was the 15-mile interurban service between Nottingham and Ripley, via Cinderhill, Kimberley and Heanor.

Longest journey by tram over continuous tracks
Seaforth Sands, near Liverpool, to Bacup via Bolton and Rochdale – 58.75 miles. The journey involved changing cars several times.

Longest tramcars
Grimsby and Immingham single deck cars built by Brush in 1911 – they were 54 ft 2 in long and seated 72. Swansea and Mumbles had the longest double deck cars. Built by Brush in 1928, they were 45 ft 1 in long and seated 106.

Manx Electric tramcars Nos. 1 and 2, built in 1893, are the oldest cars still in operation in the world. They are pictured at Groudle Glen on the scenic line between Douglas and Ramsey.

Longest-running tramcars
Manx Electric Cars Nos. 1 and 2 – built in 1893. They are still running today, and are probably also the longest-running cars in the world.

Tramway with longest mileage of reserved tracks
Liverpool – with some 28 miles.

Longest serving municipal tramway manager
T.R. Whitehead of Coventry – 37 years in office, 1896–1933. He was succeeded by R.A. Fearnley, who was manager 1933–62.

Shortest electric tramway
Alexandra Park, London – only 660 yards long. It was worked by four Hamburg-built cars. The shortest route on a conventional town system was Glossop's shuttle service from the town centre to Whitfield – little more than half a mile. See also shortest-lived tramway.

Shortest-lived tramway system
Alexandra Park, London – lasted only 18 months, from May 1898 until September 1899, when the palace lessees went bankrupt. See also shortest electric tramway.

Shortest-lived tramway depot
Shipley depot of Mid-Yorkshire Tramways – built in 1904 and demolished the same year after being taken over by Bradford Corporation.

Tramway constructed in shortest time
Luton – in four and a half months between 7 October 1907 and the official opening on 21 February 1908, 5.25 miles of track and overhead were laid and a depot built.

Municipality with shortest life as a tramway operator
Cleethorpes – took over part of the Great Grimsby street tramways in 1936 replacing them by trolley-buses a year later.

Shortest stretch of track owned by an authority
Birkenshaw UDC owned 18 yards of track – used by cars of the Yorkshire Woollen District Tramways Company.

Oldest tramway still in use
Blackpool's promenade line – opened on 29 September 1885, which in 2010 celebrated its 125th anniversary.

Oldest tramcar
Sheffield Tramways Company's No. 15 – a horse-drawn single-decker built by Starbuck in 1874 and preserved at the National Tramway Museum in Derbyshire. The oldest electric tram is Blackpool's No. 1, built in 1885 and also preserved at the National Tramway Museum.

Most northerly tramway
Cruden Bay – a 930-yard line serving a hotel near Peterhead on the north eastern coast of Scotland. It ran from 1899 until 1941 (closing to passengers in 1932) and had two passenger cars and three freight cars.

Most southerly tramway
Guernsey's three-mile line from St Peter Port to St Sampson's – operated with nine electric cars and seven trailers from 1892 to 1934.

Tramcars with most indications
Wallasey tramcars – which up to 1929 gave passengers nineteen different indications of information that was useful to them, such as destination, route, departure time, and ferry connections. The information was given using destination blinds, plates, boards, route letters, coloured lights, flags and clocks. The flags, flown from the trolley poles, indicated whether the ferries with which the trams connected were running, and the clocks gave departure times.

Widest tramway gauge
5 ft 3 in – notably at Dublin, Ireland.

Narrowest tramway gauge
2 ft 10 in – on the Warrenpoint and Rostrevor horse tramway in Northern Ireland. The narrowest gauge for an electric system was 2 ft 11.5 in at Cork, Ireland.

Narrowest tramway street
Henns Walk, Birmingham – only 5 yards wide, it carried a single 3 ft 6 in track, enabling cars to loop round from Moor Street to Dale End terminus.

Narrowest tramcars
Ipswich four-wheel open-toppers – only 5 ft 9 in wide.

Highest tramway
Snaefell, Isle of Man – the line climbs 1990 ft above sea level to within 44 ft of Snaefell summit. The highest street tramway in Britain was Huddersfield's Outlane route which was 1,245 ft above sea level.

Highest tram depot
Rochdale Corporation's Bacup depot at Britannia – 949 ft above sea level.

Restored Wallasey tramcar No. 78 at work on the Birkenhead heritage tramway. Wallasey trams were unique in that they gave passengers nineteen different indications of information, including clocks on the bulkhead (clearly shown in this view), which gave departure times.

The highest tram depot in the British Isles was this six-car shed at Britannia, Bacup, which was 949 ft above sea level.

Highest route number
London's 99 route – Stratford to Victoria and Albert Docks.

Highest fleet number
London Transport No. 2529 – an ex-LUT type W car.

Tramway with the highest number of single-deckers
Potteries Electric – with 123 cars, including ten motorised trailers.

London had the biggest fleet of tramcars in Britain. The backbone of the fleet was the standard E/1 car, of which more than a thousand were built, including this vehicle pictured when delivered in 1911/12.

Tramway with highest total of second-hand cars
Leeds – with 160: ninety-four from London, forty-two from Hull, eleven from Southampton, seven from Manchester, five from Liverpool and one from Sunderland.

Lowest-height double-deck tramcars
Six St Helens cars (Nos 1, 3, 7, 11, 14 and 15) – rebuilt as low-height cars (14 ft 7 in) to enable them to pass under Peasley Cross bridge. They were three inches lower than the low-height Cardiff cars designed by manager R.L. Horsfield.

Tramway with the biggest variety of second-hand cars
Sunderland – with cars from Huddersfield (8), Ilford (8), Manchester (6), Accrington (2), Mansfield (2), Portsmouth (1), Bury (1), Metropolitan Electric Tramways (1), South Shields (1), Sunderland District (1).

Tramway making the greatest use of interlaced track
Blackburn – with stretches on every route except Audley.

Steepest electric tramway
Yorkshire Woollen District Tramways operated trams up two 1-in-8 gradients – one up Mutton Hill above the Shoulder of Mutton Inn near Dewsbury and the other at Popely Fields, Gomersal. Cable trams operated up steeper gradients, the severest being 1-in-5.5 at Matlock.

Street with most tramway tracks
O'Connell Street, Dublin – with six parallel tram

tracks at Nelson Pillar. There were also six parallel tracks at Birkenhead's Woodside Ferry tram terminus.

Tramway with most level crossings
Trafford Park – 34 in 2 miles.

Worst tramway accident
Dover – on 19 August 1917, when car No. 20, overloaded with passengers, ran out of control at the top of Crabble Hill and overturned at the bottom, killing 11 and injuring 60.

Only town to introduce trams and trolleybuses on the same day
Aberdare – in 1913.

Only town to replace trolleybuses by trams
Aberdare – in 1922.

Only municipal tramway to be taken over by a company
Ilkeston – on 16 November 1917 by the Nottinghamshire and Derbyshire Tramways Company.

Only tramway to run first class cars
Liverpool – from 1908 to 1923.

Only tramway with a single-track grand union junction
Southend-on-Sea – at Victoria Circus.

Only tramway to operate vestibuled single-ended open-toppers
Plymouth – ten cars (Nos 114–123) from 1922 until withdrawn in the 1930s.

Only open-toppers fitted with bow collectors
Twelve cars at Sheerness.

Only tramway to be operated by a bus company
Swansea and Mumbles – operated by South Wales Transport Co. Ltd.

Only town to have a dual-gauge electric tramway system
Wigan – 4 ft 8 in and 3 ft 6 in.

Only tramway operator to run electric trams over and under the same bridge
Stockport – trams going under and over Wellington Bridge in the town centre.

Only tramway to replace its entire fleet of double-deck trams by single-deckers
Taunton – six single-deckers replacing six double-deckers on 7 November 1905.

Stockport trams running under and over Wellington Bridge in the town centre. It was the only place in Britain where trams of the same operator passed over one another.

Poems

Ballad of the Met

Anon.

From the *Train-Omnibus-Tram Magazine*, 1927.

The news had spread around the shed and all along the line,
That the oldest driver on the job had abandoned Twenty Nine.
He picked the big brass handles up, and dashed them to the floor,
And swore by all that's holy he would drive the car no more.
'There's something radically wrong – Lorlumme ain't she slow!
I'd like to see the driver who can get the tub to go.'
A hiss came from the speaker's lips, like water mixed with lime;
'I'll challenge any blooming chap to run that car to time.'
A figure moved from out the ranks, a figure tall and fair,
He towered head and shoulders over any figure there.
He said 'Give me those handles, as I'm Senior Man!
For the honour of the MET I'll do the best I can!'
The trip was seven-thirty and the track was fairly clear,
And he left the seven-fifty a long way in the rear.
He was eager at the handles, like a jockey near the post,
But it was the big controller that he had his doubts of most.
The notches spoke with sudden jerks, as the handle flew around,
But old Twenty Nine responded and she quickly covered ground.
The trolley threatened at the frog, the insulator flashed,
And, with a proud majestic sweep, into a curve she dashed.
The vibration clanked the guard-chain as she rattled on the straight.
Did they ever drive as he drove in the days when they were late?

The tram drivers struggling in 1927 with the old 'Twenty Nine' trams in the *Ballad of the MET* would have been over the moon when brand new cars like this one were introduced onto north London streets a few years later.

There is music in the rattle of the ratchet as she flies,
And the armature is singing as she labours up the rise.
The old car knows the driver, and the driver knows her well,
And if he does abuse her, the auto-switch will tell.
These are cars that we have driven, we would like to drive again;
These are cars that we have slaved on, and have given us much pain.
There are men today among us, who are always running late,
When the track of life is breezy but the car is going straight.
Though the youngster did his utmost, and his utmost's hard to 'bate',
As he passed the Jubilee Clock, he was half a minute late!

As the poles fly by in driving, so the years fly by in life,
And in Youth we use the current as we conquer tracks of strife.
But with age the power weakens and a mist obscures the line,
Yet we struggle ever onward – thus it is with Twenty Nine.
She is somewhere on the track today, among the busy throng,
And the oldest driver on the line still pilots her along.
And the Greybeard of the service swears he still will set the pace,
Till his last long shift is ended and he drops out of the race!

Hey Ding-a-Ding!

Anon.

Fifty-two can sit inside,
Seven on the platform ride;
While between each sliding door
There is room for twenty-four.

Still along each end they throng,
Refusing to be moved along;
Those passengers who always jam
The platforms of each crowded tram.

Sing hey ding-a-ding for the joyful tramcar,
Gay is a tramcar in the spring,
Sing ho nonny-no for a clatter and bang car,
Sweet are the bells that the motormen ring.

Sing ho for the twang of the trailing trolley,
The shine of the perfectly parallel rails;
Sing hey for the crush and the crowd so jolly,
And the flutter of tickets in southerly gales.

Looking like a scene from a Lowry painting, this early commercial view of a Grimsby tramcar in Cleethorpes Road catches the atmosphere of the tramcar when it was one of the wonders of the age.

How They Take the Cars at Blackfriars Bridge and Other Places
By Sea-Hay

Together they huddle
Like sheep in a puddle,
Till clang goes the bell, and a car rolls in sight;
Then they who have waited
Become agitated,
And, weary and wretched, prepare for the fight.
Without any warning
(All courtesy scorning)
They all commence pushing,
And rushing and crushing,
And laughing and chaffing,
And scowling and growling
(With little kids howling),
And staring and swearing,
And sighing and crying –
And thus it continues from morning till night.

The policeman has told them
The car will not hold them:
They laugh at his pleading, and struggle the more;
At handrailings grabbing,
With umbrellas stabbing,
Like stampeding cattle they rush by the score.
Inside they are standing,
And seats they're demanding,
And squeezing and teasing,
And squabbling and wobbling,
And sneering and jeering,
And calling and bawling
(Whilst women are falling),
Till 'clang!' they are starting,
And homeward departing –
Disgusted and breathless, perspiring and sore.

Thou Shalt Not
By Arthur Mee

Thou shalt not use cuss words or swear,
Or play sweet music on the air,
Or give out tracts or ask for alms,
Give way to cards or such-like charms.
When drunk thou shalt in nowise ride;
No dog or beast shalt with thee bide.
Thou shalt not cut or scratch thy name,
Defile the car, deface the same.
Thou shalt not smoke, thou shalt not spit,
No antics, mind, but merely sit.
Don't try to boss or interfere,
Or show the driver how to steer;
Just sit you down and take your rest –
The men must know their business best.
And keep your hands off curious things,
The trolley-rope, the bell that rings.
Upon or off a moving car
Thou shalt not jump, so friend, beware.
Nor carry gun or dangerous thing,
Nor with disease that risk may bring.
Pay up, nor grumble at the fare,
Before you quit or leave the car.
Such is the law, don't say it nay;
There's fines for those who don't obey.

Ode to the Tramcar

By Elaine Loader

This poem by Elaine Loader was published in *Leicester's Trams in Retrospect* by Mark Pearson (published by the Tramway Museum Society in 1970) and is reproduced by permission of her daughter, Joan Pearson, Mark's widow.

When I was a child it used to be fun,
On an old-fashioned tram to ride:
More exciting by far, than a bus or a car,
Provided you sat outside.

With the wind in your face on the open-top deck,
All around you could easily see:
You could watch the action of the trolley contraption,
And pluck leaves from a passing tree.

As you climbed up a hill, so slow it would seem,
But once you were over the ridge,
Much faster you'd go, as you swayed to and fro,
'Keep your seats please, under the bridge!'

Those days are now gone, and the tram, like the horse,
Has no place in today's traffic jam:
Car 49 has reached the end of the line,
The end of the day of the tram.

Morning Tram

By Dr William A.S. Sarjeant

This poem, by Dr William A.S. Sarjeant of the University of Saskatchewan, first appeared in the midsummer 1956 edition of *Arrows*, the magazine of the Sheffield University Union.

Chill harmonies of grey and drab and brown,
The near-deserted streets unfriendly seem,
Lacking the kindness later lent to them
By sunshine, bustle, and advancing day.
The waiting figures cower in the wind
Or press in doorways of the shuttered shops.
Occasional cars go by with hurried roar,
The empty roadways echoing behind.

At last, away along the shivering road,
A tram emerges; voyagers coalesce,
The cold shrugged off by purpose for a while,
And duly board it, as it halts by them,
To shrill injunctions from the conductress
Who stands concealed in shelter 'neath the stairs
Waiting, her fingers poised, to start the tram
With two-note signal of a querulous bell.

Upon the upper deck, the passengers
Sit scattered, silent, unfriendly with cold,
Their shoulders hunched and faces tiredly drawn.
Some huddle near the windows and look out
With sleep-dulled eyes at buildings passing by
In orderly procession, vague with fog.
Others clutch newspapers in frigid hand
And scan uncomprehendingly the print
With red-rimmed gaze and sleep-befuddled mind.

Increasing nearness of the City brings
A new, more prosperous chiaroscuro
With larger buildings, edged by bomb-wrought gaps,
And spacious, busier streets; the passengers,
Each singly stimulated by the sight
Of long familiar landmarks, gain their feet
And rattle down the winding metal stairs.

Their wares spread out before still-slumbering shops,
Newspaper vendors ply at intervals
With coat collars upturned and stamping feet
Maintaining warmth within; hands jingling change
Thrust deep in crumpled pockets; grime-edged eyes;
And voices raucous with repeated shouts.

The matinal scene progressively is lit
By shivering, sallow sunshine; other trams,
The blue and yellow caravels of haste,
Go staidly dancing down the wakening streets:
The pavements, now more thronged, reflect the light.
With engines coughing in the frosty air,
Lurching abruptly, buses hasten by
Towards their far suburban termini.

Quite soon the city centre is behind
And craggy factories bestride the road,
Each swallowing its complement of men
To shudder as machines within restart.
Occasional shabby houses gasp for air
Pressed in by towering, grimy industry;
And, odorous, oily, rubbish-choked and slow,
A river flows between its brick-built banks
Amid the unlovely city it gave life
(they called this 'Salmon Pastures' long ago).

The destination reached, the travellers gone,
The humming engine halts for a brief space.
At length, progressing time dictates return
And with a rising drone and clanging bell
The tram departs along its line-marked course,
The wires' swing decreasing as it goes.

Managers in Verse and Song

Anon.

Two London tramway managers had their names featured in verse, while a famous Glasgow manager is recalled in a music-hall song.

While many poems have been written about tramcars, very few have been written about tramway managers. One verse, however, was composed about Sir James Clifton Robinson, promoter, managing director and engineer of the London United Tramways (1884–1910). Although Sir James was generally considered to be London's greatest tramway manager, the verse, alas, was not altogether complimentary, making a dig at his ambitions to run trams in Kingston. The verse was given much airing by factions in Kingston who wanted to operate their own tramways, but it was Sir James in the end who won the battle, his trams eventually expanding in all directions from Kingston.

> Who wants the tramway here?
> 'I,' said Cock Robinson, 'What, ho!
> My tramway shares must upward go,
> I want the tramway here.'

The other London manager remembered in verse is Aubrey Llewellyn Coventry Fell, who was general manager of the LCC tramways (1903–24). His name (perhaps the most poetical in tramway history) was one of the longest to appear on the side of tramcars in the metropolis. This verse, too, is not very complimentary.

> Aubrey Llewellyn Coventry Fell,
> When I ride on your trams I feel quite unwell.
> They pitch and they sway and I get quite excited;
> I'd much rather go on the London United.

The manager whose name is remembered in song is the charismatic James Dalrymple, who was at the helm of Glasgow's tramways for twenty-two years, from 1904 until 1926. It was James Dalrymple who extended Glasgow's tramways far out into the countryside, with more than a third of the tracks stretching beyond the city boundaries. It was James Dalrymple who became probably the greatest recruiting agent that Scotland produced in the First World War when he raised a brigade of artillery, two infantry battalions and five companies of engineers. And it was James Dalrymple who introduced the

maximum tuppenny fare in his last year of office, inspiring the song *Glasgow's Tuppenny Tram* by R.F. Morrison which honours his name.

> There's no' much wrang wi' Glasgow, auld Gles-ca on the Clyde;
> St Mungo's name is known to fame, ower a' the world wide.
> There's bonnie places roon aboot, that thousands never see,
> You need no ship to make the trip, so be advised by me.
>
> *Chorus*
> Take a trip on a tuppenny tram, and happy you will be.
> From daylight till dark, there's many a park awaitin' for you and me.
> Don't use your hoard for a Daimler or Ford, like the workers o' Uncle Sam.
> Since Maister Dalrymple made motorin' simple, wi' Glasgow's Tuppenny Tram.
>
> You canna get to Rothesay, sweet Millport, or Dunoon,
> But you a' ken the Rouken Glen, no' far frae Glesca Toon.
> There's Hogganfield, and mony mair, where youngsters like to play.
> You may get next year to Balloch pier, for Tuppence, all the way.
>
> *Chorus*

Predestinate Grooves

By Maurice Hare

There was a young man who said 'Damn!
It appears to me now that I am
Just a being that moves
In predestinate grooves –
Not a bus, not a bus, but a tram.'

Memories

By Dennis Gill

See the trams glide along,
Hear their bells ding and dong.
Catch their whine, down the line,
Any time, rain or shine.

Always there, never late,
Taking us for a date.
Tripping round flood-lit bays,
Swaying down better days.

Swishing up city roads,
Taking home heavy loads,
Crawling down busy streets.
'Hold on tight! Keep your seats!'
Says the guard, with a smile
As he moves down the aisle,
'Any fares? Tickets, please!'
Wonderful memories.

Inventions in Guinness Time...1860

THE TRAMCAR

Of Electricity I sing,
 And someone's useful notion
To use this scientific thing
 For human locomotion.

I sing the fearless artisans
 Versed in its mystic action,
A mixture of (one understands)
 Repulsion and attraction.

I sing (until my larynx fails)
 The fate of these aspiring
To stand with one foot on the rails
 And one foot on the wiring.

In fact I'll sing (while I can stand)
 The tramcar, and the speed it
Will bear me to my Guinness, and
 My Goodness, how I'll need it!

O Ampère, Volta, Watt and Ohm!
 No wonder you look gloomy—
The Guinness that I have at home
 Sends stronger currents through me.

Guinness is good for you

*"What'll happen in a thunderstorm,
I'd like to know?"*

Copies of this page may be obtained from Arthur Guinness, Son & Co. (Park Royal) Ltd., Advertising Dept., London, N.W.10

This advertisement, one of a series which appeared half a century ago, vividly captures the magic of tramcars.

The Pirate Tram

Anon.

From *Pennyfare*, the London Transport Staff Journal.

Let me tell you the tale of two pirates bold,
Two pirates of great renown,
Who ran what was known as a Pirate Bus
In busy old London Town.
But after a while, they tired of this,
For other such pirates came,
They decided to give up their omnibus,
And start on a different game.
In secret they worked for weeks and weeks
On figures and diagram,
And, early one morning, in Kennington Road,
They started a Pirate Tram.
Nobody knew how they got it there,
For it came in the dead of the night,
Such a beautiful car, with a vestibule end,
And all painted a darkish white.
The seats inside were covered with plush,
Each one was an easy chair,
They gave away sweets and cigarettes
To all as they paid their fare.
Thousands of people, all day long,
Came rushing from near and far,
Fighting and struggling like hungry wolves
To get on that Pirate Car.
Its fares were reduced from ten till four,
The same as the Transport Board,
In addition to which they gave each one
Free tea as an added reward.
The people who matter conferred at length,
But couldn't think what to do,
They knew if they cut the main juice off,
It would stop all their own trams too.
They summoned another meeting then
To look up their list of fines,
And ordered the 'breakdown' to catch that tram,
And lift it from off the lines.
A brain-wave came to a charge-hand then,
On a night that was foggy and dark,
Disguised in a beard and a pointsman's cap,
He waited by Kennington Park,
And there on the curb, with bar in hand,
He carefully viewed the points,
Then sighted the Pirate coming along
To where the main track disjoints.
Quick as a flash the lever he pulled,
And gave them the onward sign,
The fog was so thick that they could not see
They were now on a different line.
The Driver, unable to see the change,
Continued his aimless crawl,
When he thought he was passing the Bon Marché,
It was really the Holborn Hall.
A couple of gangs went in advance,
Not an item did they lack,
To a spot in the Caledonian Road,
Where they laid down a brand new track.
The Pirate Car soon came in sight,
As they waited far up the hill,
And they shunted it on to the new laid lines
That led to Pentonville.
When the Pirate Tram was safely inside,
The gates clanged to with a slam,
And the Tramways Department gave three hearty cheers,
For they'd captured the Pirate Tram.

The Tram

By Keith S. Mason

From *Scottish Transport*, the magazine of the Scottish Tramway Museum Society, November 1971.

I stood at the stop, waiting, wondering
If it would ever come,
It was cold, very cold, foggy and miserable,
Oh, how I wished it would come.

The rails, they shone like gleaming gold
Guiding the trams both battered and old,
They went on through the night, straight and bright,
Never ending, not feeling the cold.

And then I heard it, clanging and rattling,
Rounding the 'hairpin' bend,
Its trolley whirled, sparkled, crackled,
I felt it was a God-send.

The lights, they were bright, shining and sparkling,
Oh, what a welcome sight,
I waited, thinking, watching them blinking,
Like sparkling jewels, they shone through the night.

I boarded it thankfully, ever so thankfully,
Pleased to get in from the cold,
I purchased a ticket, the conductor he clicked it,
His hands, weather-beaten and old.

I sat down on a comfy seat
And shut up like a clam,
Slumbering, dreaming, slumbering, dreaming,
To the clanging of the tram.

What a Blessing!

Anon.

Never full! Pack 'em in!
Move up, fat man, squeeze in, thin.
Trunks, valises, boxes, bundles,
Fill up gaps as on she tumbles.
Market baskets without number,
Owners easy nod in slumber
Thirty seated, forty standing,
A dozen more on either landing …
Toes are trod on, hats are smashed,
Dresses soiled, hoop-skirts crashed.

Thieves are busy, bent on plunder,
Still we rattle on like thunder.
Packed together, unwashed bodies,
Bathed in fumes of whisky toddies;
Tobacco, garlic, cheese and beer
Perfume the heated atmosphere.
Old boots, pipes, leather and tan,
And if in luck, a 'soap-fat man'.
Aren't this jolly? What a blessing!
A streetcar salad, with such a dressing.

To the Memory of the Midnight Tram

Anon.

There were tipsy blokes sae happy,
Bawlin' out 'Sweet Adeline',
There were lovers in the corner
Thinkin' everything was fine.
An' some folk tae see a sodger aff
Who sang 'For Auld Lang Syne',
On the dear auld midnight caur.

It usually was crooded out,
Wi' passengers a roar'n,
An' mony saw it flyin' past
When rain was steady pour'n,
But now it disnae rin at a',
An' mony mair 'll mourn
The passing o' th' midnight caur.

The Broomstick Train

By Oliver Wendell Holmes

Oliver Wendell Holmes (1809–94) was fascinated by the first electric trams to run in Boston's historic Beacon Street. He described them as 'new-fashioned cars with witch-broomsticks overhead', and wrote this poem about them.

They came, of course, at their master's call,
The witches, the broomsticks, the cars, and all;
He led the hags to a railway train
The horses were trying to drag in vain.
'Now, then,' says he, 'you've had your fun,
And here are the cars you've got to run.
The driver may just unhitch his team,
We don't want horses, we don't want steam;
You may keep your old black cats to hug,
But the loaded train you've got to lug.'

Since then on many a car you'll see
A broomstick plain as plain can be;
On every stick there's a witch astride –
The string you see to her leg is tied.
She will do a mischief if she can,
But the string is held by a careful man,
And whenever the evil-minded witch
Would cut some caper, he gives a twitch.
As for the hag, you can't see her,
But hark! You can hear her black cat's purr,
And now and then, as a car goes by,
You may catch a gleam from her wicked eye.
Often you've looked on a rushing train,
But just what moved it was not so plain.
It couldn't be those wires above,
For they could neither pull nor shove;
Where was the motor that made it go?
You couldn't guess, BUT NOW YOU KNOW!

T is for Tramway

Anon.

This Irish alphabet rhyme refers to the Bessbrook and Newry tramway in Northern Ireland, which opened in October 1885 and closed in January 1948.

T is for tramway, I speak it with awe,
Such a well-conceived project the world never saw.
The clean gorgeous cars are propelled by a power
Which resistlessly drives them at nine miles an hour.

Songs

Riding on Top of the Car

By Fred W. Leigh and V.P. Bryan

Famous in the music halls at the beginning of the twentieth century, this song, written by Fred W. Leigh and V.P. Bryan, with music composed by Harry von Tilzer, was sung by George Lashwood and other popular singers of the day.

Some people declare that a quiet country lane
Is the very best place for a spoon;
An old rustic stile must be there, they'll explain,
And not too much light from the moon.
Now, my girl and I live in town, you must know
Where quiet country lanes can't be found;
We've no rustic stile in our neighbourhood, so
Every time Sunday ev'ning comes round
Then we …

Chorus
… go go go for a ride on a car car car,
For we know how cosy the tops of the tramcars are
The seats are so small, and there's not much to pay,
You sit close together and spoon all the way,
There's many a Miss will be Missus some day
Through riding on top of the car.

We climb on the car where the journey begins
And we make for the first vacant seat,
For all other people we don't care two pins
So long as our comfort's complete.
And when the conductor comes up for the fares,
He punches our tickets then goes,
But gives us a wink as he pops down the stairs,
Like an overgrown Cupid in clothes
When we …

Chorus

We get to the end of the journey all right,
Or, at least, to the end of the track,
But while all the others prepare to alight,
We remain on the car and go back.
And when we get married – now, boys, here's a tip
That ought to be useful to you
We shan't spend too much on our honeymoon trip,
For we've made up our mind what to do.
We shall …

Chorus

Celebrating the centenary of the Blackpool and Fleetwood tramroad in 1998, these trams, on loan from the National Tramway Museum, return on an enthusiasts' tour to their former haunt at Fleetwood Ferry.

The Tramcar Song

Anon.

It was tuppence all the way and that was all you had to pay,
On the jingle jangle tram in London Town.
She was shaped just like a boat, throughout the streets she seemed to float,
She was painted very smartly gold and brown.

Chorus
When you took a penny single you could hear the bell punch jingle
As you rode a number sixty-one to Bow.
To be back in time for tea you could just catch a sixty-three,
With a jingle jangle jingle tingle glow.

For one shilling all the day, and that was all you had to pay,
You could ride from early morning until dark.
You could ride just where you like; it was much better than a bike –
All the way from Hampstead down to Richmond Park.

Chorus

Now in sun or rain or snow she kept on going to and fro.
She was painted just the same at either end.
At the end of ev'ry track, you'd find her front became her back,
And we knew her as a dear old faithful friend.

Chorus

The Tram

By Howard Broadbent and Jackie O'Connor

Howard Broadbent sang and co-wrote a song called 'The Tram' with Jackie O'Connor. A recording was made at the Cavalier Studios in Stockport in 1986, and Howard has kindly given me permission to reproduce the words. The whistling conductor mentioned in the chorus was Howard's uncle, George Greenhalgh, who survived Passchendaele in World War One. He was a poet and socialist and was known for the tunes he whistled on the Bolton Chorley New Road route to Horwich.

I can remember the days gone by,
Me and me Dad and me Mam.
Warm summer evenings we'd wait at the stop,
Listening for sound of the tram,
Clattering along on them tracks of steel,
Sparks flying, eh it were grand.
On down the hill it would screech to a stop,
Conductor would give us a hand.

Chorus
We would travel to town on the tram,
Me and me Dad and me Mam.
And the whistling conductor would whistle away
As we travelled to town on the tramcar,
Travelled to town on the tram.

I looked at conductor so longingly,
In truth I was quite mesmerised.
His uniform, cap and his ticket machine
Were magic to my little eyes.
He smiled at me and said, 'Come along,
We can't have you left at the stop.
Step on the platform and climb up the stairs,
There's plenty of room on the top.'

Chorus

Once up the stairs and we'd settled down,
Me and me Dad and me Mam,
We could see roof tops all over the town,
Travelling along on the tram.
Dad would say, 'Look, there's the Town Hall clock
Over them chimney pots there.'
I felt important on top of the world,
There's nothing could ever compare.

Chorus

The (Burnley) Tram

By Henry Nutter

Praising the Burnley and District steam trams, this song by Henry Nutter was first published by B. Moore in 1880 and sung at the Literary and Scientific Soirée in Burnley on 13 December 1881. It was brought to the attention of tram enthusiasts by the late Dr Michael Harrison in the autumn 1993 edition of *Tramway Review*.

Come around my merry boys, you that merit earthly joys,
While I sing a simple ditty here tonight;
Of the railway and the 'bus, people make a mighty fuss,
But a ride upon the tram is my delight.

Chorus
Then, tram, tram, tram it along the road boys,
With freedom, ease and elegance combined,
You will never have a jar, as you ride upon the car,
And you'll leave the rumbling omnibus behind.

The genius of our race has been moving on apace,
And inventing everything that we require,
You can travel now with ease on to Padiham when you please,
And the guard will put you down when you desire.

Chorus

Passing on to Brierfield, what a pleasure it will yield,
When you gaze on Pendle's noble crest of blue:
And the silent wheels will spin, straight away to Nelson Inn,
With the town of bonny Colne within the view.

Chorus

When conditions will afford you may trip to Barrowford,
'Tis the boast of Pendle Forest, and its pride:
The sweet village in the dale, where the pretty girls prevail,
Though the stately buildings stand upon one side.

Chorus

As you fleetly pass along, you may hear the Cuckoo's song,
And the little birds will chant upon the trees;
You'll repose in graceful style sat upon the velvet pile,
And from the danger well protected, and at ease.

Chorus

There is nothing that will mar people's comfort in the car,
Tis a place where use and ornament combine;
Thus a lady or a queen may be proud of this machine,
As she smoothly skims away upon the line.

Chorus

As along the road you pass, there will only be one class,
Where the rich and poor together may rejoice;
There is no distinction there for an Alderman or Mayor,
But the ladies though must always have a choice.

Chorus

Horses, waggonettes and sheep, must a proper distance keep,
And the cabman with his precious little load;
And the bridegroom with his bride must keep on the proper side,
For the tram has got a charter on the road.

Chorus

You will never hear the crash of the driver's cruel lash,
Nor his curses at the humble plodding team;
But with pleasure you'll proceed by a bonny iron steed,
For the easy cushioned carriage goes by steam.

Chorus

All the novelties in dress will around you gently press,
When you take up your position in the car:
Thus you'll have a pleasant ride with a lady by your side,
But the swell must go aloft with his cigar.

Chorus

On a Good Old Trolley Ride

By Jos C. Farrell and Pat Rooney

Sometimes on Sunday, for that is my fun day, you'll find me in the park
Watching the spooners and stargazing mooners, skylarking after dark,
But there's a pleasure, it's one which I treasure on Sunday afternoon
Out with my pearlie, my steady young girlie, this is the only tune:

Chorus
When speeding along on the trolley
I feel like a big millionaire,
A ride on the trolley is jolly,
Whatever you give up is fare;
The trolley's a hummer in summer
If you've got a girl at your side
To tease in the breeze while you're stealing a squeeze,
On a good old five cent trolley ride.

Some folks are wealthy and I'm only healthy, but health is wealth to me,
Pity the party who isn't so hearty, and can't stand jollity;
Keep all your wheeling and automobiling, that's not the only thing,
When it is sunny just give me my honey, and then you'll hear me sing:

Chorus

You don't have to go all the way to Hong Kong to ride on a Chinese tramcar; two run on the Birkenhead Heritage Tramway. Car 70 leaves Woodside Ferry, in the early days of the line, with a view of Liverpool's waterfront behind it.